Phaidon Encyclopedia of
Surrealism

Phaidon Encyclopedia of
Surrealism
René Passeron

Phaidon

Translated by John Griffiths

Phaidon Press Limited
Littlegate House, St Ebbe's Street, Oxford

Published in the United States of America by
E. P. Dutton, New York

This edition first published 1978
English Translation © 1978 by Phaidon Press Limited
ISBN 0 7148 1898 4 Hardback
ISBN 0 7148 1912 3 Paperback (U.S. only)
Library of Congress Catalog Card Number: 78-62587

Original French edition *Encyclopédie du Surréalisme*
© 1975 by Editions Aimery Somogy, Paris
Illustration © S.P.A.D.E.M. and A.D.A.G.P.

Printed in Italy

Contents

Introduction

It may seem rather odd to write about Surrealist art, for the Surrealists in propounding their theory consistently adopted the abusive anti-art propaganda of the Dadaists. At the very least Surrealism has treated the ideas of the work of art and art as a profession as generally ludicrous products of the conceit to which artists are notoriously subject. Nevertheless André Breton himself testifies to the existence of Surrealist art in his *Genèse et perspective artistiques du surréalisme* (1941). Following Breton, I include under Surrealist art everything within this still inadequately charted movement that has to do with the visual arts, painting, sculpture, collage, objects, photography, and cinema—but that is all. Surrealist verse and associated topics, as well as Surrealist philosophy and ethics, are touched on in this volume only insofar as they help to elucidate what Brauner has called 'picto-poetry'. It is sometimes said that Surrealist art is a literary art; on the contrary, as against the far too 'retinal' sense-impressions that Impressionism contributed to twentieth-century art, Surrealist painting adopted a programme already associated with the Symbolists (and before them with Leonardo da Vinci), which declared, in effect, that painting is properly a spiritual activity. Psychoanalysis encouraged the Surrealists to allow the painter's spontaneous impulses full rein, in contradistinction to an abstract art for which the pictorial was in fact the geometrical. This spiritual activity—and in 1934 Tristan Tzara defined poetry thus—is accordingly a function of the imagination and, more profoundly, through the imagination, of desire.

Before giving essential details of the life and works of Surrealist artists, I want to examine the creative approaches and achievements of the movement. The nature of Surrealism requires us to be aware not only, in aesthetic terms, of the works it has produced but of the practice which it represents. The visual world on the fringe of the extraordinarily swift and far-reaching linguistic revolution brought about by Surrealism was the field of play of the dialectic of the visible and invisible realms. The problems to be resolved there were all the greater because of the prestige with which Monet's 'eye' had invested twentieth-century art. But this reputedly civilized century has retained too many dark shadows for us to rest content with any mere ocular pleasure. Essentially, Surrealist painting is a matter neither of the eyes nor of the hands. It has to do with the heart.

A Short History

The literary period

Immediately after the 1914–18 War, the cultural sensibility of Europe was in a lively state among those young people whom the slaughter and the high-minded propaganda of the belligerents had brought to a state of heart-felt protest. Among others it was still somnolent, seemingly atrophied indeed by nationalist manifestations and the depressing fear that the best people were dead. The period before the war had been rich in discoveries and innovations: in painting there had been Fauvism, Cubism, the abstractions of Kandinsky and the Blue Rider movement (centred on Munich), the extension of Expressionism from the last sparks of the *Jugendstil* version of *Art Nouveau*; in poetry the works of Apollinaire, Reverdy, Max Jacob, Marinetti and the Futurists; in fiction the novels of Proust and Joyce; in sculpture Boccioni and the first exploitations of the potential of reinforced concrete (Frank Lloyd Wright and Walter Gropius); in music the achievements of Stravinsky and Schönberg; in the theatre Claudel, Copeau, Appia, Edward Gordon Craig; in dance Isadora Duncan and Diaghilev; and in the cinema a new wave with the Feuillade series which among other things made film the kind of popular art which was to inspire Magritte. Europe was certainly not without genius, before war brought a murderous rebuff to the optimism of industrial civilization and a rift in the European unity which had been forming, at the level of the arts at least.

Dada was carving out its place. The anti-art manifestations of Marcel Duchamp which had been building up from 1914 were supplemented from 1916 by the uproar organized and promoted by Tristan Tzara and the leading lights of the Cabaret Voltaire in Zürich. The irony of the Dadaists was directed against art, of course, and particularly academic art, but also against political society as a whole, and against manners and conventional ideas. Tzara arrived in Paris in 1919, at a time when the review *Littérature*, which had just been founded, was bringing Louis Aragon and André Breton in touch with such writers as Fargue, Gide and Valéry. *Littérature* was destined to become the centre of Parisian Dadaism, and the first 'Monday articles' of the journal, January 1920, provoked a scandal and a riot. Meanwhile, in Berlin events had taken a more tragic turn: the Communist politicians and writers Karl Liebknecht and Rosa Luxemburg had been assassinated. *Der Dada* (Huelsenbeck, Hausmann) proclaimed the death of art and that Dada was 'politics'. The only issue of *Der Ventilator*, in Cologne, printed 20,000 copies. Max Ernst and Hans Arp together with Baargeld, the founder of *Der Ventilator*, organized an exhibition which brought the police to the little restaurant where it was held.

BELLMER, HANS: *Tristan Tzara*, 1954. Pencil drawing,
60 × 40 cm

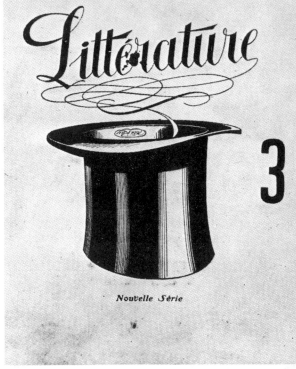

RAY, MAN: *Cover of No. 3 of 'Littérature', New Series*. May
1922

The means used by this agitation passed at the time for anti-art, but they very soon became—to some extent along with Surrealism—an integral part of a renewal of artistic activity: phonic poems (Schwitters), 'words in freedom' from the Futurist Marinetti, noise recitals by the Futurist Russolo, 'ready-mades' from Marcel Duchamp, drawings combined with texts (Picabia), collages (Ernst), ink blots (Picabia), assemblages of rubbish (Schwitters), *Mona Lisa* moustaches (Duchamp, Picabia, the cover of *391*, No. 12, March 1920), and recourse to the strangest materials as well as to sheer chance (Arp, Sophie Taeuber-Arp). A number of technical processes and creative approaches applied by the Surrealists were invented by the Dada movement.

Breton, like most of the future Surrealists, took part in the Dada meetings, and the first 'automatic' text that he published with Philippe Soupault in 1921, *Les Champs magnétiques* was classified as Surrealist much later on. It was written in the spirit of Dadaist spontaneity. But it also proves by the power of the imagery and a certain experimental seriousness, that Breton in spite of all the Dada fuss never lost hold of the thread which joins his poetry to that of Apollinaire and Reverdy, and to Symbolism. That was why he was soon to break with Tzara and Picabia.

Francis Picabia arrived in Paris at the same time as Tzara. He came from America by way of Barcelona, where the journal *291* became *391* in 1917. This review-pamphlet reached nineteen issues by 1924. On arriving in Paris, Picabia had shocked the Salon d'Automne, of which he had been a member since the time of *Udnie* and of *Catch as Catch Can* (1912), which are among the most important non-figurative paintings of the twentieth century, by exhibiting the products of his mechanist period. His playful, cheeky works were loaded with 'adjunctions', or additions, such as matches, feathers and fuses. During the same period, Marcel Duchamp was in New York working on his large painting on glass,

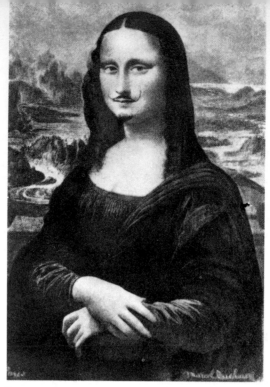

DUCHAMP, MARCEL: *L.H.O.O.Q. Reproduction of the Mona Lisa of Leonardo da Vinci with Moustache and Beard Added in Pencil*. 1919. 17.7 × 12.7 cm. Collection: Mrs May Sisler, New York

The Bride Stripped Bare by her Bachelors, Even, which he abandoned unfinished in 1923 in order to devote himself—so he claimed—to chess. After his success in the Armory Show, a major exhibition of modern art in New York in 1913—among the works Duchamp showed there was his *Nude Descending a Staircase*—he had signed, from 1914 onwards, ready-mades or mass-produced commercial objects obtainable from an ironmonger, and had exhibited them as sculptures. The most daring of these was a porcelain urinal signed 'Richard Mutt', which the Independents' Show in New York had indignantly rejected. Duchamp never allowed his renunciation of art to separate him from his friend André Breton, and he was one of the inventors of Surrealist objects who remained most faithful to the Dada spirit; his inventiveness was to prove invaluable to the great international Surrealist exhibitions. He had worked at New York, in the *Camera-Work* circle (Stieglitz's review), together with the young Man Ray who as draughtsman and photographer was to become one of the assiduous illustrators of *La Révolution surréaliste*.

But on the eve of the Barrès trial[1] in 1921 the break came between Breton and Dada. It was not because Breton wanted some kind of return to peace; the Surrealist 'interventions' show rather that it was a question of making the effect of public scandals more obviously offensive: more serious and less diffuse, in fact. The Barrès trial, the celebration of the death of Anatole France by the pamphlet *Un Cadavre* (*A Corpse*, 1924) the *Lettre ouverte à Paul Claudel, ambassadeur de France au Japon* (1925), and the outrageous Saint-Pol Roux banquet at the Closerie des Lilas (1925), sufficiently indicate the aggressiveness of the young Surrealists. It is true to say that the essence of the matter was already elsewhere, and the spirit of experiment was trying to link poetry and knowledge. That association is a basic principle of Surrealism. The title of the review *Littérature* was a 'wholly imaginary label' (Breton); it records the results of the decisive experiments which are at the roots of Surrealism: the 'sleeping period' or 'era of dream-work', which Aragon was to speak of in *Une Vague de rêve* (*Commerce*, 1924), covered the years 1920–3. *Littérature* published Breton's text, *Entrée des médiums*, which contains descriptions of the hypnotic sleep sessions during which Creval and Desnos talked, wrote and drew. Accounts of such sessions appear in the issue of

1 December 1922. There is Desnos (alias Rrose Sélavy) asleep, playing language games which from time to time conjure up a sparkling image. But Surrealism was in no position to become a metaphysical research institute, and experiments on the periphery of insanity aroused a certain fear that that might be happening. Breton cancelled these exercises, and art and poetry assumed their rightful places once again, but having benefited from the lesson that had been learnt.

When Dada split into mini-groups, a single, compact Surrealist group eventually formed. In June 1924 the last issue of *Littérature* appeared. The headquarters of Surrealism, the *Centrale Surréaliste*, were established and from here was published on 1 December 1924 the 'most shocking review in the world', *La Révolution surréaliste*. And Breton published the first *Manifesto*. Surrealism had arrived.

The Surrealist revolutions

The vagaries of history have obscured many people and events yet the lasting products of the movement are brought into sharp relief; the written and painted works, the tracts, manifestos and reviews

'*La Révolution surréaliste*'. *Cover of No. 8, second year.* December 1926. Bibliothèque Jacques Doucet, Paris

GIACOMETTI, ALBERTO: *The Time of Traces.* 1930–1. Object with symbolic function. Kunstmuseum, Basle

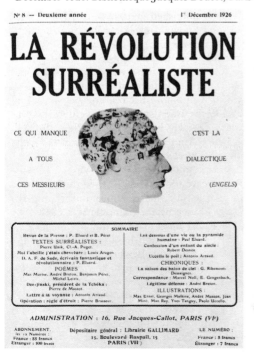

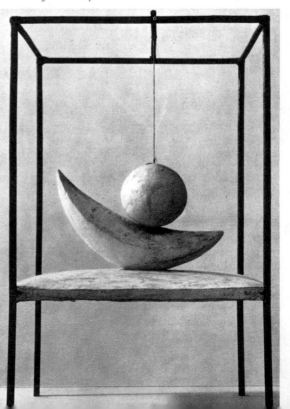

—the liveliest expressions of the group's collective life. The reviews themselves are remarkable signs of the ideological development of Surrealism. The first two used the word 'Revolution', then the term disappeared.

Directed at first by Pierre Naville and Benjamin Péret, then from issue No. 4 (1925) by André Breton, twelve numbers of *La Révolution surréaliste* appeared between December 1924 and December 1929, the year of Dali's arrival, but also and most importantly the year of the *Second Manifesto* which Breton used for a fierce purification of his group.[2] Aragon, Breton, Eluard, Péret, Unik were then and had been since 1926 members of the Communist Party. They were expelled in 1933, the year of the last issue of the review *Le Surréalisme au service de la révolution* (*L.S.A.S.D.L.R.*), six numbers of which were produced between July 1930 and May 1933.

La Révolution surréaliste deliberately practised intellectual violence. The first issue published a photograph of Germaine Berton, who had just killed Marius Plateau, a member of the extreme right-wing *Action Française*; the portrait appeared surrounded by photographs of all the members of the group. It also raised the question: 'Is suicide a solution?' and contained a number of dream reports and 'automatic' texts. We must remember of course that for most of the Surrealists suicide was never a solution. The second issue (January 1925) featured the text 'Open the prisons, disband the Army!'. Open letters, such as those of Breton to Delteil, or of Desnos to Pierre Mille, an address to the 'warped Pope' (No. 3, 1925), and a 'letter to the medical directors of asylums for the insane', are complemented by a dispute between Aragon and the Communist journal *Clarté*.

However, a committee for action against the war in Morocco having issued a manifesto, the Surrealists associated themselves with it, made their peace with *Clarté*, and signed the violently anti-nationalist text 'La Révolution encore et toujours' published in *La Révolution surréaliste* (No. 5, 1925). Violence and black humour did not put a stop to the poetic and ethical experimentation: issue No. 9–10 (October 1927) was devoted to 'automatic writing' and the last issue posed the famous question: 'What hope do you place in love?' The illustrations in this review, intentionally austere in appearance, were much less politicized than the content, and less anxiously polemical. Man Ray, Chirico, Ernst, Klee, Masson, Picasso, Magritte, Miró, Tanguy and Arp let the others speak out, secretly sure that in the long term they would be the vehicles of the real revolution in sensibility.

That revolution also took place through the medium of automatic writing; especially Eluard's poems, like *Capitale de la douleur*, 1926, and novels such as Aragon's *Le Paysan de Paris*, 1926, and Breton's *Nadja* (1928). Breton knew what Surrealism owed to the painters and in *La Révolution surréaliste* (No. 4) had begun a series of articles on painting which were collected in 1928 as the first edition of his now famous book *Le Surréalisme et la peinture*.

When the first issue of *L.S.A.S.D.L.R.* appeared, the *Second Manifesto* had made ravages in the ranks of the Surrealists, and those expelled answered Breton with a caustic pamphlet, *Un Cadavre*. Breton had supported Trotsky who had been refused political asylum in France. The following year, Aragon attended the Kharkov Congress and discovered Soviet reality in the arms of Elsa Triolet. The Aragon who now became so enamoured of Stalinist Communism had previously written of the October Revolution: 'On the ideological level, it is at most a vague ministerial crisis'[3] and had lumped together the 'tapir Maurras' (of the Right) and 'imbecilic Moscow'.[4] Leaving his friends in 1931, he turned as violently against the dreams of his youth as Chirico, whose 'apostasy'[5] he had condemned. In spite of this crisis, 1930 was a vintage year for Surrealism: in addition to the new review, there appeared one of the most beautiful poetic texts of the movement: *L'Immaculée Conception*, an attempt at pathological simulation by Breton and Eluard. Giacometti also produced his first 'dumb mobile object', *The Time of the Traces*. Henceforth there was no stopping the creative impulse of Surrealism. In 1931, Breton published *Les Vases communicants* and allowed himself the luxury of a dispute with Freud. Dali was breaking out, and together with Buñuel produced his second film: *L'Age d'or*, which was as lyrically shocking as *Un Chien andalou*, 1930.

'Transform the world, said Marx; change life, said Rimbaud; these two instructions are one as far as we are concerned', Breton wrote in 1934 in *Position politique du surréalisme*. But, to do it justice, *L.S.A.S.D.L.R.* did make an attempt to unite free poetic and moral creation with the discipline of revolutionary struggle, as if individualism and 'party spirit' were really compatible. The political stalemate of Surrealism arose from its inability to overcome this contradiction, which was perhaps one that never could be overcome. Zhdanov imposed on the Soviet Union in 1934 the notion of art as a political weapon, and laid down the tenets of 'Socialist realism'. The Stalin era had begun. It was time to pull back. 'Traduced' by a revolution which they had said they 'saw only on a social level',[6] the Surrealists withdrew into the labyrinth of myth. The review *Minotaure* was about to be launched.

From Minotaure to VVV

In 1933, for the first time for nearly ten years, Surrealism had no review of its own. It was entering a phase of worldwide expansion. The exhibitions, such as that of 1932 in New York and that of 1933 at

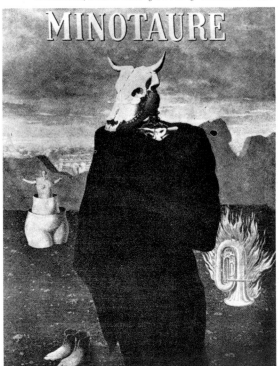

MAGRITTE, RENÉ: *Cover of No. 10 of 'Minotaure'*. 1937

the Pierre Colle gallery in Paris, André Breton's lectures and interviews (Prague, Zürich), the founding of several groups abroad (in Czechoslovakia, Switzerland, Great Britain, Japan) showed not only the inward vitality of the movement, but the need for it in a world where anxiety about the immediate future recurred on the fringe of full-blown Fascist régimes, industrial civilization could hardly overcome a crisis for which capitalism was responsible, and art was typified by the rise of geometrical abstraction and what Dali was to call 'our masochistic architecture'.[7] Dali himself had just proved a great success in New York. A brilliant eccentric and fabulator, he had become associated with the Surrealists in 1929 and had suggested—mainly in *La Femme visible* a new means of achieving a fusion of the imaginary and the real—his 'paranoiac-critical method'. His paintings, for instance *The Enigma of William Tell* (1933), had abandoned automatism for a kind of dream record.

The review *Minotaure*, beautifully produced by Skira, appeared for the first time in June 1933. It was edited by E. Tériade. The Surrealists co-operated to some extent and in 1935 published an *International Bulletin of Surrealism* (No. 1, Prague; No. 2, Brussels; No. 3, London, 1936). Breton and Bataille took part in the anti-Fascist group Counter-Attack. It was only with the tenth issue of *Minotaure* (December 1937) that the Surrealists took complete control of the magazine. Some newcomers, Hérold, Bellmer, Paalen (1935), Dominguez, who invented his 'decalcomania' technique in 1936, Ubac, and Seligmann (1937) swelled the ranks of the painters and object makers who together with Picasso (then very close to the Surrealists) illustrated the review. In spite of its lasting though uneasy political concern (a tract against the Moscow trials, 1936, Péret's part in the Spanish Civil War, the expulsion of Eluard and Dali for otherwise contrary political reasons, the meeting of Breton and Trotsky in Mexico in 1938), Surrealism made an 'artistic' turn emphasized by the considerable success of the major international Surrealist exhibitions, in London in 1936 and in Paris in 1938. Breton was running the Gradiva gallery in Paris and published *L'Amour fou*, a lyrical essay in which questions of premonition appear together with those of automatic writing.

In the *Minotaure* era Surrealism really came into its own, both on the theoretical and political levels and on that of the various arts. The international exhibition at the Galerie des Beaux-Arts in Paris in 1938 was deeply innovatory in its very conception: instead of exhibiting works, the Surrealists poetically transformed an office building into a quasi-magical location, and the Surrealist Street, decorated with suggestive models, was as successful as the whole enterprise (though this success owed nothing to the scandals that had marked the first stage of Surrealism). Breton and Eluard were already generally respected major poets; Dali, Ernst, Miró and Tanguy, just like Magritte later, were acknowledged as first-rank painters, and Arp developed—half-way between Abstraction· and Surrealism—a form of sculpture that won acclaim. The Surrealist objects that, in the manner of Giacometti, all the sculptors in the group produced at the level of an independent art-form, were typified by Bellmer's *Doll* and Meret Oppenheim's found things. In short, Surrealism was in the process of becoming a School.

It was just then that the Second World War broke out. In 1939 Dali, Tanguy (who followed his wife, Kitty Sage) and Matta went to the United States. Paalen moved to Mexico, where Breton and the painter Rivera published the bulletin *Clé*, the organ of the *F.I.A.R.I.*—the French initial letters of International Federation of Independent Revolutionary Artists. An international Surrealist exhibition was held in Mexico in 1940. In the same period France experienced both exodus and collapse. Most of the Surrealists, including Breton, who had returned to Paris in the meantime, and Ernst, released from Milles camp where the French had interned him (he was German by nationality), met at the Château d'Air-Bel, near Marseilles. There the Fry Commission was looking after refugee artists. They played Surrealist games; they invented the Marseilles 'tarot'; then they were all taken by sea to America. Eluard, Picasso, Brauner, Dominguez, Hérold, Bellmer remained in France, and Magritte in Belgium. Their diverse fate (or destination) had two main consequences: on the one hand, the Surrealists in exile gave new strength to the American artistic avant-garde; on the other, the return of the exiles after the war did not provide the

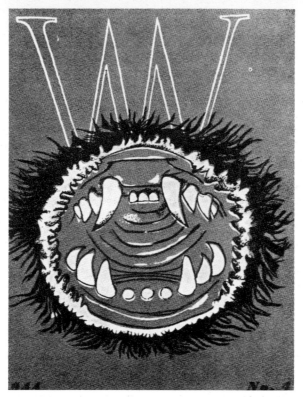

MATTA, ROBERTO MATTA ECHAURREN: *Cover of No. 4 of VVV.* 1944

opportunity for a general regrouping of the Surrealists, since the experiences of those who had stayed in France had been too different from that of the refugees.

In the United States Breton broadcast on the radio. In 1941, he took his bearings in *Genèse et perspective artistiques du surréalisme.* The word 'artistic' in the title shows how far he was from the anti-art concerns of early Surrealism; the *Minotaure* era had not come to an end. Breton met the painter Motherwell and members of the New York School who were then followers of Picasso. Motherwell, Gorky, Baziote and Pollock were stimulated by the example of Ernst, Masson and Tanguy. Breton published *Prolégomènes à un troisième manifeste du surréalisme ou non*, which recalled the principles of the movement, and David Hare published the review *VVV*, edited by Breton, Duchamp and Ernst. Three issues came out from June 1942 to February 1944.

It is important to note that the lack of café life in the United States, and the way in which the painters were dispersed—with some in Arizona (Ernst, Dorothea Tanning), some in California (Man Ray), and some in Connecticut or elsewhere—did not allow the re-establishment of the European pre-war system in which the Paris cafés had played such a major part. This dispersion was complemented by various differences made worse by disputes. Masson parted company with Breton; Paalen left Surrealism in order to start the review *Dyn* in Mexico and the Dynaton movement. Peggy Guggenheim's Art of this Century gallery in New York exhibited the Surrealists, but Abstract Expressionism was already making itself felt in Pollock's work. Only one major exhibition was held in New York under the aegis of the Surrealists, the *First Papers of Surrealism* (1942).

In the same period the Surrealists in Europe had gone to ground. Miró went from Varengeville to

Montroig, in Catalonia, to finish his *Constellations* series. Bellmer hid in the Toulouse area. Brauner, in the Alps, started painting in wax, for want of other materials. In Paris, the young poets, supported by Picasso, published the *La Main à plume* issues, especially *Poésie et Verité 42* by Eluard. Antonin Artaud was in the psychiatric clinic at Rodez, and Desnos died in a concentration camp (1944). When Breton returned to Paris in 1945, the era of retrospectives had already begun with a Max Ernst exhibition. Maurice Nadeau published his *Histoire du surréalisme* in which he seemed to set it in a buried past.

Obscurity and fame

The movement had to recover, reanimate its followers, and open the way for newcomers. In fact two things helped to extend the rift caused by exile. The first phenomenon was political; in the Liberation euphoria the French Communist Party, which was at that time *the* Party of the Resistance, won a size and influence without precedent. It was not until 1948 with the beginning of the Cold War that it returned, on the cultural plane, to the most sectarian kind of Zhdanovism. The young Surrealists from the *La Main à plume* group connected with the Dutch *Reflex*, the Czechoslovak *Ra* and the majority of the Belgian Surrealists, had fraternized with the Communists during the Occupation. Noël Arnaud, Christian Dotremont, and Asger Jorn thought they could repeat Breton's experience between 1926 and 1933. They founded the Revolutionary Surrealist Group, which wanted both freedom of poetic creation and disciplined militant action. Scorned both by Breton's group and by the Stalinists, the French revolutionary Surrealists disbanded in 1948, leaving Copenhagen, Brussels and Amsterdam to carry on with purely artistic activity in the *Cobra* group (1948–51).

Breton, however, whose anti-Stalinism had become a firm anti-Communism in the United States, gave an interview to *Le Figaro* on arriving in Paris, and published *Rupture inaugurale* and then *La Lampe dans l'horloge*, a kind of manifesto for a pessimism which henceforth would be associated with his group. Certainly he had good reason for his conduct in the scandal of the Soviet concentration camps, and the Prague *coup d'etat*, even before the Hungarian uprising and other similar events. Nevertheless, the anarchist tendency of Surrealism furthered its decline into obscurity. The second phenomenon was that in the United States Surrealism had burgeoned and broadened, and had even experienced the sweet smell of success, whereas in Europe the talk was of 'going to ground'.

On the other hand, those who had survived the Occupation, whether they were from the old guard of Surrealism (Eluard, Tzara, Magritte), or younger (Dominguez, Hérold, Ubac), wished to publicize a new-found vitality. Far from sharing the increasing admiration of Breton's followers for esotericism, alchemy, and voodooism—an admiration shown in the occultist character of the International Surrealism Exhibition in 1947 (Galerie Maeght, Paris)—and far from searching for a 'new myth', even to the extent of adopting the myth of Gary David, 'citizen of the world' (1948), they shared in the humanist generosity that had emerged from the Resistance. They found in Bachelard's surrationalism, as in lyrical abstractionism, new forms of the freedom of the spirit. In fact, aware of the utopian character of what they were doing, the revolutionary Surrealists gave an intentionally Dadaist twist to their lively sessions of 1947–8 in the Salle de Géographie in Paris. It was then that the circle round André Breton, which published the review *Néon*, broke up. Matta was expelled on the basis of gossip; Brauner and Alain Jouffroy followed him.

This seems to have been a period of marking ideological time, to a certain extent, for Surrealism was between its weighty and brilliant past and an ill-defined future; the Carrouges affair, in which Breton

brutally quashed the possibility of a Catholic Surrealism,[8] is indicative of its attitude (1951). The group's political tracts kept a firm line: *Hongrie, soleil levant* (1956), *Contre les physiciens nucléaires* (1958), the signing of the *Manifeste des 121* for rejection of the Algerian War, and so on. But more reviews continued to appear, as if none of them had succeeded in finding an effective voice for a murky struggle. After *Néon*, there was *La Brèche, action surréaliste* (eight issues from 1962 to 1965), *Médium* (thirteen issues from 1951 to 1955), *Surréalisme même* (five issues from 1956 to 1959), *L'Archibras* (seven issues from 1967 to 1969), and finally the *Bulletin de liaison surréaliste*, the internal organ of the group of poets and painters who had remained faithful to the movement after the death of André Breton (1966).

Those were dark years in which death seemed at times to have the upper hand: Artaud (1948), Eluard (1952), Picabia and Heisler (1953), Tanguy (1955), Wilhelm Bjerke Petersen (1956), Tzara (1963), Arp and Brauner (1966), Magritte (1967), Duchamp (1968), Picasso (1973). The following committed suicide: Gorky (1948), Dominguez (1957), Paalen and the young Jean-Pierre Duprey (1959), Kay Sage (1963), Seligmann (1962). Of course life continued with Toyen, Wifredo Lam, Leonora Carrington, Meret Oppenheim and Bellmer, and brought a new wave of poets and painters: Bédouin, Bounoure, Joyce Mansour, Octavio Paz, André Pieyre de Mandiargues, Marcel Jean, Remedios, Jean Benoît and Mimi Parent, Enrico Baj, Alechinsky, Télémaque, Gironella, Silbermann, Svanberg, Sterpini, Klapheck, Lagarde and Camacho. The relative obscurity of Surrealism did not affect the success of its major exhibitions, such as *L'Ecart absolu* (Paris, 1965), or, a few years earlier, the EROS exhibition (1959–60) where the problems of love, eroticism and sexual freedom, which have recently become such fashionable issues, had been treated in depth by this 'obscure' Surrealism. The contribution of Molinier and the growing fame of Bellmer are, as far as painting is concerned, testimony of this.

Is it possible for poetry and painting to be so obscured by events that they 'go to ground'? Of course a sect can do that, and seek refuge in its rituals. But the works remain. Like life itself, they are expansive. They are intended to confront the world, and they have and acquire a sometimes unforeseeable meaning. The worldwide fame of Max Ernst, Miró and Magritte dates from the 1950s. The Venice Biennale acknowledged Arp, Ernst and Miró in 1954. Masson was given official commissions, like that for the ceiling of the Odéon (Paris, 1964) which is one of his masterpieces. Picasso drew the crowds at his Paris retrospective in 1966, while Magritte was an example to the young Pop Artists. The fame accorded to individual artists was accompanied by an increasing spread of the principles of Surrealism, and since the American period automatism had given rise to a kind of abstract Surrealism, before launching into lyrical Abstractionism. Since the last war there had been evident a contradictory phenomenon, well assessed by Robert Lebel when he remarked that 'Surrealism tends to become obscure at the very moment when the Surrealist painters become famous.'[9]

Of course fame is not without risks. Surrealism breathes with difficulty in an air heavy with its own spirit. We have now entered the era of diffuse Surrealism. It is not that appearances deceive us; it is not only a question of the lasting effect of oneirism, the marvellous, eroticism or anti-art in the scanty products of young painters of today; it is the true spirit of Surrealism which circulates here and there and which we saw explode in Paris in an insurrection. In 1968 'the spirit of May' was not that mixture of aggressive excess and sectarianism which is only a degraded form of that true spirit. It was a great life-giving breath. A crowd that hardly believed what it was doing shocked institutions and complacent officialdom. Young people were alarmed and concerned at the inadequacies of the world imposed on them by their elders and the uncertainties of the roles accorded them, especially when their future seemed to be an uneasy choice between unemployment and acting as the punitive instruments of the bourgeoisie. Michel Leiris came a cropper in 1920 for having cried in public: 'Long live Germany!' The Surrealists had left the 'somnolent period' to put themselves at the service of the Revolution, knowing that they were the bearers of its lyrical utopia and any remaining hope from the romantic dreams of 1917. In 1968 the Surrealists were present at a summons to life, a descent of poetry to the thoroughfare: 'We are engaged in spontaneity!' 'The

beach beneath the street!' 'Create, for whom, for what?' In these slogans and their associated attitudes there are traces of anticultural mysticism, of a rejection of cretinization through labour, of an allergy to the language of domination and a desire for dialogue, a demand for free love in flower-people fashion: 'Make love, not war!' The atmosphere of Paris 1968 recalled the cry of 'Open the prisons, disband the Army!' of *La Révolution surréaliste* (No. 2, 1925), the right to indolence, the 'unlimited eroticization of the proletariat',[10] and the love credo of the great poets of Surrealism.

It is outside my brief here to analyse more precisely the situation which the disciples of André Breton found in the hippy movement, the renewal of spontaneity, the eulogies of utopia evoked by our ecological worries, the development of Freudian and Marxist studies, the interest of young people in Marcuse and Reich, the critical attack on museums and the taste for popular culture, anti-psychiatry, anti-authoritarian teaching, the struggle of the women's movement against outdated laws, and talk—whether official or not—of the 'quality of life'. It is interesting that the pundits of the socially acceptable intelligentsia and cultural fashion—who had just discovered, not without some delay, the Russian Formalists of the early years of the century and the importance of linguistics—arrived at a form of structuralism grounded in the ethnological study of myths, whereas young people when they opened a few windows in May 1968, inveighed against all structures, politics, poetics, whether rational or irrational, innovatory or traditional. They brought with them a whirlwind of contestation which has not yet finished with our society. Certainly in contemporary painting we see an interest in structure dominant over the abstractionist interest in 'support surface', and hyperrealism paying homage to the 'external model'. But overall painting is in a full crisis of self-contestation. Art is dead. Anti-art is on the way out. Neo-Dadaism, pataphysics, new objectivism or conceptual art—various echoes perhaps of Vaché's harsh verdict: 'Art is absurd'. Certainly the modernist wing of painterly and sculptural research finds a renewal of means in technology, and the 'retinal' products of Op Art sometimes claim to condition the masses by means of cybernetic ploys. But the individualism of those who are not yet reduced to the condition of Pavlov's salivating dogs, and scorn the publicity, and educational and televisual forms of this conditioning, sometimes turns (as with the most recent form of Surrealism) to violent or non-violent anarchism. It discovers in the 'poetic life' the best form of rebellion against a society which far from cultivating its poets, excludes them by the sheer fact that, whether it is capitalist or socialist, East or West, society above all is functioning, it is order, it is a productive machine, a consumer machine, a machine to make consume: in short, philistine.

All that I am about to say about Surrealist painting will make sense only if the works are constantly seen—even when conserved and restored by museums—in the light of this refusal to join what was—and remains—the radiant core of the poetry of Surrealism.

Pictorial Surrealism

A canvas by Max Ernst

The fingers are holding a brush and describe wandering lines on the canvas, trajectories of a kind in a nebulous space, where the ghost of a vegetal form threatens to coalesce. The hand is a left hand; and the wrist, as smooth as a woman's, moves with affected grace. I am describing the right-hand side of Max Ernst's *Surrealism and Painting*.[11]

Here Ernst has represented painting itself—just as Surrealism should be thought of as conceiving it—as creation, rather than aesthetic emotion. The left-hand section of the picture shows Surrealism on a pedestal: it is a monster. Resting on a kind of block—not without a certain majesty—and on the double foot of a pachyderm, its greenish mass invades the milky light over the heavily emphasized base horizontal. Its flaccid or merely fluid shapes recall those of Hans Arp's sculpture, but evoke internal viscosities, the burdened unconscious, more than any elegantly described volume. They move upwards, and the great arch of the back joins the heavy leg that dominates the left-hand side to the unnaturally feminine arm sinuously extended in the act of painting in the right-hand section. At the centre there is a magma where the forms are entangled and interlaced in lascivious contortions. It is possible to pick out a few bird's heads with half-closed eyes, some female curves, possibly a pre-pubescent pubis, the shape of a breast, knees, and a flexed thigh. This organic knot seems wholly self-centred, and it is surprising to note, after careful observation, that its tentacle (which would be a wing if the bird with the larger head was a feathered creature) is in fact actually drawing. On the pedestal are the shapes of utensils, displayed as emblems, including a painter's scraper.

The whole picture is like a slowly unfolding stage set. Since it is a representation of pictorial Surrealism, the image is more important than the actual painting, technical effects (though Ernst was often concerned with them) being wholly excluded in this case. The title the painter gave the picture stresses his debt to narcissism, eroticism, masochism, black humour, the spirit of revolt and the dialectic of truth. It might seem that Max Ernst—like Nietzsche, who said that one ought to write with one's blood—is recommending that we should paint with the libidinal shapes and phantasms that inhabit us. In fact he is recapitulating his own past. This canvas is one of the last in which Ernst gives expression to the demons which powered his series of collages, his feather-flowered *Jardins gobe-avions*, and his birds. He turned to the representation of happiness, one might say, and this picture is a farewell to what had gone before. A few years later, after meeting Bazaine, he was to include his *School of Gulls* among the works of the School of Paris.

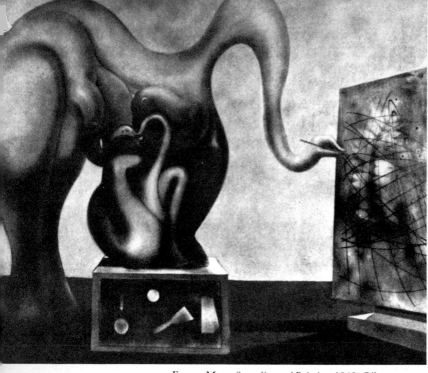

ERNST, MAX: *Surrealism and Painting*. 1942. Oil on canvas,
195 × 233 cm. Collection: William N. Copley, New York

Nevertheless this painting, more than Breton's book from which Ernst took the title, seems to symbolize the Surrealist attitude in art. It is not a lecture but a self-critical image. It is a self-portrait of the painter at work. We admire the precision and the careful distances between the abstract lines described on the canvas within the painting, and the fact that the monster produces them with a blind limb, like a sleep-walker. For the monster is at the same time both the painter and his model—that 'interior model' to which Breton said painting should be restricted if it was to be authentic. Surrealism as a whole is present here, but it is Surrealism in action rather than the verbal variety. The man who paints, his unconscious, and the canvas he is painting all depend on different existential and semiotic registers which are probably irreconcilable. Only the artist is able, by virtue of his visionary recall, to judge the mutual incomprehension of the unconscious and the painting at the very moment when his picture displays the presence of this inadmissible obscurity at the superficies of the world of forms.

To paint a monster which itself is painting, in order to state that one must paint with one's monsters, means that the artist both submits to this demand and at the same time evades it, by means of something approaching a surgical intervention. The source monsters suddenly become, by their translation into the world of paint, mere products: the objects that in fact they cannot become. They are seized in an external aspect and moved to the level of appearance, indeed of pictorial appearance. This gives them, despite their monstrosity (insistent lest it disappear), the factitious status of those overly pretty and intellectual, quasi-mathematical lines, which the unconscious, disloyal to its own nature, is describing. The painting within the painting which is half-visible on the right suggests the facticity of the work as a whole which strives nevertheless to be an authentic representation of its origins. Ernst's picture is a portrait of the painter at work with his model; it is at the same time a demonstration of the infidelity of the painting to any model; it is, in short, the portrait of an unfaithful bride.

This triple portrait allows a suggestion of a family relationship between the painter and his monsters in order to deny any resemblance between them and the work itself, which Surrealism nevertheless maintained ought to be their daughter. It is something like the Cretan paradox (the Cretan says that all

Cretans are liars). Ernst seems to be affirming the failure of the Surrealist approach in painting by means of a canvas which, so it appears, testifies to its success. Ernst's own hand (even if the monster's arm is its reflection) has not described any pleasing or musical curves on the canvas. It has expressed the compact physiology of an inward eroticism in which, before Bellmer and Molinier, the origin of these viscous disturbances was to be sought.

This very viscosity, shown by Dali in certain other aspects, was alien to most of the poets of the Surrealist group: Breton, Eluard, Péret, Char. It seems to me one of the very sinister representations that painting (and nothing else but drawing, followed only at a distance by photography and the cinema) has offered of the 'internal model' from which the 'marvellous' was to spring. We know that techniques did not leave the Surrealist message intact. It was given one emphasis—or many—by the painters, and others by the poets; it was also sharpened by the theoreticians and the pamphleteers, diluted by the arbiters of fashion, and dogmatized by the dogmaticians. Even if it is really possible to reduce that message in its entirety to the thought of André Breton (which is not quite just), it cannot be entirely located in any one place or time.

But the doctrine of Surrealism is there and it does have a certain consistency. The word has taken its place in history. I intend here to show how the specific pictorial character of Surrealism accords (or does not accord) with the emotional and spiritual essence of the movement. Certainly Surrealist painting has fully deserved its place in the reference books, but there has been the same danger as with any other movement: that of falling victim to an ideology. Yet Surrealist art has often created and given rise to an ideology; but inasmuch as it has met the central requirement of Surrealism: that all that men create in the arts, in language, in life and even in politics should be poetry.

Fantastic precursors

With the introduction of oneiric, or dream, fantasy into pictorial vision, Surrealism takes its place in a special tradition of painting ensured a noble pedigree by its countless precursors. The representation of dreams has recurred in painting over the centuries, enriched from time to time by fantasy, symbolism, allegory, magic and delirium, each with its own power that cannot be reduced by the claims of mythologies and religions.

We could easily go back into the history of fantastic painting and select from among the enormous number of religious images those which are not mere aids to dogma but instead opened for the imagination the gates of a supposedly supernatural though in fact quite obviously libidinal world. The 'fantastic Middle Ages',[12] the apocalypses and demonic wood engravings of the fifteenth century, the alchemical emblems, the various *Temptations of St Anthony* (Grünewald, 1515; Hieronymus Bosch, 1505; Huys, 1547), the cosmic landscapes of Altdorfer and the mysterious austerities of Cranach, the taste for monsters and orgies in Flemish painting, Pieter Bruegel the Elder, Lucas van Leyden (the strange *Daughters of Lot* in the Louvre), the scenes of cruelty (the Christian martyrs—men and women—of the *Quattrocento*, Gérard David's *The Flaying of Sisamnes* at Bruges, or the famous Goyas), the extraordinary Gothic *Maria Aegyptiaca* at Warsaw (the vixen, Venus in furs, a Melusina of animality), or that Gorgon's head which broods in a dark corner of the Uffizi Gallery in Florence, the wonderful *Simonetta Vespucci* of Piero di Cosimo at Chantilly, a masterpiece of Surrealist portraiture, the beautiful Baroque compositions of Antoine Caron, the monsters sculpted for Vicino Orsini in the Bomarzo gardens[13] near Viterbo (*c.* 1564),

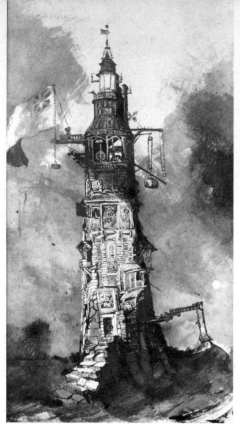

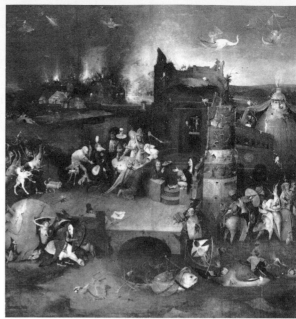

Bosch, Hieronymus van Aeken: *The Temptation of St Anthony*. Detail. 1505. Lisbon

Hugo, Victor: *The Eddystone Lighthouse*. 1866. Lavis.
Private collection

the *Perspectiva corporum regularium* (1568), Arcimboldo's optical games, Bracelli's *Oddities*, the anamorphoses, Callot and his grotesques, the cosmonautical dreams of the eighteenth century (it is permissible to speak here of dreams, for in this regard the realities of the twentieth century were sham as far as the Surrealists were concerned[14]), the best of the libertine pictures, Morghen's engravings (*Recolta delle Cose*, 1764), the architectural visions of Piranesi (1745), William Blake's mystical illustrations, the nineteenth-century illustrations for the *Tales* of Hoffmann and for the *romans noirs* of the time, all the fantastic engravings of Goya, Grandville, Bresdin, Félicien Rops (who put a prostitute in place of Christ on the cross), the illustrators of Lewis Carroll or of Jules Verne, and not forgetting the popular works of the period[15]—the paintings of Fuseli, Victor Hugo's wash drawings, Gustave Doré's drawings, the popular prints of the various series of *images d'Epinal* and similar works, the traceries and sinuosities of the turn of the century, and Klimt's fierce eroticism—in short, all the documents with which *Minotaure* surrounded the reproductions of various Surrealists and which fed with their oddities the luxurious *Verve* volumes. If that is not enough, there are all the objects, fetishes, idols, decorated weapons and tools which the ancient civilizations of Africa, Oceania and America, together with those of prehistory and the Celts, have offered through the mediation of ethnologists and historians.

In fact there were not so many objective sources of Surrealist art at the beginning of the century. You would search in vain if you wished to discover the equivalent for painting of what Sade, Lautréamont or Jarry meant, not only to the poets but to the theoreticians of the group. An interesting point about the products of Surrealist painting is that Masson's sand pictures, the Mirós of 1924, and Max Ernst's *frottages* are characterized by a certain absolute novelty that not even the most beautiful and most personal poems of Tzara, Breton, Eluard or Char ever display.

The 'literary' quality of Surrealist art is in a line of descent from the English Pre-Raphaelites and the European Symbolists, as well as a few primitives. Before them, from 1783 onwards, William Blake opened the great Romantic way and furnished it with visionary scope: a celestial world in which male nudes reminiscent of Michelangelo pass through fire and air. These engravings are religious fantasies in the best sense of emergent Romanticism, and the Surrealists learned much from the dreamwork of this graphic expression of the free-ranging sensibility.

The Pre-Raphaelite Brotherhood was founded in 1848 by Rossetti, Hunt and Millais. Far from restricting its activity to painting and poetry the Brotherhood became something of an ideological power. It pleaded against the academicism and machine culture of an unscrupulous business society and for the Middle Ages, 'truth', religious and morally emphatic concern, and symbolism. Ruskin supported this movement which was strengthened in 1857 with the adherence of Burne-Jones and William Morris, and opposed the rise of Impressionism. In several of its aspects—its clannishness, its spiritual striving, the political commitment of some of its members (Morris, for instance, who became a democratic Socialist *c.* 1883), its extension of the area of artistic representation to everyday life (by the promotion of the decorative arts and the birth of the Modern Style)—it makes us wonder what Surrealism might have been without two of its main sources: Dada violence and psychoanalysis. Some rather sugary or 'refined' Surrealists proved in fact to be very close to the Pre-Raphaelites: there is something of Millais's *Ophelia* in Leonor Fini's *The Useless Toilet*, and Burne-Jones's *The Golden Stairs* leads easily to Delvaux.

On the Continent, Neo-Romanticism and Symbolism, whose developments were largely literary and musical, had more scattered representatives in painting and sculpture. Delacroix influenced the first period of Gustave Moreau (*The Song of Songs*, 1853), but Moreau, after his visit to Italy (1858–60), began to draw more inspiration from myths and legends. *Oedipus and the Sphinx* (Salon of 1864), *Galatea*, *Jupiter and Semele*, *Orpheus at the Tomb of Eurydice*, his last work (1898), are refined and artistically intelligent paintings. This explains why Moreau (whom Huysmans admired) had also taught at the Beaux-Arts, where his skill as a teacher certainly impressed such painters as Matisse, Marquet and Rouault, who were among his pupils. His Paris house in the Rue de La Rochefoucauld, willed to the State, contains a number of sketches, intentionally unfinished we may be sure, which brought him back into fashion in the 1950s, at the height of 'lyrical abstraction'. The smooth, though somewhat sugary, images he produced of the women of legend accord so well with the *Eve with Two Amphorae* meticulously evoked by the author of *Arcane 17*, that it was no surprise to find that Gustave Moreau was given a full place among the precursors of Surrealism at the 1965 retrospective.

The Basle artist Arnold Böcklin (1827–1901) was a direct influence on Chirico at Munich between 1907 and 1909: the theme of death so often treated by Böcklin is not unconnected with the anxiety-ridden aspects of *Pittura metafisica*. The esoteric and spiritualist interests of Gabriel Cornelius Max (1840–1915) accord with the consistent oddities of Surrealism.

There are other Neo-Romantics: Feuerbach (1829–80, like Manet a pupil of Couture's), the Swiss Welti (a pupil of Böcklin's), Max Klinger (1857–1920) who tried to place *Christ on Olympus* (1897), Hans von Marées (1837–87), the Berne painter Ferdinand Hodler (1853–1918), and those who co-founded with Hodler the Vienna Secession in 1897—Klimt and Munch. They show how Romantic Symbolism fed the *Jugendstil* movement, parallel to the Modern Style imported into France from Britain from 1895 onwards.

It should be noted in passing that in German-speaking countries the word Secession (*Sezession*) signified at the end of the nineteenth and the beginning of the twentieth centuries, artistic events and especially exhibitions in which the concern to break with the past, whatever it might be, was the essential impulse of the movement. In 1892 in Munich, in 1889 in Berlin (Liebermann, Slevogt, Corinth, Hodler), in 1900 in Vienna, the Secessions were landmarks in the birth of German painting in the twentieth century.

When Stieglitz, editor of the review *Camera-Work* in New York (from 1903), founded the Photo-

Secession Gallery in 1906, he used the word in the same sense. His intention to break with the past, a prescient sign of the Dada rebellion, was not so very novel. The haughty claim that a new era had begun was not an original characteristic of Surrealism: since the Romantic era all avant-garde movements had 'seceded'. An initial step for all of them was the discovery that the values of industrial society were neither their values, nor those of art, poetry, or true knowledge. The rights of dream in a civilization which wished to pass as positivist became eminently defensible. The violence which Surrealism was able to muster in defence of such a claim shows the strength of the constraints imposed by that society.

The Pre-Raphaelites, the Neo-Romantics, and the Symbolists turned to the literary sources of Romanticism. What is known as the 'Symbolism of the period 1860–70'[16] preceded Impressionism and, when Impressionism broke the banks of European academicism, Symbolism reacted against it, even at the risk of being thought academic or conventional in its turn. Odilon Redon, whom Bresdin introduced to lithography *c.* 1860, wrote that 'nothing in art is produced by merely willing it. Everything happens by virtue of docile submission to the advent of the unconscious.'[17] It could be a Surrealist speaking. Lithographs like *Limbo* (in the series *Dream-world*, 1879) and above all *Shapeless Polyp* (1883) are intended, he said, 'to produce in the spectator a kind of diffuse and dominant fascination for the world of the indeterminate'.[18] Breton cited Seurat more often than Redon among the precursors of Surrealism. It is disputable whether that was because Seurat was an artistic innovator, because he was inspired by popular colour-prints (especially in *The Circus*), or because he included dream-content in *A Sunday Afternoon at the Île de la Grande Jatte*. In the meantime a 'synthesis' was reached—especially at Pont-Aven—of Impressionism and Symbolism. They were trying to produce 'what Albert Aurier would have called an "ideism", an art which expresses ideas by treating them in a special language: that of painting, irreducible to any other, and coherent in and by itself.'[19] Filiger, already praised by Jarry, was in Breton's eyes the best of the Pont-Aven group, just as Charles Angrand was the best of the followers of Seurat: they were 'oriented to the world within'.[20]

In fact Redon attempted a kind of dream record, whereas Seurat, like the Douanier Rousseau and Chirico later, introduced oneirism, or dream-content, into the external world. Surrealist dream-work is not confined to the traditional category of the fantastic. When Roger Caillois opined that the 'heart of the fantastic'[21] was to be found more in the strangeness of a detail, in the strange, inexplicable nature of a painting's attraction, while the image itself was often banal—as in the case of Balthus's *The Street*, for example—he offered a more apt definition of Surrealism than of traditional fantasy painting. But a number of Surrealists, with Dali foremost among them, tried to evoke the actual dream on the canvas in its raw state.

Chirico was not among such artists. His cities, arcades, monuments in a square, passing train, dressmaker's models, are bathed in a light which makes their state one of ambiguous expectation. It is an evening light; it is oblique, and warm; it is a harbinger of night. The shadow is the shadow of someone outside the painting but already there (or still there) in absence, like night in day. And there is pain. It is not surprising that the term 'metaphysical painting' should have been applied to all Chirico's works between 1911 and 1918 (Carrà joined him at Ferrara in 1915). Painting has rarely succeeded to the extent that it can make visible the world's non-answer to the question 'why?'. *The Enigma of the Time* (1912), *The Poet's Disquiet, Anxious Journey* (1913), these titles, which in many cases were suggested by the painter's friends, give their own philosophical interpretation of paintings which are surely of interest to psychoanalysts.

Chirico's obsessions are released in the objects he places in his enhancing, or rather 'sublimating', light: the absent father, those locomotives (*The Square*) which evoke the engineering vocation of a man who went out of the painter's childhood too soon, the looming presence of the mother, those often adipose truncated antique statues, the bananas, the dressmaker's models with empty eyes reproaching a fleshly world; the immobility of a time that memory would like to stop short, and the strangely sonorous space

BALTHUS, BALTHAZAR KLOSSOVSKI DE ROLA (known as Balthus): *The Street*. 1933. 193 × 238.7 cm. Collection: James Thrall Soby, Connecticut

CHIRICO, GIORGIO DE: *Metaphysical Interior*. 1917. Oil on canvas. Collection: Barnet Hodes, Chicago

(empty squares, perspectives) where one searches for something that can never be found. The architectural reverie—after Piranesi, Bresdin and many others—finds in Chirico a kind of austere peace, where every venture into the labyrinth, far from being as in Kafka a dark judgement of fate, becomes serenely useless—stuck, as it were. The *Metaphysical Interiors* of 1915–18 reveal a certain degree of awareness of his own universe, which Chirico amplifies and exhausts. We have here, I suppose, a reason deeper than any other for the painter's break with the era. Since the question remained unanswered and even hardly askable, Chirico stopped asking it and left the waste areas of human reflection, but without seeing that the human spirit has performed an honourable act by its very ability to stay there and try to question. Chirico turned to '*la grande peinture*' and departed for the halls of fame.

Henri Rousseau, the Douanier, is a painter in whose work it is impossible not to find a 'snake charmer of Martinique'[22] more minutely naïve and therefore more oneiric, than the one Wifredo Lam was later to set among his wooden idols. The Surrealists were not of course landscape painters, but Breton was to respond to the luxuriant vegetation of the Islands, just as the humble civil servant Rousseau responded during his Paris walks to the sinuosities of the Modern Style, the *Art Nouveau* of the Paris Métro stations. There is certainly exoticism and worse in a number of his dreams and Rousseau would have admitted that he was out of his element. Perhaps he was so fascinated by luxuriant growth because he was a native of Normandy; an artist born under the Tropics would find Norman apple trees the stuff of dreams, to be sure. But it is still true that the so-called monstrous ambiguity of the vegetable and animal worlds, for example carnivorous plants and mimetic animals, are able to feed an imagination accustomed to equivocation, to shifts in meaning. *The Dream* shows a small nude on a red sofa in the middle of the African jungle listening to an Indian flute. Who is dreaming? The woman or the flute player? No one knows.

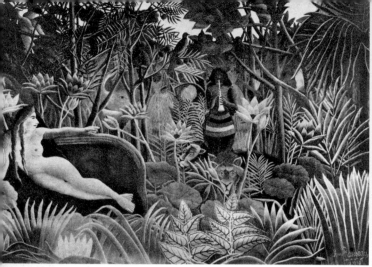

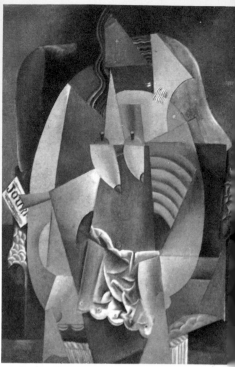

ROUSSEAU, HENRI, called LE DOUANIER. *The Dream*. 1910.
200 × 296.5 cm. Museum of Modern Art, New York

PICASSO, PABLO RUIZ: *Woman in Chemise in an Armchair*.
1913–14. Oil on canvas, 148 × 99 cm. Galerie Louise
Leiris, Paris

We are dreaming together with Rousseau. The sofa was in his room, and he shifted it to an environment in nature; he was an urban customs official showing us the way out of the city.

Marc Chagall, who came from a poor Russian Jewish background, puts us in a village world where his naïve religiosity and imperturbable gaiety introduce us to a marvellous realm of flying lovers and donkey musicians. Yet Chagall cannot pass as an orthodox Surrealist. His religious tendency and his personal independence kept him at a distance from the movement. But Breton, in his *Genèse et perspective* of 1941, while regretting the delay in Surrealism's recognition of Chagall as a true poet, wrote about him: 'It was then (1911) that metaphor, in him alone, announced its triumphal entry into modern painting.'[23] Even though Chagall is almost indifferent to a physical reality all of whose laws he transgresses, he is often able to translate verbal propositions into imagery: *The Drinker* (1911) 'loses his head', the lovers are 'in a seventh heaven'. Chagall's inspiration cannot be reduced to such techniques, but there is a degree of rhetoric in the humour of his artistic poetry. His bridge between word and image was a road for Surrealism to take. The immediate post-war period opened up other perspectives too.

The joyous fantasy of Chagall was contemporary not only with Chirico and the Picasso of *Woman in a Chemise* (1913), a painting which entranced Breton and Eluard, but with the experiments of Kandinsky and the Blue Rider movement founded at Munich in 1911. This was one of the sources of pictorial Surrealism. Kandinsky opened his lyrical period with the revolutionary application of what Picabia and the Surrealists were later to christen automatism. In his *Über das Geistige in der Kunst*, 1912 (*On the Spiritual in Art*) Kandinsky (though not at all Surrealist, given his cult of the artist as aristocrat and his spiritualism) represented the inward world as the privileged location of artistic inspiration, and freed painting from its traditional references to perceived objects. Those among the Surrealists who took the road of lyrical automatism—in other words the dream narrators—eventually paid due homage to the Kandinsky of the lyrical period; Breton placed him among the great poets of painting.

26

Duchamp and Picabia

On either side of the door through which Surrealism entered the world there stand two masters of the confrontation of art with life, two arch-enemies of the sacred, Marcel Duchamp and Francis Picabia. Duchamp confronted artists, with whom he was only too well acquainted in his family, with an intellectual's insolence. He wanted to 'get away from the physical aspect of painting' and 'once again to put painting at the disposal of the spirit'. He phrased it concisely: 'It was ideas that interested me, not just visual products. . . .'[24] And he unequivocally condemned 'retinal art'. Following this road, which the Symbolists above all had taken, he arrived at ready-mades. And from ready-mades he moved on to the mechanistic fiction of *The Bride Stripped Bare by her Bachelors, Even*.

The ready-made is not only an object taken out of context and made into a work of art by means of a signature which brings out its latent charm. It is a trivial object introduced almost violently into a place consecrated to art (a gallery, museum or salon), and taking the place of a work of art. It is, in all senses of the term, a displaced object. We invite you to admire this masterpiece, a bottle-rack! Of course, the arrangement and presentation of the object, the bicycle wheel mounted on a stool, or the suitcase swimming in a room, can evoke the imaginary. But the white porcelain urinal signed 'Richard Mutt' which Duchamp sent to the first exhibition of the New Society for Independent Artists in New York (it was rejected) has no meaning apart from cocking a snook at the high priests of art. But in the name of what? Of life, and, more exactly, of what Duchamp called the 'beauty of indifference'. The 'freedom of indifference' upheld by the classical philosophers[25] makes one absolute master of a choice without motive. The 'beauty of indifference' makes one absolute master of the decision that this or that object, whether found insignificant or ugly, should enter the category of 'objects of beauty', decisions which are supposedly reserved to art.

A few years later Max Ernst entitled some drawings (which he later destroyed) *Fiat modes, pereat ars*. The death of art, on which so many homilies have been composed in our time, must be a violent death under the onslaught of a life which bears within itself the powerful embryo of art. Creative life kills art, yet in so doing revives it. This is a fundamental paradox which Marcel Duchamp lived to the point of demoralization when producing his famous Large Glass, which he left unfinished in 1922. He introduced ready-mades into a calculated, patient, alchemic but also artistic work of art. The ready-mades were no longer 'chocolate grinders', or 'bottle-racks'; they were not products of the industrial world of the era but had emerged from an artist's natural philosophic and misogynist imagination. *The Bride Stripped Bare by her Bachelors, Even* which, together with its mass of preparatory and explanatory documents,[26] is the glory of a great museum, is neither Dadaist, Futurist nor Surrealist; it is one of the three or four fetish art-works of the twentieth century.

Together with his friend Picabia, Duchamp in fact attacked a work of art that had become a fetish when he added a moustache and beard to a reproduction of the *Mona Lisa*.[27] To look at the *Mona Lisa* and to state that, in all truth, L.H.O.O.Q. (*'Elle a chaud au cul'*—'she has a hot arse') means admitting one's indifference to the two sacred values attributed to the picture: Woman and Painting. The ostentatious Picabia with his avant-garde cars, worldly successes and sentimental irony, always flaunted his childhood genius. Like Duchamp, he came from a family that was receptive to Art, though his maternal grandfather, the photographer Davanne, a friend of Nadar's, had been heard to say that art wasn't so important after all. The young Francis was already exhibiting with the *Artistes français* at the age of seventeen. But Impressionism (strong all over Europe), then a little Fauvism, and the first daring ventures into abstraction,[28] in short the usual routine, gradually bored him, for he as easily tired of the tedious as he was unable to stand (like Baudelaire) its tragic aspects. The gifted Picabia proved impervious to all schools and theories, which he treated as so many toys. He was less arrogant than Duchamp or Vaché (for whom

PICABIA, FRANCIS MARTINEZ DE: *The Match Lady*. 1920.
Oil and collage. Collection: Simone Collinet, Paris

tedium was also a familiar experience), but more temperamental and lucid enough to be delightfully ironic. He wanted to express life as against the ludicrous institutions of art. But what did he want to express? For life, 'monstrous life',[29] does not speak. It is knowledge; that is, nothing. But at least it is able to refute the cackle of the acolytes of art, to kill art by giving it its proper childlike power: to be; but to be nothing.

More than *Parade*, more than the famous *Girl Born without a Mother* (a drawing very much indebted to the machine-motif dream pictures of the period), and in spite of the symbolism of emergence *ex nihilo* revealed in its title,[30] it is the pictorial works of 1919–20 whose extraordinary effervescence now seems linked to the great Dada era of *391* and *Cannibale*, and whose great joy in life rocks the narrow confines of art. Remember what happens to the society portrait in *Woman with Matches II* (1920). Landscapes and portraits are sent up by all kinds of additions, or adjunctions: steel pen-nibs, a comb instead of hair and electrical fuses. Later, in his transparencies, such as *Hera* (1928) and *Salome* (1929), Picabia returned—by means of glazes and scumble—to the technique which he had earlier mastered so superbly.

The attack against the 'passé' technique of painting had already been made by the Futurists, who quite justifiably required an extension to the territory held by oils by the adoption of all kinds of material. The *papiers collés* of Picasso and Braque (1912) retain under their external high-art harmony a whiff of the daily newspaper; and the inscriptions that Picasso integrated in his cubism—*My Pretty* for instance—allow us to escape the orthodoxy of the schools. Before Dada, in New York, with Stieglitz and the review *Camera-Work*,[31] the old art had been buried already. Around Man Ray, Duchamp and Picabia, 'in an unimaginable release of sex and an outburst of jazz and alcohol',[32] with the night life and ardent conversation, the important thing was to 'unlearn painting'. Work on glass proceeded apace and adjunctions were commonplace. Man Ray used a spray gun in his aerographs. More apparent than the spirit of

the laboratory which Surrealism was to develop was the atmosphere of feverish excitement and rebellious gaiety. The year 1915 was a decisive one for Hans Arp too. He met Sophie Taeuber, whom he married in 1922, and in Zürich both of them worked on cloth and paper compositions. The dionysiac atmosphere of the Cabaret Voltaire as described by Hans Richter[33] was febrile enough to allow the members of the 'band' to make the most extraordinary finds; and the electric vitality of Tzara complemented Hugo Ball's 'deep reserve'. As for Schwitters who never mixed with the Dada group, but was Hans Arp's friend, he composed his 'rubbish sonatas' with the patience of an insect and founded the *Merz* movement, of which he was the only member for some years. A collage in which part of a German bank-note showed only a fragment of the word *Commerz* supplied the name for his review, works and even houses. He eventually proclaimed: 'I am a Merz'.[34] And so art, in its turn, encroached on life.

The lettrist poems of 1948, suggested by Futurism, had been created more than thirty years before by Schwitters and Hausmann. The accumulated objects of Arman and the trap-paintings of Spoerri are rather obese, satisfied descendants of the pioneer Schwitters. Everyday existence, in the form of its trash, is valued in itself through such products, and Surrealism, speaking through André Breton, was able in 1965 to admit the 'new Dadaist' Rauschenberg to the company of witnesses to the essential.

Breton and painting

On looking at the successive editions of Breton's *Chroniques* on painting,[35] one is struck by the internal logic of a theory which continually returned to its sources. Breton scanned a still obscure past in order to light his pictorial lanterns. He was much more interested in the past than in a future where political concern would find reasons to approve a basic moral consideration; it would also find reasons for pessimism, considering the way the hopes of October 1917 had gone. Hence Breton's extraordinary chapter on Symbolism which replaces the conclusion in the 1965 edition. Perhaps the historical introduction to Surrealism is also the ultimate key to its destiny.

When Breton began to write the articles which he published on painting in *La Révolution surréaliste*, some of his close friends denied the claim that a Surrealist painting could exist without traducing the demands of the 'automatic dictation' characteristic of the movement.[36] Since Masson and Miró had not shown in their first spontaneist works the precious matter which mediates the surreal, the collages of Max Ernst, the oneiric paintings of Chirico—the metaphysical period—those of such great neighbours as Picasso and Kandinsky, the over-religious Chagall and several primitives, were used to defend the pictorial possibility of a fusion of the imaginary and the real.

The road of dream narration—which Breton declared was secondary to that of automatism[37]—was nevertheless chronologically prior, and Dali's 'paranoia-criticism' was welcomed by Breton in 1929 as an 'instrument of the first order'.[38] Breton's 'tone-deafness' (shared by others, especially by Chirico, and dogmatically imposed on the Surrealist group) did not make him ready to welcome non-figurative 'plastic music', produced by spontaneous gesture; hence Breton's non-recognition of Hartung. Of course the hand left to its own devices runs the risk of being more mechanical than mediating, more repetitive than revelatory; that would justify Breton's reticence in the face of the highly 'retinal' forms of lyrical abstraction. The method of figurative oneirism which came from Chirico—and was adopted by Tanguy, Dali, Magritte, Delvaux and a few others—ultimately remained the most faithful to the Bretonian

core of Surrealism thought—which one might justly term a form of Symbolism enriched by psychoanalysis (and certain aspects of Marxism), together with the practical invocation of the oneiric and erotic marvellous.

Automatism in painting and sculpture and the invention of new techniques—Miró's figurative signs,[39] Masson's sand pictures, Max Ernst's collages and *frottages*, Dominguez' 'non-objective decalcomanias', Paalen's *fumages*, Man Ray's photographic found objects—had the merit of novelty; they were always 'marvellous' in their first freshness, but ultimately more capable of creating than of recording that 'interior model' which so concerned Breton. A number of serious acts of dissidence can certainly be explained by that fact. The progression of painting towards abstract expressionism and the technical extension of its territory were logical steps in the general history of the art between the two wars. For André Breton, painting is only a 'lamentable expedient'[40] if it is not supported by the libidinal dynamic arising from the 'inalienable kernel of darkness' which inhabits us—a dynamic which enlivens all forms of poetry, whether produced in bed, on a written page or on a painted canvas.

Given such a source, painting had to find an appropriate goal. It had to end in something other than the iridescent sensation with which Impressionism had remained content. Remember Breton's formula: 'I find it impossible to consider a picture as anything other than as a window, in which case my first concern is to know what it looks out on.'[41] We must look through a painting just as we look through a window, but one which opens on the world within. On what could it open other than its source? Painting is poetry, but poetry is knowledge. Here there is a return to or rather a perpetuation of the Symbolist ambition. Breton's theory takes it to its limits. And then paradox arises, as it does when one takes an essential intention to its limit point. For Breton and Surrealism, the work becomes vain and factitious if one devotes any effort to its production. As the product of a behaviour, but one that is not of the same order as labour, it should disappear before the rise of the 'light of the image'.[42] A number of Breton's writings try to disqualify the idea of the work of art, to demystify the supposed privilege of the artist, and to ridicule the naïvety of those who wish to make their career in this area where, more than elsewhere, careerism is a moral error. 'Poetry was made by all, and not by one.'[43] But is that also true of pictorial poetry?

The facts are there. In admitting that they had also declared 'We have no talent',[44] the artists who had tried to 'unlearn painting', to 'kill painting',[45] nevertheless posed as painters within the bosom of Surrealism. They did so, indeed, with the blessing of Breton who like Aragon and Eluard knew how to tell what was an analytical document, or a poem, or a painting. The idea of the work of art would not be excluded. All that happened (in the best cases) was its purification by *simulations* of creation. The history of Surrealist painting offers clear evidence that when the work of art is rejected, it rises up again dialectically, in all its fulness.

It does so at the point where a desire for knowledge which hoped to be satisfied as soon as it was confirmed, finally retires in favour of the reign of enigma. Magritte, it would seem, went so far as ironically to put forward enigmas without any solution. In the pictorial work of art it is the pleasure principle which sticks out but does not explain itself. Libido can justify the work of art, but it would seem that it cannot be at one and the same time the source and the end of a will to knowledge. When art tries to beat science on its own ground and to open existential perspectives which are closed to science (Romanticism, Symbolism and Surrealism are connected in this regard), one imagines that the irrational can actually be known through the irrational. But it is always reason which knows; and Breton offers an excellent definition of reason (following Bachelard) when he describes it as a 'continuous assimilation of the irrational'.[46] Reason comes into its own in scrutinizing works of art and integrating them in a scheme of thought.

We shall have to decide how much painting contributed in Dada and Surrealism (which for this purpose we take as one movement)[47] to the promotion of an open-ended reason. The automatist approach

shows how liberating art was at the same time as it promoted new techniques. The 'other way' of dream-work, of oneirism, allows us to follow the Surrealist 'beyond painting', among 'objects with a symbolic function'. If we examine these aspects of Surrealism we shall be able to draw from the strange objects it produced its major world themes in its two aspects of inward desire and outward society.

If we follow that road we shall see that Surrealism, even though restricted to creative approaches which it in fact wished to surpass, made clear at one and the same time the structural nature of those activities and their specific character: there is really no knowledge through art. That is why Ferdinand Alquié spoke of an 'unfinished Platonism'.[48] A demystified Platonism can no longer offer access to an empty transcendence. All art and poetry which claim to know what is essential open only onto nothingness, yet that same nothingness has the valuable effect of ventilating the spirit and revealing its superior status—which is, paradoxically, that it opens on nothing.

Access to the Surreal

Nothing is a word with too many implications for me to escape the risk of being misunderstood. The Surrealists were not nihilists, whatever Camus may have thought.[49] The limpid indifference of Lao-Tse was alien to them, as was the nirvana of physical asceticism. They saw the East only as a far-off mirage. Too restless and really too Western for such things, they found the *Nada* of the Spanish mystics suspicious. The Surrealist Nothing was instead that of Jaques Vaché. Ironic, sparkling, aggressive; it is an optative Nothing, the Nothing of a radical rejection of a world sprawling so obscenely in its self-satisfaction that the hope of ever changing anything in it gave way to the duty of constantly opposing it. But whereas Vaché when he committed suicide surely inferred his own nihilism, there was nothing suicidal about the Surrealists.[50] We had to wait until after the Second World War for some of their names to appear on the long list of intellectuals and poets whom a definite renewal of Stoicism in the twentieth century persuaded to 'leave this world as if it were a smoke-filled room'.

Perhaps the Surrealists were too full of wonder to commit suicide. The feeling of the 'nothingness' of a sordid existence became all the keener among them, dialectically, because of an emotional exacerbation of noble values, such as 'love the admirable'. The Surreal might well be confused with the supernatural proper to religions, if we read certain statements, especially in the *Second Manifesto* (1929), in which Breton 'asks for a profound and authentic occultization of Surrealism', indulges in astrological specu-lation, and presents the movement as a continuation of esotericism and alchemy. In the era of automatic writing and dream-work, Aragon spoke naturally of a 'mental matter' distinct from thought in that thought would be only one instance of it.[51] In 1925 we read in an internal document of the group: 'The immediate reality of the Surrealist revolution is not so much to change anything in the physical and apparent order of things as to create a movement of spirits. The idea of any kind of a Surrealist revolution has to do with deep substance and the order of thought. . . . It has above all to do with a new kind of mysticism.'[52] In order to destroy Western rationality, they proceeded to compose an *Adresse au dalaï-lama* and a *Lettre aux écoles de Bouddha*. Admittedly it was still the period of trial and error, and Surrealism could not give in to a confused sub-mysticism.

But it did return to it before and after the War; and in *Prolégomènes à un troisième manifeste du surréalisme ou non* (1942), where it made a profession of anti-rationalist faith and criticized the non-operative revolutionary parties, there was the statement that Surrealism should devote itself to working out a 'new

social myth', even though it might give rise to 'accusations of mysticism'. André Breton himself did not reject a proposition which seems without even a spark of Surrealist humour: the myth of the '*grands transparents*'. Since man is not the centre of the universe, 'we may indeed hazard the assumption that there exists beyond him, in an animal world, beings whose behaviour is as alien to him as his would seem to the mayfly or the whale'. Novalis, William James and others are invoked in order to establish the claim that 'a wide range of speculative thought would support this notion'. Surrealist activity as a whole, after Breton's return to Paris at the end of 1945, was marked with a sectarian and esoteric tendency, in which the 'Carrouges affair' took natural root. The tract *A la niche les glapisseurs de Dieu* (1948) is evidence of this deviation, which was certainly the real reason for the failure of the Surrealists to reform effectively at the time (apart of course from political reasons and personal quarrels).

Are we then to seek the essentials of religious art in Surrealist painting? Perhaps Surrealism is in fact a kind of atheistic religion, a more or less 'enlightened' metaphysics? Anti-clericalism is conventional among all kinds of mystics, and the anti-Christianity of the Surrealists could pass for a return of Gnosticism, a revival of vanished sects against the power which triumphed over them only because of the strength of the Empire (and not through its own heroism), and reduced them, even as they rose up again, to the marginal state of heresies, with all the known consequences. The Surrealists were on the side of heresies, for they were heretics themselves. They were not associated with any triumphant dogma, not even in politics for they violently denounced Stalin and oscillated between Trotsky and Stirner. They felt themselves to be brothers of the deviants, the drug-addicts, the mad, the exalted, hysterics, children under punishment, prostitutes, tramps, subject peoples, Indians, Blacks, for all that these exploited people, whether in a minority or not, are bearers of aura. Hence their religiousness cannot desiccate into religion, nor their politics cease to be mystical. Love, freedom, knowledge, nobility of outlook, generosity, humour— their meaning is to be found in the midst of life, not elsewhere. And no paradise, even on earth, and no God, even one made man, can make these poets kneel in worship.

Surreality is not a spiritual substance, nor a mental 'matter', nor a soul, nor a God; it is a *point* to be aimed at. Breton wrote: 'I believe in the future resolution of these two states which are so contradictory in appearance: dream and reality. I believe that they will be resolved in a kind of absolute reality—a condition of surreality, if the term is permissible. I advance towards that point, certain that I shall never reach it, but too careless of my death not to estimate to a certain degree what the joys of possessing them might be.'[53] In the famous *Second Manifesto* he says: 'Everything goes to show that there is a certain point of spirit at which life and death, the real and the imaginary, the past and the future, the communicable and the incommunicable, high and low, cease to be seen as contradictory. One would search in vain for any other impetus for the activity of Surrealism than the hope of determining that point.' This hope corresponds to an active will, when Breton states in regard to Max Ernst that 'surreality will be a function of our will that everything should be out of place.'[54] This out-of-placeness, alienation, or 'spirit of evasion' (as Breton termed it in regard to Picasso) has nothing to do with vague yearnings or a neurotic flight into dream. The Surrealists are realists first and foremost; they are the most sure of realists, as their title indicates. Their lucidity has to do with the world, and man in the world—what else could it refer to?—but it pierces appearances and unmasks the deceit that entangles most of the conventional realists, whether they celebrate Socialism or Coca Cola. Surreality resides at the very heart of reality and at the very heart of the 'real operation' of thought. 'Everything that I love, everything that I think and feel, persuades me to adopt a special philosophy of immanence according to which surreality would be contained in reality itself, and would be neither superior not exterior to it. The opposite would also be true, since the container would also be that which is contained in it.'[55]

That is the dialectic of nothing and everything which takes pictorial Surrealism to the extremity of one of the most excitingly ingenious ventures of twentieth-century art: the negation of the apparent real by means of the expression of total reality. Every picture should be not merely an encounter of the

MIRÓ, JOAN: *Head of Catalan Peasant*. 1924–5. César de
Hauke Collection, Paris

imaginary and of the actually perceived, but a fusion of perceptual appearances, reduced to nothing, and appearances intermingled with dream, which have become a totality of being. When, as Michel Leiris says, Miró reaches an understanding 'of the void'[56] he penetrates forcefully to one of the least frequented pathways of Surrealism, where the least shape, on the verge even of absolute silence, becomes a sign for all. For the nothing of Surrealism, even if it is not that 'rift in being' of which Heidegger and Sartre both speak, nor the abyss of the world in itself, dreamed of by those spirits who are metaphysically masters of their own vertigo, is nothing other than the simultaneous presence of everything in everything else, just as the saying goes, like a Dadaist joke: 'Everything is contained in everything and *vice versa*.'

This everything aspect of *Everything* is to be found for instance in the *Head of a Catalan Peasant* by Miró (1925). It is a blue canvas (the colour of dreams, if we are to credit another of his pictures[57]), but it is neither sky, nor water, but the one and the other; it is a flat yet modulated tint, a space which is neither smooth nor rough, but both. There are some orthogonal marks like Cartesian co-ordinates and some partly ironic signs which evoke both Catalonia and peasants as well as women, birds, night, and eyes (which are so often to be found in Miró's lyrical meditations), or the sea viewed from above, or the sky seen from below, and joy or naïvety, childhood, gracefulness, or 'the being of the Existent' (Heidegger, as well as Descartes) and the fluidity of the world (Heraclitus), the sun together with the moon, and therefore the constellations. The series of gouaches which he started at Varengeville in 1939 and finished shortly afterwards at Montroig were rightly entitled *Constellations*. This interworking of signs and lines—perhaps what Max Ernst's monster was drawing on his canvas—in the end showed Breton that Miró had not only reached at a very high level the union of dream and the objects of desire, but that he had also achieved a union of painting and the totality of possibilities.

When touched on at this level, where desire shares in its fundamental energy, the world becomes absolute scandal. It is no help to say that social censures, ritual threats and monumental idiocies, which so often claim to be laws of nature, are no more than accidents, made ludicrous or null and void by a mere (revolutionary) cry. Nature, which is more fiercely coercive than any society, with death as necessity and sexual fatality or physiological inevitability as its Russian roulette, is then itself confronted, and pinned down like an insect on the canvas. I mentioned Stoicism earlier. Here at least Surrealism, like poetry and the passion of absolute dignity, parts company with hoary resignation. Surrealism is above all concerned with 'things which do not depend on us': not in order to oppose apathy but to exhibit the proudest of sensibilities.

Automatism

'Winged automatism'

'Secrets of Surrealist magical art. Written Surrealist composition, the first and last draft: have someone bring you writing materials, once you have got into a position as favourable as possible to your mind's concentration on itself. Put yourself in the most passive, or receptive, state you can. Detach yourself from your genius, your talent, and everyone else's talent and genius.' Thus, in the 1924 *Manifesto*, André Breton shows how inspiration in automatic writing should be guided—or, rather, not guided. In this fragment (what follows concerns writing first and foremost, but the entire text could be applied to the draughtsman), the master's attitude is immediately apparent, as is the part played by a location conducive to concentration of and on self; two elements of privilege which are nevertheless less bourgeois than they are religious or even 'magical'. Then comes the call to make an effort of passivity, or receptivity, an effort to play all the parts that we can play: in literature as in painting; and then, the ludicrous rules. It is a question of 'dislodging' the heart of the individual, not that the individual is about to contemplate himself as in Valéry's *Narcissus*, easing himself in his own observation: that would be the wrong path, and mere egocentric complaisance. The Surrealist should forget himself. His attention is, however, expectant. He looks for what is about to emerge from an objective situation: words, characteristics, and so on. He wants them to come freely; but he does not wish to bruise their fragility. In short, not only the eye but the hand ought to be in 'a state of nature'.

'The painter's hand truly *flies* with him (André Masson); it is no longer the hand which records the forms of objects but that which, aware of its own true movement and of that alone, describes involuntary figures in which, so experience shows, these forms are bound to reincorporate themselves.' 'The fundamental discovery of Surrealism', adds André Breton,[58] is that 'without any preconceived intention, the pen which hastens to write, or the pencil which hastens to draw, produces an infinitely precious substance all of which is not perhaps immediate currency but which at least seems to bear with it everything emotional that the poet harbours within him.'

André Masson, about whom this text was written, was in fact the true inventor of 'automatic' Surrealist drawing. He was still an obedient Cubist when, in about 1923 or 1924, his drawings developed into 'wandering lines' which here and there suggested perhaps the outline of a breast or a bird, but as if it were cradled in a to-and-fro motion of waves on a peaceful beach. His was a pleasing fluidity in which he only touched lightly on the viscous world, by virtue of the mysterious speed of each separate line. Of course, such drawings are mentally redrawn when we look at them, as if the painter took us by the hand. They are not in any way intended to offer us some particular image, even in the Surrealist sense of the word. They are an impetus to travel into the realm of possibilities.

This laxness of line is characteristic of the automatic experiments of the 'Rue Blomet group',[59] in which Miró (who was a neighbour of Masson's) was preparing for that 'assassination of painting' which I have already mentioned. If we compare the two painters we note that Miró (who had passed through Dada, in Barcelona, and then in Paris, where he met Picasso in 1919) seems fiercer than Masson, who retains a certain fluid grace without any trace of caustic comment. This absence of any sarcastic intention, and this lack of aggression against painting (Miró complained that he had been 'decadent since the Stone Age'[60]) at once placed Masson in that state of inner availability which is the precondition for automatic writing. More than Miró, undoubtedly, Masson forgot his own genius, and his talent and the talent of others. Breton admired him greatly and Masson's drawings often appeared as illustrations in *La Révolution surréaliste*.

In addition to Miró and Masson, there were other draughtsmen and painters who tried to submit to graphic automatism. Some had begun to devote themselves to that 'other path' of dreams—notably Tanguy and Dali. Tanguy's experiments before he took the great plunge into the realm of the oneiric, deserve particular attention. We should also remember, among those artists who were never closely or even distantly associated with the Surrealists (and whom Breton ignores), Hans Hartung, the pioneer of lyrical abstraction or gestural abstraction, who produced his first informal wash drawings in 1922 in the experimental spirit on which the Surrealists laid such store.[61] In fact, if we were interested in questions of who did what first, we should mention one of the greatest of Surrealism's neighbours—Kandinsky, whose 'lyrical' period, without ever reducing to a mere formula the art of tapping the inner flux, produced in 1910 or 1911 wonderful wandering lines in an explosive space. But Kandinsky was interested in a dialogue of souls,[62] whereas the Surrealists, through their desire for knowledge (which had remained more of an intellectual matter than they would have wished), very soon applied a kind of watchful curiosity to their verbal or graphic 'passivity'.

The endophasia[63] which finds release in the verbal flux of some sick people excludes all curiosity on their part about what exactly is emerging from their mouths. In the same way a number of pathological drawings are uncontrolled forms of expression which would meet with the demands of the Surrealist prescription if the latter's minimal requirement of consciousness of the real world could be slightly reduced. Most of the mentally sick who draw concentrate passionately on their work, where laxness of line is less frequently observed than a kind of knotted figuration. Even though we know of the great interest the Surrealist poets had in the 'art of the insane', we have to realize the distance between their products. The art of the mad offers only the admittedly dark image of their good health and diseased mind. For the poets it is a matter of simulation. *L'Immaculée Conception* is admittedly a collection of simulations. No poet in the group, except for Artaud, who parted from Breton from 1928, ever encouraged the experience of the 'systematic derangement of all our senses'[64] by means of drugs. And Michaux—who stayed outside the Breton circle[65]—though he was among those who tried in a more emphatic way 'to reveal the interior phrase, the sentence without words, the infinitely unravelling strong sentence that intimately accompanies everything that presents itself without as well as within',[66] did so with the suspect aid of mescalin. The *Le Grand Jeu* group, because of the interruption of parahypnotic experiments of the 'dream period', even reproached friends of Breton for remaining satisfied with such timorous experimen-

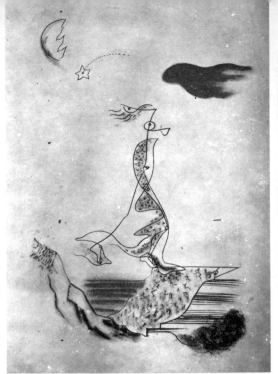

HARTUNG, HANS: *Clear and Grey Colours*. 1922. Water-colour, 32.8 × 34.5 cm. Galerie de France, Paris

MASSON, ANDRÉ: *The Sleepwalker*. 1926. Colour crayon drawing, 63 × 48 cm. Galerie Louise Leiris, Paris

tation. But fear seizes one at the edge of the abyss. And the Surrealists very soon realized that it was foolish to want to take the place of the insane, the sick and prisoners, while staying free and upright. What did they in fact get from the insane? A moral lesson, a model of creative purity. 'I am not afraid to put forward the idea, which is only paradoxical at first sight, that the art of those who are classed nowadays as mentally sick constitutes in fact a reservoir of moral heath. It is free of everything which tends to falsify the testimony with which we are concerned and which belongs to the order of external influences, calculation, success or deceptions on the social level, and so on. The mechanisms of artistic creation are then freed from all fetters. By a neat dialectical stroke, confinement and renunciation of all profits and all vanities, though individually they seem so pathetic, are the guarantors of that total authenticity which otherwise is wholly absent from life, and which we thirst after more and more as the days go by.'[67] It would be easy to twist this text into a statement of mere kindly cynicism. It is only too easy to admire those whom one can only imitate from afar lest one share their real 'pathos'.

Let us consider the 'art of the insane'. And let us admit that their life in the asylum excludes the idiocies and chicaneries of the social world (even though that is yet to be proven). What really impressed the Surrealists in the art of the insane, as in *Art Brut*, was its positive asocial character. The same is true of the graffiti which in everyday life collect in appropriate (privileged?) places, in relation to the social censure of their often obsessional lyricism. We cannot deny that the graffiti of lavatories are in a way tantamount to Surrealist activity, or even art. There the real and imaginary realms interchange their particular violences, and there is no point in anti-art, for no art has been able to render aesthetic the often extremely explicit figures of the world of graffiti.

Children's drawings, apart from the fact that they are produced in a kind of dream far from any adult prescription (when that is the case), also argue with all their luminous force for a graphic activity where genius and talent are all the more easily obscured when they have not reached self-consciousness. The same André Breton who accused Miró of 'a certain arrestation of personality at the infant stage, which never-theless does little to safeguard him from inconsistency, prolixity and mere play, and assigns intellectual

limits to his testimony',[68] also says elsewhere: 'The spirit which plunges into Surrealism relives exulting the best part of his childhood.'[69] The ambiguity here is significant. The spontaneity of play duly conducted does not free anything 'natural' in man; it does not liberate anything. The childhood which remains deep within us, even in our 'best part', runs the risk of ritualization, of becoming in fact a slave of myths and social prejudices, just as much as the supposed freedom of 'primitives'.

Of course Miró feeds his means of expression on graffiti and children's drawings. That does not necessarily indicate infantile regression. Seeking inspiration from children is an adult business. The adult should share in the child's graphic freedom. That is the essential thing. He can also borrow his use of conceptual or generic forms: the way in which a child needs only a few lines to suggest a man or a bird. A number of artists inspired by *Art Brut* (especially Dubuffet) cultivate the forms of child art in their search for the sources of drawing. That does not mean that they lose their way while searching.

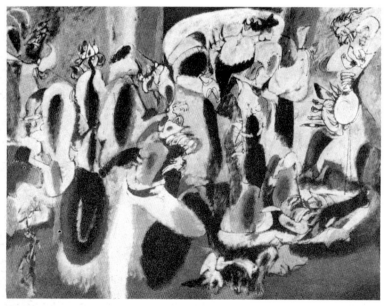

GORKY, ARSHILE: *The Liver is the Cockscomb.* 1944. Oil on canvas, 184 × 248 cm. Albright Art Gallery, Buffalo

I once watched a child of four in the phase of 'closed synthetic forms' reject with supreme disdain the 'rubbish' of his sister aged two. (By that he meant the fine interlaced lines which draughtsmen, aware of the best lessons of Surrealism, discover at the end of the process known as 'abstraction'; oddly enough, they do so by means of an unwonted persistence of figurative references.) If the very young child has something to teach us, it is that the gestural drawing he so enjoys is neither abstract nor figurative.

The adult too can suggest a world, and there his art will begin. In the drawings of Unica Zürn (who was Bellmer's mistress), forms interlace, cross and cross again, fray, and reach the point of inextricability. You find the same kind of freedom in the Danish experimental painters—Jorn, for instance—among

some young painters marked by Surrealism who regrouped in the Cobra movement in 1948, and in some more or less lyrical Tachists, defended by Edouard Jaguer in his magazine *Phases*—especially Karl-Otto Götz. Lyrical abstraction gave painting, thanks to the magisterial example of Wols's *Cathédrales éclatées* of 1947, a liberating power which was at first limited to drawing. Among the Surrealist painters who add neither chance nor novelty to their graphic spontaneity, there is Arshile Gorky whose *Agony* (1947) certainly owes a lot to Miró, but who takes automatic freedom a long way in works such as *A Seducer's Diary*. Naturally the spontaneous approach runs a risk of encountering special technical problems in painting or sculpture, whereas it yields its precious ore more easily through the medium of a pencil. In vanquishing painting, the Surrealists enriched it technically in a thousand ways.

The automatism of mediums

There are also some artists who take their laxity of approach as far as an actual dilution of forms, whereas other spontaneists, by repetitive work and a minutely attentive—even obsessional—approach produce compact drawings filled with suggestions of magic or liturgy. They are sometimes mediums. Joseph Crépin, who decorated the Institut Métaphysique in Paris, was a lead and zinc worker whom Breton discovered among the exhibitors of *Art Brut*. What he says about that is worth reading, though we do not have to accept the spiritualism which the painter adopted under the emotional pressure of his life. Instead we should study the odd states such people enter into when, to their amazement, their hand starts working outside their control. This 'spiritualist art' is more valuable as evidence for parapsychology than as a theoretical argument for the philosophies of the past. Like Crépin, the miner Lesage, whose works are in the files of the Institut Métaphysique, built highly detailed and symmetrical mystical palaces. Symmetry is one of the essential characteristics of this quasi-religious form of art, which often tends to create a sacred construction, so to speak.

There is no such complex arrangement in the ink drawings of 'Scottie' Wilson, a Toronto furniture dealer who emigrated from Scotland, but his work does feature fine parallel lines within the scales and careful shapes covering the whole design, and recalls the totemic art of the North American Indians. Scottie's works were exhibited for the first time by Mesens in London in 1945. There was also Marianne van Hirtum, an excellent poet,[70] and a very unassuming artist who spent whole nights pricking tiny holes in paper, allowing eye and hand to follow the forms suggested by the declivities of the paper, so that when she rose in the morning, dropping with sleep, she left behind her on the table an assortment of marvellous shapes. With only a slight suspension of belief these drawings, like her plaster fetishes, seem the products of some strange lunar witchcraft.

Like children and the insane or mentally ill, these inspired artists (whether mediums or not) who devote not only their leisure but all their waking hours to their irrepressible urge, make no special effort to enter the state in which they produce their apparently spontaneous art. They do not search for inspiration; they are *possessed*, in the most demonic sense of the word. Wölfli, Aloyse, and Séraphine de Senlis, Hirschfield, Hector Hyppolyte and Miguel Hernandez, do not have to 'forget their genius'. They just let it flow, and sacrifice their lives to their inspiration. The postman Cheval collected stones on his rounds and used them to build the 'ideal palace' of his dreams. The creative obsession which makes the work of art a 'consuming monster'[71] for passionately committed artists is something that consumes and transfigures the everyday life of the inspired craftsman.

The Abbé Fouéré recreated in Breton granite the legend of the Rothéneufs; the ferryman Massé of

SCHWITTERS, KURT: *The Interior of the 'Merzbau' in Hanover.* 1925

Sables d'Olonne adorned his house with shells; Raymond Isidore, a sweeper at the Chartres cemetery, covered everything around him in a mosaic of broken crockery. He said: 'I have spent my life as if under the guidance of a spirit: something which told me what to do, and told me how to do it. When it's really taken a hold in my head, then it spreads all over me, into my hands, into my fingers, and I'm forced to work.'[72] François Portrat's garden near Pont-sur-Yonne is a 'Trocadero', rich with emblems and great glittering wheels. The magical quality and fervour of their work show something of what these architects and decorators have in common with meticulous draughtsmen and painters. Each builds his own temple or obeys the 'demon' that possesses him. That, indeed, was all Kurt Schwitters was doing when he built his *Merzbau*. He constructed three in succession: at Hanover (1925), in Norway (1932) and at Ambleside (England, 1945). His friendship with Arp and his review *Merz* (1920–32) show him not as a Dada agitator but as someone who integrated in his plaster and scraps the minute detritus of everyday life and exuded, as it were, his own 'sacred edifice'.[73]

The art of chance

It is hard to imagine any of these priests of the surreal leaving any part of their creations to chance. That would be a kind of treason. Random effects would be mere negligence. You have to be an artist, someone like Arp, Ernst, Masson, Dominguez, or Duchamp and Man Ray before them, to leave the creative urge to chance. Even though outside Surrealism proper, Yves Klein ultimately allowed chance too much say in his 'anthropometries' produced by the 'living brush' (1960): and in his 'rain and wind' pictures and his 'fire pictures' (1962), for example. Automatism, whether it is the rain striking a canvas fixed to the front of a car, or a nude painted blue rolling herself up in a shroud, can of course be a matter more for the physicist than for the psychologist. We must not forget the psychological roots of Surrealism. Anyone who allows chance to dictate his work has to stand at a certain spiritual distance from it, just as he has to treat his own subjective effusions with a certain disdain. In 1913, when Dada was not even on the horizon, Marcel Duchamp, even more austere than Yves Klein, gave chance full rein in his *stoppages*. He dropped three pieces of one-metre-long thread from a one-metre height, and glued them where they fell, thus 'imprisoning and preserving forms obtained through chance'. Surely this is an example of the artist turned physicist.

This voluntary entertainment of chance is to be found under highly developed and systematic guises in the various contemporary divisions of arbitrary art. It offers, however, too little room for the artist's subjective life to be a Surrealist option—even though the final adoption of the product depends on the artist's inalienable liberty. Closer to Surrealism is the attitude of Dubuffet for whom 'the artist is harnessed to chance' in work and life. The pictorial palette allows a mixture of heterogeneous materials, with unpredictable inter-reactions. 'The term "chance" ', writes Dubuffet, 'is inexact. We should talk instead of the inclinations of the rebellious material.' Technique is liable to happy accidents, 'which are the artist's prey', and part of a painter's technique is knowing 'how to produce and master accidents due to the materials'.[74] Dubuffet in the tradition of the College of Pataphysics and Père Ubu takes up the Dada mantle with this statement. He also tells us how unforeseen incidents in daily life can interfere with a work of art. His *Big Anthracite Nude* is the result of an 'interpolation of a naked woman and anthracite' which had just been delivered to her.[75] Humour is mixed with poetry in this kind of encounter. In its anti-art actions Dada combined the various kinds of chance I have just mentioned. Hans Arp, one of the founders of

ERNST, MAX: *Lesson in Automatic Writing*. 1924. 17.3 × 169 cm. Galerie André François Petit, Paris

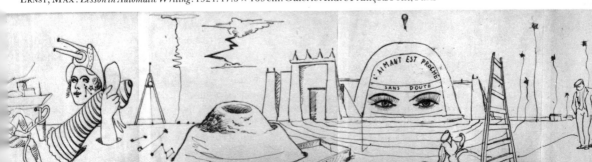

MASSON, ANDRÉ: *The Earth.* 1939. Picture in sand.
Musée National d'Art Moderne, Paris

Dada in Cologne (1919, with Ernst and Baargeld), produced automatic drawings in 1916, and together with Sophie Taeuber carried out a number of experiments with the most varied materials. One of his collages of 1916 is entitled *In Accordance with the Laws of Chance*.

But I am perhaps getting away from my subject, automatic writing. 'Objective chance' will bring me back to it. Far from being the unforeseen encounter of two independent causal series, 'objective chance' is a sign—an event more or less noticed as it occurs by the individual who witnesses it. It is soon interpreted by that person as a 'marvellous signal', or a premonition of fate. Poems such as *La Nuit du tournesol* by Breton, and certain famous pages of *Nadja* or *L'Amour fou* rely for their mysterious effects on premonitions of this kind. The connection between this attention to signs emanating from the environment and the art of mediums is obvious. The 'automatic dictation of thought' is surely intended to make us receptive to this kind of message. Michel Carrouges writes: 'Automatic writing is no more than the reintroduction of objective chance into language, whereas objective chance is the automatic writing of fate in seemingly raw facts.'[76] Painting can bear the same relation to fate as language.

This at least Victor Brauner's friends claimed when the painter lost his left eye in 1938 after being wounded by some glass splinters. Seven years earlier, before leaving Paris for Rumania, he had painted several pictures which indicated his obsession with the eye, especially *The Door*, and the very explicit *Self-Portrait with Eye Enucleated* (1931). Dr Mabille, associating the Freudian concept of the symptomatic act with that of objective chance or premonition, interprets the *Self-Portrait* and the accident as signs of one and the same masochistic impulse, counterbalanced by the artist's firm belief that he is joining the company of the initiates of antiquity who were, of course, 'blind'.[77] Brauner, whose first picture (painted in Paris, in 1925) was called *The Medium City*, had been present as a child at some spiritualist séances. The spectral phases of his work, for example in 1939, with the *Chimera* which reappeared in *Philosopher's Stone* (1940), or the odd shapes of *Being Retracted, Refracted, Spied on by Consciousness* (1951) and the amazing luminous coffin of *Realization of the Couple* (1957) are surely derived from a fantastic vision. Its straightforward expression makes Brauner one of the main Surrealist mediums of the mysterious.

If Surrealist spontaneity consists in 'reintroducing objective chance into language' or into art, it is not surprising that we should be indebted to it for a number of technical discoveries. These are not inter-

pretations of spiritual messages about the individual; they are the products of amazement reflected on in wonder. This is the difference between the serious aspect of Surrealism and mere titillation of the eye.

In his paintings Masson obtained the same effect of freedom as in his drawing, and did so by a kind of *coup de force*, as he admits when he describes how he invented his sand paintings: 'I saw how necessary they were when I realized the distance between my drawings and my paintings—the gulf between the spontaneity, the lightning speed of the former and the fatal reflection of the latter. I suddenly lighted on the answer when I was at the seaside, looking at the beauty of sand with its many nuances and infinite variations from mattness to glister. As soon as I got back, I placed an unprimed canvas on the floor of my room and threw some blobs of glue on it, then I covered the whole thing with sand from the beach. . . . I enriched the work with successive layers of glue and sand of different consistencies and grains. Ultimately, as with ink drawings, a figurative appearance was needed, and this heterodox picture was completed with a trace of pure colour applied with a brush.'[78] Later some *matiéristes*, such as Tapiès, were content to leave the sand as it was without any final quasi-figurative additions. In Grémillon's film *Les Quatre eléments* (an act of homage to Masson), the magical process is shown: a ready-painted picture is placed on the ground, sprinkled with glue and covered with sand under which a secret process seems to take place. The canvas is picked up and the sand falls off, remaining only where it is held fast by the glue. This sudden appearance of the unforeseen, recorded on film, is breathtaking. It shows that painting is better grasped in the creative moment than stuck on walls to be contemplated. It is first and foremost 'doing'; but a doing that leaves traces, which the painter can sign as his handiwork.

Jackson Pollock's 'drippings'—to be found also, but in a subsidiary form, in Max Ernst's *Man Intrigued by the Flight of a Non-Euclidean Fly* (1947) and in Masson's *Contest of the Comets* (1957)—are of the same order. In this case drops of paint from a pierced tin are thrown on the canvas as it lies on the ground. The painter's entire body is engaged in a dance and he moves to a more or less regular rhythm, bending over the canvas like a man watering the soil. He is a demiurge hardly aware of the forms he produces, for they are the mere trajectories of his gestures. After the excitement of the act, he emerges from the turbulence to inspect the product and decide whether this colossal labyrinth of spray effects should become 'a Pollock'. It is not so strange therefore that a pioneer of Action Painting should be classed among the descendants of Surrealism, because the resemblance of such practices to those tried by most Surrealists is clear, and there is also an actual historical influence. Pollock's adoption of drip techniques was directly linked to the arrival of the Surrealists in the United States, to Max Ernst's stay there during the war, to Ernst's meeting Peggy Guggenheim, whom he married in 1941, and to her ownership of the famous Art of the Century Gallery in New York where Pollock exhibited his 'drippings' in 1946.

At the Museum of Modern Art in New York an entire room is occupied by a version of Monet's *Water Lilies*. They are a rich experience for even the most modern eye. Not far away you can see the big Pollocks. There is nothing Impressionist about their pointillism. They are products of the hand, of the body, of dance and vertigo, not of the eye. They look rough. They mix anger and *angst*. The freedom of each line, meeting and dividing the freedom of so many others, eventually weaves an extraordinary prison of spots, blotches and creepers. If you react to symbols you will find them in these miasmas where you breath the air of great cities and the jungle of a society so ineptly liberal that violence and drugs await you at the corner of every street and giant bombers are ready to make another pattern on the earth.

Twenty years earlier, at the seaside (like Masson—coincidence or not?) Max Ernst broke with appearance. He obtained the necessary alienation effect not by waiting to see what would come from his hands, but by suddenly seizing whatever impression his eyes, in the 'natural' half-awake state, took from the veined planks of a well-scrubbed wooden floor. The text of Breton's with which I opened this chapter needs the company of a no less famous text in which Max Ernst tells us 'how to force inspiration'.[79]

'Starting from a childhood memory in the course of which a false mahogany panel facing my bed played the rôle of optical provocateur in a vision of half-sleep, and finding myself one rainy day in an inn

near the sea, I was struck by the magnetism exerted upon my excited gaze by the floor—its grain accented by a thousand scrubbings. I decided thereupon to examine the symbolism of this obsession; and to help my meditative and hallucinatory faculties, I pulled a series of designs from the wood by laying sheets of paper on them and rubbing lead pencil over them. On looking carefully at the drawings obtained thus, I saw the dark parts and the soft penumbra and was astonished by the sudden intensification of my visionary faculties and by the sudden hallucinatory succession of contradictory images superimposed one upon the other with a persistence and speed usually characteristic of love remembered.

'My curiosity having been awakened and delighted, I began to use the same means to discover haphazardly the effects of all kinds of materials that happened to be in my visual field: leaves and their veins, the roughened edges of a piece of sackcloth, the brush-marks on a "modern" painting, an unravelled thread, and so on.'

An orthodox Surrealist at the time and (as always) an introvert, Max Ernst opened up the possibilities of the forms he selected by means of his allusive vision. He learned the nature of closed systems. His elevation of *frottage* to the category of work of art, and his use of poetic language to describe the uniqueness of the work, correspond to the dogmatic necessity of furnishing images in Surrealism. Masson finally established his sand pictures with a few marks. Max Ernst supplied highly effective titles that deprive the spectator's unconscious of the freedom to dream up a meaning; *The Bride of the Wind*, *Vaccinated Bread* or *System of Solar Cash* could only take their place in the *Natural History* album[80] by their power to evoke all nature—which of course includes human dreams.

The same is true of what Dominguez in 1935 called 'decalcomanias without object' or 'automatic decalcomanias with premeditated interpretations'. These are monotypes, a new version of an old process used by many artists. One prepares a surface (paper, cloth, glass, or marble) with paint (often gouache) or ink and water and places a sheet of paper on it, pressing it down lightly with the hand. Then the sheet is withdrawn or rather peeled off, leaving—or bearing as the case may be—unforeseen effects which can be very beautiful and evocative. Dominguez and Marcel Jean would not leave the process of interpretation to the observer's imagination—as one would do with Rorschach ink-blots, for instance; instead of allowing people to see a new world in the arbitrary patterns, they insisted on deciphering them.[81] When Max Ernst used the process during his stay in Arizona, he found he had to add a figurative element to the rich field of chance.

But poetry is not to be found in paint and figure alone. From *frottage* or rubbing, one can move to *raclage*, combing or scraping the paint with a ruler or a comb. Max Ernst does not hide his *raclage* in the famous 1927 *Forests* or his *frottage* in *The Palette* (1953). In about 1946 Kujawski took care to emphasize his comb scrapings. There are many opportunities for the Surrealist to be amazed by the effects of his materials. In spite of the feverish search for new techniques by Dadaism in the past, and nowadays by the '*matiéristes*', optico-kinetic artists and technological artists oil is still a richly productive medium. On the other hand, forging ahead of known methods can bring the Surrealist painter to what André Lhote (whose own painting is quite different) calls 'technical hysteria'.[82] He means by that a real loss of control by the painter of the ability to handle his processes, and his exceeding any limit set by his conscious mind on his practice. Then the painter, when faced with his finished work, is the first to ask how he produced it. He no longer studies potential—the 'risks of the material'—but invites them (for a few minutes of artistic frenzy at least) to interrupt the too structured order of his style, his skill, and the procedure he uses to 'force' his inspiration to respond.

But in the very moment of discovery, a new approach can afford a happy result—by breaking with technical routine rather than looking for new methods. Dada and Surrealism were both active, adventurous and experimental techniques in this regard. They have produced no less than thirty technical discoveries in the various divisions of art.[83] If we take into account the originality of every work produced, that indicates a passionate care for all the as yet unexplored possibilities of the matter and materials which

Below
ERNST, MAX: *The Petrified Forest*. 1929. Frottage,
46 × 55 cm. Galerie André François Petit, Paris

Bottom
ERNST, MAX: *The Stallion and the Wind's Future Wife*.
1925. Frottage, Bibliothèque Nationale, Paris

POLLOCK, JACKSON: *Cathedral*. 1947. Canvas,
182.8 × 88 cm. Museum of Fine Arts, Dallas

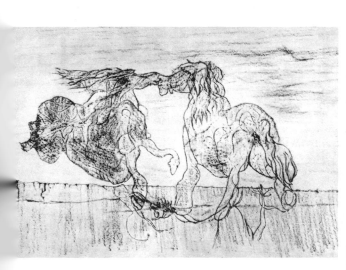

DOMINGUEZ, OSCAR: *Decalcomania*. 1936.
Museum of Modern Art, New York

surround us. They are to be found not so much in the studio as in the world around us—in the town, in the countryside, at the seaside, in life.

And Dominguez in 1939 or so, when distractedly he allowed his brush to pass several times a day over the same surfaces, while chatting with friends, or drinking a glass of wine, invented no new process. Instead he delivered up his hand voluntarily, as it were, on the periphery of his conscious mind, to a gestural dream-process whose recording apparatus it became. He called the products of this graphic sub-discourse 'litho-chronicle surfaces', because they superimposed the successive strata of ordinary time. The products of what Marcel Jean and Arpad Mezei call 'pure laziness'[84] comprise Dominguez' 'cosmic period', one of the richest phases in his life. His work, like that of the others I have just mentioned, shows how the Surrealist painter who chooses not to scrutinize fate can nevertheless tap the treasures of sheer chance.

Paul Eluard seems to approve Dominguez' 'lazy' procedure when he writes: '*Poetic objectivity* is to be found only in succession, in the interlacing of all the subjective elements of which the poet is . . . not the master but the slave.'[85] But Eluard also sets 'intentional poetry' against 'involuntary poetry'. This clear distinction makes a poet both master and slave, two positions which after a certain point are no longer mutually exclusive. They are both aspects of one spiritual activity whose perspectives they serve to diversify. Poetry, like painting, remains an organized yet libertarian practice of inspiration as it swings from automatic (involuntary) writing to the (intentional) elaboration of works which are obviously dependent on themes—wonder, the extraordinary, cruelty, passion, love.

Eluard also says: 'We have to know if poems result from an appropriately defined will, the echo of a formulated hope or despair.'[86] Aragon, who shared Breton's provocative statement that 'We have no

talent' (*First Manifesto*), offers some harsh formulas in his *Traité du style* when he castigates all forms of mental laziness which might take refuge in Surrealism: 'Under the pretext of Surrealism, the first cur to come along thinks he is entitled to equate his insignificant rubbish with true poetry.'[87] Similarly, Breton (who demands a return to the real and the emotional: to the 'living hearth from which only emotion can radiate') writes that 'subjective emotion, however intense, is not directly creative in art; it has value only inasmuch as it is returned and incorporated indirectly in the emotional source from which the artist must draw.'[88] And by 'draw' he evidently means 'choose'.

In a letter of 1920, published for the first time by Olivier Revault d'Allonnes,[89] Picabia wrote that the 'regression to childhood' in which—in psychoanalytical terms—the Dadaists indulged, had nothing to do with *dementia praecox*: 'One thing refutes that supposition; *dementia* requires the obstruction or at least an attenuation of will, *and we have our will. . . .* We choose from associations of ideas and words which are supplied by our brains in the psychic process. It is that choice which sometimes makes our works look "laboriously unreasonable", as you claim. That will be all the clearer to you if I explain how our will works: it is negative when the association of ideas is formed, but becomes positive during the actual process of choice which follows[90] . . .' The first movement of spontaneity is succeeded by the movement of responsible choice which, for the painter, is often technical elaboration. Miró is very clear on this point. Starting from sheer emotion before his material, he allows his passion full expression. Then, 'when the first fire has died down', he forgets his canvas, sometimes for months on end. One day he comes back to it 'and works coldly, like an ordinary craftsman.'[91]

Dada and Surrealism are not suggesting that in 'automatism' we should abandon ourselves to

DOMINGUEZ, OSCAR: *Nostalgia for Space.*
1939. Oil on canvas, 70 × 90 cm.
Museum of Modern Art, New York

egocentric self-indulgence. What they do propose is an art of living poetry, an ethics of permanent creation. Here freedom is the goal of will and hope, more than a condition for a measurable responsibility. The difficult synthesis of Romantic fatalism (where the artist is only the sacred plaything of uncontrollable nature) and of a humanism firmly entrenched in the rationalist tradition (where man is the lucid master of his own nature) is the philosophic wager of Surrealism. When Surrealism opens the valves of psychological spontaneity, it cannot banish from the human ambience either the supposedly obscure world of dreams and the unconscious, or the passionate forces which constitute genius. In espousing automatism Surrealism has gone beyond Dada, which had little interest in the world of dreams.

Oneirism

The image and the marvellous

Several Surrealist texts evoke nocturnal walks, especially *Le Paysan de Paris*, *Nadja* and *L'Amour fou*, and the enchantment of the city,[92] its mysteries and the strange meetings possible in it, the physical character of its various districts, the least interesting of which was certainly not the Place Dauphine[93] where so many dreams have accumulated generation by generation, and which was to become the 'sex organ of Paris'. From Montmartre with its boulevards, and cosmopolitan Montparnasse, from the Tour Saint-Jacques to the Île de la Cité, where the last Grand Master of the Templars was burnt—the poets of the Surrealist group revivified all these 'magical places'.

We must not of course forget Man Ray's and Brassaï's photographs. Thanks to them the traces of those years are not completely effaced: the *Air de nager* of a dancer in a night club, a brothel with the sign 'Fortune'. The Surrealist photograph was both poem and document. It meant a complete renewal of an art which is now called popular but then was restricted to the society portrait and the platitudes of war reportage. The technical possibilities of photography as an art were developed from its fundamentals. In 1916 Christian Schad invented 'schadographs', and a few years later Man Ray produced his 'rayograms' and 'solarizations', while Raoul Ubac offered in his 1937 photo-reliefs strange 'fossilizations' of Paris sights. But from the abstraction of *Boulevard Edgar Quinet at Night* (Man Ray, 1925) to the litter of *A Corner of Les Halles* as seen by Brassaï, the photo-poem did not always need special processes or equipment in order to express the strange and marvellous. In Cartier-Bresson and in Jean Clergue, Eluard's illustrator, there is also an attentiveness to signs of the imaginary in the midst of the real. The objective difficulties are solved by the happy chance of the photographic lens.

Areas other than Paris at night engaged the Surrealists' attention: Nantes, the Château Lacoste, where Sade lived, Teneriffe, Martinique (the snake-charming island of the Douanier Rousseau), Prague, 'the magical capital of Europe', and the lost villages where the Surrealists went to live, Penne-du-Tarn, Saint-Martin d'Ardèche, or the ghost cities of Arizona, which were painted by Kay Sage, Tanguy's mistress.

But the Surrealists, though they were impressed by certain exotic effects in nature, were not landscape artists. Little attracted by the scenes and actions to be found in the rural novels of Giono or Ramuz, for them the countryside was as dull as the human face. Breton reproached Giacometti for his obsession with the portrait: 'After all, we do know what a head is!' The countryside, the forests, after all, we know what they are! The Surrealists were city-dwellers, from the time when the air of cities became breathable; they were citizens of the land of the wine merchants. They were habitués of many cafés where they met for their discussions: the Certa in the Passage de l'Opéra, the Dôme in Montparnasse, the Cyrano in the Place Blanche, the Deux Magots after the Second World War, and many others, where they drank the new Beaujolais and Cabernet. The Parisian cafés are almost one with the street. It was easy to move from one location to the other, with an eye open for adventure, an eloquent tongue, and amazed laughter. Some flea markets like that at Saint-Ouen were hunting grounds for the imagination. They went there greedily in search of 'found objects', which they bought for next to nothing, or just looking for chance images. The strange and wonderful was to be found there. The Surrealist image— typically represented still by the 'chance encounter' of the sewing machine and the umbrella on Lautréamont's dissecting table—is always available from, and to, the genius of 'involuntary poetry'.

It was by means of the image in the sense in which Reverdy already understood it that daily life could be transfigured. 'It seems more and more that the main generative element in this world which we wish to adopt in place of that of the past is none other than what poets call the image. . . . Only the image in its unforeseen and sudden aspects allows me the full extent of possible liberation, a liberation so complete that it frightens me. It is by the power of images that in time all "true" revolutions could be brought about. In some images there is already the beginning of an earthquake. This unique power is available to man, and if he wishes he can exploit it on an ever-increasing scale.'[94] The threat implicit in the last few lines of this text of 1925 could take us along the wrong road of 'false' revolutions. We know only too well in these days of the 'civilization of the image' and the imagery of different political religions and 'personality cults', served by a proliferation of mass media, how far 'new myths' can take us. We must not confuse the Surrealist image with the publicity image, as those do who see Pop Art as a child—even though a bastard child—of Surrealism. The Surrealist image is not a copy but an event, an encounter. 'It is from the to some extent fortuitous association of two terms that a special light shines forth, the light of the image, to which we shall be most sensitive. The value of the image depends on the beauty of the spark it gives off.'[95] Breton later drew attention to the 'convulsive' nature of the Surrealist image, which recalls the reference to the earthquake quoted above and allows us to suppose that the image-event of Surrealism might be like lightning, but as brief too, and lose its magical power with time. But does that matter? The image is not made to be contemplated. In life itself it should be constantly discovered and rediscovered. If we have volumes of these images we can flick through, the reason is not the mere delight of our collector's sensibilities.

Max Ernst's account of how he invented his collages in 1919 is interesting for his reference to everyday life. 'I was struck by the fascination the pages of a catalogue had for me. It was illustrated with objects intended for anthropological, microscopic, psychological, mineralogical and palaeontological demonstration purposes.'[96] The 'absurd' encounter of these disparate documents which were made to be looked at one by one, but are here connected by Ernst's sarcastic discourse, awakens the image. Mesens was right to distinguish Max Ernst's collages from the *papiers collés* of Braque or Picasso. The latter, he wrote, 'are simple plastic solutions in which the cut pieces imitating a real material (wood, marble, newspaper) work in counterpoint with the lines or shapes which the artist has interpreted or invented. In his collages, on the other hand, Max Ernst is only secondarily interested in plastic construction. In one go, as it were, he plunges us into the drama by opposing elements from our known world in a disturbing way, thus violating the conventional laws of thought, logic and morality. . . . What was only an art revolution became—thanks to Ernst—a form of mental subversion.'[97]

The hallucinatory faculties which intervene in the swift fusion of two or several heterogeneous elements, which do more than suggest, in fact constitute and impose, a strange vision of things, powered by a libidinal force, was something that all the poets of Surrealism—whether artists or not—could release in collages, object-poems, 'objects with a symbolic function' and '*cadavres exquis*'. Breton, Eluard, Stýrský,

PASSERON, RENE: *Judith*. 1965. Collage, 41.7 × 34 cm. Property of the author

PICABIA, FRANCIS MARTINEZ DE: *Feathers*. 1921. Oil and collage. Galerie Schwarz, Milan

Prévert, Bona (Mandiargues' wife), Léo Malet, (he added mirror games which multiply and invert the image), Hayter, Hérold, Malkine, Mesens, Penrose and Bucaille made effective collections of contemporary engravings or magazines. The photomontages of Raoul Hausmann or Hannah Höch, *c.* 1920, were of the same kind. Variants have been produced since then in the alchemical techniques which render the images of our 'civilization' unrecognizable. Jiri Kolár invented his *rollages* by juxtaposing parallel strips cut from the same picture. The optical effect interferes interestingly with the hallucinatory effect.

Hallucination is not an excessive term here if we recall Taine's dictum, which so impressed Breton: 'Perception is a true hallucination.' We add a great deal to the little that our senses receive from the world by physical and physiological routes. The mental patient suffering hallucinations is only sick to

MORISE MAX, RAY MAN, TANGUY YVES, MIRÓ JOAN:
Cadavre exquis. Private collection

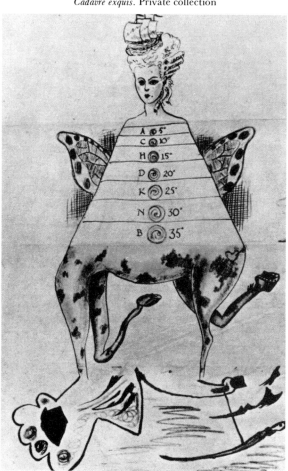

the extent that he is taken in by his visions. They break out as major syndromes, but the worst thing is that the victim of the hallucination loses the ability to distinguish what is real from what is imaginary. The hallucinatory faculty of the Surrealists is in fact a game played with reality, the perception of which remains intact. It is reality rather than the inspiration which is 'forced' in order to produce a vision in which the unalienated individuality of the artist triumphs. Then we may speak of hallucination. We have seen that the term is appropriate for collages which are not rearranged fragments but rapid razor cuts in a magazine illustration on which a subjective vision has been quickly superimposed. It is usually a detail of the first image which instigates the 'psychological crisis' of the second image, as for instance in *Judith* (taken from the cover of a Christmas number of *Elle*)—the coat of mail and the red pullover turned to blood, the smile of the jockey whose ear is licked by a horse.

In fact not all 'hallucinations' contain the 'light of the image'. To be a Surrealist, it is not enough to evoke fantasies which if not vulgar are at least complaisant or even plain silly. An example of this tendency would be Dali's Hitler works—which ought to be excommunicated. There is a Surrealist art of dream, or rather a dream ethics in Surrealism. This art is located at the heart of life, in the emotional terror where dream finds its roots. From the wells it sinks the marvellous springs forth. It uses a number of often very old techniques, some party games, for instance, which are promoted to the category of 'Surrealist games'.

'The exquisite corpse will drink the new wine' was the first sentence produced at 54 Rue du Château, in 1923, in a game hardly distinguishable from Consequences. Every participant writes or draws something, one after the other, without knowing what has been written by the previous player. At the end of the game the piece of paper is unfolded to reveal a composite image. Is that just puerile? Anything can be puerile, even love or war. Anything can be serious, even a game. The Surrealist devoted to such 'distractions' a quasi-experimental curiosity about what might come into existence at the periphery of the psychological. The mere chance of verbal or graphic associations could not, they thought, explain the persistence of certain happy occurrences in the admittedly often absurd conjunctions of words and drawings. 'Conditions' is one such game: 'Y.T.: If children strike their fathers. . . . A.B.: The young folk will all have white horses.'[98] Or there is questions and answers. Your turn comes to ask a question: 'I have a question.' Another player says: 'I have an answer', and a third: 'I have a counter-answer.' Each then reveals, in the same order, the sentence he has conceived. Try it. Other games, sometimes more dangerous ones, occasionally took the group's fancy: the truth game, for example, or, in the occultist period just before the Second World War, certain erotic games. These were intended more to test each participant's power of spirit, and, for example, his truthfulness, than to try the common bonds of sympathy. The Surrealists were less sentimental and dreamy than one might think. Their passionate concern for truth and the undeniable attractiveness of the egotistic practice of spontaneous inspiration, only given to those who are worthy of intentional poetry, separate them from those who confuse the new and the vague, and think that foolish and lazy devices are typically Surrealist. Surrealist eroticism has nothing to do with the *dolce vita*. Though the Surrealists believed that 'poetry is made in bed', for them physical love, fed from the same sources as poetry, only became uplifting and admirable if it was transfigured by poetry. *L'Amour la poésie* is the title of one of Eluard's collections. If life is really inspired, these two words, love and poetry, have only one meaning. Such is the marvellous.

In the friendship for one another and in love, which for them transcended faithfulness, pleasure or tragedy, the Surrealists showed what is truly marvellous. Breton could say that 'abandonment to the marvellous' was the 'only source of everlasting communication between men'.[99] The Surrealist group was a passionate centre of reciprocal inspiration where quarrels and expulsions were often only negative expressions of the one desire to change life. The games they played, or even the conversations, which unfortunately, no machine has ever recorded, prepared them for the mysterious revelations of the oneiric depths, where in solitude the work of each had its origins.

The art of dreaming

The deliberate introduction of the function of dream into a 'superior' activity (to use the psychological term) such as artistic creation, remains (despite the exceptional facility shown by a few like Desnos or Crevel) a complex and risky process. Freud, after all, distinguishes [100] between 'clear and reasonable dreams' (particularly children's dreams where a conscious desire is satisfied by images), and reasonable but astonishing dreams, and dreams whose 'manifest content' is only chaotic as far as the conscious mind is concerned, because of the distortion of 'latent ideas' and 'repressed desires' which take advantage of the weak censorship function exercised in sleep in order to gain satisfaction. This travesty is the product of 'dream work' which uses such processes as substitution, condensation, displacement and symbolization, so that the inadmissible impulses or drives they represent and the unaccomplished acts therein accomplished, remain unrecognized by the subject's conscious mind, but are accessible to the analyst.

There is no question of confusing 'dream work' in that sense and the artist's work, even though the artist evaluating the oneiric world (like the Surrealist[100b]) practises, in spite of himself, the same procedures when physically executing in a work of art an image that has risen to the level of his conscious mind. The artist's work in some way supplements his oneiric labour, and must transform it, even when he tries to be faithful to it. The distortion of dream work is rendered more complex in the process of artistic creation. But the artist's work also transforms dream work when he tries to arrest it, and tries analytically to return to that latent content which has been distorted in imagery. He then falsifies it by means of suspect self-analytical interventions and rationalizations, or artistic conventions—aesthetics, as fashion and convention show, can supply alibis enough.

In spite of a few examples of Surrealist painting supplying psychoanalysis with *ad hoc* material—this is the case especially when the image is less chaotic (Dali) than clear (Chirico, Magritte)—we can find the reasons for our distrust in the scientific foundations of psychoanalysis. Too many artistic procedures come between the work of dreaming and the work of painting for the pictorial product to escape all suspicion of being oneirically worthless. Dream is a veracious process, as is painting. It is by the superimposition of lies that the end product acquires its status as a work of art.

However, I would maintain that oneiric art is not a false idea. The images supplied by the Surrealists, whether 'dream narrators' or not, are very often what Freud called 'dream-stimuli'. Their ability to make us dream (immediately or later) justifies their obviously shocking content, since dream, as we know, is neither a luxury of consciousness, nor its waste product, but the product of psychological liberation. We do not perhaps dream *with* Henri Rousseau, but it is thanks to him that we have dreams. The same is true of Ernst, Tanguy, Dali, Toyen, Magritte, Delvaux and a few others.

Surrealist dream-art may be divided into three different categories, or modes. By ignoring everything other than the particular image or 'provocative' form which fascinates him, the artist hopes for—and often receives as a gift of chance—the onset of the hallucination I have already described. It is something like a stroke of dream-lightning which must be instantly seized and fixed in the image as it flashes out. Max Ernst's collages are characteristic of this process. There the (waking) dream is, it would seem, master of the work of art. The laws of collage are substitution and condensation. Ernst sticks a falcon's head in the collar of a major-domo, and hey presto! there is a bird-man. He puts cocks in drawing rooms, introduces someone from Easter Island to an intimate gathering, puts naked women into corridors, lets waves wash close to the beds of sleeping women, and allows all this to happen in one nightmare night. In their erotic cruelty, terrible animality, passionate disproportion, Ernst's collages and those of artists who have drawn from the same sources, like Max Bucaille, exploit the oneiric power of the Romantic engravings to which they apply their 'hallucinatory faculties'. But scissors and gum are within reach; the image must not be allowed to stay in the hit-and-run category. Everyone can day-dream. Surrealist art tries to hold the

image as it is dreamed: to pin it down like an insect.

Those who dream a lot at night and whose minds are packed with dream imagery when they wake up, can draw on memory and reproduce the latest dream on canvas. The *Ideal Palace* of the postman Cheval was the persistent acting-out of a dream he had when he was thirty. Pierre Roy surely dreamed of the snake descending the stair (*Danger on the Stairs*, 1927). Dorothea Tanning in *Birth Day* (1942) opens the

ROY, PIERRE: *Danger on the Stairs*. 1927. Oil, 92 × 60 cm. Museum of Modern Art, New York

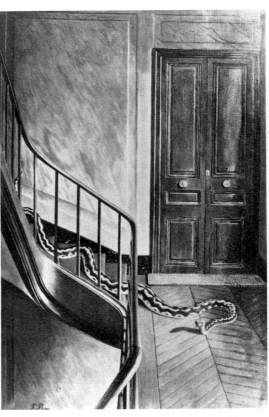

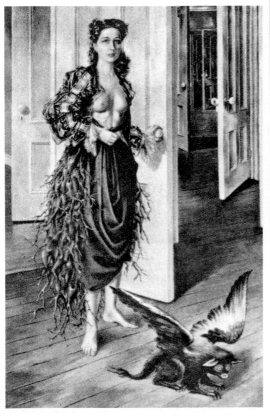

TANNING, DOROTHEA: *Birth Day*. 1942
Property of the Artist

55

doors to a never-ending empty corridor, and near a half-naked woman a little winged monster has fixed his claws in the floor-boards. Valentine Hugo entitles one of her paintings *Dream of 17 January* (1934), and Dali pays homage to the 'viscous period' of his 'limpid watches' in *The Persistence of Memory* (1931). Dream and memory are too intimately linked in the nostalgic mind for all Chirico's oneiric pictures not to be taken as strange fictive operations of memory. As for Giacometti, in an article in *Minotaure* (No. 3, 1934), he tells us how he works: 'For some years now I have produced only those sculptures which have occurred to me mentally and in a finished form. I have done nothing but reproduce them in space without changing anything . . . (all I have to do is to change a part or think about whether it's right this way or that for the whole thing to be lost and the effect to vanish).' The creative rôle of the day-dream, of reverie, is clearly stated in regard to *Palace at Four in the Morning*, 'which came into being gradually at the end of 1932. . . . By the autumn it was so real that its execution in space took me no longer than a day.' This speed of production, made possible by meticulous imaginary preparation, indicates a fear that the oneiric image would disappear during the work process. Most Surrealists felt this difficulty acutely.

It was probably to avoid it that attempts were made to paint in a state of imaginative excitement, so that by a wholly subservient technique the dream images are set down on the canvas as they occur to the conscious mind. Dali made an attempt to seize them almost at the gates of sleep. He describes the somewhat naïve process he sometimes used to grasp dreams and set them in his paintings: 'At dawn, I woke up and without washing or dressing I sat down at the easel opposite my bed. The first image of the morning was that of my canvas, which was also the last image I would see before going to bed. I tried to go to sleep by fixing my eyes on it so that the design stayed in my mind while I slept; sometimes, in the middle of the night, I would get up to look at it for a moment in the moonlight. Or between two naps I would put the light on to study the work, which never left my mind. All day long, sitting at my easel, I would gaze at the canvas like a medium to see the elements of my own imagination spring from it. When the images were very precisely there in the picture, I painted them as they were, hot, at once. But sometimes I had to wait hours and stay there doing nothing, holding the brush immobile in my hand without anything coming up.'[101] Dali the medium awaits the visit of his own genius, sitting in a kind of anxious immobility—a rather surprising patience for the most eccentric of the Surrealists.

These three ways of introducing dream-content into paintings are specific techniques in a much larger context. The waking dream often becomes for the painter what Bachelard calls a 'dream activity', distinct from nocturnal oneirism. Then the process of imaginary confabulation is synonymous with the stages of invention of the painted image. That is the case with Tanguy and Kay Sage, Ernst, Delvaux, Labisse and even Magritte, whose pictorial paralogisms are often the found objects of dreams. Dali's paintings are hardly touched by the sleep that he tried to induce at his easel. The poetic life introduces oneirism into the most intense waking state. Dali was the theoretician of this state of fictive over-excitation.

Dali and 'paranoia-criticism'

We now know from the evidence of its inventors—especially Picabia and the Dadaists—that automatic writing is less passive than it seems. However, when Dali proposed his 'paranoiac-critical method' in 1929, he claimed to substitute for, or at least add to, 'passive' states of automatism an activity that was capable of 'systematizing confusion and contributing to the total discredit of the world of reality'.[102] He too proceeded to 'force inspiration', and very often even to force himself to the point of inspiration. Neverthe-

less, more than anyone else, he tried to make painting submit to the law and caprice of dream. Dreaming is not 'automatic'. The introduction of waking or day-dreams into pictorial practice requires the painting itself to be a dream material. When Desnos was in the state of half-sleep that he could induce at will, and allowed a veritable verbal flux to gush forth (he only became aware of this later when listening to a recording), he benefited from the automatisms of a cerebral function long used to such a language. But what is sometimes called 'pictorial language' does not talk in the same way. Have you seen a painter work in the state into which Desnos allowed himself to drop, or as a sleep-walker walking? An entire psychological discipline has to be applied if painting and dream are to join forces.

Whether it is 'paranoia-criticism' or 'automatic writing', art is unable to follow what is sometimes the essential matter in dream, its plot. There are few examples of pictorial narratives in history, in spite of the extraordinary expedients used by the writers of sacred scriptures in Egypt. The succession of juxtaposed scenes, or the multiplied images of the same person in the picture do not break the yoke of immobility. Film is a much more appropriate technique in this respect and Dali took advantage of it.

In fact painting is not oneiric but becomes so fully if it establishes a dream-including image to initiate the imaginative process, supplies the day-dream with its dynamic impetus, and suggests the theme that will possess the observer. Too much figurative detail or any kind of medley will be less stimulating than certain quasi-abstract patterns of Miró or Brauner, or material effects such as those we have met with in Ernst, Masson or Pollock. Is there any need for the dream to be chewed over first, as it were? That is what some dream narrators, Pierre Roy, Dorothea Tanning in her figurative phase, and others seem to do. In order to provoke dream, the figurative image should contain the potential of its expression, as in the best photographs of Man Ray, or in the paintings of the Douanier Rousseau and the Chirico of the metaphysical period.

In 1934 Breton reacted, in *Les Vases communicants*, against the 'flood of dreams' which had engulfed Surrealism in the 'sleep period'. It was not a question of allowing the tyranny of dream to rule, but of achieving a fusion of the imaginary and the real in order to satisfy desire, and achieving it in the creation of works of art—not documents. 'Paranoia-criticism' is a version of this process of fusion. It ironically oneirizes all everyday activities, but the word 'desire' is hardly used by Dali. I shall return later to his eroticism, and his apologia (verbal, at least) for 'perversions of all kinds'. But he is too full of himself to feel the need for inward liberation. His paintings, films, objects are replete with his genius. Why then should we ask them to explicate the psychological depths? He is the opposite to Breton in refusing to engage in self-analysis. That surely explains his privileged yet episodic relationship with Freud,[103] for whom self-analysis is contrary to the basic principles of psychoanalysis. But art as catharsis is, however, somewhat dated; Surrealism renewed its foundations, thanks to psychoanalysis, but psychoanalysis, like the treatment of neurosis, has kept scientific silence on this point.

Desire, a key concept of the freedom for which Surrealism fought so hard, only takes dream as an outlet if reality is deficient, and nearly everyone would agree, in fact, that it is better to enjoy access to reality than to dream. Hence the simultaneously libidinal and intellectual imperative, 'Change the world!'. Certainly the limitless aspect of desire must also come up against obstacles other than social taboos and the repressive structures of culture and the police. The human condition, for instance, makes it impossible to rediscover in reality the beloved who returns every night as a dream-creature, something that impressed Breton in the film *Peter Ibbetson*.[104] The oneiric cruelties, the dreams of flights and erotic aspirations to infinite performance, would meet with real-life obstacles which have nothing to do with moral or social suasions: the exhaustion and death of the victims (whereas Justine in Sade's books is always innocent, always fresh, in spite of all she undergoes), waning powers, and the sheer earth-bound nature of the human body. Hence art is not only a means of compensation that would be pointless if all censorship were to disappear (a death of art that would accompany the death of religions), but the means of access to a *third* human condition, and one lucidly and ironically conscious in a superior way of what its true utopia is.

This way-in would be a happy mean between the real—indeed, the 'too' real—route and the imaginary, too ghostly, even neurotic route. The way to this third condition of man is the way of art, and the Surrealists realized that it is also the way of revolution. And that of course is where Dali missed out—in never really knowing how to be a genuine revolutionary.

'Paranoia-criticism' is less a simulated (or stimulated) form of paranoia than a mode of mythomaniac and fiction-spinning excitation, very close to what might be called the 'poetic life'. Jacques Lacan's medical thesis *De la paranoïa dans ses rapports avec la personnalité*, 1932 (*Paranoia Considered in its Relation to Personality*), was read attentively by the Surrealists, and bolstered their conviction. The picture of paranoia as a delirium of interpretation in the Freudian sense, but a permanent one categorized in accordance with the two complementary delusions of grandeur and persecution, and persisting together with normally functioning mental faculties, appeared to support the Surrealist insistence on the 'minimal reality' of the objects of perception. But the systematic and inflexible aspects of paranoia should have alerted them to the dangers of authoritarian megalomania (a form of delirium of grandeur). Gilles Deleuze in his *Anti-Oedipe*[105] is more perceptive than the Surrealists in contrasting fascist paranoiacs with schizophrenics, whom he sees as the real utopians of the vision of a transformed life. On the other hand, Lacan's orthodox Freudian diagnosis, illustrated in terms of Aimée's paranoia (the only case-history he studies in his thesis) as a 'curable' masochistic complex,[106] supplied the Surrealists with ammunition for their defence of psycho-

DALI, SALVADOR: *The Great Masturbator*. 1929.
Private collection, Paris

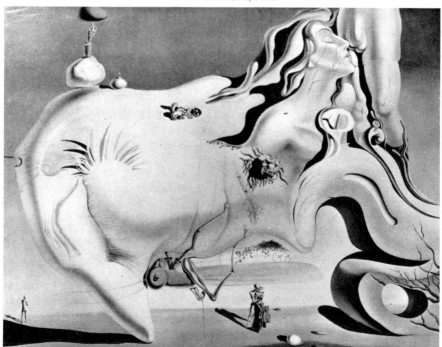

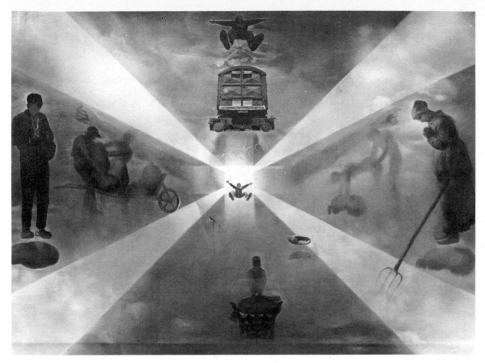

DALI, SALVADOR: *Gala Looking at Dali.* 1965. Oil,
294.6 × 406.4 cm. Galerie André François Petit, Paris

analysis at a time when it was not accepted culturally. In the 1930s psychoanalysis and its associated theories were suspiciously avant-garde enough to offend those, for instance, who defined their use of lyrical paradoxes as a 'spontaneous method of irrational cognition based on the critical interpretative association of delusional phenomena'.[107] This (deliberately) confused definition ignored the fact that paranoia, as a psychosis, is not an interpretation or an interpretative association, even in a critical sense, of any delusion, but an unconscious delirium of interpretation, or delusional system of interpretation of the real, perceived world. The delirious or delusional phenomena which Dali mentions are hypnagogic phenomena, day-dreams, 'half-waking visions' (in Ernst's terminology), nocturnal dreams and, in certain cases, hallucinations. Delusional art consists for Dali in encouraging what Ernst called the 'hallucinatory faculties' by feeding them with themes which become the poet's or painter's 'obsession' for a certain time.

Shortly after the success of his film *Un Chien andalou*, which he made with Buñuel, Dali devoted his time to William Tell and *The Great Masturbator*. He was preoccupied by the father image and quite explicit representations of castration and detumescence, well before he moved, *c.* 1931, to coprophagic themes. In 1933 he became fascinated by Millet's *Angelus*. He introduced it into his paintings, and interpreted it in a ludicrously erotic way, associating it with the image of Gala. For Dali and his wife these lonely peasants praying in a field emanated something like inverted narcissism. Then Dali turned to Meissonier of all people and tried to make him a pioneer Surrealist. This was to lose all sense of actuality. As for Hitler, on the pretext that he had dreams about Hitler at night Dali thought it was permissible to offer an apologia for him in front of his friends and in the name of Surrealism; he was abruptly corrected on this point.[108] The Surrealist ethic does not go so far as to say that everything is justified by nocturnal fantasies. Then Dali turned to the pregnant Virgin Mary, and to the Christ of St John of the Cross. The American period of society portraits found an appropriate complement in these 'paranoiac' incursions into traditional religious motifs. The tendency continued in a *Mystical Manifesto*.

Dali's feverish imagination has always made him a brilliant conversationalist. His loquacious genius has also enabled him to produce verbal nuggets of the 'pataphysical' variety in which his intellect takes the opportunity to christen certain peculiar aspects of his art Anamorphoses, which were well known to Dürer and the Renaissance esoterics,[109] and what Dali more freely calls 'anamorphic images', like those produced by deforming mirrors, are like anaglyphs or delusional analogical signs: an intellectual process in pictorially fictive form. Without taking the linguistic analysis beyond the tenable limits suggested by Dali himself, the prefix *ana* should not be confused with the *para* of paranoia. A paralogism is not an analogy. And Dali prefers to stay in the world of the second, so often the practice of those who resort to the metaphoric and metonymic devices proper to poetry. Magritte also had recourse to another, fruitful use of paralogism and its lyrical possibilities.

Breton, who wrote the introduction to the first of Dali's Paris exhibitions, at the Galerie Surréaliste on 20 November 1929, did not hesitate to greet paranoia-criticism as a 'really first-class tool'. Of course he could use the word 'tool' in a pejorative sense. Painting is a tool, and hence 'ludicrous'; 'paranoia-criticism' is a way of being. Dali is hysteroid—his irrepressible laugh fascinated the Surrealists—rather than paranoid or schizoid. He took to an extreme his ability to overstep lyrical play while remaining its willing victim. Auto-suggestion, a principal characteristic of his particular emotional type, finds the best food for its ironic confabulation in insistence on one's own genius, as practised by Dali. Salvador, the saviour of modern art, he constantly calls himself in *Dali de Draeger*.[110] 'Am I a genius?' he asks at the beginning of his *Secret Life*.[111] In fact his whole life has been a fierce proclamation of his conviction that the only possible reply is 'Yes!'

The 'fusion of the imaginary and the real'

Initially Dali the painter had demonstrated his dream techniques in areas other than painting. Dali and then Giacometti were the first Surrealists not only to make films but to produce those famous 'symbolically functional objects' which exceed the introversion of dreams and bring about the 'fusion of the imaginary and the real' at a higher level.

Of course Man Ray had made films before 1929. *Emak Bakia* was made in 1926, followed shortly after by *Retour à la raison* (in collaboration with Rigault) and *L'Etoile de mer* (with a script by Desnos). As for *Mystères du château de dés*, it was eclipsed by *Un Chien andalou* by Dali and Buñuel, which appeared the same year, 1929. This film like *L'Age d'or* in 1930 is deliberately intended to be a celluloid nightmare. It is closer to Fritz Lang and Murnau than the somewhat skimpy experiments of the Futurist and Dadaist avant-garde. If the cinema is, as Ado Kyrou remarked, 'essentially Surrealist',[112] that is not really because 'everything is possible' there but because the dynamic imagery can come closer in film than in any other art to the odd evolution of the dream process. I remarked before that Dada was not very interested in dreams. That was why the Dadaists produced so few films. Richter's *Rhythmes* (1921, 1923, 1925), his *Film Studies* (1926), his *Chapeau vol-au-vent* (1927), the *Anaemic cinema* (an appropriate title) of Duchamp and Allégret, are too 'ludic' and are still within the tradition of the famous *Entr'acte* by Picabia and René Clair (in the ballet *Relâche*, 1924).

On the other hand, the two films of Dali and Buñuel whose themes of aggression and sadism caused a scandal were replete with dreams. Later in Buñuel's career *Viridiana* (1961) and *The Exterminating Angel* (1962) were to bear special witness to the persistence of the influence of Surrealism, which also reached

Above
BUÑUEL, LUIS: Still from the film *L'Age d'or*.
1930. Cinémathèque de Paris

Top right
RICHTER, HANS: Scene from film '*8 × 8*'. 1956–7

a wide public in the films of Prévert and Carné. *Record* by J.-B.-Brunius, Buñuel's assistant for *L'Age d'or*, Storck and Labisse's *La mort de Vénus* (1930), the films Richter produced in the United States, *Dreams that Money Can Buy* (1944) and *8 × 8*, from which *Dadascope* (1957) and *Passe-temps passionné* were taken, Freddie's two shorts, *Refus définitif d'une demande de baiser* (1949) and *Les Horizons mangés* (1950), the film of Raymond Borde on Molinier (1966) and above all *L'Invention du monde* by Bédouin and Zimbacca (1952), are more in accord with the ambitions of Breton, Man Ray and Eluard recorded in their *Essai de simulation du délire cinématographique*, an unfinished film from which some fragments were published by *Cahiers d'Art* in 1935. This was a curious piece of work. Admittedly, the *Immaculée Conception* is a verbal simulation of schizophrenia or paranoia, but the cinema is not a psychosis and has no need of a simulation of form of delusion which is, in fact, natural to it. Dream art is certainly hindered by too many technical realities and that is probably why Surrealism with its insistence on spontaneity hardly developed its creative potential in this field.

On the other hand the production of significant objects which are non-decorative and useless, but full of oneiric and libidinal power, was Surrealism's most original contribution to the sensibility of the time.

If you look through the special issue of *Cahiers d'Art* (1936) on the object, or the catalogue of the exhibition in the same year at Ratton's, with an introduction by Breton entitled 'Crise de l'objet'[113], the first thing that will strike you is the broad field of endeavour available for the passionate intensity of a poet's mind. Apart from significant or 'suggestive' minerals and vegetables, there are such animals as the ant-eater and armadillo—and some of these natural objects are interpreted or incorporated in compositions, 'disturbed objects' (such as glass with interesting patterns produced by volcanic action or mineral salts in the ground), and found objects, some of which are 'interpreted', enhanced, or heightened. A little later Roger Caillois signed mineralogical specimens, thus imitating the Chinese artists of the nineteenth century.[114] The collection and display of flotsam and jetsam, glass and wood polished and worn by wind and salt, was a favourite pursuit of the visually cultured. A poet like Jean Carteret (a Surrealist, if only in the fact that he never sank to the level of writing a single line) made his room a veritable display-case of odd and marvellous objects.

The Ratton exhibition included ethnological objects, above all from America and Oceania, analytical geometrical montages (a Surrealist can also be a mathematician), and the inevitable ready-mades of Duchamp. There was also the special field of Surrealist objects, those of Giacometti, Dominguez, Arp, Maurice Henry and Marcel Jean, and the picture-objects of Breton and his wife Jacqueline Lamba, Hayter, Hugnet, Miró, Picasso, Tanguy and a few others. Among them are some obvious gallery objects which drew their magical note from a life setting. Meret Oppenheim's *Fur Cup and Saucer* is an example of this kind of object. There is also Seligmann's *Ultra-Furniture*, a kind of stool with three women's legs; or seat your guest instead at Brauner's *Wolf-Table* (1947) and serve him the odd pair of shoes in the form of roast chicken entitled *My Governess* by Meret Oppenheim. Magritte could supply a bottle of wine transformed into a girl or—more vulgarly—into a carrot. You could switch on *Found Object Having Served M.E. as a Television Set* (1964 collage-object) and make good use, if only for a little privacy, of the *Five-Panel Screen* found by Tanguy (1936–9). The best game you could play would be with Bellmer's *Doll*. Children are cruel and childhood is a torture, but this awful toy-child would soon make any adult distraught with the multitudinous possibilities of her limbs. You would, we trust, have had no need of Dali's *Aphrodisiac Waistcoat* (rather difficult to wear) nor, we hope, of Arp's *Truss for a Shipwrecked Sailor*. But your girl-friend could have capped her hair-do with a Dali-esque *Slipper-Hat* or Hiquily's (1959) biretta with its insidious glass eye. In any case, on rising from your ivy-mantled chair (Paalen, *Chair Cover*, 1936), you would have at your disposal for various kinds of rest, the two main divisions of Surrealism: creative sloth and individual rebellion in Sterpini's *Armed Armchair* (1965). If you have nothing better than a crossword to take your mind off things, there's always the Petit Larousse dictionary newly illustrated by Tanguy (1934), but if the telephone rings, be extra garrulous, for Dali has replaced the receiver with a

BRAUNER, VICTOR: *The Wolf-Table*. 1939–47. Object,
50 × 55 × 30 cm. Musée National d'Art Moderne, Paris

JEAN, MARCEL: *The Ghost of the Gardenia*. 1936.
Object in plaster covered in velvet,
height 25 cm.
Galerie Françoise Tournié, Paris

live lobster. If you need a cab for your friend, don't call Dali's *Rainy Taxi*—it is occupied by a beautiful woman covered in snails. Don't despair, however, there's always the wheelbarrow upholstered and signed by Dominguez in which Man Ray can photograph your girl in a Lelong dress (1937).

At the 1947 exhibition André Breton wanted to include Giacometti's *Invisible Object* among the Surrealist fetishes. This vaguely African statue, whose hands appear to be holding an object that is not there, provided a basis for his meditation *Equation of the Found Object*.[115] This was the last of the objects created by Giacometti during his short Surrealist period. The first, *The Time of Traces* (1930) inspired all those who were then working on objects, primarily Dali. It is both simple and suggestive, and on closer inspection evokes the latent erethism of certain embraces, reduced here by mechanical sterility to a suggestion of masturbation. If any symbolic object can be interpreted psychologically as a projection of the organism, or of the couple, by the mere suggestion of specific forms of behaviour, it is *The Time of Traces* in its more unnerving than erogenous effect drawn from a very simple structure.

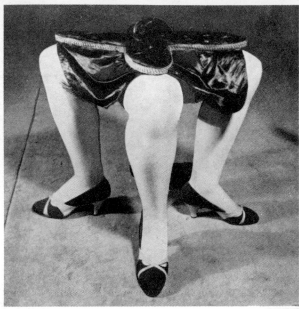

SELIGMANN, KURT: *Ultra-Furniture*. 1938. Object.
International Exhibition of Surrealism,
Galerie des Beaux-Arts, Paris

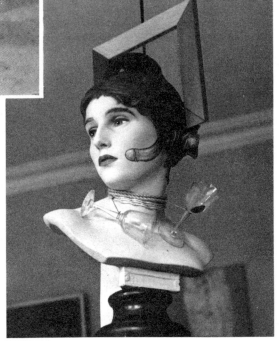

FREDDIE, WILHELM: *Object*. 1936. Private collection

The equally abstract quality in the almost classical and rich sculptures of Hans Arp offers an analogous effect of sensual undertones, and the objective immobility of sculpted mass evokes movements more subtle and varied than Giacometti's time-pendulum. Nevertheless Giacometti's *Time of Traces* is one of those montages which can disturb the *sang-froid* of the most indifferent spectators. In Léo Malet's *Surrealist Street* of 1938 the elegant model has a red fish in an aquarium in place of a stomach and was found too suggestive for exhibition, and a similarly sensual message is to be found in Pol Bury's objects in which some elements work with almost imperceptible movements. At the Salon Comparaison, I have seen a girl suddenly discovering on a wooden column the organic movement of its external characteristics, and unable to tear herself away from it. After inventing his *Multi-Plans* (1957–8) made of slats which turn very slowly in

various rhythmns, and imperceptibly alter the forms the picture takes, Bury covered them with a cloth or plastic sheet which subtly revealed the movement beneath. These suspicious palpitations could evoke thoughts of the most mysterious spasms.[116]

There have been many descriptions of the international Surrealist exhibitions.[117] Three of them took place in Paris, in 1938 at the Galerie des Beaux-Arts, in 1947 at the Maeght Gallery, and in 1959–60 at Cardier's (EROS exhibition), and offer the best examples of the creative transformation of a space in which the internal architecture itself becomes an art of the object. Duchamp was a past master of this, and the great exhibition hall in 1938 with its ceiling hung with 1,200 sacks of coal, its floor covered with dead leaves and swampy patches, its central brazier and four welcoming beds in each corner, was his product; like the covering of the Baroque décor of the Reid Mansion (New York, 1942), the billiard

International Exhibition of Surrealism.
1938. View of the central hall.
In the foreground *Never*, object by Oscar
Dominguez. Galerie des Beaux-Arts, Paris

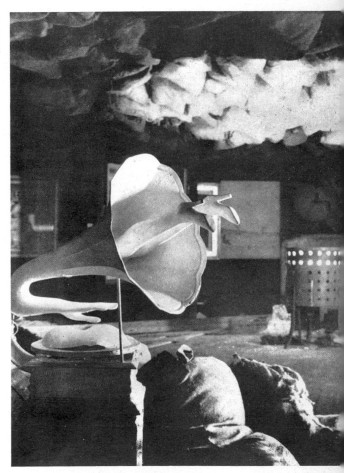

table in the 'rain room' (1947) or the heightened white-rose ceiling of 1960. The common feature of these exhibitions was their arrangement in an initiatory liturgical pattern leading to a kind of Holy of Holies. The development of Surrealism between 1938 and 1960 was clear from the thematic differences in these exhibition circuits. Before the war Surrealism descended to the street. You were greeted first by Dali's rainy taxi, where the beautiful passenger seemed voluptuously to welcome the caresses of the snails crawling

RAY, MAN: *Dress of Lucien Lelong Photographed in a Wheelbarrow of Oscar Dominguez.* 1937

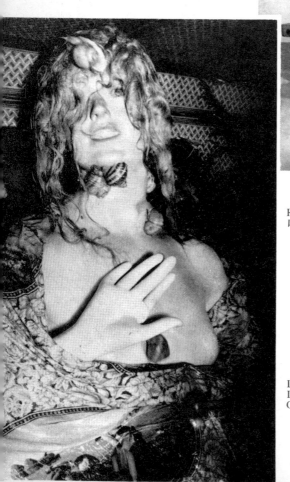

DALI, SALVADOR: *The Rainy Taxi* (detail). 1938.
International Surrealism Exhibition,
Galerie des Beaux-Arts, Paris

International Exhibition of Surrealism. 1947.
Hall of Superstitions: from left to right
Man-Anguish by David Hare,
Waterfall by Joan Miró,
Black Lake by Max Ernst,
Cloud by Yves Tanguy.
Galerie Maeght, Paris

over her, then by the Surrealist street with its famous wax models of twenty women dressed or undressed by members of the Surrealist group as the fancy took them. This street led to Duchamp's hall where the smoky, puddly atmosphere still had a whiff of urban life about it. Dominguez had positioned one of his masterpieces there: the silent gramophone with a stomach turntable moving beneath a pick-up hand; feet

ERNST, MAX: *Euclid*. 1945. 65.4 × 57.5 cm.
Bibliothèque Nationale, Paris

LAM, WIFREDO: *Altar for 'La Chevelure de Falmar'*
from 'Chants de Maldoror'. 1947.
International Exhibition of Surrealism,
Maeght Gallery, Paris

HÉROLD, JACQUES: *Altar for the 'Grands Transparents'*
of André Breton. 1947.
International Exhibition of Surrealism,
Maeght Gallery, Paris

shod with high-heeled shoes poke out of the horn in which a woman has been tragically swallowed up
(*Never*). The *Ultra-Furniture* and *Fur Cup and Saucer* were there. And everywhere in the darkness there were
hands. At the opening the loudspeakers emitted the sound of the German army marching.

In 1947 religious motifs were fashionable and traditional magic set the tone. The twenty-one motifs
of the Tarot pack appeared on the twenty-one stairs at the Maeght Gallery. The first room was entitled
Superstitions. The Surrealists of course were not really superstitious and gave the word the same meaning
it had in the eighteenth century. Hence the egg shape of the room could be taken as symbolic. The
meaning was probably that, to attain to poetry it is necessary to leave the egg of superstition. This room
contained, among other exhibits, Max Ernst's painting, *Euclid*, the architect Keisler's *Totem of Religions*

International Exhibition of Surrealism. 1959–60.
The Cannibal Feast. Galerie Daniel Cordier, Paris

(he had designed the overall effect), a vampire by Diego and Donati's *The Evil Eye*. You had to pass under a scaffold signed Tanguy and through a purifying rain before entering a labyrinth where there were a dozen altars consecrated to Surrealism. An entire bestiary of the surreal was at their devotions: *The Worldly Tiger*, symbolic of the uncontrolled libido (Jean Ferry had narrated in a long short story how the libido had snarled in the smoking-room of the Opera, for every man carries a tiger in his heart—a sleeping tiger); other mythical and real animals included the *Suspected Heloderm*, a nasty little saurian who never lets go once he has his teeth in, *The Secretary Bird*, *The Condylure* (a linen-faced mole), and Brauner's *Wolf-Table*, covered in tulle like a baby's cradle. An extraordinary range of beasts, especially when one considers that they have nothing to do with Lautréamont's dog-fish or louse—which was nevertheless celebrated by Wifredo Lam's altar of devotion (*La Chevelure de Falmer*).[118] Hérold had erected a statue to Breton's *Grands Transparents*. But there were only two heroines in all this array: the camp-follower of Jarry's *The Dragon* with a weather-cock by Jindrich Heisler, and Léonie Aubois d'Ashby, taken by Breton from Rimbaud's *Dévotion*. Not very many for a group of poets who, from Germaine Berton to Mélusine by way of Justine, Violette Nozière, la Chimerè and Nadja, often made woman a deeply symbolically agent. The EROS exhibition compensated for this oversight.

The EROS show coolly invited visitors to attend a Black Mass. After the stretched pink satin by Duchamp in the entrance you had to go through a 'vaginal door' and enter a 'labyrinth filled with sighs and swooning on the way to a room of fetishes and a red room where a daring cannibal feast was being held'.[119] This noble feast offered a beauty stretched out on a tablecloth. She was much more delectable even under

69

her golden wax than her snail-assaulted predecessor. At this feast there were bananas, nuts and apples. The whole was much closer to Dali or to Gayelord Hauser than to Breton. Meret Oppenheim had laid the table. Bellmer's *Doll* was there too. In a few newspapers, an anxious paterfamilias or other patriarch deplored the infectious decadence of the proceedings. But there was nothing comparable to the major scandals of *L'Age d'or* or *Un Chien andalou*. It was obvious that in spite of a rather too heavy emphasis, the religious theme of this exhibition excluded barrack-room humour and obscenity, both of which are rich soil for the essential shame of Puritanism.

Pictorial Surrealism:
Erotics, Politics and Logic

My intention was to describe the creative activity of the Surrealist painters and to make a contribution to what might be called a 'poetics' of Surrealism.[120] I shall give only a short outline of the themes and the aesthetics of different styles, matters which other authors have treated in detail.

I shall not expatiate on the obvious diversity of Surrealist art for the exhibition *Surrealist Diversity*, which Mesens organized in London in 1945, is evidence enough. Formal themes appear behind approaches as contrary and as diverse as those of Miró and Dali, Masson and Magritte. The themes are as follows:

ERNST, MAX: *Le Déjeuner sur l'Herbe*. 1935–6. 46 × 55 cm.
Private collection

PICABIA, FRANCIS MARTINEZ DE: *Hera*. 1928.

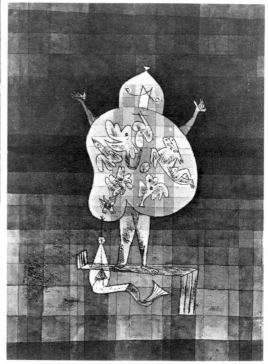

KLEE, PAUL: *The Ventriloquist*. 1923.

The *viscous*. Well before Sartre offered a 'phenomenology of the viscous', Surrealist painters, nostalgic for the viscosities of *Art Nouveau*, defied the angular and Neo-Cubist aesthetic of the period between the wars: Masson in his automatic drawings, Ernst with his *Head of a Man* (1934) and *Déjeuner sur l'Herbe* (1935–6) and the grand 'interpreted decalcomanias' of the Arizona period; Dali with his 'limpid watches', excrescences supported by a crutch, his *Nightmare with soft Violins* and his *Agnostic Symbol* (1932), and Freddie, one of Dali's disciples. There was also Man Ray, who solarized a nude and entitled it *Primacy of Matter over Thought* (1931).

The *Transparency*. Often close to Eluard's luminous world, or exhibiting the fluid 'de-realization' of *Soluble Fish* in which Alquié saw the fundamental character of the Surrealist sensibility, the Surrealist 'transparencies' had their own significance. Duchamp worked his *Bride Stripped Bare by her Bachelors, Even* on glass. Klee's depictions of linear characters, for instance *Hetaera* (1922) and *The Ventriloquist* (1923),

MAGRITTE, RENÉ: *The Breast*. 1960.
51 × 70 cm. Private collection

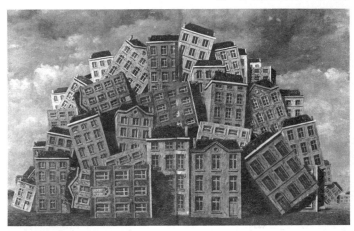

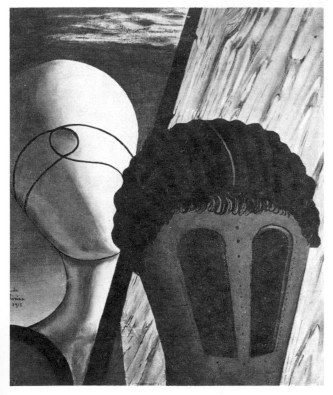

CHIRICO, GIORGIO DE: *The Two Sisters,
or the Jewish Angel*. 1915. Private collection

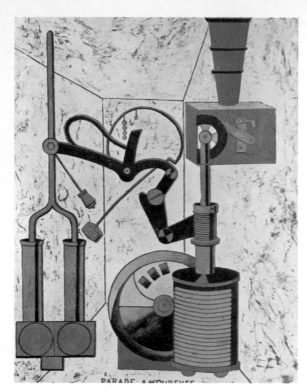

PICABIA, FRANCIS MARTINEZ DE: *Amorous Parade*. 1917.
Oil on canvas, 96 × 73 cm. Private collection, Chicago

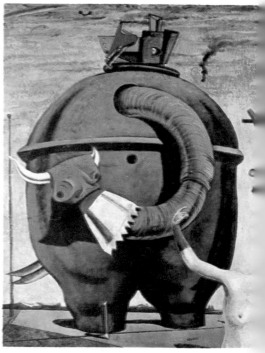

ERNST, MAX: *The Elephant Celebes*. 1921. Oil on canvas,
130 × 100 cm. Collection: Sir Roland Penrose, London

the Picabias of the transparent period (*Hera*, 1928), the clear dusks of Brauner, certain drawings of Man Ray and Masson, the milky horizons of Tanguy, Matta's bottomless space, Giacometti's *Palace at Four in the Morning*, Calder's wire figures, Raoul Ubac's photo-fossils and, above all, Bellmer's marvellous erotic imbroglio, all show how appearances are penetrated by the Surrealist vision.

The *void*. The vision of the void focuses on the Nothingness of the surreal, as we know. The pictorial expression of the void is certainly metaphysical, as, for instance, in the deserted towns of Giorgio de Chirico's *Melancholy of an Afternoon* (1913) and *The Two Sisters* (1915). Other examples are Toyen's *Sleeper* and Magritte's *The Breast* where the absence of the mother from the deserted house gives the work its feeling of catastrophe. Yet Miró reaches an understanding of the void by way of formal design.

CHIRICO, GIORGIO DE: *Melancholy of an Afternoon.* 1913. Oil
on canvas, 57 × 48 cm. Private collection

Reification. The process of alienation, of reification, reducing living matter to minerals or machines, and the human to the animal or to a thing, is part of the Dada spirit. Breton, pleading in favour of the 'uplifting aspect' of the Surrealist image, condemns Tzara's 'guitar, his singing bidet'. Picabia's *Amorous Parade* (1917) and Duchamp's *The Bride Stripped Bare by her Bachelors, Even* foretell Ernst's *The Elephant Celebes.* And a consequence of Dadaist scorn is to be found in the cold petrifications of birds or trees which so often appear in Magritte, or in his 'clay *trompe-l'oeils*' such as the extraordinary *Private Diary I* (1951). As for Dali, he changed Mae West's face into an apartment.

Euphoric levitation, a feature of dreams of flight, appears in Chagall constantly. This theme is associated with the bird motif in Max Ernst (*Monument to the Birds,* 1927). It occurs in *The Battle of the Princes of Saturn* by Paalen (1938). And Magritte suspends in weightlessness the *petits bourgeois* of *Golconda* (1953) and the rock in *Castle in the Pyrenees* (1959). And of course there is the delicate suspension of Calder's mobiles.

In contrast, *entanglement* is also a constant theme with its aura of obsessional suffocation. It can apply just as much to accumulations of objects as to cobweb shapes. Tanguy's odd creatures, the interpreted decalcomanias of Dominguez and Ernst, the forest-like crowd of Wifredo Lam, the saturated forms of Masson or Alechinsky, the infinitely detailed imagery of Le Maréchal or the tumultuous crowds of Dado, depend on the same inspiration as the formal abundance of Miró's constellations or Pollock's large dripped canvases.

These formal themes allow the contents of the paintings to be analysed in the three areas in which Surrealist art has tried to modify the doctrinal orthodoxy of the theoreticians and poets.

Eroticism

If you study in this book the most libidinous works of Bellmer, Dali, Labisse, Miró, Molinier and Clovis Trouille, and if you recall the incantatory love poems of Aragon, Breton, Eluard and Péret, you will find a contrary attitude to women in painters and poets. Surrealist painting seems closer to Sade than to Eluard. Xavière Gauthier tries to explain, in Freudian terms and using specific pictorial imagery more suitable for dream-interpretation of the ambivalence of masculine castration fears, the fact that 'in Surrealist poetry woman is good and loved, whereas in Surrealist painting the woman is bad and an object of hatred'.[121]

What are we to make of Miró's *Head of a Woman* (1938) and the Picassos of the Boisgeloup period?

STÝRSKÝ, JINDRICH: *Collage.* 1934
Private collection

LABISSE, FÉLIX: *The Future Unveiled*. 1955

Not only is it the abusive wife who provokes this artistic rage—and Niki de Saint-Phalle's *Nana*s show that this type is unisex—attractive girls are just as liable to be reduced to monsters. Bellmer distorts the limbs of a prepubescent girl who seemingly provokes the games she is forced to suffer. Stýrský shows us a woman's legs caressing a knife (*Collage*). And all kinds of sadism are to be found in Max Ernst's collages. Toyen's *Respite* shows a woman hanging by her feet. In a collage by Brunius the woman seems to have been consumed by a bearded man. Dali paints two tigers leaping towards a beautiful sleeping girl (1944). *The Future Unveiled* of Labisse adds the motif of clothes fetishism where the breasts are left exposed and the woman slowly bleeds to death. In Leonor Fini's *Essayage* (1966) a jovial dressmaker binds a woman with a sharp wire. In Clovis Trouille's *Lust*, under a ruined Château Lacoste, the woman abandoned to the whip of the Divine Marquis does not seem to be suffering too much—but that is probably the essence of the male dream!

The sublime 'Eve with Two Amphorae' of *Arcane 17*—the adored heavenly double of the screaming victim in Sade's dungeons—is not absent from Surrealist painting. Leaving aside Gustave Moreau, as 'restored' by André Breton, Max Ernst's woman usually has a fresh beauty and her nudity seems appropriate to the nightmares of the collages, or she might appear in the fetishist yoke of her decalcomaniac finery (*The Stolen Mirror*, 1939, *Napoleon in the Desert*, 1940–1). For Brauner she is the luminescent *Chimera* filled with occult power and *Interior Life* (1939), or the enchanted walker of *The City* (1939). Magritte makes woman an untouchable serene nude, whereas the man is a ridiculous bowler-hatted *petit bourgeois*. Delvaux exalts feminine hauteur in his nocturnal processions. Leonor Fini offers a hieratic *Guardian of the Egg* but also female sphinxes that are obviously dreamed up by a man. Clovis Trouille works in a more popular style, adulating the sexy little woman, yet his heroine is *Death in Beauty*. The schizophrenic Aloyse avenges all the unfortunate female lovers of history, and F. Schröder-Sonnenstern identifies

woman with *Practice* (1952). As for Svanberg, he has always celebrated the radiant woman.

Woman is not the only object of Surrealist eroticism. Representations of love-making and its various modulations, including the supposedly perverted, have only emerged from the seclusion of the great collections of erotica by disdainful permission of Surrealists like Bellmer, and more complaisantly by Molinier with his fierce erotic entanglements. Woman as the subject (of desire and pleasure) in the tragic community of insatiable longing is understood conspiratorially by the male voyeur. Any painter who takes up an erotic theme is a voyeur (of his own pictures). The same is true of certain Surrealist women painters. Dorothea Tanning with her couplings between women and dogs, Bona and her 'spirals',

TROUILLE, CLOVIS: *Death in Beauty*. Homage to Marilyn Monroe. Above the frontispiece, Marilyn Monroe. Left: Lollobrigida (friend of Marilyn) with Nijinsky. Right: a woman whose name I have forgotten with Nijinsky at her side. 1963. 65 × 45 cm. Private collection

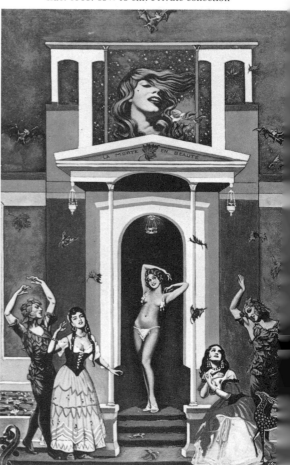

ERNST, MAX: *Napoleon in the Desert*. 1941. Museum of Modern Art, New York

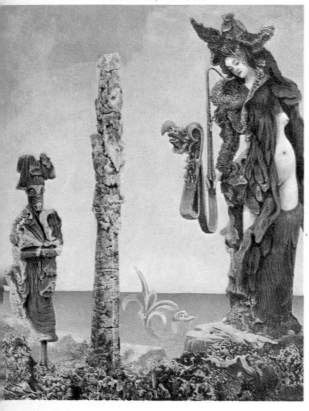

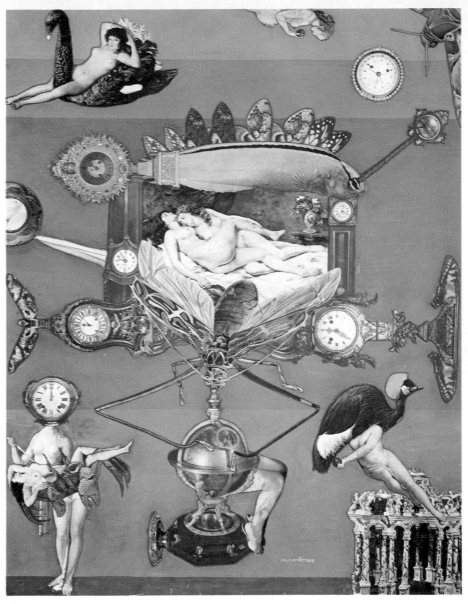

SVANBERG, MAX-WALTER: *Homage of the Strange Constellations to G in Ten Phases (Phase 10)*. 1964. Moderna Museet, Stockholm

Leonor Fini, who illustrated *The Story of O* and records her 'train observations' in pastels (*Journey*, 1965, *Harmonica-Train*, 1966, *The White Train*, 1966, *Along the Way*, 1967), are no more cold than Balthus intent upon his delectable Lolitas, Dali carefully composing the reflections of *The Young Virgin Self-Sodomized by the Horns of her own Chastity* (1954) or assembling with Buñuel the sequence of caressed breasts in *Un Chien andalou*, and that of the Lya Lys suck-kiss in *L'Age d'or*, Bellmer illustrating Sade, or Molinier composing *To the Skies* (photomontage 1972).

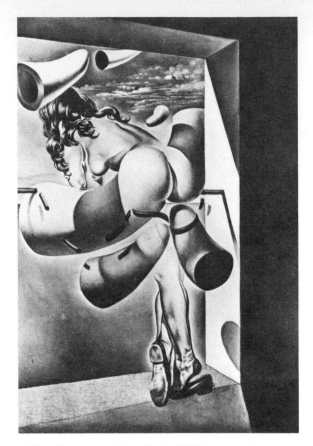

DALI, SALVADOR: *Young Virgin Self-Sodomized by her own Chastity*. 1954. Collection: C. B. Alemany, New York

Xavière Gauthier rather reductively sees 'the truth of Surrealism' in *To the Skies*. In spite of its pleasures, it depends on those sexual gymnastics in fashion in the porn and sex instruction manuals attacked by Aragon: 'When they have built a pyramid with their bodies, they have plumbed their imagination.'[122] The Surrealists had no more taste for such gymnastics than for blue jokes. Sensation, like purely 'retinal' painting is not enough for them. Their first concern in regard to sex too is to know where it leads. Their eroticism is one with their thirst for knowledge, even though the 'sexual world' unceasingly opposes their 'desire to penetrate the irreducible core of darkness in the universe'.[123] Even in their most erotically liberated paintings the Surrealists showed their predilection for 'true love', which they exalted as much as genius; but both love and genius are idealist concepts, it would seem.

Politics

If a 'transformation of life' means a 'rediscovery of love' and the converse, it is clear, if only to those least puzzled by ideological simplifications, that the 'irreducible core of darkness' has to some extent held back the irrepressible hope of a just and free society. The political thought of the Surrealists who accompanied

Breton in his move from Marx to Trotsky and from Trotsky to Fourier (not forgetting the Surrealist version of Freud which Reich tried to link with Marxism) was always doomed to be in the minority, or solitary, in practice. But the Surrealists were convinced of their rectitude, and quoted La Mothe Le Vayer: '*Vae soli*, it is misfortune to stand alone, but terrible to be in the wrong company.' I shall not attempt a

PICASSO, PABLO RUIZ:
Dreams and Lies of Franco. 1937.
Galerie Louise Leiris, Paris

survey of Surrealism and politics in general but only look at the rôle of painting in their association.

It was very restrained. Surrealist painting never claimed to live by its own invention but opposed the various forms of abstraction, claiming itself to be a form of art concerned with content. We might therefore expect some polemical activity from the Surrealist painters, some nightmare delineation of the satraps of society, or prophetic visions of conflagrations and massacres. The approach of revolutionary dream work, a tradition going back to the Middle Ages (which excludes neither eroticism nor fantasy), could have been drawn on effectively. What do we find instead? Picasso's series of *Dreams and Lies of Franco*, biting postcards sold for the benefit of the Spanish Republic during the Civil War, the albums of Toyen, *The Shoot, Hide Yourself, War!*, and the paintings of Freddie which brought him exile and threats of death from the Nazis: *Liberty, Equality, Fraternity, Memorial of War* (1936), *A Meditation on Anti-Nazi Love* and *Stroll at the Front* (1943–4). Freddie achieves a kind of vengeful lyricism with viscous effects close to those of Dali. There is also Matta's work in memory of the Rosenbergs (*Rosenbelles*) and on the Algerian War (*The Djamilla Question*) and some humorous drawings by Maurice Henry.

It is not very much, after all, if we are to follow Breton's formula and find 'the point of intersection of the political (philosophical) line and the artistic line, from which *we hope* they will unite in one and the same revolutionary consciousness, without any confusion of the differently inspired impulses within them'.[124] Yet the impulses which determine creativity in art and politics, with their common revolutionary denominator, are not so very different. Desire rules Surrealist art and poetry as much as truly revolutionary utopia and action.

In the area of anti-Christianity and anti-clericalism, where Surrealism was always aggressive, sarcasm persists only in a marginal figure like Clovis Trouille, or in some film sequences in *L'Age d'or* and *Viridiana*. André Breton, of course, suggested to Max Ernst the engaging idea of *The Virgin Punishing the Infant Jesus in the Presence of Three Witnesses—André Breton, Paul Eluard and the Artist* (1928). The canvas created a scandal when exhibited in Cologne. But it is the only one of its kind.

In fact, however unified the deep impulses of human action are, eroticism makes a pact with the reasons of the heart, and politics in its struggle for justice could not proceed without reason and science. The political protest of Surrealism, in spite of its emotive roots and its links with the general anti-rationalism of Surrealist theory, should be restored—like Freud's scientific effort—to the mainstream of rationalism.

TOYEN, MARIE CERNUNOVÁ: *The Shoot.* 1939. Private collection

ERNST, MAX: *The Virgin Punishing the Infant Jesus in the Presence of Three Witnesses: André Breton, Paul Eluard and the Artist.* 1928. 195 × 130 cm. Collection: Mme Jean Krebs, Brussels

Like art in general, painting as far as its specific means are concerned is a wretched instrument of struggle for justice. Unlike the novel, the cinema, and even music, arts in which Surrealism has been nothing short of reticent, painting seems to me inherently incapable of the practical effect called for by the circumstances. It is not so much that I am accusing Surrealism of default as accusing painting of incapacity. It is true of course that Surrealism chose painting, as against action.

Logic

If logic, in the broad sense, is the conception we have of the spirit (that is, the mind) in its efforts at coherence, Surrealism (for which reason was initially no more than a handmaid of positivism, but which adopted Bachelard's 'surrationalism' in 1936) is not an anti-rationalism of the Bergsonian or existentialist type, whatever anyone might say. It has a reasoning tendency which was already there in Dadaism where it somewhat austerely promoted the sense of the universal as against national, family, religious and

moralizing sentimentalities. The encounter between Surrealism and Marx, if it took place at any one time, occurred at the table of Hegel, the over-optimistic father of modern rationalism. Even though Ferdinand Alquié, commentator on Descartes, Spinoza and Kant, found vestiges of Platonism in the philosophy of his friend André Breton, the reason is that the passionate love of knowledge which runs through Surrealism is not opposed to the heart, the belly or the head, but rather, Surrealism, like Plato, demands that the whole man should reject the illusions of the cave (cf. *The Republic*). We cannot absolve Plato from the charge of an imperialist use of reason, and for the Surrealists that was as intolerable an imperialism as any other. Reason, which Breton defined Bachelard-style as a 'continuous assimilation of the irrational',[125] is dynamic and open. Far from anxiously keeping to the principle of identity, it knows how to reach that 'point of the spirit' where all antinomies 'cease to be perceived as contradictory'.[126]

Nevertheless, Surrealist painting, even though it has little to do with reason in all its forms, retains in Magritte's work a rational irony of the Dada kind which Surrealism never ceased to maintain was properly its own.

Magritte is no somnolent painter. 'I take care', he writes, 'to paint only images which evoke the mystery of the world. To do that I have to stay wide awake.'[127] He cannot be classed among the dream analysts, even the waking dream, nor among the mediums of automatism. His cold and intentionally 'realist' account takes painting to zero point yet allows room for the oneiric vision, especially in the paintings of 1926–7 such as *The Thoughts of the Solitary Walker* or *The Threatened Assassin*. The main intention is to express what the painter calls 'ideas', found things analogous to verbal witticisms and so defying the natural laws governing objects that they reach the borders of paralogism.

When Magritte puts an egg instead of a bird in the cage (*Elective Affinities*, 1933), he is not playing on an analogy. There is no formal or even biological analogy between a bird and an egg; at most they might suggest the stages of a natural process, but that owes nothing to logic. A logical shift is what is happening.[128] There is, of course an 'affinity' between the egg and the bird, as there is between bird and tree, or sky, glacier and eagle, woman and bottle. But Magritte does not stop there. Here is a brick bird, a trombone on fire (gouache, 1948), a door which blows in the wind on the beach (*Victory*, 1939) and the living dead in their coffins.

Magritte does not compose involuntary sophisms (for that is how philosophers define paralogisms), but images which are both absurd and exact. The eagle-glacier is an open object whose mental evidence is accompanied by a kind of ironic joy. These double objects force us to see double, and when Magritte offers, among other drawings and paintings of the same order, his *Dream Key* (1930), he seems to be reinforcing the lesson learnt from the Surrealist games. One word below each object upsets the definition (paralogism), but at the same time brings about a 'fortuitous' and illuminating encounter of the two elements of one 'image' and reveals the principle of identity: the egg is acacia, the bowler hat is snow, a hammer is the desert. Or there is the picture of a pipe, very much a pipe, with the peremptory inscription 'This is not a pipe!'[129] That is going much further than the 'systematic process of the visual image' (Breton), which might well be content with dubious perspectives or physical distortions (in *Personal Values* [1952], for example, the comb is bigger than the bed). Magritte says that his art is 'the description of an absolute thought: that is, a thought whose meaning remains as unknowable as the meaning of the world'.[130] He deliberately lays before us enigmas without a key, and in his paintings establishes a metaphysics in which the nothing onto which it opens is itself a demiurge of the human spirit.

The thirst for knowledge characteristic of Surrealism may be pictorially satisfied at three levels: ·

1. The level of Giacometti who minutely explains the meaning he gives to every detail of his object by means of a kind of oneiric fabulation.[131] The explanations which Duchamp offers of his Large Glass in *The Green Box* are of the same kind. Symbolism and allegory are sometimes taken to the point of abstruse complications, reminiscent of esoteric tradition, and then we must decipher the 'legend' to discover their secret.

2. The level of Dali and the dream interpreters, good subjects for psychoanalysts, to whom they offer images ready for deciphering which, though obscure to the creators, are rich with psychological clues. As Dali writes: 'The fact that I don't understand the meaning of my own pictures doesn't mean that they haven't any.'[132]

3. The level of Magritte, for whom the mystery of the world and the interior model are one and the same, and who (more consciously than Chirico) offers images which we can only call metaphysical. They are images which reason, exceeding its limits without denying them, offers on the evidence of nothingness.

There are no mere vestiges of Platonism. It is all or nothing. For Surrealism, 'a magnificent ceremony in a cave', everything is *there*. Plato is banished by poets offering flowers. The themes of Surrealism are very worldly: the immanence of desire and the immanence of happiness and of human dignity. Yet in the depths of the cosmic cave there is a division between the individual who argues his doubts in the darkness and the institutions which keep him there in fetters. The very individuality of the living subject, desiring, suffering, dreaming, rejects as external the social machine and the ideologies in which it decks itself, or

MAGRITTE, RENÉ: *The Dream Key*. 1930. Private collection

which are used to justify it. A duality reappears in this philosophy of unity. Of course man is within and without; and the institutions are still man; but they are only to a very small extent the products of his individuality, and still less in the moment when that individuality confronts them. Hence the bifurcation of the essential themes of Surrealism: on the one hand it scans the psychological depths to sound the messages of the unconscious; on the other, it intervenes on the moral and political level with categorical rejections and lightning attacks. And here, entangled rather than unified, are the two formulas which the Surrealists liked to put together, in the hope that they would become one: that of Rimbaud and that of Marx: 'change life' and/or 'change the world'.

The Marxists think that it is also (or only) in changing the world that one changes life, and even, more subtly, that inner life whose impulses, far from being the gifts of an everlasting nature, also have a history. But the Surrealists, however impressed they were by Marxism in their high period, did not go so far as to historicize the various psychological functions, the individual, desire, and dream itself. They were less concerned to adopt an exhaustive philosophy of human reality than to make the flux of poetry spring forth here and now and prevail against those social structures they thought did no more than induce mass stupidity. All that is indiscreet, violent, offensive, uncouth, out-of-place in the themes of Surrealist art comes from the life, sap and pus, sperm and blood, that course through them. But the high level of the Surrealist's moral demands could never relinquish the sharp weapon of rational thought, which at the same time they maltreated with a kind of cruel love. And Surrealist painting, so ill-fitted for sheer discourse, has taken its images and its forms from that admiring yet fierce critique of the human condition.

N.B.: The reader who wants to supplement this book with a good anthology of Surrealist poetry in the verbal sense should consult *La Poésie surréaliste* (Paris, second edition, 1975), ed. L. Bédouin, and *English and American Surrealist Poetry*, ed. Edward B. Germain (Harmondsworth, 1978).

The Precursors

ALTDORFER Albrecht (probably Regensburg c. 1480–Regensburg 1538). He became a citizen of the city in 1505 and later its burgomaster. Towards

ALTDORFER, ALBRECHT: *The Victory of Alexander the Great.* 1529. Panel, 158.4 × 120.2 cm. Pinakothek, Munich

the end of his life he devoted himself to architecture. His theory of visible and invisible worlds resembles that of Paracelsus. In his thick forests (*St George,* 1510) and especially in the fantastic sunset of the *Battle of Alexander* (1529) Altdorfer's cosmic landscapes reach the tragic intensity of the greatest images of nightmare.

APOLLINAIRE Wilhelm Apollinaris de Kostrowitzky, known as Guillaume (Rome 1880–Paris 1918). 'To have known Apollinaire will

count as a great privilege', said André Breton in 1927. Undoubtedly, the author of the poems *Alcools,* the critic of *Cubist Painters* and the maker of the film *Soirées de Paris* was one of the major influences on Breton at a time when Breton's own surrealism was forming. He was excited by Apollinaire's personal magnetism, his sense of the modern, his gift of strange utterance, and the extraordinary assurance of his choice in paintings. It is to Apollinaire that we owe the invention of the term 'surrealist' (see his letter to Paul Dermée of March 1917, the year of *Les Mamelles de Tirésias,* a 'Surrealist play'). Nevertheless, for all his rich eclecticism, Apollinaire could not have foreseen the way in which the Surrealist movement would later supplement his wideranging, dionysiac creativity with the comparative rigour and exactitude of a theory and, indeed, an ethics of knowledge and perception.

ARCIMBOLDO, GIUSEPPE: *Winter.* 1569. Collection: Man Ray, Paris

ARCIMBOLDO Giuseppe (Milan 1527–Milan 1593). A painter who enjoyed the protection of Maximilian II and Rudolf II. His assemblages have been reproduced countless times since the Surrealists drew attention to them. *Fire, Water* (1566), *Summer* and *Winter* (1569) are quasi-allegorical heads, composed of animal or vegetable imagery.

BEARDSLEY Aubrey (Brighton 1872–Menton 1898). A draughtsman and illustrator and friend of Oscar Wilde. Some of his drawings appeared in *The Yellow Book* of which he was art editor. He was

BEARDSLEY, AUBREY: *Climax*. Illustration for Oscar Wilde's *Salome*. 1894. Harvard University, Massachusetts

among the 'decadents' who, with their refined humour and extravagant behaviour, deliberately set out to shock the last representatives of Victorian England. Many of the bold devices of the 'Modern Style' or *Art Nouveau* derive from Beardsley.

BLAKE William (London 1757–London 1827). Blake was the son of an obscure hosier. From childhood he was of a sensitive disposition and subject to mystical visions. After seven years as an apprentice he set up as an engraver. He preferred to live quietly with his wife eking out a meagre living rather than take up the official post he was offered. He devoted much of his life to the search for an appropriate expression of his mystical insights. He illustrated Dante, read deeply in Swedenborg and wrote, among other books of verse, the *Songs of Innocence and Experience* and *The Marriage of Heaven and Hell*. He printed and illustrated them himself with engravings heightened with watercolour; the result was a series of 'total masterpieces'.

BLAKE, WILLIAM: *The Circle of Lust: Paolo and Francesca*. 1824–7. Watercolour, 37 × 52 cm. City Museum and Art Gallery, Birmingham

BÖCKLIN Arnold (Basle 1827–San Domenico, Italy, 1901). An extremely active painter, musical in the romantic tradition, a cultivated humanist, Böcklin was possessed by the notion of death. In his constantly flower-filled studio he produced nine versions of *The Island of the Dead*. His works are mythological and academic in style and in, for example, *The Villa by the Sea*, *The Huntress Diana* or *Storm*, have a peculiar dreamlike anxiety which continued to influence German culture into the

BÖCKLIN, ARNOLD: *The Island of the Dead*. 1880. Oil on canvas. Öffentliche Kunstsammlung, Basle

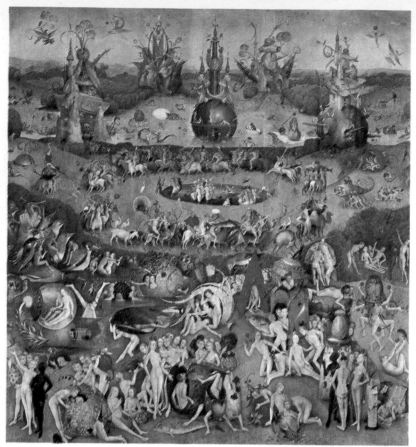

BOSCH, HIERONYMUS VAN AEKEN: *The Garden of Earthly Delights*. Central panel of triptych. Wood, 220 × 195 cm. Prado, Madrid

early twentieth century. Giorgio de Chirico among others was influenced by Böcklin.

BOSCH Hieronymus van Aeken (Hertogenbosch *c.* 1450–Hertogenbosch 1516). Bosch was a citizen of his native town and probably stayed in Castile between 1495 and 1505. Philip II commissioned the famous *Last Judgement* from him. Bosch works in terms of popular medieval tradition where the figure of the devil and monsters are images of terror, and gives free rein to his rich imaginative store of sarcastic, erotic and sadistic motifs. He was an acute observer of everyday life and aware of the dark delights of infernal fires. He gave his many *Temptations of St Anthony*, his *Garden of Earthly Delights*, his *Musical Hell*, his *Seated Elephant* (engraving by Alaert du Hameel, after a lost painting by Bosch) and *Listening Forest*, a violent hallucinatory emphasis of value to the Surrealists—though they hardly mentioned him, probably because of his

Christian moralizing and his fame—as a source or at least a point of reference.

BOULLÉE, ÉTIENNE LOUIS: *Project for a Cenotaph in Memory of Isaac Newton*. 1784. Lithograph. Bibliothèque Nationale, Paris

BOULLÉE Etienne Louis (1728–1799). Boullée was the son of a celebrated architect and on completing his studies became a painter and then took to architecture. From 1778 onwards he produced some town houses for the aristocracy of Paris, but after difficulties with the financier Nicolas Beaujon he hardly ever again went in for actual building, but devoted himself to devising projects without any thought of possible execution. His taste for the monumental and his free exercise of imagination were combined in an impressive design for a *Cenotaph for Isaac Newton* (1784).

BRACELLI Giovanni-Battista (mentioned in Florence and Rome, *c.* 1624–1629). He engraved some mechanical figures which appeared in the portfolio *Oddities* (Florence, 1624); these elicited from Tristan Tzara the remark: 'This series bears the fateful mark of the indefeasible right to imagina-

BRACELLI, GIOVANNI BATTISTA: *Composite Figure*. 1624.
Etching. Bibliothèque Nationale, Paris

tion and free fantasy' (quoted in the exhibition catalogue, *Quelques ancêtres du surréalisme*, Paris, Bibliothèque Nationale, 1965).

BRESDIN Rodolphe (Ingrandes 1825–Sèvres 1885). In 1839 he made his first etchings. He evolved a fantastic vision of considerable range though his subject matter was conventional, for example, *The Good Samaritan*, *The Capture of Jerusalem*. Bresdin introduced Odilon Redon to lithography and worked with Gustave Doré. Champfleury used him as a character in his novel *Chien-caillou*. This visionary print-maker deserves

BRESDIN, RODOLPHE: *The Good Samaritan*. 1860

recognition as one of the most powerful of nineteenth-century engravers.

BROWN Ford Madox (Calais 1821–London 1893). After studying in Belgium and in France, he went to England where he was associated with Rossetti and the Pre-Raphaelite Brotherhood. He sometimes attempted social themes (*Work*), and devoted himself to the decorative arts and especially stained glass.

BRUEGEL Pieter, known as the Elder (Breda *c.* 1528–Brussels 1569). Bruegel, a peasant's son, was introduced to painting by a follower of Hieronymus Bosch; he was accepted as a freemason in the Antwerp guild in 1551. Immediately after this he left for Italy. He arrived in Rome in 1553 and returned to Antwerp in the following year where he lived for nearly ten years before moving to Brussels. He had two painter sons, Pieter and Jan, and many painters among his descendants. In Brussels he painted his famous realistic works, which conjoin a lively popular Flanders spirit with

BRUEGEL THE ELDER, PIETER: *The Triumph of Death.*
Wood, 117 × 162 cm. Prado, Madrid

the contemplative eye of the humanist. His *Mad Margot* (*Dulle Griet*, 1564) is a study of insanity. It has been suggested that in his fantastic paintings Bruegel recorded the hallucinations of sick people who confided in him (T. M. Torrilhon, *La Pathologie chez Bruegel*, Paris, 1958). That alone would associate him with certain aspects of the Surrealist movement.

BURNE-JONES Sir Edward (Birmingham 1833–London 1898). Burne-Jones was a friend of William Morris and joined the Pre-Raphaelite movement in 1857. He visited Italy with Ruskin who, from 1851, firmly supported the Pre-Raphaelites in their attempt to fuse literary and pictorial values. Burne-Jones was prominent in the second stage of the movement and was much appreciated for his decorative ability. *The Depths of the Sea* (the siren) and *The Golden Stairs* are reminiscent of Delvaux.

CALLOT Jacques (Nancy 1592–Nancy 1635). The son of a fencing-master at the court of Lorraine, Callot ran off to Italy with the gypsies at the age of twelve. He made other visits to Italy and trained as an etcher in Rome and then in Florence, before coming under the patronage of Cosimo II de Medici (1614). A brilliant and much admired etcher he engraved his *Caprici de varie figure* and his *Impruneta Fair* in Italy before returning to Lorraine in 1621 where he produced his famous series *The Balli*, *The Beggars*, *The Tortures* and *The Siege of Breda*. When Nancy was taken by Louis XIII in 1633 he engraved *The Miseries of War* working in proud but lonely solitude. In 1635, the year in which he died, he painted his most famous *Temptation of St Anthony*, a fantastic vision in which fire supplies the tragic note.

CALVERT Edward (Appledore 1799–London 1883). A seaman who took up painting, Calvert

engraved a series of biblical scenes on wood in an extremely successful 'visionary' academic mode. The titles of his works—*The Primitive City, The Chamber Idyll, Ideal Pastoral Life*—indicate the syncretic nature of Calvert's Romanticism.

CARON Antoine (Beauvais 1521–Paris 1599). After producing some works (which have now disappeared) in his birthplace, Caron went to Fontainebleau to work with Primaticcio and then with Germain Pilon. He later became a painter for Henri III, Henri IV and Catherine de Medici. He illustrated Ovid's *Metamorphoses*. A large number of his paintings remained undiscovered until recently. *The Triumph of Summer, The Triumph of Winter, Astronomers Observing an Eclipse, The Emperor Augustus and the Tiburtine Sibyl, The Apotheosis of Semele* and

CARON, ANTOINE: *The Massacre of the Triumvirs* (detail). Louvre, Paris

The Martyrdom of an Old Man place Caron among the most imaginative Baroque painters.

CHEVAL Ferdinand, known as the Postman —the Facteur Cheval (1836–1924). Cheval was a postman at Hauterives (Drôme, France) and in

CHEVAL, FERDINAND (known as Facteur Cheval): *The Ideal Palace*. 1912. Hauterives, Drôme, France

the course of thirty-three years of deliveries collected stones with which he built an 'ideal palace' he had seen in a dream when he was twenty-nine. The fantastic style of the palace, which can be visited at Hauterives, was often referred to by the Surrealists as an example of dream-life entering the real world.

CRANACH Lucas, know as the Elder (Kronach, Bavaria 1472–Weimar 1553). First at Vienna, and then at Wittenberg, Lucas Müller, called Cranach, knew many of the humanists of his time and met Luther who called him 'our dear cousin'. His prolific work, court paintings and commissioned portraits retain certain harsh medieval themes and have an exact draughtsmanship which gives his female figures an exquisitely delicate but at the same time cold mystery which especially influenced Michel Leiris, among others. His *Venus Standing* (1509), *Nymph at the Spring* (1518), *Eve* (1528), *Judgement of Paris, Original Sin, Lucretia, Judith* and the charming *Venus* (1532) at Frankfurt, with their fetishist hair-styles, jewels and ultra-flimsy veils, exhibit a form of the female nude that is both mannered and austere—a kind of haughty eroticism.

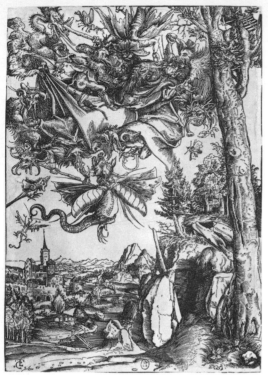

CSONTVARY Tivadar Kosztka (Kisszeben, present-day Sabinov, Czechoslovakia 1853–Budapest 1919). Descended from the Hungarian branch of a family of Polish aristocrats, Csontváry first studied pharmacy. He became an artist suddenly after a 'prophetic dream' in 1880. He knew nothing about painting at first, yet decided that he would be 'greater than Raphael'. He went to Rome in 1881. Then he rented out his pharmacy in 1894 and left for Munich to study painting. His art shows the influence of Expressionism and *Art Nouveau*; it grew exact and close to the work of primitives. His vision developed through travel, a shipwreck, the onset of a mythomaniac psychosis and an ultimate fixation on the cedar myth. He exhibited at Paris in 1907 and at Budapest in 1908. After 1910 he stopped working. The last part of his life was passed in sickness and suffering. Some late sketches such as *Arpadian Victory* are forerunners of Surrealism, and the full range of Csontváry's work allows us to classify him among the painters of waking dream.

DAVID Gérard (Oudewater *c.* 1460–Bruges 1523). David was entered as a member of the Bruges guild in 1484 and, on the death of Memling (1494), became the city's official painter. The second panel of *The Verdict of Cambyses* (1498),

CRANACH THE ELDER, LUCAS: *The Temptation of St Anthony*. 1506. Woodcut. Bibliothèque Nationale, Paris

CSONTVARY, TIVADAR KOSZTKA (known as Csontvary): *The Solitary Cedar*. 1907. Oil on canvas. Private collection

showing *The Flaying of Sisamnes* (Bruges Museum),
is one of the most cruel nightmare scenes in Western
painting.

DORÉ Gustave (Strasbourg 1832–Paris 1883). A
lithographer from the age of eleven, and a wood
engraver, Doré won fame in Paris for his illustra-
tions for the works of Rabelais (1854). He engraved

DORÉ, GUSTAVE: Illustration for *Don Quixote*. Biblio-
thèque Nationale, Paris

DORÉ, GUSTAVE: *Between Heaven and Earth.* 61 × 51 cm.
Musée de Belfort

DORÉ, GUSTAVE: Illustration for Balzac's *Droll Tales*.
1855. Woodcut. Bibliothèque Nationale, Paris

plates for the album *Folies gauloises* (1859) and
subsequently illustrated more than a hundred and
twenty works, among them Balzac's *Droll Tales*,
Perrault's *Fairy Tales*, *Don Quixote*, the Bible,
Pantagruel, *The Divine Comedy*, *Orlando Furioso*. His
abundant vitality and lyrical impulse influenced

all the fantastic engraving of the nineteenth century. He set up in London towards the end of his life where he produced some extra-large canvases (20 × 30 m.) of religious and mythological subjects. His painting *Between Heaven and Earth* (Belfort Museum) makes him a master of the bizarre yet sublime.

DÜRER Albrecht (Nuremberg 1471–Nuremberg 1528). The son of a goldsmith of Hungarian origin and the third in a family of eighteen children, Dürer followed his art apprenticeship with a four-year-

DÜRER, ALBRECHT: *Sea Monster. c.* 1500. Engraving on copper. Bibliothèque Nationale, Paris

DÜRER, ALBRECHT: *The Apocalypse: Great Whore of Babylon.* 1498. Woodcut. Bibliothèque Nationale, Paris

long journey, but his itinerary is not fully established. In 1494 he married a shrewish matron in his native city. He made several other journeys, first to Venice (1494–5) where he met Titian and Giorgione, then later to the Netherlands (1520–1). His major religious paintings, such as *The Massacre of Ten Thousand Christians* (1508), made him famous, but his fame was due even more to his copperplate engravings, which are still celebrated objects of contemplation and prime examples of rigorous execution. Dürer was a friend of both Luther and

Raphael, and may be counted among the humanists of his time. *The Four Witches, The Doctor's Dream, Sea Monster Bearing off a Woman*, his *Apocalypse* and *Melancholia* (1514) are rich with dream symbols. One night he dreamed of the end of the world and the horror of this nightmarish scene affected a number of his works.

ENSOR James (Ostend 1860–Ostend 1949). After completing his studies, and at the instigation of Félicien Rops, Ensor began to exhibit in 1881. From the start he painted with a brilliant yet bold brush, producing works which make him a master of Expressionism, though no label does justice to his original spirit. *The Entry of Christ into Brussels, The Dark Lady, Meat, The Skate* (1892) are pictures which at first met with a shocked reaction only to be exhibited later in the major retrospectives of 1954 (Paris) and 1958 (Brussels). Towards 1885 Ensor made his first attempts at engraving: *King Plague* and *Skeletons Squabbling over a Hanged Man* are titles which give some idea of the nightmare universe in which he immersed himself. Some of Ensor's satirical bite is to be found in Georg Grosz. He might be classed as a more thorough precursor of Surrealism but for his lack of that metaphorical brilliance which Breton found supremely present in Chagall.

Ensor, James: *Strange Masks*. 1892. 100 × 80 cm. Museum of Modern Art, Brussels

FEUERBACH Anselm (Speyer 1829–Venice 1880). This 'historical painter' worked at Munich, then at Amiens and Paris. He was professor at Vienna for three years. His painting sometimes

Filiger, Charles: *Chromatic Notation No. 1. c.* 1900. Watercolour, 24 × 24.5 cm. The Museum of Modern Art, New York

comes close to that of Thomas Couture, but rises above the conventions of the time in original touches which reveal Feuerbach's essentially adventurous spirit. His *Flight of Medea* and *Fall of the Titans* have real visionary power.

FILIGER Charles (Thann 1863–Brest 1928). A friend of Gauguin's, Filiger went to Pouldu in 1890 and decided to stay in Brittany although he wandered around for some years before settling in a Trégunc inn where he devoted himself to painting and lived the life of a recluse. His mystical gouaches, which Jarry brought to public notice, are among the symbolist works referred to by Breton with the greatest admiration in the last edition of *Surréalisme et la peinture* (1965).

FRIEDRICH Caspar David (Greifswald 1774–Dresden 1840). After studying in Copenhagen, Friedrich went to Dresden in 1795. He was one of the masters of the German Romantic school. Both

Friedrich, Caspar David: *The Crucifix on the Mountain.* 1808. Oil

realist and symbolist in his approach, he expressed the inward life in terms of misty and moonlit landscapes. He managed to avoid mawkishness and evoked a dream universe on which Romanticism drew heavily for inspiration.

FUSELI Henry (originally Johann Heinrich FÜSSLI) (Zürich 1741–London 1825). Fuseli was forced to escape from Switzerland when he pub-

He visited Italy from 1770 to 1779. Here his admiration for Shakespeare was supplemented by a new enthusiasm for Michelangelo. *The Nightmare* (1782) is characteristic of his dream eroticism and was exhibited by the Surrealists at the 1965 Paris exhibition *l'Ecart absolu*.

GAUDÍ Antoni (Reus 1852–Barcelona 1926). The architect of the Sagrada Familia and of the Güell Park in Barcelona had an undoubted influence on Surrealism. It is to the interest in Gaudí that we can ascribe the return to fluid or even viscous forms at a time when an aesthetic of the dry and angular was dominant in what Dalí has justly termed an 'architecture of masochism'—in France at least. Dalí published in *Minotaure* (1933, Nos. 3–4) an article entitled 'On the Terrifying and Edible Beauty of Modern Style Architecture'. Freedom of invention embracing even the most dream-like fantasy is a lesson that the Surrealists learned from Gaudí as from the Postman Cheval and a few others. But Surrealist architecture has still to come into its own.

FUSELI, HENRY: *The Nightmare*. Detail. 1782. Watercolour, Goethemuseum, Frankfurt-am-Main

GOYA Y LUCIENTES, FRANCISCO JOSÉ: *Los Caprichos: Pretty Mistress*. 1799. Etching. Bibliothèque Nationale, Paris

lished a controversial pamphlet and settled in England. He was a disciple of Jean-Jacques Rousseau and intended to pursue a literary career but Reynolds encouraged him to take up painting.

GAUDI, ANTONI: *La Sagrada Familia. One of the four bell-towers of the Nativity façade. c. 1924. Barcelona*

GOYA y Lucientes, Francisco José (Fuende-todos 1746–Bordeaux 1828). It was mainly in his engravings that Goya, a painter who mixed in court circles and was a friend of the king, showed that he was a powerful visionary. Goya became deaf after an illness and withdrew into solitude between 1793 and 1798 when he produced his *Caprichos* etchings (published in 1799). His fusion of fantastic poetry and savage social satire, which was directed mainly against the Inquisition, inspired the Surrealists to some extent, but *The Disasters of War*, a series of eighty etchings produced between 1801 and 1826, go beyond the tragic nature of the Napoleonic invasion of Spain and the atrocities committed to reach a universal level. For Goya dream and art are linked, as is shown by the eight pen and wash drawings he made of several nightmares he experienced in the same night (before 1808, Prado, Madrid, Nos. 264 to 271). His sensibility, however, is essentially distinct from that of the Surrealists because of his critique, in keeping with the moral traditions of his time, of any form of passion.

GRANDVILLE Jean-Ignace Gérard (Nancy 1803–Vanves 1847). Grandville was introduced to engraving by his father and arrived in Paris at the age of twenty. He published *A Bourgeois's Sunday Life* and then a series on the *Amusements of Childhood, The Pleasures of Youth, The Joys of Maturity* and *The*

GRANDVILLE, JEAN-IGNACE GÉRARD: *The People Sacrificed to Sucking Taxes in the Great Ditch of the Budget*. Print taken from *Hundred Proverbs*. Bibliothèque Nationale, Paris

Pastimes of Old Age. He was known mainly for his numerous satirical drawings for which he was highly acclaimed. Gradually he turned to fantastic subjects. He illustrated *Gulliver's Travels* and, at the end of his life, wishing to 'escape into the land of dreams', he produced his last collections, *The Stars, Another World* (1844), *Scenes of the Private Life of*

Animals, A Hundred Proverbs, Living Flowers, which acted as precursors of Surrealism by reason of their vividly humorous dream fantasy.

GROSZ Georg (Berlin 1893–Berlin 1959). A draughtsman and caricaturist connected with the Berlin Dada movement. In 1917–18 he painted a large fantastic lyrical work, *Dedicated to the Poet*

GROSZ, GEORG: *Dedicated to the Poet Oskar Panizza*. 1917–1918. Oil, 140 × 110 cm. Staatsgalerie, Stuttgart

Oskar Panizza (the author of *Council of Love*), which the Surrealists included in their 1965 exhibition (*l'Ecart absolu*, Paris). After a trial in Germany, Grosz emigrated first to France (Provence) then to the United States and became an American citizen. This savage draughtsman, who had published his first collection, *Ecce Homo*, in 1923, directed his graphic acerbity against all those who 'make life sordid'. His first retrospective in Paris was not until 1966 (Galerie Bernard).

GRÜNEWALD Mattias (Würzburg *c.* 1455–Halle *c.* 1528). His biography is obscure but we know that he lived in Mainz and that he visited Alsace in 1479 and 1480 (Strasbourg) and from 1513 to 1515 (Isenheim). There he painted the famous altarpiece which is now in the museum at Colmar. The monastery of Isenheim was a hospital

HÖCH Hannah (Gotha 1897). Höch lived in Gotha, Germany, where she was a pupil of Orlik's. In his memoirs Richter describes her as a clever little girl with a slight voice. Together with her friend Raoul Hausmann, she took part in the Berlin

Höch, Hannah: *The Mother*. 1930. Collage. 24.5 × 18 cm. Property of the artist

Grünewald, Mattias: *The Dead Lovers*. Musée de l'Oeuvre, Strasbourg

where Grünewald, while carrying out the superior's commission, was able to observe the most advanced cases of physical decay and disease. His triple triptych includes, in addition to the Crucifixion, the panels of the Resurrection and the *Temptation of St Anthony*. The minute realistic detail in no way impairs a visionary mysticism in which nightmare and euphoria are joined in the most startling way.

Dada demonstrations. Her watercolours and especially her photomontages (1920) indicate a pre-Surrealist sensibility. She was later involved in a tempestuous relationship with Kurt Schwitters.

HODLER Ferdinand (Gürzelen 1853–Geneva 1918). Hodler was the son of a poor carpenter and spent a difficult childhood surrounded by numerous brothers and sisters. Nevertheless he learned to paint and set up in Geneva in 1872. He developed his subjects are 'historical', but he also produced 1891 but only gained success after his exhibition at the Vienna Secession in 1903. His fame then brought him some honours but he died shortly after at sixty-five. His work is essentially realist and

HODLER, FERDINAND: *The Night*. 1890. Canvas. Kunst-museum, Berne

his subjects are 'historical', but he also produced symbolist allegories such as *Eurythmia*, *Truth* and *A View of Eternity*.

HUNT William Holman (London 1827–London 1910). A friend of Millais's and co-founder of the Pre-Raphaelite Brotherhood in 1848, Hunt painted *The Light of the World* in 1854 and assiduously applied the moralizing principles of the Brotherhood.

JANCO, MARCEL: *Clear Garden Sun*. 1918. Paint on plaster relief. Michel Seuphor Collection, Paris

JANCO Marcel (Bucharest 1895). After studying architecture, Janco met Tzara and went with him to Zürich where he became involved in the Cabaret Voltaire. From then on (1917), Janco produced painted plaster reliefs (*Sunlit Garden*) and cardboard masks which mix abstraction and lyricism. Together with Hans Arp and Kurt Schwitters, he helped to introduce the use of different kinds of materials into lyrical art. When the initial Dada fire had died down, Janco returned to Bucharest to make his career as an architect. He now lives in Israel, where he is a lively presence in the artists' village of Ein Hod.

KANDINSKY Wassily (Moscow 1866–Neuilly-sur-Seine 1944). After studying law and travelling, especially to Paris, Kandinsky refused a university chair in order to devote himself to painting (1886). He studied art until 1900 and in 1911, together with Marc, founded the Blue Rider movement. His book *The Spiritual in Art* appeared in German in 1912; in it he justifies in terms of the intensity of his interior life the painterly freedom of lyrical abstraction. This proved to be one of the major turning-points in twentieth-century art: painting was freed from all reference to an external world in order to show more appropriately what is specific to it. This was Kandinsky's lyrical period (*Painting on Glass, Chimerical Improvisation*). Later he taught at the Bauhaus, after some experiments as a commissar for the arts in Russia in 1917. His painting remained essentially free but became somewhat more reserved. André Breton, who was well aware of what the visual music of the Kandinsky of that time owed to the 'interior model', constantly paid homage to Kandinsky and from 1933 onwards persuaded him to take part in a number of Surrealist exhibitions.

Will Grohmann: *Wassily Kandinsky* (London, 1959).

KANDINSKY, WASSILY: *Black Traces*. Solomon R. Guggenheim Museum, New York

KHNOPFF Fernand (Grembergen-lez-Termonde 1858–Brussels 1921). Khnopff went to Paris in 1879 and worked under the guidance of Gustave

KLIMT Gustav (Vienna 1862–Vienna 1918). One of the prime movers of the Vienna Secession which was a very lively centre of the *Jugendstil* movement. Klimt influenced, among others,

KLIMT, GUSTAV: *The Kiss*. 1907. Oil, 180 × 180 cm. Österreichische Galerie, Vienna

KHNOPFF, FERNAND: *I lock my door before myself*. Canvas, 72 × 140 cm. Staatsgemäldesammlung Munich

Moreau. He was associated with the XX Group, the Essor and the Libre Esthétique (1884) and evolved a sentimental symbolism close to the Pre-Raphaelites.

Munch, Hodler and Vallotton. He produced several decorations, notably a mosaic in the Stoclet Palace in Brussels. The passionate intensity of his female figures with their shimmering decorative surfaces and the sensitive contours of their flesh make him fresh and contemporary. From *Living Water* (1898) to *Danaë* (1907), *The Kiss* (1907) and *Salome* (1909), the formal exactness of his work increased along with the erotic intensity.

KLINGER Max (Leipzig 1857–Grossjena 1920). A pupil of Böcklin's in Berlin, Klinger made his début in about 1878 with realistic works, first paintings then engravings, which evoked violent reactions. He left for Brussels where he came under the influence of Wurtz. Then he went to Paris, Vienna and Munich, before settling in Rome in 1888. In 1892 he turned up in Leipzig where he entered his symbolist, or so-called philosophical period. Klinger's was a restless talent in pursuit of a total art form. He attempted some polychrome

sculptures which astonished his contemporaries. His series of engravings, especially *On Death*, the *Love of Psyche* and *A Life*, are imbued with the meditation on the infinite that so possessed him.

KUBIN, ALFRED: *Lively Discussion. c.* 1912. Pen drawing, 230 × 155 cm. Oberösterreichisches Landesmuseum, Wernstein am Inn

KLINGER, MAX: *Beginning of Spring*. Etching and aquatint

KUBIN Alfred (Leitmeritz, Bohemia 1877– Zwickledt-am-Inn, Austria 1959). Kubin lived in Munich after 1898. The discovery of Ensor's works and of Redon directed him towards a form of expressionist symbolism. During his visit to Paris, Kubin was to some extent influenced by Impressionism, but the 'interior model' and the dream world remained at the centre of his art. He was present in 1911 at the first Blue Rider exhibition in Munich. He made some remarkable fantastic drawings and wrote a novel—*Die Andere Seite* (The Other Side).

LARMESSIN Nicolas de. Three members of the numerous Larmessin family who took up engraving were called Nicolas. There are first of all the two

sons of Nicolas I, a bookseller, Nicolas II (c. 1638– 1694) and Nicolas III (c. 1640–1725), then Nicolas IV, son of the former (1684–1755). The last-named was the best of the three. He devoted his brilliant career to the reproduction of Watteau's and Boucher's works, and above all those of Lancret. He was well able to interpret their spirit, which was less superficial than some would think, in terms of eighteenth-century *galanteries*.

LAUTRÉAMONT Isidore Ducasse, known as the Count de Lautréamont (Montevideo 1846– Paris ? 1870). After studying at the Pau Lycée and at Tarbes, Ducasse went to Paris to enter the Ecole Polytechnique. He published only two books, *Les Chants de Maldoror* (1869) and *Poésies*, but they were enough to make him, together with Rimbaud and a few others, a leading prophet of the Surrealist spirit. The lyrical savagery of Maldoror—'I am alone, against mankind' (Chant IV)—whose metamorphoses comprise a nightmare bestiary (louse, leech, octopus, fly, rhinoceros, shark, spider, swordfish, hyena, mastiff, black swan, cricket) takes

resentment of God to the point of blasphemy. What the Surrealists were to call the 'light of the image' is accompanied by blinding irony in the reveries of Maldoror. In the poems, the famous dictum 'poetry will be made by all, not by one' is realized. In 1936 the Surrealist painters illustrated an edition of Lautréamont's complete works.

HOUPLAIN, JACQUES: *Illustration for 'Les Chants de Maldoror' by Lautréamont.* 1947. Etching

LAVIROTTE Jules (1864–1924). A disciple of Guimard, Lavirotte was an architect who expressed his personality in the ornamentation of his façades. The building at 29 Avenue Rapp in Paris (1901) is evidence of the freedom and rich lyrical style which he brought to the floral and feminine themes of Art Nouveau.

LEDOUX Claude-Nicolas (Dormans, France 1736–Paris 1806). After studying in Paris by means of a scholarship, Ledoux made his name in 1762 with his decorative schemes. A few years later he became one of the architects of the aristocracy and built a number of *hôtels* which have now dis-

appeared. His 'sanctuary of voluptuousness', designed in 1771 for Mme du Barry at Louveciennes, made him famous and Louis XV commissioned from him the famous salt-works at Arc-et-Senans, one of the few Ledoux monuments still in existence. His architect's imagination, in contradistinction to the Neo-Classical taste of the time, led him to conceive a number of unrealized projects, and most of his finished works suffered demolition. In 1794 he just escaped the guillotine. Released and rehabilitated, he wrote his book *Architecture Considered from the Viewpoint of Art, Manners and Legislation* before dying in misery. It is not possible

LEDOUX, CLAUDE-NICOLAS: *Plate from 'Architecture Considered from the Viewpoint of Art, Manners and Legislation'*

to claim with assurance that Ledoux was a Surrealist in advance of his time, but his setbacks, like those of Boullée, show how the imagination can suffer in architecture.

Yvan Christ and Ionel Schein: *L'Oeuvre et les rêves de Claude-Nicolas Ledoux* (Paris, 1971).

LEYDEN Lucas van (Leiden 1494–Leiden 1533). He met Dürer at Antwerp in 1521 and entered the guild there. He was a precocious painter and engraver; the *Lot and His Daughters* in the Louvre is ascribed to him. It offers a mannerist expression of biblical eroticism and an astonishing degree of dream-like precision.

MARÉES Hans von (Elberfeld, Germany 1837–Rome 1887). After studying in Berlin and Munich, Hans von Marées travelled extensively in Europe and settled in Italy from 1873. His visionary treatment of his subject matter places him among the Symbolists with Feuerbach and Böcklin.

MARTIN John (Haydon Bridge, Northumberland 1789–Douglas, Isle of Man 1854). This historical painter chose immense topics: *The Celestial City and Rivers of Bliss*, *Joshua commanding the Sun to stand still*, *Satan Presiding at the Infernal Council*, *The Destruction of Babylon* (1819), *The Deluge* (1821). He had started modestly enough. He arrived in London in 1806 and exhibited at the Royal Academy from 1812. Co-founder of the Society of British Artists he was much admired by the French Romantics for his dizzying visions and colossal prospects. He introduced a cosmic dimension into his great academic studies.

MAX Gabriel Cornelius (Prague 1840–Munich 1915). The works of this Romantic and Symbolist painter have significant titles such as *The Crucified Woman* (1857), *The Child Murderess* (1879), or *Astarte* (1887). Adept of mystical tradition, spiritualism and transformism, this odd Munich professor was still of interest to the Surrealists in 1957 (*Le Surréalisme même*, vol. 3, Autumn 1957, p. 71).

MILLAIS John Everett (Southampton 1829–London 1896). A precociously talented painter, Millais together with Rossetti and Hunt founded

LEYDEN, LUCAS VAN: *Lot and His Daughters*. Musée du Louvre, Paris

MILLAIS, JOHN EVERETT: *Ophelia*. 1852. Canvas, 76 × 112 cm. Tate Gallery, London

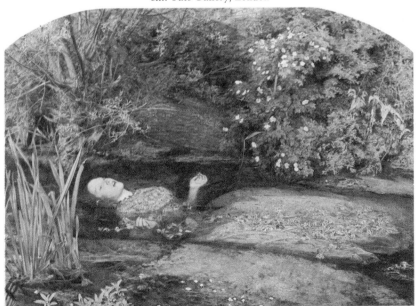

the Pre-Raphaelite Brotherhood in 1848. Outwardly a realist, his *Ophelia* (1852) has inspired a number of painters (*The Useless Toilet* of Leonor Fini, 1963). In 1858 he left the P.R.B., and took to academic portraiture.

MOREAU Gustave (Paris 1826–Paris 1898). Breton (who celebrated Moreau as a precursor of Surrealism [*L'Art magique*, 1957]) declared that

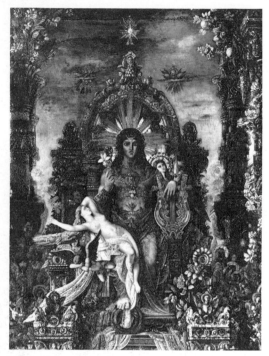

MOREAU, GUSTAVE: *Jupiter and Semele*. Detail. Musée Gustave Moreau, Paris

since the age of sixteen he had been infatuated by the women in Moreau's paintings. Moreau's heroine is simultaneously mythical, nude, almost sleepwalking, adorned with jewels, defined by beautifully fluid contours, and answers to one of the main fantasies of the Surrealist painter. She seems to be arbitrarily accorded names from legend or allegory: *Medea and Jason* (1865), *Young Thracian Woman carrying the Head of Orpheus* (1866), *Europa* (1869), *The Chimera* (1869), *Salome* (1876), *The Apparition* (watercolour, 1876), *Helen on the Walls of Troy* (1880), *Galatea* (1880). After the death of his mother, to whom he had been, and still remained, very attached, Moreau withdrew to his studio in the Rue de la Rochefoucauld in Paris, which has since become a museum. His fame was recognized

throughout the capital. He was elected a member of the Académie des Beaux-Arts in 1888 and professor at the Ecole des Beaux-Arts in 1892. Some of his pupils, especially Matisse and Rouault, were to become famous, without however being his direct artistic heirs. In 1926 for the centenary of his birth, the retrospective organized at the Georges Petit Gallery included works offered in homage by his pupils. But it was not until the advent of Surrealism with its notion that painting is not a matter of the eye but of the spirit and the dream, that Gustave Moreau found his true place.

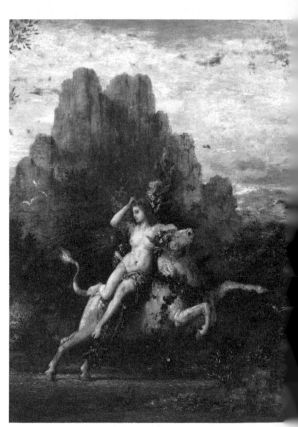

MOREAU, GUSTAVE: *The Capture of Europa*. Detail. Musée du Louvre, Paris

MORRIS William (Walthamstow 1834–Hammersmith 1896). Morris was a poet, designer, and craftsman as well as painter. He orientated the Pre-Raphaelite movement towards the decorative arts. In 1881 he founded a firm of decorators. From 1883 he became for a few years a militant democrat and socialist.

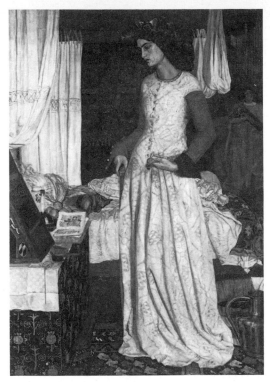

MORRIS, WILLIAM: *Queen Guinevere*. 1864. Tate Gallery, London

life during the German occupation of Norway. Considered a master both by the *Jugendstil* artists and by the Expressionists, he was honoured by the Surrealists and present at their exhibitions. Sensitive to the 'great infinite cry of nature', his expression of suffering does not exclude a wonderful form of darkness enlightened by fervent love (*The Kiss*, woodcut 1897–8).

Arve Moen: *Edvard Munch, Age and Milieu* (Oslo, 1956).

MUNCH, EDVARD: *The Scream*. 1895. Lithograph, 35 × 25 cm. Bibliothèque Nationale, Paris

MUNCH Edvard (Loiten, Norway 1863–Ekely 1944). His mother and one of his sisters died of tuberculosis (in 1868 and 1877) and the young Munch developed a dark vision of life when a young student (1881). He stayed in Paris in 1885 and caused a sensation at the Oslo autumn Salon in 1886. His first exhibition (one hundred and ten works) took place in 1889, the year of his father's death, which affected him greatly. Although often ill, he continually travelled over Europe: Nice, Paris, Berlin, Oslo. His brother Andreas died in 1895. He engraved reproductions of his own works, *The Scream* (1895), *Anguish* (1896), and illustrated Baudelaire. He was a member of the Berlin Secession when he produced his famous *Dance of Life*. He entered a sanatorium for the first time in 1899 and then a clinic for nervous depressives in 1909. He finally set up home at Oslo fjord, at Hvitsen, and decorated the main hall of the University of Oslo. Despite his considerable fame, and his move to Skoyen he continued to travel. But in 1930, affected by an eye complaint, he withdrew to lead a solitary

PATON Sir Joseph Noël (Wowers' Abbey 1821–Edinburgh 1900). After studying industrial drawing, Paton moved towards historical painting. He concentrated on mythological subjects with a strain of religious romanticism. He was a sculptor, writer and poet. He enjoyed Queen Victoria's patronage and considerable fame. His most famous canvases, *Oberon's Quarrel with Titania*, *The Reconciliation of Oberon and Titania*, take academicism to the doors of the Baroque and are heavy with an eroticism, which was far from Victorian.

PIERO DI COSIMO (Florence 1462–Florence 1521). Born Piero di Lorenzo he was a pupil of Cosimo Rosselli whose name he subsequently took. He worked first in Rome for Pope Sixtus IV. Then he decorated the monastery of San Ambrogio in Rome. He was criticized for mixing themes from pagan poetry with the Christian subjects commissioned from him. As Vasari describes in his *Lives* he

PIRANESI, GIAMBATTISTA: *The Remains of the Portico of a Villa of Domitian Five Miles from Rome on the Frascati Road.* Bibliothèque Nationale, Paris

spontaneous. He avoided preparatory drawings and attacked the copper directly. The architectural fantasy of his collection *Carceri d'Invenzione* (1745) still haunts the Surrealist imagination.

REDON Odilon (Bordeaux 1840–Paris 1916). From the start this contemporary of the Impressionists avoided an art too restricted to sensation. He thought that painting and engraving should

REDON, ODILON: *The Origins.* 1883. Lithograph. Bibliothèque Nationale, Paris

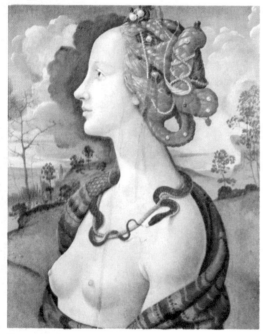

PIERO DI COSIMO: *Simonetta Vespucci.* Musée Condé, Chantilly

loved to look at the saltpetre forming on old walls or the crackle marks on them in order to discern fantastic cities and battles. This visionary activity intrigued Leonardo. A number of works by Piero di Cosimo seem still to be attributed to others, but his portrait of *Simonetta Vespucci* (Chantilly Museum) is worthy of a place in the first division of Surrealist portraits.

PIRANESI Giambattista (Mogliano di Mestre, Italy 1720–Rome 1778). Architect, archaeologist, and engraver of Roman ruins, Piranesi studied in Rome from 1738. He had a violent disposition and once wanted to kill his engraving master, Vasi, for inadequate instruction. He left soon after for Venice and then for Naples, before going to Rome where he married suddenly. His approach to art was

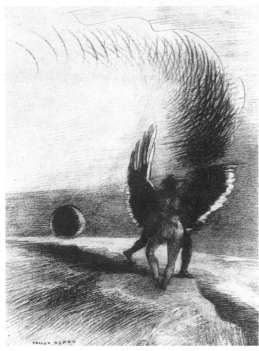

REDON, ODILON: *Dreams*. 1891. Lithograph. Bibliothèque Nationale, Paris

The Invasion of the Belgian army by the Crinoline. A little later he produced some violent political drawings, which are reminiscent of Daumier and Gavarni. Later, attracted by the possibilities of the aquatint, he went to Paris (1862), after meeting Baudelaire in Belgium. He left the *Spiegel* and, under Baudelaire's influence, entered his 'satanic' period. Haunted by the notion of death and fascinated by the theme of fallen women, he produced drawings such as *The Lover of Christ* and watercolours such as *The Absinthe Drinker* or *The Quarrel*. A theme to which he returned constantly was the woman and the puppet. Félicien Rops is a precursor of Surrealism only in certain dark emphases which run through his work but which he could not lift to the level of the sublime.

ROSSETTI Dante Gabriel (London 1828– Birchington-on-Sea 1882). Co-founder in 1848 of the Pre-Raphaelite Brotherhood, which was dissolved in 1854 or thereabouts, Rossetti reorganized the group in 1857. Against an academicism which they saw as descended from Raphael, the P.R.B. wished to rediscover the real and true. They may be classed as heirs of Blake in their opposition to the machine-world (like the Socialists), their idealization of the Middle Ages (like the Romantics)

aim higher. His albums *In the Dream* (1879), *To Edgar Poe* (1882), *The Origins* (1883), *Homage to Goya* (1885), *Night* (1886), *Dreams* (1891), his illustrations for Flaubert's *Tentation de saint Antoine* (*The Temptation of St Anthony*) and Baudelaire's *Fleurs du Mal* (*Flowers of Evil*) grouped him with the Symbolist poets. He was a friend of Mallarmé's and wrote notes and a journal which contain such formulas as: 'Nothing in art is brought about solely by the operation of will. Everything occurs through humble submission to the advent of the unconscious.' His fame grew after 1894, and he emerged from his isolation with the encouragement of Durand-Ruel and Vollard. His charcoal sketches, such as *The Masque of the Red Death* and *I am the First Consciousness of Chaos* comprise the most esoteric part of his complete works which after 1900 included some pastels and watercolours.

ROPS Félicien (Namur 1833–Essonnes 1898). Rops was born into a comfortably well-off family and drew from childhood. When he met Courbet in 1861 he was already well-known in Belgium where he founded the Atelier Saint-Luc. He was a journalist and drew for *Crocodile*, and he founded *Uylenspiegel*. It contains such satirical drawings as

ROSSETTI, DANTE GABRIEL: *Beata Beatrix*. 1863. Canvas, 85 × 65 cm. Tate Gallery, London

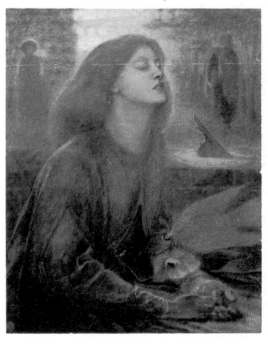

and their openness to a renewal of religious feeling. Rossetti's first works were religious in tone, but after the founding of the P.R.B. he often worked on the theme of love (*Dante's Dream at the Time of the Death of Beatrice, Beata Beatrix*) and founded the review *The Germ*. His chaotic love-life, the suicide of his wife two years after their marriage (1860), his opponents' criticisms, and a suicide attempt led to his becoming a chloral addict.

ROUSSEAU Henri, known as the Douanier (Laval 1844–Paris 1910). Rousseau was a humble civil servant in Paris who began to paint in 1880. He left the Customs service in 1885. With the assistance of Jarry (also born at Laval), he met Gauguin in 1890, together with Pissarro, Seurat, Redon and then, in 1906, Picasso and Apollinaire's friends.

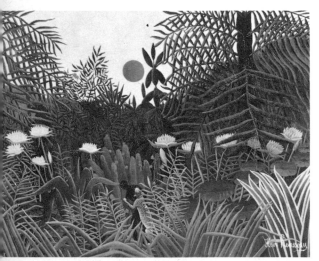

Rousseau, Henri, called Le Douanier: *Virgin Forest Landscape with Sun Going Down.* Oil on canvas. Kunstmuseum, Basle

Yet he was not influenced by these or other artists, nor even by Bouguereau whom he admired. In his landscapes with their luxuriant vegetation he is in pursuit of a dream. His paintings *The Dream, The Snake Charmer, Tiger Attacking a Buffalo, Sleeping Gypsy, The Tiger Hunt* were therefore much admired by the Surrealists. We now know that he copied some of his themes from the volume *Bêtes sauvages*, published by the Galeries Lafayette, and the red sofa that is shown in the midst of the forest in *The Dream* came from his own room. Clearly, his translation of everyday themes and objects into a poetic

form of the exotic, which was Rousseau's essential approach, opened one of the major roads of Surrealist pictorial lyricism.

Philippe Soupault: *Henri Rousseau, le Douanier* (Paris, 1927).
Wilhelm Uhde: *Cinq Maîtres Primitifs: Rousseau, Vivin, Bombois, Bauchant, Séraphine* (Paris, 1949).

SADE Alphonse François Donatien, Marquis de (Paris 1740–Charenton 1814). For twenty-seven years of his life, Sade was imprisoned in various gaols by all political régimes in turn, including the revolutionary Convention, which held against him his indulgence when presiding over a revolutionary tribunal. Sade was an aristocrat who advocated some of the most advanced ideas of his time. In his novels and tales—for example, *Justine or the Misfortunes of Virtue* (illustrated by all the foremost Surrealist painters)—he describes libertine behaviour and forms of sexual violence, thus becoming a precursor of modern psychology. The Surrealists defended him against the criticism of the establishments under which he suffered and made Sade a hero of the libertarian fusion of desire and reality.

Saint-Aubin, Charles Germain de: *Human Butterflies: Pyrotechnics.* Bibliothèque Nationale, Paris

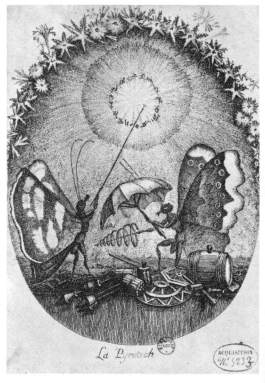

SAINT-AUBIN Charles Germain de (Paris 1721–Paris 1786). The son of an embroiderer, Saint-Aubin left his family in 1745, married, became a widower and travelled in Flanders (1770), then in Provence. Later he came under the patronage of Mme de Pompadour. He was known mainly as a decorator, but he was also an avid botanist and produced watercolours full of imaginary flowers and engravings. His *Essays on Human Butterflydom* are witty and odd.

SCHWITTERS Kurt (Hanover 1887–Ambleside, England 1948). He started as a draughtsman in a steel-works and his first paintings were Constructivist designs (1918), but he soon devoted himself to his famous montages and collages made from rubbish and discarded odds and ends. In

Ambleside 1945) were temples of everyday life, humour and dream. Schwitters was also the author of 'sonatas', phonic poems interspersed with cries, and the forerunner of the torn paper and object collagists of the 1960s. A marginal figure rather than a precursor of Surrealism, he offered the Dadaists and then the Surrealists the example of uninhibited dream.

SEGHERS Hercules (Haarlem 1590?–Amsterdam 1638?). A member of the Haarlem guild in 1612, Seghers was living in Amsterdam in 1629 and in Utrecht in 1631. He certainly visited Italy. He is said to have died of a fall when drunk. His very Rembrandt-influenced engravings give his landscape a visionary dimension.

SCHWITTERS, KURT: *Merz 94 Green Patch*. 1920. Collage. Collection: E. Neuenschwander, Zürich

1919 he founded the *Merz* movement and the review of that name, though he was the only member and sole Merz artist until 1932 (*Merz* 24). He was not so much a fierce prophet of his form of art as the practitioner of a kind of reclusive religiosity. He transformed the interior of his house by building a column up to and through the first floor, the so-called *Merzsäule*, and his successive *Merzbau* (Hanover 1925; Norway 1932; and

SEGHERS, HERCULES: *The Mossy Pine*. Bibliothèque Nationale, Paris

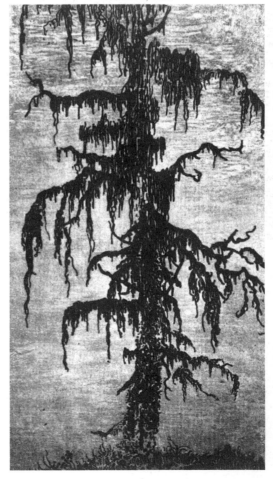

SIU-WEI (1529–1593). Reacting against the painting of precise academic functionaries, Siu-Wei was one of that long line of odd, offbeat, individualistic Chinese painters. He preferred to live in poverty and remained obscure all his life. Accused of leading a dissolute existence and even of murder, he produced in seclusion some of the most demanding works of the time, the Ming period. He had an undeniable influence on the best independent artists of the seventeenth and eighteenth centuries. His wash drawings have a characteristic spontaneity which suits the violence of his nature, and therefore he may be cited as a precursor of automatic writing—and its expressive extensions—for practice can often precede theory, even by centuries.

STÖR Lorenz. An artist of the sixteenth and early seventeenth centuries, Stör lived in Nuremberg. He was a wood engraver and in 1555 published *Geometria et Perspectiva*, noteworthy for the rich fantasy of its architectural plates.

TENNIEL Sir John (London 1820–London 1914). A watercolourist of some renown, Tenniel was an illustrator and from 1850 editor and cartoonist for *Punch* where some 2,500 of his drawings appeared. In the Surrealist perspective, his most interesting works are his illustrations for Lewis Carroll's *Alice in Wonderland* and *Through the Looking Glass*.

TOOROP Johannes Theodorus (Poerworedjo, Java 1858–The Hague 1928). Toorop arrived in Holland when he was fourteen and settled in The Hague in 1888. He was a friend of Ensor and the Belgian Symbolists and made the transition from Neo-Impressionism to Symbolism, becoming one of the masters of *Art Nouveau* in a stylized, biting, melancholic and floral technique, in the Japanese tradition. The figures in *The Three Brides*, for instance, (pastel, 1893) are imbued with a kind of languorous delirium. Toorop became a Catholic in 1905.

WÖLFLI Adolf (Berne 1864–Berne 1930). After a harsh childhood as a farmhand Wölfli spent two years in prison following an accusation of rape in 1890; later, as a recidivist, he was imprisoned in the Waldau. In about 1899 he produced some drawings in coloured crayon, and began writing poems and music. His obsessive themes, which were gradually dominated by real artistic power, led to his masterpiece, *The Great Screen* (1922), with eight decorated panels. In 1921, the psychiatrist Morgenthaler made Wölfli the subject of a now famous case-study. The Surrealists considered Wölfli one of the greatest painters of his generation. They exhibited one of his drawings at the *l'Ecart absolu* show in 1965 and Wölfli was given a prominent place at the exhibitions of the Art Brut group.

TOOROP, JOHANNES THEODORUS: *The Three Brides*. 1893. 78 × 98 cm. Rijksmuseum Kröller-Müller, Otterlo

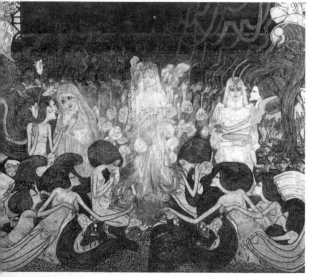

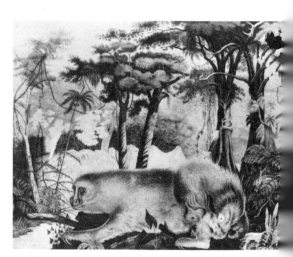

ZÖTL, ALOYS: *The Unau*. 1840. Private collection

ZÖTL Aloys. In 1956 Breton (*Le Surréalisme et la peinture*) drew attention to this precursor of the Douanier Rousseau who was a dyer in Upper Austria. He died an obscure death, but produced between 1832 and 1887 a fantastic bestiary of exceptional power.

The Surrealists

ALECHINSKY, PIERRE: *Vulcanology*. 1970–1. 137 × 180 cm.
Galerie de France, Paris

ALECHINSKY Pierre (Brussels 1927). Alechinsky studied architecture in Brussels and had his first exhibition in 1947. He joined the Cobra group (1948–51). In his reply to an inquiry conducted by

ALECHINSKY, PIERRE: *Very Agile Rabbit*. 1972. Acrylic, 100 × 154 cm. Galerie de France, Paris

Arts magazine (see Nos 10–11, 25 June 1965), André Breton listed him among the ten painters under fifty years of age asked for by the journal. His painting· is neither automatic nor oneiric. It owes much to German and associated Expressionist forbears and cannot easily be classified as abstract or figurative.

ALVAREZ-RIOS (Havana 1932). After attending the San Alejandro School of Fine Arts in Havana, Alvarez-Rios moved to Paris in 1958. His numerous one-man exhibitions since 1962 have been noteworthy for the somewhat decorative though expressively simple imagery of his paintings, which are full of humour and dream reference, for instance *Lovers in Equilibrium* (1972).

AMARAL Jim (Pleasanton, U.S.A. 1933). After completing his studies, and then his national service in the Philippines, Amaral went to Columbia in 1958. He soon exhibited there as well as in

ALVAREZ-RIOS: *Lovers in Equilibrium*. 1972. 73 × 60 cm.
Galerie Jean Prud'homme Béné, Paris

AMARAL, JIM: *Reliquary: A Letter for Traces*. Mixed media
on paper, 52 × 37 cm. Galerie Octave Negru, Paris

Venezuela and the United States. He visited New York in 1966–7. Afterwards he travelled to Europe and exhibited in Paris, at Loeb, in 1971. His heightened drawings include an obsessional precision and a kind of icy sadism in his figurative treatment of parts of the body: fingers, mouths, nails, teeth, penises, nipples, unseeing, scarred heads. Amaral takes the oneirism of touch a long way. He now exhibits at Octave Negru's gallery.

AMATE Miguel (Cartagena 1944). A Spanish painter who has lived in Paris since 1968 Amate first exhibited paintings influenced by Tapiès at the Salon de la Jeune Peinture and in Stockholm. Not so long ago, however, he began to produce model-paintings of great erotic force. He is a self-taught painter and knows nothing of Baj and Surrealism. His puppet-pictures are permanently on show in a shop in the Marais, where the neighbours find them rather upsetting. In Amate's works Spanish Expressionism, minus its mystical elements, combines with Surrealism.

ARAGON Louis (Paris 1897). Aragon's physical courage and fierce discourse made him, together with Breton, Eluard and Soupault, a front-rank Surrealist from the first *Littérature* days up to 1932. He was present at the Dadaist celebrations and at the 'graveside' of Chirico (*Ci-gît Giorgio de Chirico*, 1926). His *Traité du Style* (1928) is one of Surrealism's basic texts. Another important essay on

ERNST, MAX: *A Meeting of Friends* (detail, portrait of
Aragon). 1922. Collection: Lydia Bau, Hamburg

the plastic arts was his pamphlet *La Peinture au défi* (1930), a kind of manifesto of the art of collage. After 1932, his discovery of the Soviet Union, his love for Elsa Triolet, his attachment to the Communist Party and his nationalist lyricism led him to reject what he had most admired. Nevertheless, in spite of his dreary praise of Socialist Realism, and even of Bernard Buffet, Aragon is still sensitive to the poetry of collages: 'The history of collages is not of course the history of realism, yet no one could write a history of realism without referring to that of collages' (*Collages*, an anthology, 1923–65, Paris, 1965, p. 149). A way of saying, of course, that it could not be written without the history of Surrealism. 'And that is where my treachery is to be found', Aragon adds.

ARMAN Fernandez Pierre (Nice, 1928). He exhibited for the first time in 1956. Under the label of the New Realism, Arman produced, in a style which recalls the work of Schwitters, accumulations in glass cases: for instance, the contents of a dustbin, musical instruments, or wads of bank-notes. Arman was of interest to Surrealism because of his experimentation beyond the limit of painting, his anti-art spirit, and some poetical surprises. Like Spoerri he has earned a place in the history of the still life.

ARP Hans (Strasbourg 1887–Locarno 1966). After studying painting at the School of Decorative Arts in Weimar, where he was very moved by a Maillol exhibition, Arp went to Paris in 1908 (to the Académie Jullien). He took part in the first exhibition of the Modern Bund of Lucerne (1911), and met Kandinsky and members of the Blue Rider group in Munich. He exhibited with them at the group's second show in 1912. In this way the spontaneity and inwardness of the Blue Rider were passed on to the future Surrealist, who at first found Dada the best means of achieving technical freedom. In 1913, he collaborated with *Der Sturm* (Berlin) and met Max Jacob in Cologne in 1914. He again visited Paris, where he got to know the Delaunays, Max Jacob, Picasso, Apollinaire and Eggeling. In Zürich in 1915 he met Sophie Taeuber with whom he produced embroideries, *papiers collés* and tapestries. He married her in 1922. Together with Richard Huelsenbeck, Hugo Ball and Tristan Tzara he joined the Cabaret Voltaire and produced his first wooden reliefs in 1917. Dada was born. Arp launched it at Cologne together with Ernst and Baargeld, made contact with the Berlin Dada group and found himself in 1921 in the Tyrol with Eluard, Ernst and Tzara. In the next few years he worked with Schwitters returning to Paris in 1925, and staying in the Avenue Tourlaque, where Ernst and Miró were neighbours. His personal style had reached a high point, and the lasting friendships he had formed enabled him to enjoy a fruitful collaboration with the Surrealists as well as with the

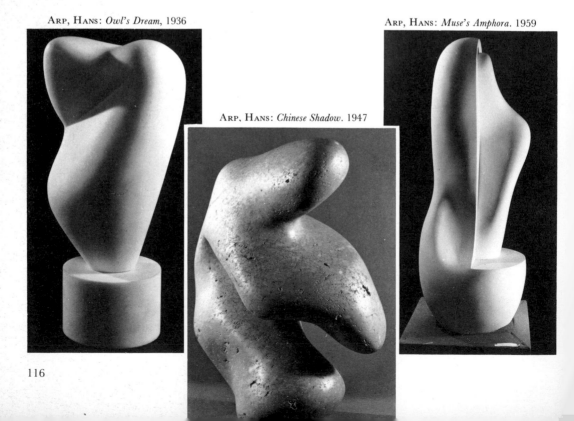

ARP, HANS: *Owl's Dream*, 1936

ARP, HANS: *Muse's Amphora*. 1959

ARP, HANS: *Chinese Shadow*. 1947

abstractionists of the *L'Esprit nouveau* group (1938), the *Cercle et Carré* group (1930) and the *Abstraction-Création* group (1931–2). In Meudon from 1926, he began work (*c.* 1932) on his round-boss sculptures (*Chinese Shadow, Amphora, Owl's Dream*) and took part in the big international Surrealist and Abstractionist exhibitions. He took refuge in Switzerland in 1942 and Sophie Taeuber died there the following year. He did not return to Meudon until 1946, when he published *Le Siège de l'air*, a collection of his French-language poems. Two trips to the United States in 1949 and 1950 cemented his fame and in 1953 he produced a monumental sculpture at Caracas—*Shepherd of the Clouds*. He did not visit Greece until 1954, the year he was awarded an important sculpture prize at the Venice Biennale. He travelled and received a number of official awards. His works became monumental (Paris, Bonn, Basle) and, in the same way as the small sculptures which filled the shelves of his Meudon studio, showed that forms and volumes in space can offer a life that is much richer in its sketched movements and suggested profiles than figurative narrative.

Jean Cassou: *Arp*, Paris, 1962.

ARTAUD Antonin (Marseilles 1896–Ivry 1948). Actor, theatrical genius, script writer for the film *La Coquille et le Clergyman* (1926, directed by Germaine Dulac), author of *Théâtre et son double*

MASSON, ANDRÉ: *Portrait of Antonin Artaud*. 1925. Drawing

(1938), friend of painters (such as Masson), Artaud has many links with pictorial Surrealism. But, above all it is his tragic sensitivity, his sense of creative cruelty, his plunge into physical delirium, that enable us to rank him with the Surrealists. He is against that sentimental sweetness which the practitioners of a slick 'marvellous' style could too easily slip into. The pessimism of Surrealism after the Second World War corresponded more to the lacerations of his *Lettres de Rodez* (1946) or of his *Pour en finir avec le jugement de Dieu* (1948), than to the imagery of *Arcane 17*.

ATLAN Jean-Michel (Constantine 1913–Paris 1960). The retrospective at the Museum of Modern Art in Paris after Atlan's premature death emphasized the importance of this painter, who first experimented with and succeeded in enlivening

ATLAN, JEAN-MICHEL: *Le Kahéna*. Oil on canvas, 146 × 89 cm. Musée National d'Art Moderne, Paris

ATLAN, JEAN-MICHEL: *Composition*. 1956

André Breton referred to him when he defined reason as a 'continuous assimilation of the irrational' ('Crise de l'objet', 1936, *Surréalisme et la peinture*, 1965). He managed to reconcile intellectual revolutions and revolutions of artistic sensibility. However, in *La Formation de l'esprit scientifique* (1938),

BELLMER, HANS: *Gaston Bachelard*. Pencil drawing, 60 × 40 cm

so-called abstract forms (*Composition*, 1956). He had a degree in philosophy. Arrested in 1942 for resistance work he simulated madness. He took part in Surrealist 'revolutionary' work in 1947. His paintings were among the most forceful of his generation. They joined a rigorous spirit to pictorial intensity.

AXELL Evelyne (Namur 1935). She exhibited at the Palais des Beaux-Arts in Brussels in 1966 and was a disciple of Magritte's, but moved in a Pop Art direction.

AZEVEDO Fernando (Porto 1923). The leading light of the Portuguese Surrealist group his paintings went on exhibition in 1952. This marked both the height and the end of his fame.

BACHELARD Gaston (Bar-sur-Aube 1884– Paris 1962). Bachelard was a philosopher of science and author of a series of famous works on the imagination in its relations to the 'four elements of matter'. With his 'open rationalism' Bachelard offered theoretical justifications for Surrealism.

a kind of psychoanalysis of rational knowledge, Bachelard examined the transition from reverie to representation, not so much in a scientific framework, but as a victory of spirit over 'epistemological obstacles'. Should any Surrealist follow the Romantics in 'elevating' poetry as a form of cognition, Bachelard would totally reject the notion.

BAJ Enrico (Milan 1924). Baj started the Nuclear movement, then met Asger Jorn and took part in the debates of the Non-Constructivist Bauhaus group (1953) which led him to a collaboration with the review *Phases* of the poet Edouard Jaguer. He was present at the international Surrealist exhibitions in 1960 (EROS, Galerie Cordier, Paris) and 1965 (*l'Ecart absolu*, Galerie de l'Oeil, Paris). His pictures of pasted trimmings and cloth fragments (*Mademoiselle Raucourt, French Tragic Actress*) represent—often forcefully—Ubuesque people such

BAJ, ENRICO: *Lieutenant John Talbot, First Earl of Shrewsbury.* 1967. Collage, 73 × 60 cm. Galerie Jacques Tronche, Paris

festo, *Le refus global* (1948). He has lived in Paris (1962–4), New York (1964–8) and California (1969–70). He now resides in Paris where he is pursuing his experiments in sculpture.

BARON Karol (Levoca, Czechoslovakia 1939). After studying in Bratislava, Karol Baron had several exhibitions at Presov, Berlin, Mons, Brno

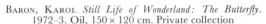

BARON, KAROL: *The Mutants, Gryphons, Skyles and Palaeologoids.* 1971–2. Oil, 150 × 180 cm. Private collection

BARON, KAROL *Still Life of Wonderland: The Butterfly.* 1972–3. Oil, 150 × 120 cm. Private collection

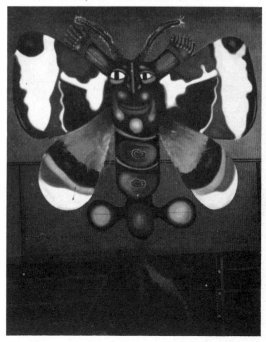

as 'generals and their ladies'. In Paris in 1970 Baj exhibited his personal interpretations of Picasso's work. Baj's originality is due less to the black humour of the Surrealists than to a joyous and playful ferocity.

Edouard Jaguer: *Enrico Baj*, New York, 1956.

BALTHUS Balthazar Klossovski de Rola, known as (Paris 1908). He exhibited for the first time at Pierre Loeb in Paris in 1934. His retrospectives at the Museum of Modern Art in New York (1956), at the Musée des Arts Décoratifs in Paris (1966), at the Tate Gallery, London (1968) have given him (he is at present director of the French School of Rome) a certain official fame. *The Street* (1933) fascinated the Surrealists because of its mysterious fantasy. Since then, Balthus has concentrated on interiors in which pre-pubescent girls indulge in erotic daydreams. A wistful academic style suits this kind of eroticism.

BARBEAU Marcel (Montreal 1925). A painter and sculptor, Barbeau first studied at a school of furniture in Montreal. From 1946–54 he belonged to the automatist group and he signed their mani-

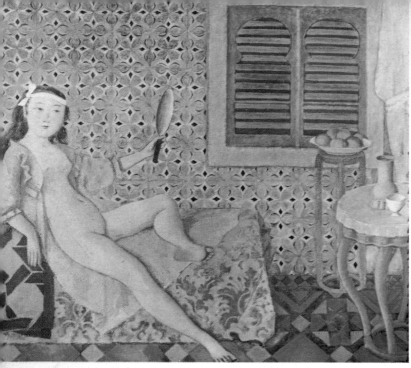

BALTHUS, BALTHAZAR KLOSSOVSKI DE ROLA (known as Balthus): *The Turkish Room*. 1963–6. Private collection

and Bratislava (1970). He is a member of the present Prague Surrealist group. His painting, especially in his *Mutants* series, forcefully unites rigorous form with strange found objects. Hung from the ceiling of his studio, his vast polychrome wood butterflies have a disturbing presence.

BÉDOUIN Jean-Louis (Neuilly-sur-Seine 1929). Poet and author of several books, especially *Vingt Ans de surréalisme, 1939–1959* (Paris, 1961). He remained faithful to Surrealism after Breton's death in 1966. In December 1971 he began to construct objects with flotsam and jetsam from the Oléron beaches. The rough poetry of these object-sculptures, to which a slight detail often lends a certain humour, recalls so-called primitive art, especially that of Oceania which Bédouin also drew on for his film, made with Zimbacca in 1952: *L'Invention du monde*.

BELLMER Hans (Katowice 1902–Paris 1975). Son of an authoritarian engineer, young Hans was forced to follow a course in coal mining and to enrol at a technical university in Berlin (1923). His passionate interest in drawing soon freed him, and Georg Grosz, the Expressionist artist and caricaturist then associated with Dada, taught him his profession. Bellmer worked as a typographer before becoming a publicity artist. In 1927 he married Margarete, who helped him make his famous *Dolls*

in Berlin-Karlhorst. Perhaps as a protest against Nazism, he abandoned his publicity agency in 1933, withdrew into private life and devoted himself to his 'dolls'. The first of these was made from pieces

BÉDOUIN, JEAN-LOUIS: *The Shaman*. 1973. Object

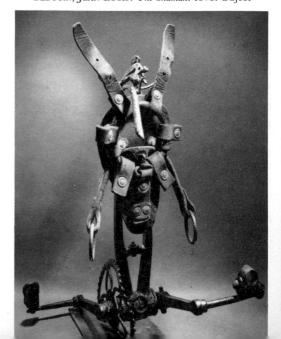

120

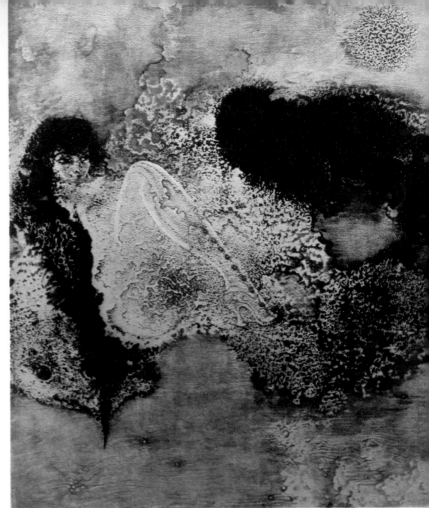

BELLMER, HANS: *The Two Friends*

BELLMER, HANS: *The Doll.* 1934

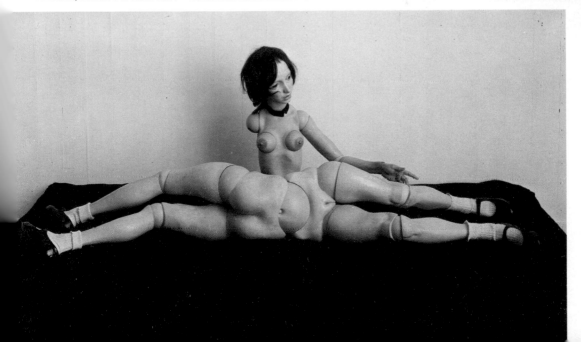

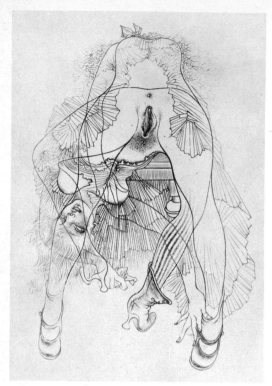

BELLMER, HANS: *Illustration for a work by Georges Bataille.*
Galerie André François-Petit, Paris

In 1938 Margarete died and Bellmer left Berlin for Paris. He was interned in 1939 and, as a German citizen, sent to the internment camp at Les Milles (where Max Ernst was to follow him), then released. At Castres in 1941 he threw his passport down a drain and took refuge at Toulouse, where his first exhibition in France was held in 1943, the year in which he met Joë Bousquet. He married for a second time and eventually had two daughters. But he was soon separated from his wife. During the Occupation he worked on a special formal

BELLMER, HANS: *Illustration for 'Madame Edwarda' by Georges Bataille.* 1965. Heightened dry-point, 18.5 × 8 cm. Galerie André François Petit, Paris

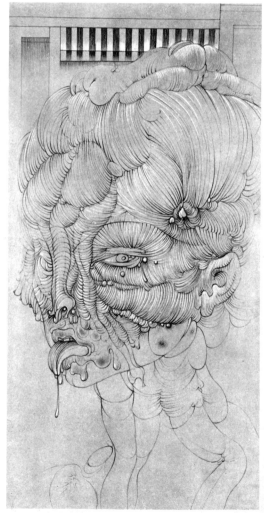

of toys found in a childhood box and was tantamount to a sadistic fantasy in which an easily available, unprotesting young girl is subjected to the worst excesses. The toy is an infant martyr and queen of desire; it gazes salaciously from between two silhouetted breasts. This Lolita conveys a certain cynicism in the very freedom she gives the imagination to take the possibilities of eroticism to infinite limits. She is both tempting and innocent in her temptation; a child-woman rather different from the one Breton dreamed of in *Arcane 17*; even Bellmer was disturbed by the postures he could make her adopt. There were two successive series of dolls. The first was produced in 1933 to 1935 and appeared in photographic form under the title, 'Variations on the construction of an articulated child', in *Minotaure* No. 6—to the great fascination of the Surrealists. The second series, produced in 1937–8, was illustrated by a series of poems from Eluard, 'Jeux vagues de la poupée', published in the journal *Messages* in 1939 and reprinted in 1949 in *Jeux de la poupée*. In 1937 Bellmer produced his *Machine-gun in a State of Grace*, an 'objet provocateur', or provocative object.

theme based on the architectural qualities of bricks and suggesting the wartime cellars where bodies often lay. In 1946 Bellmer returned to Paris and took part in the Surrealist exhibition organized at the Maeght Gallery the following year. It was at this time that he met Nora Mirani, whose premature death interrupted the book on him she was working at, *Rose au coeur violet*. Bellmer was a friend of Paul Eluard, Michaux, Tzara and Georges Bataille, whose *Histoire de l'oeil* (1944) and *Madame Edwarda* (1965) he illustrated. He produced some

BELLMER, HANS: *For Margarete*. 1938. Drawing and collage. Galerie André François Petit, Paris

BELLMER, HANS: *The Top*. Painted bronze. Galerie André François Petit, Paris

excellent pencil portraits of a classical quality. Bellmer's pictures are sometimes colour drawings, such as *1000 Girls* (1939–41), but he also produced some decalcomania-gouaches (*The Two Friends*), some collage-drawings (*For Margarete*), and a number of engravings. *Boots* and *Undress* are colour lithographs (1951).

A new period in Bellmer's life began in 1953. He met Unica Zürn on a trip to West Berlin and they lived together in Paris in the Rue Mouffetard from 1955. Zürn's precise features appeared in several of his works from then on. Bellmer introduced her to drawing. Unfortunately she was a schizophrenic. Several recurring attacks forced her into clinics and reduced their life to near-tragedy. Photographed by Bellmer in the nude and in chains, Unica Zürn appears on the cover of No. 4 of *Surréalisme même* (1957). In 1970 she jumped out of a window and killed herself.

BELLMER, HANS: *Iridescent Cephalopod.* 1939. Oil on cardboard, 49 × 44 cm

Erotic experimentation in art was taken to an extreme by some Surrealists after the Second World War and it is true, if we accept the premiss that 'poetry is made in bed', that everyday life and the life of poetry ought to fuse together in the marvellous universe of art. Bellmer was closer to Artaud

BELLMER, HANS: *The Bat.* 1968. Etching, 29.6 × 37.5 cm. Galerie André François Petit, Paris

than to Breton in revealing the cruelty of the erotic forces in life. In his work a tragic Surrealism is contrasted with the magical, sentimental, ironic and fantastic forms introduced into Surrealism by Brauner, Delvaux, Magritte and Dali. Bellmer was a draughtsman and engraver with a sharp line who managed, as in his dolls, to express the exasperation of physical passion without ever falling into the traps of narrative or complaisance. On looking at the series of engravings *To Sade* (1961), *The Bat* (etching, 1968), *Death's Head and Girl* (heightened pencil, 1963) or *Little Girl on Black Sofa* (charcoal, 1960), one realizes how the tragedy of death is an integral part of the world of desire; for death becomes visible by means of the Surrealist device of 'transparency' in the human anatomy. Bellmer tried to explain his obsession with what was underneath the skin—symbolically associated with interest in what was underneath the clothes—in several texts; among them, *Petit Anatomie de l'inconscient physique ou anatomie de l'image* (1957). He added the physical unconscious to the affective unconscious mind of Freud. In every desirable body, he argued, in every one that is unconscious of its mortality, ultimately it is death that fascinates whoever possesses it. Hence the obsessions with sadistic, anal and oral penetration which recur in the engravings of 1966–8, together with texts from Sade. High stools are mixed up with fluid limbs, which always end in high-heeled shoes, the erogenous zones of the body are exhibited in tumescence (*The Top*), and extreme fetishist acts are arrested by the convolutions of their own excess.

This graphic orgy at first kept Bellmer the property of a few specialized patrons but brought him fame after 1958 with the William and Noma Copley Foundation prize. The Surrealist exhibitions (1947 and 1959–60), a few one-man exhibitions (Paris, 1963, 1967 and 1971; Munich, 1967), and several books on his work, placed Bellmer in the front rank of those who knew how to rescue modern eroticism from Puritan vulgarity and from rejection in order to integrate it in a tragic vision of human existence.

Joë Bousquet: *Hans Bellmer*, Paris, 1945.
André Pieyre de Mandiargues: *Hans Bellmer, oeuvre gravé*, Paris, 1969.

BENOÎT Jean (Quebec 1922). Benoît has lived in Paris since 1947 and together with his wife Mimi Parent offers in the ceremonial costumes they design a fusion of the imaginary and the real which integrates the body with the magic of disguise. *The Execution of the Testament of Sade* (1949–50) gave rise in 1959 to a kind of masochistic ceremony in front of a few guests. His *Necrophilic Costumes* (1964) apparently revive certain classical images from horror films.

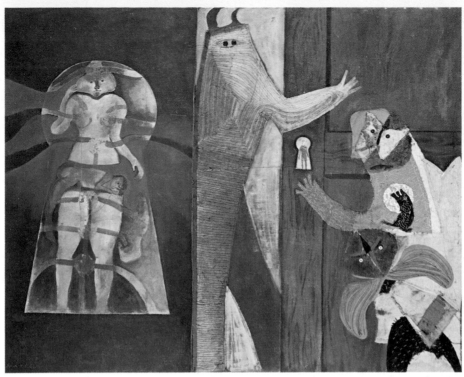

BONA, BONA TIBERTELLI DE PISIS (known as Bona): *The Guardian of the Threshold.* 1966.
Oil and collage, 116 × 145 cm. Galerie de Seine, Paris

BIEGAS Boleslas (Koziczin, Poland 1877–Paris 1954). Biegas started as an apprentice carpenter. With the aid of scholarships he studied as a sculptor in Cracow in 1896 and then went to Paris in 1901. The plaster casts, terra-cottas and bronzes he sent

BIEGAS, BOLESLAS: *Venus and Pegasus.* 1919. Oil on panel, 60 × 81 cm. Galerie de Seine, Paris

to the Paris Salons before the First World War were redolent of Symbolism and *Art Nouveau*, and had a fantastic element which drew the attention of Apollinaire. *Thinker* (1910, plaster), *God's Dream* (1905, bronze), *The Power of Thought* and paintings like *Venus and Pegasus* (1919) place Biegas among the artists of oneiric *Art Nouveau*.

BONA Bona Tibertelli de Pisis, known as Bona (Rome 1926). Introduced to painting by her uncle Filippo de Pisis, she met André Pieyre de Mandiargues in Paris in 1947 and got to know the Surrealists. Her paintings such as *Young Prey* or *The Depths of Nature* unite plastic power with oneiric interest. The eroticism of her *Colimaçonneries* (1974), especially those in pastels, exhibit oral obsessions that are not without a certain humour (*Hans and the Mice*).

BORDUAS Paul-Emile (Saint-Hilaire, Quebec 1905). He is one of the painters who went through a Surrealist automatism period before turning to lyrical abstraction. He is the guiding spirit of the Canadian automatism group which in 1948 published the pamphlet-manifesto *Refus global.*

BRAUER, ERICH: *Soldier with Butterflies*. 1967. Watercolour,
26 × 29 cm. Galerie Oscar Negru, Paris

BRAUER Erich (Vienna 1929). After studying at the Vienna Fine Arts Academy until 1951, Brauer travelled in France, Spain, North Africa, Greece, Israel and the Yemen as a folk-singer and dancer. Then he went to Paris in 1958 and began to paint. He is a member of the Fantastic Realist group of Vienna and introduces strong colour passages into a viscous, nocturnal world. At present he divides his time between Vienna, Paris and the Israeli village of Ein Hod.

BRAUNER Victor (Piatra-Naemtz, Rumania 1903–Paris 1966). Brauner spent a happy childhood in Bucharest, in spite of the political agitation and wars which shook the Balkans in 1912 and 1913 and preceded the world conflagration of

1914–18. His father dabbled in spiritualism and the painter later invoked his memory of such occasions. His own mysterious and inward temperament inspires his meditations on the weird and marvellous. He painted his first canvases *c.* 1921 in Balcik, a fantastic city on the shores of the Black Sea, and an artists' resort. These first works were intelligent Rumano-Cézanne essays.

Through his friendship with the poet Ilarie Voronca, Brauner was introduced to the Rumanian avant-garde in which the Dada spirit works alongside the symbolical traditions of the East. Bourgeois mediocrity and the idiocies of the social whirl both seemed intolerable. Pictures such as *Christ at the Cabaret* and *The Factory Girl* caused a furore when exhibited at the Mozart Gallery in Bucharest in

1924; they were expressions of his adolescent protest. Brauner founded the review *75 HP* and published an article entitled 'Le Surrationalisme'. This was a curious premonition of a word which twenty years later was to become prominent in Bachelard's philosophy. Brauner also published his *Manifeste de la picto-poésie* which shows clearly what route this painter, as yet unaware of Surrealism (which was just germinating in Paris), was to take. Brauner's picto-poetry places him at the heart of Surrealism, for poetry can be made at the periphery of Impressionist versions of realism and Cubist mathematical essays, but depends on associations with the 'inward model' of which Breton was to write. Brauner's collaboration on the review *Unu*, a Dadaist journal, did not turn him into an advocate of anti-art. He already shared the ideas of those who had gone beyond Dada to Surrealism. On arriving in Paris in 1925 Brauner painted a picture significantly titled *City of Mediums*.

Whom did he meet in Paris? his fellow-countryman, the sculptor Brancusi; then, not long after, Giacometti and Tanguy, who was his neighbour. He became a friend of Tanguy's and was introduced by him to André Breton in 1933. This was the period when Brauner painted *The Door* (1932), *We are Cheated* (1934), *Kabiline in Movement* (1934) and a few paintings on *The Strange Case of Mr K* (1934), an Ubuesque character who was not followed up. In *The Door* there are two superimposed registers. Below, against a landscape and crenellated foreground, on one side a man is maltreating a woman, and on the other a kind of rod with a steering wheel emerges from a hole, and a horrible character is set against a black background. It has a pustulous nose, a carrot tongue, an empty eye, and is inserting a torn flag into its double's neck. Above, beyond a sky-coloured river several semi-realistic monuments appear in a desert. The picture has a horizon of mountains and a night sky. Where is *The Door*? Perhaps it is the empty eye of the diseased 'porter'. A glass eye lies forgotten on the window-sill.

When we discover that in 1931, shortly before returning to Rumania after his exhibition in Paris in 1934, Brauner painted a *Self-Portrait with Enucleated Eye*, it is difficult not to take the theme of the glass eye and the empty or closed eye—a constant recurrent topic at the time—as a premonition of the accident which deprived him of his left eye in 1938. As far as his friends were concerned it was proven. Dr Pierre Mabille ('l'Oeil du peintre' in *Minotaure*, Nos 12–13, 1939), Sarane Alexandrian ('Victor Brauner l'illuminateur', *Cahiers d'Art*, 1954), Alain Jouffroy (*Brauner*, Paris, 1959, p. 26) are convinced that he foresaw the event. In 1927 or so, asked by Brancusi to take some photographs at random on the Paris streets, Brauner brought back from his walk a photograph of a pavement scene

outside the apartment block where (though he did not know it at this time) exactly eight years later he would lose his eye. From 1934 to 1938 Brauner was in Rumania, where Hitler's influence encouraged the fascist Iron Guard and where he took part in an abortive civil war, fighting against the nationalists, at the same time as the civil war was raging on a grand scale in Spain. Back in Paris he interfered in a quarrel between two friends and was wounded in the eye by splinters of glass from a bottle thrown by Dominguez. He was now one-eyed. He entered his 'dark period'.

Female figures such as *The Chimera* (1939) emit a strange light where the shapes of alchemical instruments and symbolic plants can be seen. The diamond of *The Philosopher's Stone* (1940) shines

BRAUNER, VICTOR: *Ubu M.K.* 1934. Oil on canvas, 55 × 46 cm. Private collection

from a halo surmounted by a cock with a wolf's head in front of an attractive nude witch astride a tree branch. *The Interior Life* (1939), *Anemone, the Soul of the Wind* (1938), *Departure I* (1939), *Woman into Cat* (1940), *The Offering* (1941) are characteristic of this period which is one of the best in the career of Victor Brauner. His particular combination of clarity and obscurity was appropriate to a daydream atmosphere which became increasingly symbol-charged and more heavily explicit.

Brauner produced, after *Birth of Matter* (1940), a picture typical of this transition to the representation of effigies. It cannot be looked at as a landscape but has to be read like a page of writing. A naked woman's torso in profile is surmounted vertically by four faces, with two eyes open and two eyes closed. To the right, in a kind of window, there appears against a background of dark mountains, a priestess with covered eyes. Her ceremonial robe leaves her breasts and vagina bare. In one hand she carries an Egyptian *tau* and in the other a snake. Her head is crowned with a dual countenance in

ceptual forms. This is a form of figurative abstraction, an original mixture of the intellectual and the imaginary. The use of wax technique helped the forceful simplicity of this hieroglyphic painting.

Brauner stayed in France during the Occupation and sought refuge in the Alps near Gap. The shortage of artist's materials gave him the opportunity to change his technique. *Super-hero and Deserter* (1943), *Alostrob, Wax Painting*, and *Moon Motan* (1946) owe their tonal subtlety to the use of wax. When normal materials were again available, Brauner continued to paint a number of canvases in this way, from *Anagogy* (1947) to *Object Subjectivity, Infracape* and *Walk after Love* (1957).

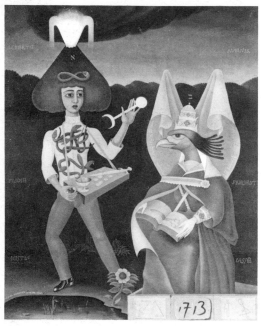

BRAUNER, VICTOR: *The Lovers. Messengers of Number*, 1947. Oil on canvas. Private collection

BRAUNER, VICTOR: *The Fashioner*. 1962. Oil on canvas, 130 × 97 cm. Musée National d'Art Moderne, Paris

which the front eye of the double view is surmounted by flames. The title of this picture, *Mythotomie* (1942), far from explaining it, only adds to the enigma of the accumulated symbols. But the important thing is not that. It is the oneiric nature of the icon. After that Brauner produced a form of writing in paint (*The Hunter of Unknowing*) in which the precise draughtsmanship was at the service of a deliberate confusion of all sorts of beings. Women, animals, plants, stars, sometimes houses, eyes, hands, claws, wings, scales appear at the level of what psychoanalysts call 'generic forms', or con-

Brauner was actively associated with the Surrealist group at the time of the Maeght exhibition where he showed his famous *Wolf-Table* (1947), but he split with Breton in 1949 when Matta was expelled from the group. A new period began for Brauner in his Alpine solitude, where his subjective

approach seems to have intensified. Some commentators have even discerned megalomania in Brauner's work of the time. In 1941, in the special issue of the American *View* devoted to Surrealism, Brauner proclaimed: 'Everything begins and ends through me, in me.' We must understand the humour of such statements, even though a certain inner anguish became evident in *Totem of Wounded Subjectivity* (1948) and the thirty-seven canvases in the series *Onomatomania*. In 1951 Brauner began his period of 'retracted' works in which (for example, in *Being Retracted, Refracted, Spied on by Conscious Mind*) he tried to produce a synthesis of diffuse twilight impressions and symbolical writing. The coffin theme (*Forgotten by Death*) now appeared and was fully expressed in a luminous and powerfully plastic style in a picture the painter was particularly fond of: *Realization of the Couple* (1957). This canvas, in which two people make one in a coffin-like aura, belonged to Brauner's last period, which offered a new serenity; characteristic works of this phase are *Depolarization of Intimacy* and *Lost Horizon* (1965).

In spite of the fame which he enjoyed after the war when he showed his work at Julien Levy's gallery in New York, Brauner remained one of the least pushy of the Surrealists. He was a meditative and solitary man, but interestingly 'self-conscious' —he insisted towards the end of his life on the use of his Christian name, Victor. In his picto-poetry he fused alchemical luminosity and a traditional symbolism in dream-vision form.

Alain Jouffroy: *Brauner*, Paris, 1959.

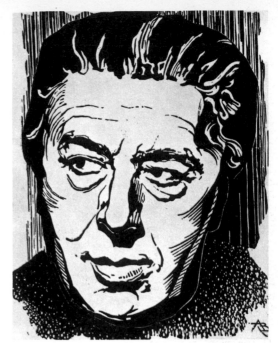

BRETON, ANDRÉ: *Self-Portrait*. Wood. Bibliothèque Nationale, Paris

BRETON André (Tinchebray 1896–Paris 1966).

The man whom his friends as well as his enemies called the pope of Surrealism was primarily the great poet of *Revolver à cheveux blancs* (1932); his rich prose also joined exactitude and lyrical power in works like *Nadja* (1928), *Les Vases communicants* (1935), *L'Amour fou* (1937) and *Arcane 17* (1945–7). The Manifestos of Surrealism were so marked at this time by the personality of Breton that Ferdinand Alquié opined that Surrealism was synonymous with Breton's thought. The *First Manifesto* (1924) relied on previous experiments and launched the notion of automatic writing. In the *Second Manifesto*, a call to order and a political statement, Breton showed the full extent of his authority: those expelled replied with the pamphlet 'Un Cadavre'. In the United States where he was exiled during the war Breton published *The Artistic Genesis and Perspective of Surrealism* (1941) and *Prolegomena to a Third Manifesto of Surrealism or Not* (1942). These texts show how much influence the course of Surrealist art had on the movement.

Breton was in charge of *La Révolution surréaliste* from 1925 (No. 2). He wrote a number of articles for it on the painters he liked. These were collected in 1928 under the title *Surréalisme et la peinture*. The successive editions of this book (English translation: *Surrealism and Painting*, London, 1972), amplified on each occasion with several articles and introductions to exhibitions, are milestones in the evolution of André Breton's thinking on Surrealist art. It may be summarized in the following two dicta: 'It is impossible for me to consider a painting other than as a window, about which I must first know what it *looks out on*'; and 'In order to respond to the necessity of absolute revision of the real values on which all minds agree today, art must refer to a *purely inward model*, or it will cease to exist.' After polite comments and circumstantial criticisms, Breton's review insist on the *marvellous* (more than on violence or humour) and the enlargement of the field of Surrealism into ethnological, popular, spiritualist and magical realms. The important thing is always that painting should be poetry, and therefore that it should be free.

Breton's thought stimulated a number of painters in the United States during the war (Motherwell, Gorky), and he brought back from his stay there an interest in Voodoo and an inclination to the occult. The esotericist recasting of Surrealism after the war also depended on the abandonment of a dream of political intervention, which had passed

BRYEN, CAMILLE: *Untitled*. 1949. Oil on wood, 89 × 55 cm. Galerie de Seine, Paris

before the war through adherence to the Communist Party, to the defence of Trotsky, before arriving at anarchism in 1950. In the end Breton, who added a eulogy of Symbolism to the last issue of *Surréalisme et la peinture*. would seem to have returned to a belief in this statement of 1925: 'In time the *true* revolutions are made by the power of images.'

Julien Gracq: *André Breton*, Paris, 1948.

BRUNIUS Jacques-B. (Paris 1906–London 1967). A poet who published very little verse, Brunius is known for his films. He was an assistant of Buñuel's on *L'Age d'or*, and made several shorts such as *Record*. Brunius lived in Britain from 1938, collaborated on the review *VVV* (New York, 1943–4) and contributed to anthologies: *Message from Nowhere* (London, 1944) and *Free Union* (London, 1949). In 1954 he published *En marge du cinéma français*.

BRYEN Camille (Nantes 1902–Paris 1977). He went to Paris in 1927 and exhibited there in 1934. He produced Surrealist objects and 'bryscopies'. During the war he made a definitive transition to painting. He is thought of as one of the fathers of Tachism. He produced *fumages*, or candle paintings, before concentrating on an informal style of painting which was both gentle and exact.

R.-V. Ginderthael: *Bryen*, Paris, 1960.

BUCAILLE Max (Sainte-Croix-la-Hague 1906). Bucaille was a mathematician and collagist who also produced paintings on glass, and sculpted roots. In 1947 he became a member of the revolutionary Surrealist group. *The Cries of Enchantment* (1939), *The Dream Scanner* (1950), and his illustrations for Noël Arnaud's *L'Etat d'ébauche*, testify to his humour and make him second only to Max Ernst as a poet of nocturnal imagery. In his paintings, decalcomanias and *raclage* techniques create cosmic visions close to lyrical abstraction.

BUÑUEL Luis (Calanda, Spain 1900). Luis Buñuel was the eldest of seven children in a rich family at Saragossa. He studied with the Jesuits, and then at Madrid University, where he met Dali and Lorca, among others. He studied to be an entomologist or an agricultural engineer, but he was also drawn to boxing and philosophy. In 1920 he founded the first Spanish cinema-club. In 1925 he was in Paris where he met the Surrealists. He followed Epstein's cinema courses and became his assistant: Together with Dali (who was still in Spain) he wrote the script for *Un Chien andalou* (1928), a synopsis of which appeared in *La Révolution surréaliste*, No. 12: A man sharpens his cut-throat razor in front of an open window at night, then his fingers separate the eyelids of the left eye of a young woman, and the blade slowly passes across the eye. In a dream donkeys rot in tailed pianos, ants eat away at a hand caught in a door, the severed hand moves on the floor, a man's hand feverishly caresses a woman's naked breasts, and finally the two blind protagonists bury themselves in the sand under a leaden sky. In 1930 Studio 28 presented *L'Age d'or* and the auditorium was ransacked by a band of young patriots. The shock-

imagery of the film clearly attacked the Roman Catholic Church, the army and the police. The archbishops chanting at the beginning soon become skeletons, a cow wallows in a girl's bed, and Lya Lys voluptuously sucks at the toe of a statue. After these films with their totally free dream sequences, Buñuel turned to depiction of reality in the documentary *Hurdes* (1931–2), which denounced the impotence of Christian charity in the face of suffering. Then he produced nothing for twenty years. His work, whatever it was, was mainly in Hollywood, but is not mentioned by his biographers. *Los Olvidados*, a film of 1950, is about the 'forgotten' adolescents of the suburbs of Mexico and their cruel world. Buñuel's real career had begun. From time to time he produced a masterpiece in the Surrealist spirit. *El Bruto* (1952), *Death in the Garden* (1956), *Nazarin* (1958) are mystico-critical films in which some Catholic critics have

purported to find evidence of Buñuel's conversion. *The Young Girl* (1960) was a prelude to *Viridiana*, which was not so much to Catholic taste and won a Cannes award in 1961. It is the story of a virtuous Christian girl, the object of the repressed desire of Don Jaime, an aristocratic old man who commits suicide. Viridiana decides to devote herself to the poor and to practise charity. She is raped by drunken beggars whose orgy in a famous scene is a blasphemous version of Leonardo's *Last Supper*. Next year, Buñuel made *The Exterminating Angel* and then *The Diary of a Chambermaid*, after Mirbeau's novel. The exterminating angel (who wipes out the self-satisfied bourgeoisie) shuts the guests at a high society party in the rooms where they are dancing. The nightmare into which these people sink in their degradation repeats some of Buñuel's obsessions, like that of the severed hand. This film is a perfect realization of the notion of the

BUÑUEL, LUIS: Still from the film *The Discreet Charm of the Bourgeoisie, 1973*

fusion of dream and reality characteristic of Surrealism. In *The Discreet Charm of the Bourgeoisie* the real and the dreamlike are contrasted. The sharp transitions from one world to the other bring a vein of tragedy into Buñuel's humour. *The Phantom of Liberty* (1974) shows that, throughout the years, Buñuel's Surrealist inspiration, far from being subdued, has in fact deepened. The outrageous poetry of his first films is admirably complemented years later by the sombre, violent thunder-clap of the poetry in his most recent films.

BURY Pol (Haine Saint-Pierre, Belgium 1922). In 1957 he invented his *Multi-Plans*, in which slats move slowly and a-rhythmically. These surfaces are covered with plastic sheeting and seem endowed with a certain life. A number of Bury's objects and sculptures (*Points Blancs*) feature these hardly perceptible movements, whose erotic and oneiric fascination is reinforced by the abstract simplicity of the forms.

CALDER Alexander (Philadelphia 1898–New York 1976). A son and grandson of artists Calder's three early passions were: technology, drawing and the circus. He constructed a miniature wire circus which was shown at the Salon des Humoristes in Paris in 1926. Then his montages became more abstract. He was a member of the Abstraction-Creation group and exhibited his mobiles in Paris in 1932. He was a friend of Hans Arp, Duchamp and Miró. He returned to the United States in 1933

CALDER, ALEXANDER: *Tom's.* 1974. Stabile, 570 × 500 cm.

and went to live on a farm where he invented the aerial mobiles that were to make him famous. The New York public discovered his stabiles at the Museum of Modern Art in 1943. In 1953 he moved to Saché, in the Loire Valley, where his mobiles and stabiles assumed colossal proportions. Some of his black plate monsters have the dark force of a Minotaur.

CAMACHO Jorge (Havana 1934). A painter who went to Paris in 1959 and is the most interesting of the new Surrealist generation. In a cruel graphic

CALDER, ALEXANDER: *Red Pyramid*. Mobile. Private collection

CAMACHO, JORGE: *The Birds*. 1973. Oil on canvas, 130 × 195 cm. Galerie de Seine, Paris

CAMACHO, JORGE: *The Dance of Death. Opus 15*. 1976. Oil, 150 × 150 cm. Galerie de Seine, Paris

CAPACCI, BRUNO: *The Laws of Legend*. 1946. Oil on hardboard, 100 × 81 cm. Galerie de Seine, Paris

style, Camacho expresses under the influence of Sade and Bataille the tragic aspect of eroticism in a kind of peaceful nightmare scenery. Often there is an animal in pain (*The Rebellion of Bravo, The Yellow Sky*) and the thongs of a whip can be seen hanging down (*The Birds*, 1973). In his paintings we are always enclosed in a claustrophobic room which adds a suffocating agony to the feasts of this surgeon of the imagination.

CAPACCI Bruno (Venice 1906). After studying in his birthplace, then at Florence and in New York, Capacci went to Paris (1932–9) and to

Brussels (1940–6) before joining the Parisian Surrealists between 1947 and 1955. Then he associated with the Belgian Surrealists. His painting unites a certain freedom of plastic imagination with a few traces of the influence of Chirico, as in *The Laws of Legend* (1946).

CARDENAS Agustin (Matanzas, Cuba 1927). This sculptor's first exhibition in Paris in 1959 and his participation at the international Surrealist exhibitions in 1960 and 1965 showed that he could introduce the ambiguous fluidities of life into abstract volume.

CARRINGTON Leonora (London 1917). Leonora Carrington was a member of the British upper class and was taught for a time by Amédée Ozenfant (1936). She met Max Ernst in London

CARRINGTON, LEONORA: *The Temptation of St Anthony.* 1946. Oil on canvas. Private collection

In 1939, Max Ernst was interned in a camp as a German citizen and she was left alone and very distressed. She gave the house to some local people and left for Spain where she was treated for a nervous breakdown. She describes this experience in a book she published in 1944. She returned to New York and settled finally in Mexico, where her painting was enriched with motifs drawn from pre-Columbian mythology.

CHAGALL Marc (Vitebsk, Russia 1887). Born into a poor Jewish family, Chagall went to Paris in 1910 on a scholarship and entered the whirl of Montparnasse. His painting is full of allusions to the primitive religiosity of his childhood, and

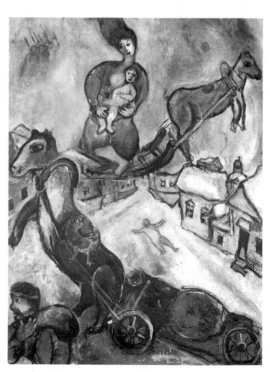

CHAGALL, MARC: *War.* 1943. Oil on canvas, 105 × 76 cm. Musée National d'Art Moderne, Paris

and followed him to Paris in 1937 before living with him at Saint-Martin d'Ardèche. She wrote fantastic tales of a remarkable poetic strength, which were collected in volume form in 1938 and 1939 (*The House of Fear* and *The Oval Lady*). Her paintings might well be illustrations for her books.

includes a certain ironic tenderness in the anti-realistic fantasy. Breton was to write later: 'From this time (1911) metaphor in Chagall's works alone marked its triumphal entry into modern painting.' War broke out and Chagall returned to Vitebsk and married Bella in 1915. The theme of happiness and lovers was constantly to recur in his works. Neither the unhappy experiences of his official post

at Vitebsk in 1917, nor the Second World War and the massacre of his co-religionists, nor the rape of Vitebsk, nor even the death of Bella (1944)—he

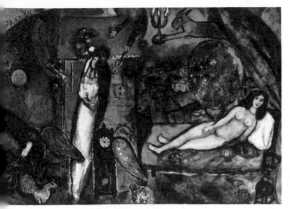

CHAGALL, MARC: *To my Wife*. 1933–44. Oil on canvas, 131 × 194 cm. Musée National d'Art Moderne, Paris

CHAGALL, MARC: *The Acrobat*. 1930. Oil on canvas, 52 × 65 cm. Musée National d'Art Moderne, Paris

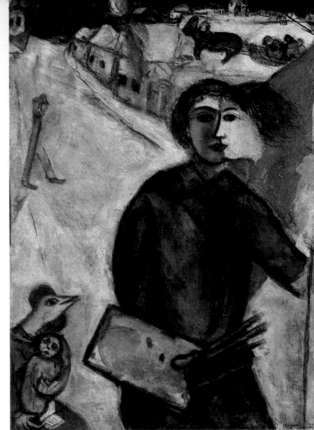

CHAGALL, MARC: *Between Dog and Wolf*. 1944. Oil on canvas, 100 × 73 cm. Private collection, Basle

married again in 1952—truly depressed this trend in his art. From *Lovers above the City* (1913–18) to *The Big Circus* (1956), by way of *The Lovers* (1923), *The Married Couple of the Eiffel Tower* (1928 and 1939), *Between Dog and Wolf* (1944), the treatment is the same. Apart from the religious and popular sources of his painting, the constant happiness in his work is probably a reason for the Surrealists' reticence about Chagall—Surrealists are not often inclined to the expression of happiness.

CHAILLET Françoise (Paris, 1936). After studying architecture, Françoise Chaillet, who is of French and Swiss nationality, became a *Vogue* dress designer and a researcher for a publishing house. She took part in the international Surrealist exhibition at Paris in 1965 and at the Design International in Darmstadt in 1967. Two one-man exhibitions in Paris in 1966 and 1969 and the Copley Prize in 1965 are the first awards of this subtle draughtsman who in *Derivations of Thought* or *Not a Tear*, for example, adds a delicate and sadistic eroticism to Paul Klee's lesson.

CHIRICO Giorgio de (Volo, Thessaly 1888).
The son of an Italian engineer who died in 1905,
the young Giorgio spent his adolescence with an
authoritarian mother and left Greece at eighteen.

CHIRICO, GIORGIO DE: *Self-Portrait*. 34 × 29 cm. Private
collection

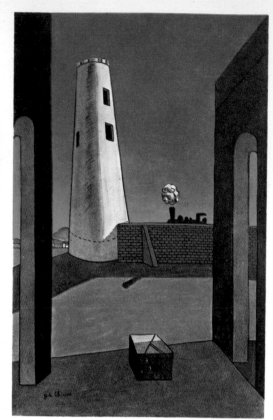

CHIRICO, GIORGIO DE: *Melancholy of a Politician*. 48 × 45
cm. Emmanuel Hoffmann Foundation, Kunstmuseum,
Basle

CHIRICO, GIORGIO DE: *Metaphysical Landscape with White
Tower*. 1914. Canvas, 59.5 × 39 cm. Private collection

He completed his art studies in Munich, where he
came under the influence of Böcklin, Max Klinger
and German Romanticism. After a short stay in
Italy, he settled in Paris from 1911 to 1915, and in
his Montparnasse studio gave free expression to his
enigmatic and lonely inspiration. *The Enigma of the
Time* (1912), *Memory of Italy*, *The Poet's Disquiet*,
Melancholy of an Afternoon (1913): the search for
some obscure memory seems to haunt these arcaded
squares, where the light of a fading Mediterranean
day prolongs the shadows. There are no answers.
There are the dumb models, the *Disturbing Muses*
(1917) and the *Big Interiors* of his *pittura metafisica*,
which he painted at Ferrara, where he moved in
1915 to be close to Savinio, his brother, and Carlo
Carrà. Then, quite suddenly, in about 1919,
Chirico shook off his terrible melancholy to devote
himself to a more banal *grande peinture*. Breton,
Aragon (though not Eluard) expressed their con-

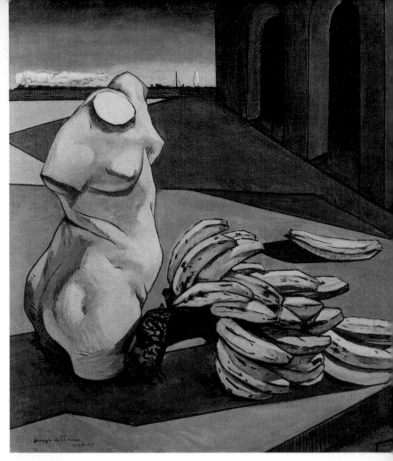

CHIRICO, GIORGIO DE:
The Poet's Disquiet. 1913.

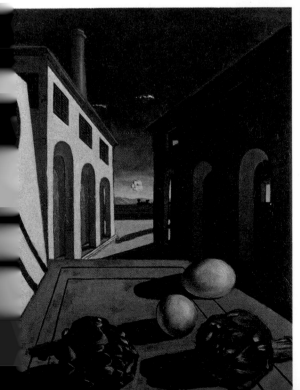

CHIRICO, GIORGIO DE: *The Enigma of a Departure.* 1916.
65 × 50 cm. Galerie de Seine, Paris

tempt for this 'defection' and dragged his name in
the mud because he so fiercely renounced his former
style. His novel *Hebdomeros* (1929) is testimony to his
genius, but more recent written works such as his
Memoirs (1962) show how he continued unaware
of it. But this lack of self-knowledge should not
surprise anyone who knows anything about
psychoanalysis.

James Thrall Soby: *Giorgio de Chirico*, New York, new
edn, 1966.

**CONSTANT Constant Nieuwenhuys, known
as** (Amsterdam 1920). He was first associated with
the review *Reflex* and joined the revolutionary Sur-
realist group in 1947 before taking part in the
activities of the Cobra group. His painting is in the
tradition of Abstract Expressionism.

CORNEILLE Van Beverloo, known as (Liège
1922). He was also a member of the revolutionary
Surrealists before joining Cobra. His painting is
sometimes done with sable brushes, as he tries to
accommodate subtle nuances of matter.

137

CORNELL Joseph (Nyack, New York 1903). He discovered Ernst's collages in 1930 and held his first exhibition in New York in 1939. He specializes in the construction of glass cases, in which he arranges a few evocative objects very precisely before a starry sky or a newspaper background.

CORNILLEAU Jean-Loup (Nogent-le-Rotrou 1943). This young painter is outside all groups. In 1971 he exhibited in Paris his black boxes contain-

CORNILLEAU, JEAN-LOUP: *Untitled*. 1973. Ink and pencil, 31.5 × 23 cm. Private collection

ing microsculptures of physiological and oneiric shapes. His big red pictures offer a fantastic vision of the mysteries of the blood. His plastic poetry is developing towards a lighter universe in the acetone-treated images he showed at Rome in 1973.

CRÉPIN Joseph (Hénin-Liétard 1875–1948). At the age of sixty-three Crépin produced, almost unconsciously, his first automatic and spiritualist paintings. The mystical themes, symmetry and refined colour work are supplemented by a kind of serene grandeur (*The Wonderful Star*).

CREVEL René (Paris 1900–Paris 1935). Surrealism is indebted to Crevel for his example of uncompromising demands and his valuable contribution to the experiments of the 'sleep period' (1922). As far as Surrealist painting was concerned, the author of *La Mort difficile* (1926) made his

Portrait of René Crevel

contribution by publishing a book on Paul Klee (Paris, 1930) and *Dali ou l'anti-obscurantisme* (1931). His complete works are in course of publication in France. He committed suicide in 1935 the day before the Congress of Writers for the Defence of Culture met at Paris.

DADO Miodrag Djuric, known as (Cetinjie, Yugoslavia 1933). After studying art in Yugoslavia, Dado arrived in Paris in 1956 and worked as a lithographic assistant. He was discovered by Dubuffet and introduced to the public by Daniel Cordier. The world into which he draws us is one of a mass of monsters who seem to be screaming with pain (*The Bad Pupil of Vesalius*) in a pastel-toned fog. This nightmare is in the tradition of a Surrealism marked by the experiences of the concentration camp.

DADO, MIODRAG DJURIC (known as DADO):
The Bad Pupil of Vesalius II. 1967.
195 × 130 cm. Collection:
André François Petit, Paris

CRÉPIN, JOSEPH: *The Wonderful Star*. 1944.

DADO, MIODRAG DJURIC (known as DADO): *Small Vegetal Police*. 1969. 195 × 130 cm. Galerie Jeanne Bucher, Paris

DALI Salvador (Figueras, Catalonia 1904). The son of a lawyer and much doted on by his mother, whose eldest son died of meningitis, Salvador was a hyper-nervous child. He paid little attention to his studies with the Marists, and they only increased his wish to be a painter. He was soon consumed with desire to answer the question he asks in his autobiography (*The Secret Life of Salvador Dali*, 1943): 'Am I a genius?' He exhibited Cubist paintings at Barcelona, and led the life of a student in Madrid, where he met Lorca and Buñuel and was sent down from the School of Fine Arts.

DALI, SALVADOR: *Melancholia or Portrait of Clare*. 1942. Oil, 78.5 × 58.5 cm. Private collection, Geneva

DALI, SALVADOR: *The Rotting Donkey*. 1928. Oil

In 1927 he discovered Surrealism in the magazines. It was a revelation. He painted *Blood is Sweeter than Honey* (1927). Geometrically divided into squares, this painting already features objects which were to obsess Dali, for instance the dead donkey (*The Rotting Donkey*). He wrote—for Buñuel —the script for *Un Chien andalou*, before meeting the Surrealists. This film created a scandal in Paris in September 1929. Joan Miró (the anti-Dali of Surrealism) introduced his fellow-countryman to the Surrealists. Dali surprised them with his intriguing behaviour and irrepressible laughter.

Eluard and his wife Gala, the Magrittes and Goemans the merchant, came to see Dali at Cadaquès in 1929. Dali fell for Gala who came to live with him. She looked after him, calmed him, and inspired several pictures and poems such as *I am eating Gala*. He introduced her into his erotic paintings, and painted her as a pregnant Madonna (1950) or as *Leda Atomica* (1949). The unique love of Dali and Gala corresponds to a major characteristic of the Surrealist sensibility, especially when this 'unique love' does not exclude such statements by Dali as: 'In love I attach special value to everything known as perversion and vice. I consider perversion and vice to be the most revolutionary forms of thought and action, just as I consider love to be the sole attitude in a man's life' (*La Femme visible*, 1930). Gala, whose personal authority was already of long-standing among the Surrealists, helped greatly in integrating Dali with the movement. She did not, however, prevent him later from submitting to one of the most confused mixtures of Spanish and papist mysticism.

Towards 1930 Dali became one of the key figures of Surrealism. His first exhibition at Paris in 1929 was introduced by André Breton. Dali was provocative, theatrical and a magnificent speaker. He became the apostle of the irrational. This was the period in which he painted canvases which later became very famous: *Illuminated Pleasures*, *The Lugubrious Game*, *The Accommodation of Desire* (1929), *The Dream*, *The Persistence of Memory* (1931). The treatment is academic but the obsessional details are so extraordinary and so minute that they defy description. A less well-known unfinished picture of 1929, *Imperial Monument to the Child Woman*, seems to summarize all Dali's experimentation at

woman with a bare breast, an eyeless face, and a dead mouth. Far off, in the interstices of a viscous stele, if you look closely, there are keys, flies, and perhaps ants. Near at hand someone kneeling is only a delirious skeleton. Dali before woman? Or perhaps the subject is the viscosity of a world in which desire blows its mad wind and which death petrifies.

In somewhat lyrical prose works, *La Femme visible*

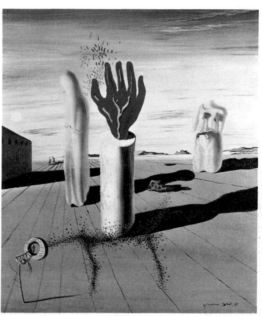

DALI, SALVADOR: *Semblance of Night*. 1930. Oil on canvas, 55 × 46 cm. Collection: T.A. Musto, Hillsborough

DALI, SALVADOR: *The Giraffe on Fire*. 35 × 27 cm. Emmanuel Hoffmann Foundation, Kunstmuseum, Basle

the time. Here is his method of mixing spatial scales: at the foot of a rather phallic rock the objects and people have the dimensions of far-distant things. The details are cumulative: Mona Lisa, Napoleon, the two peasants from Millet's *The Angelus*, a petrified wave, wrinkled hands, the lion's head from *Accommodation of Desire* and a marble

(1930), *L'Amour et la mémoire* (1931), and *La Conquête de l'irrationnel* (1935), Dali proposes to add to the 'passive' states of automatic writing a confabulatory technique which he calls the 'paranoiac-critical method'. 'All my ambition in painting,' he writes in *Conquête de l'irrationnel*, 'consists in rendering material with the most imperialist concern for precision, the images of concrete irrationality.' Dali defines 'paranoia-criticism' as a 'spontaneous method of irrational cognition based on the critical interpretative association of delusional phenomena' (*La Femme visible*). All the terms in this definition, and especially the first two, 'spontaneous method', are selected in order to inject the greatest possible confusion into the practice of the waking dream.

DALI, SALVADOR: *The Phantom Tartan*, 1934.
Galerie André François Petit, Paris

DALI, SALVADOR: *The Persistence of Memory.*
1931. Museum of Modern Art, New York

DALI, SALVADOR:
The Old Age of William Tell. 1931.
Private collection

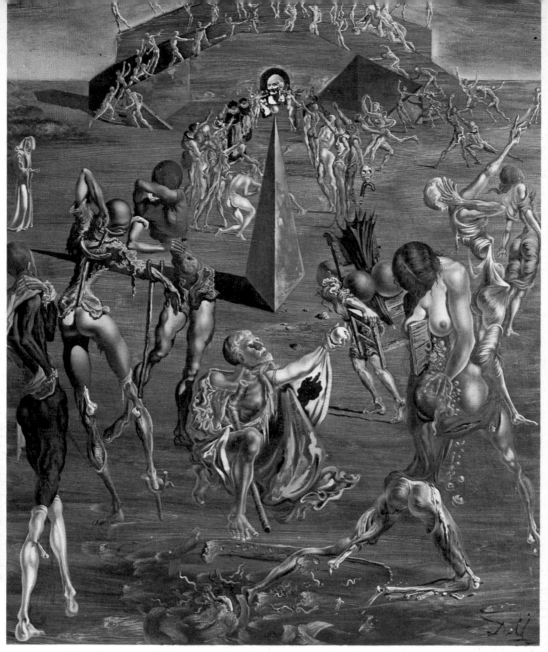

DALI, SALVADOR: *The Resurrection of the Body.* 1961. Collection: Bruno Pagliai, Mexico

Instead of indulging in oneiric visions, Dali anguishes on the borderline of the real and the imaginary. There he started to produce a series of fanciful canvases. *The Great Masturbator* (1929) was succeeded by William Tell who appears in several pictures, where the erotic themes extend to coprophagy. Then there was Millet's *Angelus*. Dali showed the greatest possible enthusiasm for this fetish-picture of the right-thinking low-brows of the nineteenth century. He includes it in the erotic dream-work in *Meditation on the Harp* (1932–3). His love for Gala and his celebration of them as a couple induce a kind of greedy tenderness in Dali before this peasant couple praying when the Angelus bell sounds (*Gala Looking at Dali*).

The Surrealists were able to tolerate these 'paranoiac-critical fantasies'. But Dali went further. He became fascinated by Meissonier and said he was a precursor of Surrealism. Some Surrealists, Ernst among them, began to grow rather shirty. Meissonier, the battle painter who had praised the worst colonialism of the rulers of his time. . . . And now Dali was dreaming of Hitler, whom he confused with Maldoror. Dali was summoned to explain himself to the Surrealists. In spite of the 'paranoiac' found-phrases of his speech he was expelled. It was not so much his fantasies as the ideologies he had been brought up in that Dali was following. His father broke with him definitively when he discovered that he was a Surrealist. Dali lost himself in a maze of Catholic, nationalist and monarchist ideologies. A *Premonition of the Civil War* painted in typically Daliesque style in 1936 is entitled *Soft Construction with Boiled Haricots*. And his *Secret Life* which he wrote in the United States when staying with Caresse Crosby, after 1940, takes up on the ideological level conventional political opinions quite unworthy of the 'first-class intellect' which Breton had acknowledged in Dali. In a text of 1936 (*Le Cas Dali*), in *Des tendances les plus récentes de la peinture surréaliste* (1939), and then in a paragraph of *Genèse et perspective artistiques du surréalisme*, Breton criticizes Dali for his 'cynical indifference to the means by which he makes an impression', and executes someone he calls Avida Dollar. From *The Enigma of Hitler* to *The Apotheosis of the Dollar* (1965) by way of the society portraits of the American period (Helena Rubinstein, Lady Mountbatten, and so on), Dali's not illogical 'evolution' was no longer of interest to Surrealism, whose core is ethical. Such an evolution does not exclude but on the contrary favours a painting of the Christ of St John of the Cross and the despatch of a canvas to the Pope. This mystical period (*The Resurrection of the Body*) opened into a luxurious *Mystical Manifesto* (published in Latin, 1951) as distant from Surrealism as from true mysticism. A nuclear period (another capricious dictate of

paranoia-criticism, of course) interfered with these religious stirrings, for instance in *Exploded Raphaelesque Head* (1951). Then there were his eccentric lectures on the rhinoceros (Sorbonne lecture, 1955), the illustrations of *Don Quixote*, the series of engravings in homage to Dürer (1971), the baroque appearances on television, and the very non-mystical *Diary of a Genius*.

The most original aspects of Dali as a Surrealist would seem to be his greedy voracity, his oral eroticism, his cheap cynical humour, his excessive

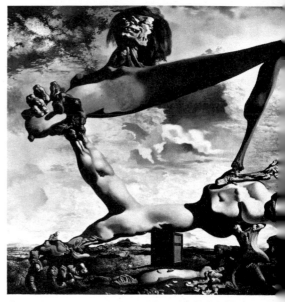

DALI, SALVADOR: *Soft Construction with Boiled Haricots: Premonition of Civil War*. 1936. Museum of Art. Philadelphia

eulogies of veal and lobster, his fascination with the creamiest camembert. In regard to *Persistence of Memory*, he writes in *Conquête de l'irrationnel*: 'Rest assured that the famous limpid watches of Salvador Dali are no more than paranoiac-critical camemberts—extravagant, solitary, the camemberts of time and space.' The entire world, once submitted to this paranoia criticism, becomes the object of his aesthetic terrorism. The viscous, which was elevated at the beginning of the century to aesthetic dignity by *Art Nouveau*, finds in Dali, Gaudí's admirer, a voluble apostle. The cookery book illus-

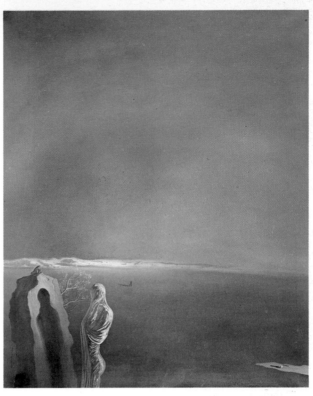

DALI, SALVADOR: *Ambivalent Image*. 1933. Oil, 65 × 54 cm

trated with collages which he published in 1971, *Les Dîners de Gala*, stands at the crossroads of the two main routes of Daliesque fabulation: the adoration of Gala and manducatory delirium.

This volubility is shown in several titles of paintings which add irony to more sinister imagery: *Average Atmosphericocephaloid Bureaucrat Milking a Cranial Harp* (1934), *Blind Horse Consuming a Telephone* (1938), *Anguish of Liquid Desires*, *Enchanted Beach with three Fluid Graces* (1938), *Laocoön Tormented by Flies* (1965, glass). Sometimes the found thing is poetic as in *Dali at the Age of Six when he Thought he was a Girl, taking the Top off the Sea, in Order to see a Dog Sleeping in the Sea's Darkness* (1950), and the picture thus designed intrigued Magritte. But he went a little too far with the following title: *Gala Looking at Dali in a State of Anti-Gravitation above his Work of Art 'Pop, Op, Yes-Yes, Academic convention', in which we can see the two worried Millet people in an atavistic state of hibernation, before a sky which can suddenly change into a gigantic Maltese Cross at the very centre of Perpignan Station towards which the Entire Universe is converging* (1965).

Dali was most active in the creation of Surrealist objects. His imagination dreamed more than he suspected. Hence some of his paintings show impossible objects. That is the case of the 'limpid' watches, or the piano sodomized by an atmospheric crane (1934). In *The Picture of Mae West which can be used as an Apartment*, the mouth-sofa and the fireplace with nostrils are Surrealist objects. There is also the *Belle Epoque* statuette with its rhinocerotic cones known as *Hysterical and Aerodynamic Woman* (1934), the famous rainy taxi, set up in the entrance of the Surrealist exhibition at Paris in 1938 (real snails walked all over the beautiful rain-drenched wax passenger), and in the same exhibition there is the model whom Dali placed in the Surrealist Street and dressed with little spoons, the telephone with a lobster as a receiver, the 2.50 m long loaf with which he arrived in New York in 1939, *The Aphrodisiac Waistcoat* (1936), and the hat-slipper worn by Gala. In reality Dali's objects do not have the same evocative and tragic power as Giacometti's 'objects with symbolic functions' (1934) or Bellmer's *Doll*. They are fantastic rather than truly disturbing. Dali likes attitudinizing so much that we might credit him with the invention of an 'art of behaviour' which was to become fashionable in the 1960s. The diving suit in which

Dali appeared at the London Surrealist exhibition in 1936, leading two white greyhounds, was not a Surrealist object. The diving suit got stuck; Dali nearly stifled and yet the public thought it was a prearranged joke.

Objects, films, behaviour, publicity: Dali's varied talents have enabled him to try many areas of art. But behind the eccentric façade of his 'paranoiac-critical' method, there is, deep down, a kind of serious dilemma. In his *Secret Life* he describes the rather simplistic method that he used to make himself a dream narrator. Everyday life is a laboratory in which the Surrealists have looked for the best means of 'forcing inspiration'. Dali put his canvas near his bed. He often looked at it before

This image of Dali as an anxious medium awaiting the descent of his own genius is a useful corrective for those familiar from magazines and television with his public image: mascaraed eyes and vertically-waxed moustaches; the instant wise man. Behind the exhibitions of forced laughter, there is a child inquiring about the night of the imagination and the mystery of genius. After his mother's disappearance, he was unable to find that protective tenderness again, either in the Catholic Church or in Spain or in love for Gala—though she was a magical spur to him—or in a fame which he thought would give him, in the face of death, the assurance of a definitive hibernation in a lost paradise.

René Crevel: *Dali ou l'anti-obscuranticisme*, Paris, 1931.
Dali de Draeger, ed. Max Gérard, Paris, 1968.
Dali de Gala, Paris, 1962.
James Thrall Soby: *Salvador Dali*, New York, 1946.
Michel Tapié: *Dali*, Paris, 1957.

DAUSSY Raymond (Rouen 1919). He is one of the founders of the revolutionary Surrealist group (1946) and later took part in the activities of the *Phases* group. He introduced into his Italianate landscapes the oneiric poetry of dreams of flight.

DAX Adrien (Toulouse 1913). This reclusive painter whose work is rarely exhibited is a keen experimenter. His 'interpreted posters', for instance *The Beautiful Mexican* (1965), accord with the poetic freedom of his designs.

DEDICOVA Irena. After studying art in Prague from 1951 to 1956, Dedicova exhibited at Bucharest and Vienna. Between 1960 and 1965 she produced stained glass and murals. She favoured a lyrical abstract style at that time. She moved to Paris in 1965 and took part in the *Phases* group. Her first one-man exhibition was held at Prague in 1968 and the next year she took part in the European Surrealist exhibition of 1969 (Cologne). Her painting has evolved in the direction of a fantastic style in which mysterious objects are enveloped in an aura, and the presentation is clear-cut and generally precise. She exhibited at the A.R.C. in Paris in 1971.

DEGOTTEX Jean (Sathonay 1918). A self-taught painter whose first exhibition was in 1950 in Paris and whose 1955 exhibition was introduced by Breton. Degottex takes gestural abstraction to the bounds of the void so that one sign in the middle of a canvas is enough to make the spectator dizzy.

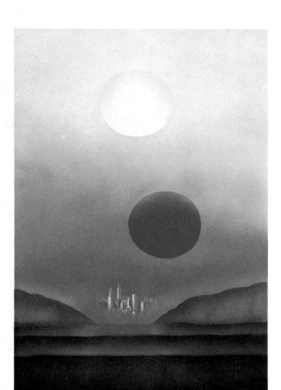

DEDICOVA, IRENA: *Two Suns*. 1976. Acrylic and Oil, 116 × 81 cm

going to sleep and tried to dream about it; on waking it was the first image to meet his eyes. All day long, he says, he was a 'medium', looking at the painting so that day-dream visions would enter him.

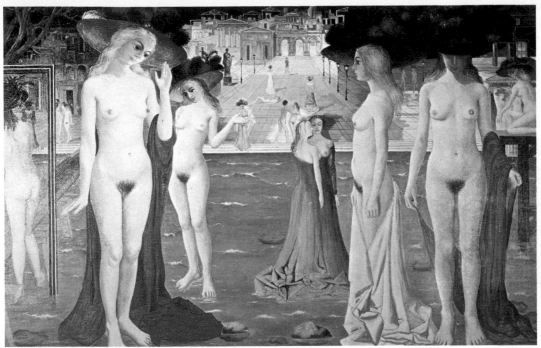

DELVAUX, PAUL: *The Dryads*. 1966. Oil on canvas,
150 × 120 cm. Private collection

DELVAUX Paul (Antheit-Huy, Belgium 1897).
The son of a lawyer and coddled by a mother who
wished to defend her son from feminine wiles,
Delvaux was later to offend against puritan taboos
and make his work a monument to female grace.
His initial art education was respectably classical
at the Académie des Beaux-Arts in Brussels. He
used Neo-Impressionist techniques in his land-
scapes. That was the dominant style in all the
academies of Europe at the time. He produced
views of Rouge-Cloître and the Soigne woods. His
first exhibition in 1924 was with the painters of the
Sillon group—landscape painters who had decided
rigorously to exclude any human figure from their
work.

But Delvaux discovered James Ensor and Ex-
pressionism. He destroyed his first landscapes and
produced scenes showing *kermesses* (fairs), and
colossal nudes, like *Sleeping Venus* (1932). The
works of his second period were exhibited in
Brussels in 1933 at the Atelier de la Grosse-Tour.
In 1934 he visited the *Minotaure* exhibition in
Brussels and experienced the revelation of Sur-
realism. His most violent shock came when he
confronted Chirico's *Mystery and Melancholy of a
Street*.

The first result of that shock was that he again
destroyed his works (of the second period), of
which only a few survive. The second result was
that with *Woman in Lace* (1934) he began the work
of an artist who 'has made the universe the empire
of a woman who always stays the same, and who
rules over the great thoroughfares of the heart'
(André Breton, *Surréalisme et la peinture*). The world
of Delvaux, who remained outside any group,
corresponded especially well to the sentimental
Surrealism that the poets of the group, with Eluard
and Breton to the fore, had developed in the
Symbolist tradition. For Delvaux as for them
woman is sublimated, whereas most of the Sur-
realist painters, from Bellmer to Molinier, subjected
women to sadistic and even destructive rituals and
devices.

Delvaux took part in the major international
Surrealist exhibitions after 1938, when he went to
Italy. His first retrospective took place in 1944 at
the Brussels Palais des Beaux-Arts, and that marks
the beginning of his real fame. He afterwards
became a lecturer at the Brussels Ecole Nationale
Supérieure d'Art et d'Architecture then he was
appointed to a chair in Fine Arts at the Belgian
Royal Academy. His exhibition at Drouin in Paris

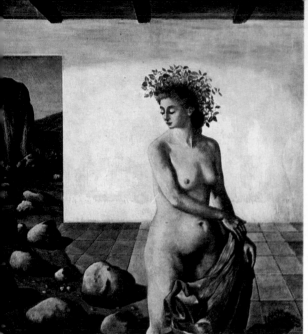

DELVAUX, PAUL: *The Vigil*. 1940. 100 × 90 cm. Private collection

DELVAUX, PAUL: *The Summons*. 1944. Private collection, New York

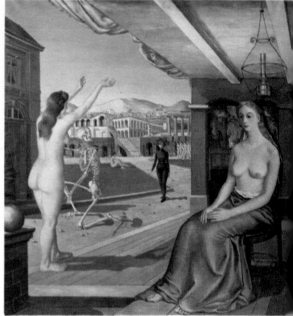

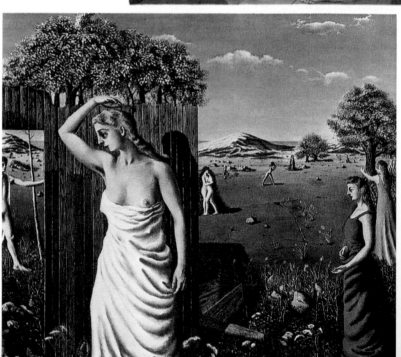

DELVAUX, PAUL: *Summer*. 1938

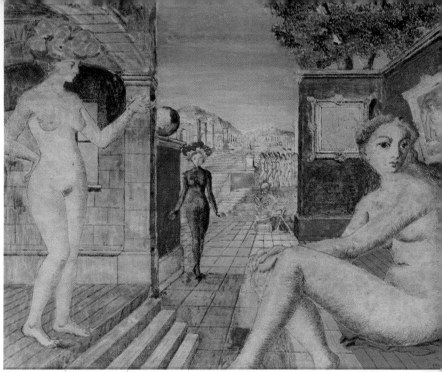

DELVAUX, PAUL: *Young Women in a Classical Landscape*. 1940

in 1948 already indicated the strength of the following that brought him his 1969 retrospective at the Musée des Arts Décoratifs. Delvaux, far from disliking large format canvases, produced some murals in Ostend, Brussels and Liège, and his decoration of the Gilbert Périer interior at Brussels is an example of a *trompe-l'oeil* painting in which humour and poetry go hand in hand.

Delvaux's style joins exact design and draughtsmanship with delicate tonal values, verging sometimes on the monochrome. He is less academic than he might at first seem. He groups his characters interestingly in complex perspectives, where architecture, streets, esplanades, avenues of trees, and the feet of mountains are distributed with a delightful grace that would have pleased Puvis de Chavannes. A good example of Delvaux's work is the 1.50 m × 2.50 m canvas of 1966, *The Acropolis*, where, in addition to Delvaux's dream themes, an almost immobile procession of unhappy women in a clear night in which oil lamps and candelabra contribute their light, space is almost divided into three interdependent sections. At the centre, there is a woman, full-face, her head bowed, and one breast bare; behind her there is a dark door, made of glass, and a gnarled tree; to the left a procession of girls ascend some steps to an esplanade which crosses the horizon; to the right, under a canopy, a Venus is sleeping on her unmade bed, and further off there are a few steps, the columns of a peristyle,

and then a lawn where, far away, some women seem to be proceeding towards an unknown destination. The horizon of this garden is lower than that of the esplanade, yet the Italian perspective unifies this vision in one nocturnal whole.

Sweet Night, the title of a canvas of 1962, is Delvaux's major theme. In the middle of the road a naked enchantress with a heavy coiffure sits at a round table covered with a carpet, while on the left the wise old man who often appears in Delvaux's works shows his astonishment, probably at his own thoughts, for he does not seem to have seen the two young beauties, more than half naked, who are gently embracing on the right. The moon draws out the shadow of the trees which seem to be moving towards the furrowed distance.

From 1934 to 1942 Delvaux uses the full light of day: *Woman at the Mirror*, *Lace Funeral* (1936), the erotic *The Sleeping City*—two exceptions are the fine twilight disturbed by waves from the *Nymphs of the Waters* (1938) and the *Nocturne* of 1939. His is a colder light than Chirico's, but—like Chirico's—it falls on warm coloured objects, especially in *Pygmalion* (1939), *The Man in the Street* (1940), *The Village of Sirens* (1942) and even more so in the *Red City* of 1944. Already thematic objects and individuals are appearing, especially the thin old man who comes straight out of Jules Verne and who looks so disdainfully at the fulness of the female nudes. In *The Man in the Street* he is reading the

149

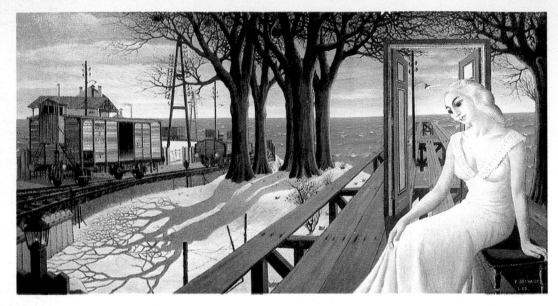

DELVAUX, PAUL: *The Shadows*. 125 × 231 cm. Private collection

paper. He recurs in 1947 in *Walker and Sage*. In *The Sabbath* he is making faces in front of a mirror. He marches in the light of the candelabra into the background of *The Extravagant Women of Athens*.

Other themes were added to Delvaux's work: the neat skeleton contributed his heavy symbolic note to *The Call* (1944), *Sleeping Venus* (1944) and *Fire* (1945), and hangs on the cross in the *Crucifixions* of 1954. Then he disappears. Trains, trams, and often pre-1914 engines—very different from Chirico's apparitions—make their incongruous appearance; and from 1946 with *The Blue Train* they are associated with an *Art Nouveau* décor (so often exploited by Delvaux) as in *The Iron Age* (1951). There are goods wagons in the station of *Christmas Night* (1956), rails and telegraphic poles in *Evening Train* (1957), and a train from another age in *End of the World* (1968).

The oneiric role of lights is interesting in Delvaux. *The Chandelier* (1952) presides at an assembly of nudes who might have come out of an Ingres Turkish bath. Candelabra punctuate the dark night. Even odder are the lights disappearing into the grass of *The Sabbath*. There is also the strange lamp held by the beautiful *Chrysis* (1967). Oil lamps are devotedly carried by the women of *The Procession* and the young girls of *The Acropolis*. The oil lamp even appears at the centre of the *Fire* composition, and in the foreground, on a plank, before *The Temple* (1949), one of the most powerful of Delvaux's nocturnal visions.

The obscure light of Delvaux's paintings is made for women without men, those cold beauties with dreamy eyes. It is with their own presence, multiplied in solitude, that their appointment is kept perpetually. What are they doing? Sometimes they are taking root, as in the *Aurora* of 1956. They are hesitant; their hands are folded. Moved by the very fact of being who they are, narcissistic, they no longer need the mirror which Delvaux painted in his first works and then omitted. Moonlight is a clear water in which they float slowly. There is also the magnificent night of *The Echo* (1943) in which the painter visually transposes this sonorous effect in a most arresting way. There is the blue night of *Sleeping Venus*, the *Blue Train* and so many others, like the very erotic *Blue Sofa* (1967). Sometimes night turns into the fresh dawns of *City Dawn* (1940) or *The Aurora* (1964). With his milky, heavy-breasted women, themselves lunar creatures, the subtle eroticism of Delvaux is evident in *Abandonment* (1964) in all the senses in which the language of the heart uses the word. Available, and forsaken, a naked woman lies stretched out at full length on the carpet in a ball-room. The piano is closed. The man in black has turned his back; he is departing, indifferent. Three standing women watch the one whose ambiguous fate they carry with them.

Paul Aloïse de Bock: *Paul Delvaux*, Paris, 1967.
Emile Langui: 'Les Peintures murales de Paul Delvaux chez Gilbert Périer à Bruxelles', *Quadrum*, May 1956.
Claude Spaak: *Delvaux*, Antwerp, 1948.

DER KEVORKIAN Gabriel (Paris 1932). Closely connected to the Paris Surrealist group and to those who remained faithful to it (Bounoure, Benoît, Bédouin, Camacho), Der Kevorkian took part in *L'Ecart absolu* and had his first one-man show in 1965. His graphic style is taut yet dreamy, and not unconnected with Camacho's, with a similar interest in fantastic shapes. But here a lively mixture of colours introduces a kind of oneiric

DER KEVORKIAN, GABRIEL: *Composition.* 1964. Pastel, 68 × 64 cm. Galerie Françoise Tournié, Paris

gaiety into the essential *angst: Guess or I drive you Mad* (1965), *Infatuated* (1967) and *Composition* (1964).

DESNOS Ferdinand (Pont-Lavoy 1901–Paris 1958). A self-taught painter who began to paint in 1926, Desnos was a daring colourist whose happy eroticism is best shown in *Leda from Tours* (1947) and *The Testament* (1950).

DESNOS Robert (Paris 1900–Terezin, Czechoslovakia 1945). In 1922 the author of *Deuil pour deuil* was noted for his ability at automatic writing, and his 'sleep period' saw some superbly successful examples of his verbal and graphic work. In 1929 he was among those whom the *Second Manifesto* separated from Surrealism. During the Occupation he was deported to Buchenwald, then to Terezin where he died of typhus.

DOMEC Claude (Paris 1902) A painter who never joined any group but was a friend of Robert Desnos's and Vitrac's. He painted passionately if reclusively and in such works as *Geogony* (a wax painting) achieved a lyrical fusion of the imaginary and the real.

DOMINGUEZ, OSCAR: *Los Porrones.* 1935. Collection: G.J. Nellens, Knokke-le-Zoute, Belgium

DOMINGUEZ Oscar (La Laguna, Canaries 1906–Paris 1957). Dominguez was the son of a rich merchant and had a very disturbed childhood. He would explain that when his mother was dying (she had escaped being poisoned by a rival shortly before her son's birth), she made his father promise that Oscar would never have any reason to weep. The father kept his word. In 1927 he sent his son to Paris on business but the young man thought only of the pleasures to be found at Montparnasse, where he also discovered painting.

Under the influence of Max Ernst and Dali, his first paintings, such as *Ecstasy* and *Desire*, brought him close to Surrealism; and he organized a Surrealist exhibition at Circula de Bellas Artes, at Santa Cruz de Teneriffe in 1933. He joined the André Breton group in 1935 and he astonished his new friends, especially Marcel Jean, his neighbour at Montmartre, with his enormous physique, his

deep voice, his short and certainly feigned bouts of anger, his unexpected tenderness, and his hoaxes. He was clever, unstable, but always lyrical and invented such Surrealist objects as *The Arrival of the Belle Epoque* (1936), a statuette with an empty space at the waist, and *Never*, an interpreted gramophone which was included in the international Surrealist exhibition of 1938 in Paris. His first Surrealist paintings, such as *Summer Desire* (1934), are not very different from his invented objects. They mix sadistic eroticism and representations of objects so fantastic that only painting could reproduce them.

In 1936 Dominguez invented decalcomanias, which made him famous. A decalcomania is in fact a form of monotype, often using gouache. Dominguez obtained extremely lyrical effects and retouched them minimally, or added other techniques, such as *raclage*. The results, apart from those entitled *Decalcomanias* (1936–7), were called

DOMINGUEZ, OSCAR: *Untitled. c.* 1949. Oil and decalcomania. Galerie André François Petit, Paris

DOMINGUEZ, OSCAR: *The Huntsman*. 1933. Oil on Canvas, 61 × 50.1 cm. Tel Aviv Museum

The Lion-Bicycle (1936) and *The Smoker* (1937). Then Dominguez entered his cosmic period. In *Cosmic Landscape* (1938), *Composition* and *Skeleton* (1938), and *Saucers* (1939), rocky and volcanic

visions seemingly swept by a desert wind are interrupted by dark passages which here and there reveal an eye, a planet or bones. This cosmic period was one of Dominguez' most original phases. It is unfortunate that he did not continue in this vein, as Tanguy would have done, in order to develop its potential more profoundly.

But Dominguez could not stay still. He experimented with the plastic and poetic effects of his decalcomanias and at the same time continued to paint canvases influenced by Dali and Picasso, like *Woman with Sardine Tins* (1937), *The Sea-Swallow* (1938) and *The Blind Ship. The Elephants* (1938) is very close to Magritte. In 1936 the Spanish Civil War began in the Canaries. Thanks to the friendship of a prostitute Dominguez escaped his comrades' fate. He returned to Paris, which he did not leave until his tragic death. From 1937 to 1939 his Surrealist automatism was expressed in the form of lazy forms which he 'allowed' his hand to trace all day long, whether he was talking with friends, drinking or smoking. These superimposed traces he called 'lithochronicle surfaces' (1939). This was the period in which his paintings changed from representations of the cosmic desert to entanglements of lines, such as *Nostalgia for Space* (1939), which is among Dominguez' most beautiful paintings.

With *Infernal Machine*, a kind of Ubuesque tank, the war period began, during which Dominguez, who was associated with the Paris Main à Plume group (1942–4), deliberately worked in the Picasso tradition. He did so not only by a post-Cubist interpretation of mass and a linear style, but with themes such as the bull: *Bull's Head* (1941), *Bull-Sphinx* (1942), *Bull Recumbent* (1944), *Picador* (1950), *Tauromachia* (1951). Picasso's violent manner was evident in *The Hand Passes* (1942), *Table and Person* (1944) and the fine monochrome work *Cannibalism*

(1945), and of course the *Portrait* of 1947, which looks like a pastiche.

But there is a certain graphic purification at work (which is reminiscent of Klee and brings Dominguez close to abstraction, towards which he never made the final decisive step) in addition to the Picasso style in the best post-war Dominguez. *Graphism* (1948), an ink drawing, *The Arrow of Love* (1951), *The Trojan War will not take place* (1950), *Ninette Arrives at the Door of Wonderland* (1952), *Mars* (1954), in which decalcomania reappears, and *Woman in Profile* (1956), show the graphic virtuosity with which Dominguez could approach a lyrical draughtsmanship of which Klee was the real master. The *raclages* of *Superimposed Composition* (1957) took him to the threshold of abstraction.

After the war Dominguez did not rejoin the Breton circle when its members returned from the United States. Instead he remained loyal to Eluard and Picasso. His part in the activities of the revolutionary Surrealists, from 1946 to 1948, was the natural result of his life in Paris under the Occupation. In 1947 he published a book of verse, *Les Dieux qui se croisent*, married and took French nationality. His first one-man show was not until 1943, at Carré, in Paris. His fame was crowned by a large retrospective at the Brussels Palais des Beaux-Arts. Then Lyrical Abstraction hit Paris and Surrealism became out-of-date. Eluard died in 1952. Dominguez, who had thrown money out of the window, was marking time. His painting became uncertain and he seemed to be looking once again for the right direction to take. Even his face, which is cruelly caricatured in the *Self-Portrait* of 1949, grew bloated. He reverted to decalcomania in order to find his own roots. Perhaps it was too late.

He painted *The Clown* a year before his death. It is a precise work to which the circular *raclages* add a derisive note. Shortly before the war he had tried to hang himself, but the rope had snapped under his weight. On 31 December 1957, when the bells began to ring for the New Year, he cut his wrists.

Gérard Xuriguera: *Oscar Dominguez*, Paris, 1973.

DONATI Enrico (Milan 1909). Donati's encounter with the Surrealists in the United States during the war led to his use of automatism. His paintings, for instance *Slander of the Void* (1943), have an ethereal grace which followed a straight path to Lyrical Abstraction.

DOTREMONT, CHRISTIAN: *Logogram: Space Turning Four Forms to Good Account*. 1971. Galerie de France, Paris

DOMINGUEZ, OSCAR: *Tauromachia*. 1951. Oil on canvas, 100 × 81 cm. Private collection

DOTREMONT Christian (Brussels 1922). One of the main organizers of the revolutionary Surrealist group (1946–8) and then of the Cobra group (1948–51), Dotremont was a writer and poet and had his first one-man show in 1949. His *Logograms* (1971) introduce the use of dream-work in a kind of fantastic calligraphy.

DONATI, ENRICO: *As Giovanni di Paolo was Saying.* 1944.
Private collection

DOUCET Jacques (Boulogne-sur-Seine 1924).
Doucet was a former inmate of Buchenwald concentration camp, having been deported during the
German Occupation. In 1946–8 he took part in the
activities of the revolutionary Surrealists before

DOUCET, JACQUES: *The Circle of Brocéliande.* 1968. Collage,
73 × 92 cm. Private collection, Paris

DUBUFFET, JEAN: *Inspectors Sinoque and Dingue.* 1967.
Vinyl on canvas. Galerie Jeanne Bucher, Paris

joining the Cobra group. His painting unites a
violent graphic style and use of paint with a subtle
palette. It introduces the imaginary into the
pictorial. His collages and petrifactions under resin
(1970) add a sometimes fierce humour to the
painterly quality of his work.

DUBUFFET Jean (Le Havre 1901). It was only when he was about forty-five that this painter, whose patron was Jean Paulhan, achieved recognition with his *matiérisme*, which is considerably indebted to *Art Brut*, the society he founded together with André Breton in 1949. His development went through stages best marked by various successive series: *Hautes Pâtes, Sols, Matériologies*, then *Paris-Circus* (1962) and *L'Hourloupe* (1964). Dubuffet is an eminent member of the College of Pataphysics and has explained his Epicurean notions of art and anti-art in some fascinating writings, especially *Prospectus aux amateurs de tout genre* (1946).

DUCHAMP Marcel (Blainville 1887–Paris 1968). Marcel was a brother of Jacques Villon, of Raymond Duchamp and of Suzanne Crotti. He was an artist to start with, and associated with the Puteaux group and the *Section d'Or*. His Cubist impression of movement was a considerable success in the form of *Nude Descending a Staircase* when he

DUCHAMP, MARCEL: *The Bride Stripped Bare by her Bachelors, Even*. 1915–23. Museum of Modern Art, Philadelphia

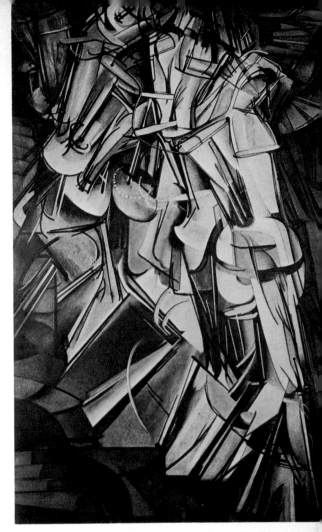

DUCHAMP, MARCEL: *Nude Descending a Staircase, No. 3.* 1916. Museum of Modern Art, Philadelphia

exhibited it at the Armory Show in New York, in 1913. Then, in a transition which may now be seen as a premonition of Dada, Duchamp tried to 'unlearn' painting and became one of the pioneers of anti-art revolt. He was a friend of Picabia's whom he met again in the United States in 1915, and it was in the Stieglitz circle (Stieglitz's review *Camera-Work* became *291* in 1915) that he signed his first ready-mades: bottle-racks, a porcelain urinal. He produced about twenty ready-mades by 1925. In about 1914 he began his 'large glass', an engraved and painted work entitled *The Bride Stripped Bare by her Bachelors, Even*, which he left unfinished in 1923. This famous work was an attempt to use a graphic transposition of the ready-made technique to give a 'mechanist, cynical interpretation of the pheno-

155

menon of love' (Breton). Duchamp subsequently devoted himself to chess, but without losing contact with his new friends, André Breton and the Surrealists. In 1934 he collected in *La Boîte verte*, then in *La Boîte en valise* (1938, published in 1940), the preparatory and explanatory documents for his 'large glass'. This anti-art prophet became the keeper of a fine collection of contemporary art (Société Anonyme, Inc., the first museum of modern art he founded in New York) at Yale University. His pleasure in making objects and his organizing talent found many occasions of expression in the international Surrealism exhibitions held in 1938, 1942, 1947 and 1959. Together with Breton and Ernst, Duchamp was co-founder of *VVV* in 1942. In spite of his refusal to create any works, Duchamp's fame spread continually and his intellectual influence has recovered its former strength among young rebellious artists in the last few years.

R. Hamilton: *Almost Complete Works of Marcel Duchamp*, London, 1966.
Robert Lebel: *Marcel Duchamp*, New York, 1959.
Walter Pach: *Duchamp frère et soeur, oeuvres d'art: A family of artists*, New York, 1952.
Michel Sanouillet: *Marchand du sel: écrits de Marcel Duchamp*, Paris, 1959.
Arturo Schwartz: *Duchamp*, Paris, second edn, 1969.

DUPREY Jean-Pierre (Rouen 1929–Paris 1959). A poet whose volume *Derrière son double* (1949, second edition, 1964) was introduced by Breton. Duprey also produced metal sculpture. He tried, not without difficulty, to keep verse and plastic art at the same high level of consistent poetry.

DUVILLIER René (Oyonnax 1919). He had his first exhibition in a prisoner-of-war camp. He was one of those who moved on from Surrealism to Lyrical Abstraction.

ELUARD Eugène Grindel, known as Paul (Saint-Denis 1895–Charenton 1952). The founder of the Surrealist movement, together with Aragon, Breton and Soupault, Eluard was one of the most important Surrealist poets and a major spokesman of the movement who paid special attention to painting and sculpture. A number of his poems, which constantly return to the theme of vision and the mirror, are dedicated to painters. His friendship for Ernst and for Picasso especially lasted all his life. During the Occupation when the Resistance was fighting back, his humanist sensibility caused him to renew his association with the Communist Party and to take part with Picasso in the activities of the Peace Movement. At the time he edited a number of anthologies of art criticism: 1. *Les Frères voyants*, 2. *Lumière et morale*, 3. *La Passion de peindre*.

MAN, RAY: *Portrait of Eluard*. 1936. Private collection

The specific contribution of Surrealism is however drowned in a flood of sentimentality, through which it is nevertheless always possible to discern the constant component of Eluard's sensibility: compassion.

ENDE Edgar (Hamburg-Altona 1901–Munich 1965). Without being linked with any group, Ende developed a fantastic vision which established a connection between the tradition of German Romanticism and Surrealism.

ERNST Max (Brühl 1891–Paris 1976). Ernst was the son of a teacher in a primary school for the deaf and dumb. He was the youngest of a family of six children, four of whom were girls. His father was a leisure painter and very pious. The sudden death of his elder sister, Maria, affected the young Max very much at the age of six. He was a nervous and imaginative child whom his father painted one day as the child Jesus. He was a philosophy student at Bonn University until the war. At the age of twenty an exhibition of the School of Paris at the Sonderbund in Cologne made him decide to be a painter. He was deeply impressed by Van Gogh,

and after a trip to Paris in 1913 he began to paint in an Expressionist style close to that of Picasso.

After four years of war service in the artillery, he was again in Cologne in 1919. He associated with Baargeld and Hans Arp in the publication of *Bulletin D* and the review *Die Schammade*. The Dadaist rebellion reached its height in Cologne with two successive exhibitions, in February and April 1920. The latter was organized in the glass conservatory of the Winter restaurant and was deliberately shocking. Visitors entered through the lavatories. A First Communist recited lewd poems. But the police intervened. In the same year, Ernst, who published a collection of lithographs, *Fiat modes, pereat ars*, in 1919 (signed Dada-Max Ernst, but afterwards he destroyed all the copies) produced his first collages, notably those which, in collaboration with Arp and Baargeld, comprise the volume *Fatagaga* ('Fabrication de tableaux garantis gazométriques': Manufacture of pictures which are guaranteed gasometric, 1920). André Breton discovered Ernst's collages when he visited Picabia in Paris. He was extremely moved. An Ernst exhibition was organized in Paris in May 1920 and the Dada group made him a success in their own way.

As a result of Dada spirit and technique, Ernst's collages are quite different from the *papiers collés* of Braque and Picasso (1912). Ernst took disconnected fragments from old anatomy books and collections of engravings and rearranged them in accordance with the irrational demands of the imagination. These collages range from humorous anti-art (*The Hat which Makes the Man*, 1919) to an oneirism which owes much to Chirico (*Place Vendôme*, *Homage to Courbet*) and proclaims the rise of Surrealism. They showed Breton in 1920 the possibility of applying in the fine arts the notion of the poetic image, as conceived by Reverdy and Apollinaire, as the random encounter of elements from which a light shines forth.

In 1921 Ernst and Eluard met in Cologne. A friendship began which was to unite the two men for the rest of their lives. Ernst was in the Austrian Tyrol during the summer of 1921 with Tzara and the Dadaists. The same year he wrote and illustrated in collaboration with Eluard *Les Malheurs des immortels* (1922). He moved to Saint-Brice near Paris, and painted *A Meeting of Friends*, a collective portrait of what would soon be known as the Surrealist Group. Max Ernst's painting at Saint-Brice, which reveals to some extent the technical problems he encountered, transposes the spirit of his first Dadaist collages. *The Elephant Celebes* (1921) is an Ubuesque machine and *Oedipus Rex* a kind of symbolical enigma, whereas *Pietà, or Revolution at Night* (1923) is an act of homage to Chirico, and *Woman, Old Man and Flower* (1924) is a caustic

fantasy. The famous picture-montage, *Two Children Threatened by a Nightingale*, which treats in an *angst*-ridden fashion the oneiric theme of the open-closed door, may stand as the conclusion of this first period of his work.

In 1924 Eluard and Gala left for Australia without telling anyone, probably applying the philosophy of 'leave the lot' which Breton advised (*Les Pas perdus*). When, somewhat desperately, they called out to their friends, Ernst decided to rejoin them in Singapore. They all went to Saigon and while Eluard and Gala returned together, Ernst went to Europe on an old tub worthy of Coleridge. In Paris, Breton had just published the *Manifeste du Surréalisme* and Ernst took his place among the leading lights of the circle. Henceforth, together with Masson, Miró, then Dali, he would be one of the foremost Surrealist painters. The year 1925 was a decisive one for him. He signed his first contract, with Jacques Viot, which put an end to the

ERNST, MAX: *Long Live Love, or the Wonderful Country*. 1923. Canvas. Private collection

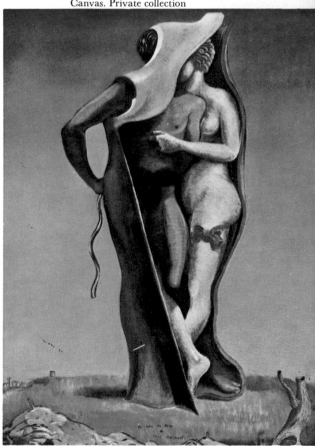

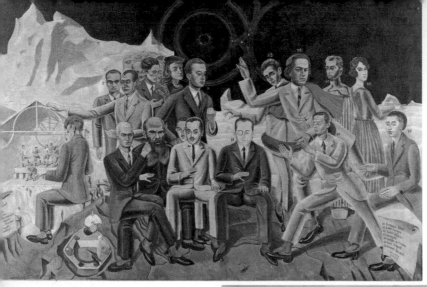

ERNST, MAX:
A Meeting of Friends, 1922

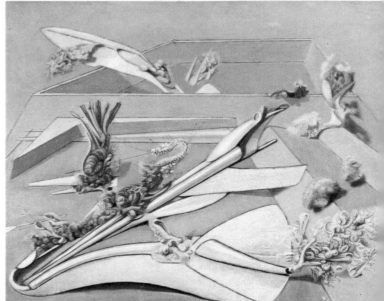

ERNST, MAX: *Jardin gobe-avions*. 1935–6

ERNST, MAX: *Illustration from the ɩ*
'For Paul Eluard'. 1923.

materially critical situation which forced him to
work for a toy factory. He invented his *frottages*. He
has described how this happened.

Finding himself rather bored one day in a Pornic
inn, he was struck by the appearance of the floor
where constant scrubbing had brought out the
grain. Always looking for means of 'forcing inspira-
tion', he placed some sheets of paper on this rough
surface and rubbed them with lead pencil so that
the irregularities could be seen on the paper. He
was astonished at the sudden intensification of his
vision. Of course this is a process known to all
children, but in terms of the creative and quasi-
hallucinatory attitude of the painter, Ernst had
discovered an unusually ambiguous poetic tech-
nique, which was both graphic and plastic, and
actual in terms of the materials which were rubbed,
yet took figuration to the bounds of abstract
simplification. Next year, 1926, Jeanne Bucher
published a fine volume containing the first fruits
of Ernst's experiment: *Histoire naturelle*—a natural
history, with a preface by Hans Arp. The 'novels in
collage' only appeared later, of course: *Woman with
100 Heads* (1929), *Dream of a Little Girl who Wanted
to Become a Carmelite* (1930), *A Week of Happiness or
the Seven Capital Elements* (1934). In 1926 Ernst was
in a strong position. Together with Miró he could
withstand the violent criticism of Breton and the
Surrealist group for having designed the scenery for
Romeo and Juliet, a ballet by Diaghilev, which was
'morally equivocal'. He forged ahead.

ERNST, MAX: *Dream of a Little Girl who wanted to Become a
Carmelite*. 1930. Bibliothèque Nationale, Paris

ERNST, MAX: *A Week of Happiness or the Seven Capital
Elements—Blood*. 1934. Bibliothèque Nationale, Paris

From this time on Ernst used another technique
which developed from *frottage*, namely, *raclage*,
which consists of the use of a comb, and a ruler, on
the freshly painted surface, allowing the canvas or
other surface to be seen variously according to
pressure and the type of comb. The first picture in
the series of *Forêt-arêtes* dates from 1926. The process
is often used in the *Flowers* series (1926–8), in the
Cities, for example *The Whole City* of 1935, and in
The Petrified Forest. Oil *frottage* was also used by
Ernst until his most recent production. It was often
hidden and mixed with other techniques, but
appears clearly in the vaguely Cubist phase of
1945–50, for example in *Cocktail Drinker* (1945),
Euclid (1945), *Moon and Mars* (1946), *Design in
Nature* (1947). It gives the painted surface a subtlety
which is not without a certain 'retinal attractive-
ness', and which foretells the colour experiments
after 1950.

A third process which Ernst used to very great
artistic effect is what Dominguez called decalco-
mania in 1935. It was used by Ernst for the ragged,
fantastic visions of *Europe after the Rain* (1940–2),
Napoleon in the Desert, the Anti-Pope (1942). *Europe
after the Rain* offers a rocky yet lacy landscape with
disturbing red flecks and a peaceful sky; it is an
interpreted decalcomania. At the centre of the
picture a man with a vulture's head and a petrified
woman turn their backs to the spectator. The
enchanted landscapes are more freely interpreted
in the 1955 pictures *Arizona Blue*, *Arizona Red* and
the beautiful *Red Forest* of 1956. Less hard on the

ERNST, MAX: *Memorial to the Birds*. 1927–8. Private collection

ERNST, MAX: *Pietà, or Revolution at Night*. 1923. 166 × 89 cm. Sir Roland Penrose Collection, London

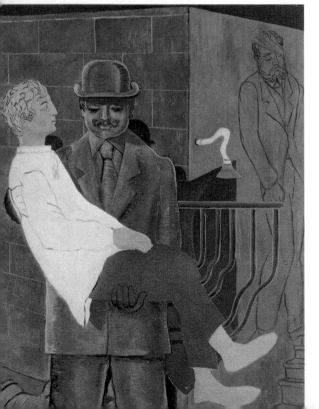

eye, the masterpiece of this technique would seem to be *The Eye of Silence* (1944), which is a rich mix of pictorial matter. A woman straight out of Gustave Moreau, with a sad expression, is turning her back on a lake of ink by which she is sitting. She is at the bottom right of the picture and leaves most of its space to a fantastic landscape of viscous, greenish rocks like some Baroque battlements against an evening sky. It is this mineral mass which so fascinates the eye of the imagination, with its opals or drops of water which are set there, the mosses and obscure orifices, spiral staircases, possibly a ruined palace in the dark shadows to the right, and a phallic emblem in the left-hand crevice, and an amazing soft lacework at the centre, a delicately wrought testimony of desolation, and a fault running from top to bottom of the picture. Crushed by the terrible petrifaction of the viscous, human weakness has no recourse but magnification of the spectacle. Max Ernst, in this period of his work at least, employed this form of sublimation more than others. Tanguy used the ossified viscous as a kind of marine fossil, and Dali positively plunged into it with outrageous delight. In his happy Arizona period, Ernst paused for a moment in front of the tragically beautiful aspects of overwhelming matter.

In 1927 Max Ernst married Marie-Berthe Aurenche. If the painter's work was never a mere reflection of his life, it is still possible to see in its evolution a progressive quest for happiness, which reached resolution in his last period, after 1950. In 1936 he met Leonora Carrington in London. She was a poet and painter of extreme sensitivity. She followed him to France and they set up together at Saint-Martin-d'Ardèche in 1938. The following year Ernst, being German, was interned, notably in the camp at Les Milles, near Aix-en-Provence, where he met Bellmer again. But Leonora Carrington, driven out of her mind by the collapse of the French army, gave the house to anyone who wanted it and fled towards Spain before going to the United States. When she got there, Ernst, who had arrived in 1941, was staying in California and had married the multi-millionaire collector Peggy Guggenheim, director of the Art of this Century Gallery in New York. It was only a brief interval. During the preparation of an exhibition of women painters' work at the Guggenheim Gallery, Ernst met Dorothea Tanning (1942). He was to marry her in 1946. He lived with her in a wooden house at Sedona, Arizona. The Arizona period is one of the most lyrical in Ernst's career and 1942, with the famous painting *Surrealism and Painting*, saw the beginning of his happy period.

Friendship was a condition of an intense life for Max Ernst. His association with André Breton was not without ruptures. In 1938 Breton took un-

friendly action against Eluard whom he found too close to the Communist Party and Ernst distanced himself from Breton. He renewed the friendship at New York in 1941 and became co-director, with Breton and Duchamp, of the journal *VVV*. But surely the expression of happiness and the acceptance of success were denials of true self by the most austerely Expressionist painter of the first wave of Surrealism. . . . The rift between Ernst and Breton became definitive in 1954. Ernst had just received his major prize at the Venice Biennale. In fact Ernst was a much greater friend of Eluard's than of Breton's. Giacometti was another friend, and Ernst stayed with him for a while in 1934 at Maloja, Switzerland, leaving some great stone sculptures in the garden. In fact Max Ernst, who was very proud of his vulture's profile, was a man given to inward meditation, and his touchy nature hardly inclined him to worldliness.

Fame came slowly. He had his first exhibition at New York, at Julien Levy's in 1931, and the Nazis honoured him in 1937 by including him among the representatives of 'degenerate art'. At the exhibition of Fantastic Art, Dada, Surrealism in New York in 1936, Ernst exhibited forty-eight pictures. Eluard organized his first retrospective at Denise René in Paris in 1945. It was followed by the retrospective at René Drouin's gallery in 1950, and in 1951 there was a major exhibition of Ernst's work in his native city. But it was in fact the retrospective organized by Mesens at Knokke-le-Zoute in 1953 and, the following year, his Venice award, that marked his emergence from the avant-garde.

He moved in 1955 to Huismes in Touraine, France, in the farm 'Pin Brûlé', after a voyage to Hawaii and a return journey from America to Paris. He obtained French nationality in 1958 and the great retrospectives followed one after another: 1956 at the Kunsthalle, Berne, 1959 at the Musée d'Art Moderne in Paris, 1961 at the Museum of Modern Art in New York. From 1962 to 1966 his works could be seen in London, Cologne, Zürich, Paris, Antibes (Musée Grimaldi) and Venice. Now and again the Galerie Iolas in Paris gave him an exhibition, and there one could see this front-ranking Surrealist's concern for painterly refinement and the display of pictorial music close to Bazaine, with pictures such as *Three Young Dionys-aphrodites* (1957) or *Sign for a School of Gulls* (1957).

His most recent period, which began with the intense red of *Two Cardinal Points* and the colourist modulations of *The Palette* (1953), mixed all his previous techniques, notably decalcomania and *raclage. The Polish Horseman* (1954), *The Red Forest* (1956), *The Poet's Tomb* (1958) and, moving beyond the minute decalcomanias of the *Microbes* series (1947–53) and the aquatints of the *Maximiliana*, the

rich colourism of *For a School of Monsters* (1966) set Max Ernst in the orthodoxy of the School of Paris.

This *School of Monsters*, with the equivocal appearance of a dinosaur on a blood-red ground, nevertheless maintained in Ernst's work a trace of *angst*-ridden oneirism. An analysis of his topics would show that this note persisted in his work in spite of his late adoption of a happy stance. Among his collages—where there is, for instance, *A Week of Happiness*—a man with a lion's head (*The Lion of Belfort*) wreaks his sadistic lust on a beautiful

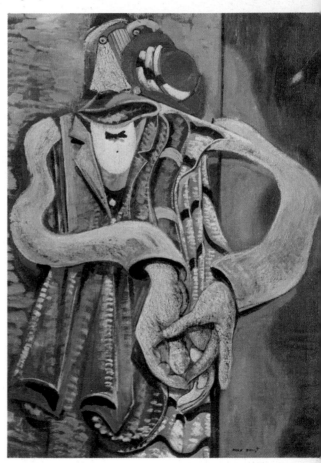

ERNST, MAX: *The Couple*. 1924. Private collection

woman whose languor only invites greater excess. This character changes into a man (or into a woman) with the head of a bird of prey: the bird obsession is one that Max Ernst never got rid of. The sexual symbolism is well-known: the attraction of the bird (with its head on the shoulders of a decapitated man) gives this symbolism a kind of

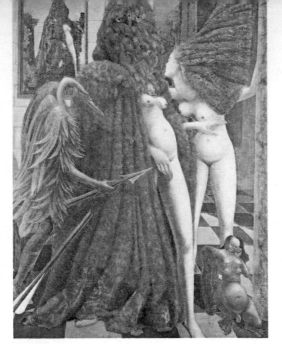

ERNST, MAX: *The Toilet of the Married Woman*. 1940. Oil on canvas. 130 × 96 cm. Peggy Guggenheim Foundation, Venice

vulsions. But the very discreet colour, the precise yet curved forms, make of these monsters sculptures which are supported in their unstable equilibrium by a pedestal. Very female curves mingle with eagles' beaks, webbed feet and elongated tentacles, and glassy eyes mark protuberances. The sky is blue. The light, indifferent to the scene, affords quite normal shadows. But these forms tell their story: the physiological aspect of things is petrified in its viscous horror.

Finally, the fact that he abandoned this kind of tragic landscape proves without any doubt that Max Ernst freed himself from his obsession—and he can free us too, through his painting. How is one to become the eagle one dreams of without first consuming the snakes and octopi one carries within, as does every man? Max Ernst's work shows his concern to go 'beyond painting' in his collages, *frottages*, sculptures. It does not in the end obscure, in spite of its apparent diversity, the internal logic which is the logic of a lifetime. From the period of Dada rebellion and criticism (1919–25), Max Ernst moved towards the most Expressionist form of Surrealism, but at the same time an oneiric (collages) and *matiériste* (*frottages, raclages*)

disturbing sadistic effect. In *Oedipus Rex*, two birds' heads seem to emerge from the table. In another work a nightingale, a harmless little singing bird, threatens two children. A bird is in a cage in the blue stripes of a convict's garb (*Caged Bird*, 1927). The *Memorial to the Birds* (1927) shows a clump of birds with closed wings lifted into the sky like a Montgolfier balloon. These are sinister shapes, very different from the sublimated shapes of *The Bird* of 1957 whose eye is a setting sun, and of the bird flying with open wings above the *Poet's Tomb* (also entitled *After me, Sleep*, 1958).

But the bestiary of Max Ernst the Surrealist who, in his collages, put snakes on boudoir carpets, evoked in dinosaurs and octopi the most monstrous entanglements; see my account of *Surrealism and Painting* in the introduction. This painting had been preceded by a few descents into nightmare; even the composition differs from Ernst's usual practice and makes this picture stand out from the others: *Human Figure* (1927), *The Wind's Future Wife* (1926–7), *The Household Angel* (1935) precede the greenish figurations of *Man's Head* (1934) and *Déjeuner sur l'Herbe* (1935–6).

This last picture hardly recalls Manet's famous work of the same title. Against a ground of rather indistinct trees, three groups, one of which looms vaguely in the background, seem seized by con-

ERNST, MAX: *The Seer*. 1935. 19 × 24 cm. Private collection

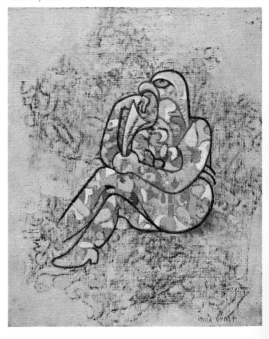

162

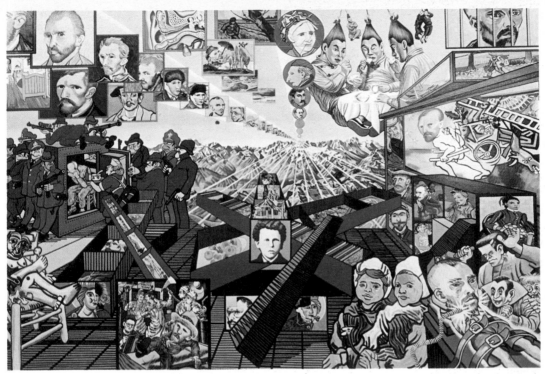

ERRÓ, GUNDMUNDUR GUDMUNDSSON: *The Life of Van Gogh.*
1975. 200 × 300 cm. Gianni Schubert Collection, Milan

form between 1925 and 1949, before reaching a colourist sublimation in which previous themes were somewhat watered down. The fact that the Surrealists expelled Ernst in 1954 is to be attributed to reasons other than his fame and worldly success. Although happiness—though a tragic happiness—was as essential an aspect of Surrealism as Eluard's, Delvaux's or Svanberg's, pictorial happiness was not what the Surrealists expected from the man who had intrigued their sensibilities with the erotic, anti-clerical, anti-militarist and intensely poetic violence of his collages. The inspired use of *frottage* and decalcomania made Ernst an alchemist of painting, but he remains within Surrealism the Max Ernst who produced *The Woman with 100 Heads* and *A Week of Happiness.*

Sarane Alexandrian: *Max Ernst*, Paris, 1971.
J. Bosquet and M. Tapié: *Max Ernst*, Paris, 1950.
Jean Cassou: *Max Ernst*, Paris, 1959.
Giuseppe Gatt: *Max Ernst*, London, 1970.
E.-L.-T. Mesens: *Max Ernst*, catalogue of the exhibition at Knokke-le-Zoute, 1953.
Robert Motherwell: *Max Ernst*, New York, 1948.
Patrick Waldberg: *Max Ernst*, Paris, 1958.

ERRÓ Gudmundur Gudmundsson (Olafsvik, Iceland 1932). Erró acquired a virtuoso technique through his studies between 1950 and 1954 at the Fine Arts Academies of Reykjavik, Oslo and Florence. It was in Florence that he held his first exhibition, in 1955. Since then his exhibitions have gone all over the world and his prolific output has taken the introduction of the fantastic into Pop Art to the point of sarcasm. In his large canvases, for example *The Abolition of Races* (1961) and *Appetite is a Crime* (1963), he used such processes as magic-lantern projection or collage in order to 'force inspiration'. Insults to the 'religion' of art were contained in his series of *Aggressions* (1967–8) which introduce disturbing elements into classical paintings by a process of 'effraction'. These elements are, however, congruent with their hosts in the aptness of the derision they carry with them. For instance Munch's *Scream* becomes *The Second Scream* by including an aeroplane taking off. Sadistic series such as *The Monsters, The Portraits, Revolving Pictures* (a fragment of a Van Gogh self-portrait is askance) and *The Tortures* (1970), free Erró's imagination in a flood of imagery, where the graphic vulgarities of advertising and comics are

offered in ironic and sarcastic counterpoint with examples of 'élitist' works. Erró owes a lot to the Dadaist element in Surrealism and particularly the contradictory release of an iconoclastic passion in a great creator of images.

FÄHLSTRÖM Oyvind (São Paulo 1928). After abandoning Lyrical Abstraction, this Swedish painter began to study comics and comic strips and tried to find a way of eliciting the spectator's own creativity: the observer can modify the picture by moving parts held in or to it magnetically. He exhibited in New York with the Surrealists in 1960. He is another proof that certain trends in Pop Art owe something to the spirit of Surrealism.

FERLOW-MANCOBA Sonja (Copenhagen 1911). Her sculpture is both rougher and more abstract than that of Hans Arp. Sonja Ferlow was associated with the Cobra group between 1948 and 1951.

FINI Leonor (Buenos Aires 1918). In 1935 Leonor Fini practised automatic drawing. She remained in Monte Carlo during the war and was closer to Cocteau than the Surrealists who had gone abroad or were otherwise dispersed. Her painting is powered by an oneirism which vacillates between a debt to the Pre-Raphaelites and the Expressionists. Her most personal myth is that of the sphinxes, or of the enchantress who combines the ambiguity of the beast and the angel. The series of *Witches* are very fine engravings which show the extent of Fini's technical virtuosity. Her sense—and this is hardly Surrealist—of physical beauty allows her to paint extraordinary portraits of her friends, *Mandiargues* (1935), *Genet* (1948). She has designed numerous sets for the theatre and the ballet.

Marcel Brion: *Leonor Fini et son Oeuvre*, Paris, 1955.
Xavière Gauthier: *Leonor Fini*, Paris, 1973.
Constantin Jelenski: *Leonor Fini*, Lausanne, 1968.
André Pieyre de Mandiargues: *Les Masques de Leonor Fini*, Paris, 1951.

FINI, LEONOR: *The Useless Toilet*. 1964. Oil, 55 × 83 cm. Jansen Collection, Brussels

FREDDIE Wilhelm (Copenhagen 1909). This Dane is perhaps the only Surrealist painter whose works have shocked both puritans and Fascists. He was a disciple of Dali and painted *Memorial to War* in 1936. His exhibition *Sex-surreal* in 1937 brought him ten days in gaol. His works were confiscated and the Criminological Museum of the Danish

Dali who happened to visit him. Freud expressed his incomprehension on the publication by Breton of *Les Vases communicants* (1934). The problem of self-

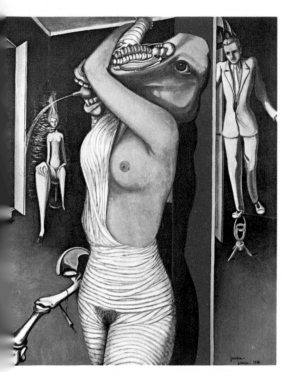

FREDDIE, WILHELM: *Zola and Jeanne Rozerot*. 1938. 100 × 83 cm. Jorn Freddie Collection, Copenhagen

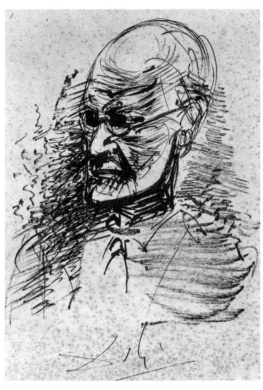

DALI, SALVADOR: *Portrait of Sigmund Freud*. 1938. Drawing, 27 × 23 cm. Galerie André François Petit, Paris

Police only returned them in 1963. *Meditation on Anti-Nazi Love, Walk at the Front* (1943–4) are images with flaccid and rugged forms. Freddie became a refugee in Sweden in 1944, and then went to Paris (1947). Around 1948 his style changed to something closer to Lyrical Abstraction.

FREUD Sigmund (Freiberg, Moravia 1856– London 1939). The founder of psychoanalysis played an important part in the formation of Surrealist thought. André Breton was acquainted with his works through studying medicine. Freud, who freely admitted his lack of competence in artistic matters, unfortunately treated the Surrealists as 'quite mad', and he had praise only for Salvador

analysis, that is, whether it was possible or not, remains the reason for a fundamental divergence of Surrealism from psychoanalysis.

FUCHS Ernst (Vienna 1930). After studying sculpture and painting until 1950, Fuchs started his own gallery in 1950 and gathered around him the Viennese painters of the 'fantastic realist' tradition. He ran a gallery with these artists until 1967. In 1968 he attended a summer school at the Bezalel School of Art in Jerusalem. His journeys to America, Paris and Israel are frequent. His works, which mix the mythical sources of ancient Greece and the Bible as in *The Island of Aphrodite before the Wall of Heaven* (1974), are a tragic treatment of the meeting of Eros and Thanatos: *The Ogre and the Doll, The Serenade*.

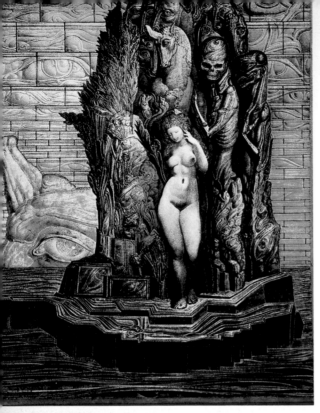

FUCHS, ERNST: *The Island of Aphrodite before the Wall of Heaven*. 1974. Egg tempera and water on paper. 63 × 49 cm. Galerie Verrière, Lyon

GAGNAIRE, ALINE: *Red Père Ubu*. André Blavier collection

GAGNAIRE Aline (Paris 1922). Gagnaire is a painter and decorator whose first exhibition took place in Paris in 1946. Her first retrospective was held in 1968 at Verviers (Belgium). She composes extraordinary portraits of cloth and trimmings, figures in which plaster covers the folds of cloth in a suggestive way. *Burst Woman* (1960), *Red Père Ubu*, *Face Undressing* (1963) and such paintings as *Mère Ubu à Gidouille* show that the fierce humour of Aline Gagnaire is supplemented with a sombre consideration of the human face and all its possible deformations.

GARCIA-YORK Roberto (Havana 1929). A self-taught painter who settled in Paris in 1964, Garcia-York initially showed his paintings in Central America and in Madrid. His first one-man

GARCIA-YORK, ROBERTO: *The Marquis of the Angels Travels in Spring*. Oil on canvas. 81 × 65 cm. Private collection, Paris

show in Paris did not take place until 1972. His precisely figurative painting mixes fantastic fantasy and a somewhat erotic dreamwork. *Double Dream Maker* (1971), for example, is a festival night with a warm wind blowing.

GERBER Théo (near Thun, Switzerland 1928). In his fantastic landscapes where fluid forms

166

bear figurative allusions sometimes tinged with eroticism, Gerber associates the Surrealist marvellous with the painterly liberties of Lyrical Abstraction.

GIACOMETTI Alberto (Stampa, Switzerland 1901–Paris 1966). A pupil of Bourdelle and famous for his threadlike, Expressionistic sculptures, Giacometti later violently rejected that period of his work which had endeared him to the Surrealists. He was first of all associated with those expelled in 1929; he criticized André Breton and between 1930 and 1934 created 'symbolically functioning objects' such as *The Cage* and *The Invisible Object*, called by the artist *Figure of a Woman*, which Breton commented on in 'Équation de l'object trouvé' (*Document*, special Surrealist issue, 1934).

Among the other 'mobile, dumb objects' created by Giacometti those now famous are his *Disagreeable Object* (1931), a kind of phallic symbol fitted with spikes, and *The Palace at Four in the Morning* (1932), a graceful framework of thin metal which reminds us that oneirism can also produce works of extreme elegance.

P. Selz: *Alberto Giacometti*, New York, 1965.

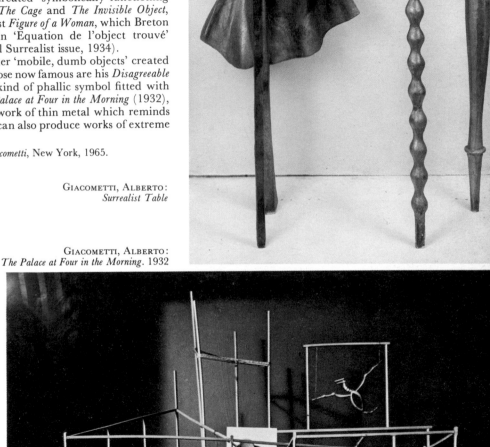

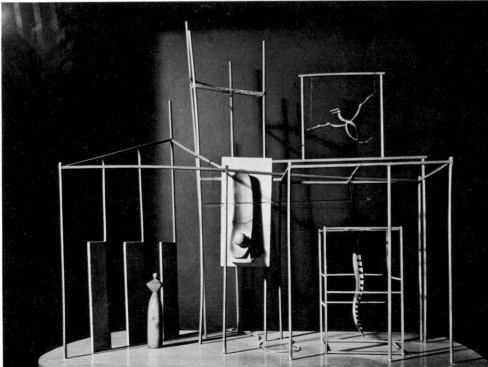

GINET Henri. Ginet was originally associated with the activities of the *Phases* group. He joined the Surrealists around Breton *c.* 1964. His prematurely interrupted pictorial experimentation owed its humour to the influence of Marcel Duchamp.

GIRONELLA Alberto (Mexico 1929). He began to paint in 1948 while following a course in literature. In 1952 he worked on some painterly paraphrases of classical works: a thirteenth-century sculpture, some pictures by Velázquez and Goya—from which he elicited revelatory states in a

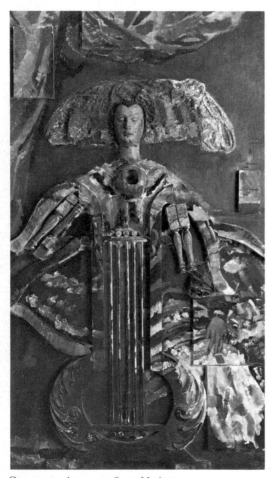

GIRONELLA, ALBERTO: *Queen Marianna*

delirious and analytical style. Velázquez' *Queen Marianna* becomes a painting-object (1961) and a pendulum gives the portrait symbolic weight.

GOETZ Henri (New York 1909). A member of the revolutionary Surrealist group in 1947, Goetz introduced the fantastic into a world of nonfigurative forms. His evolution since then has brought him closer to Hartung and Lyrical Abstraction. He was made a Professor at Vincennes University after May 1968.

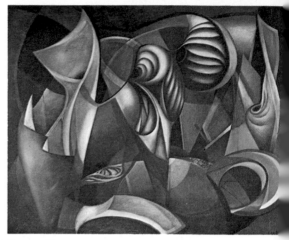

GOETZ, HENRI: *Furious Spiral*. 1947. Oil, 60 × 74 cm. Grenoble Museum

GORKY Vosdanig Adoïan, known as Arshile (Khorkhoum Vari Haiyotz, Turkey 1905–Sherman, Conn. 1948). Arshile Gorky came from a poor family which fled to Erivan in 1914 during the Turkish massacre of the Armenians. Arshile Gorky emigrated to the United States in 1920 and began to study painting. His first exhibition took place in 1934 in Philadelphia. He was then a disciple of Picasso. Later he came under the influence of Miró. In 1942 Gorky married Agnès Magruder and entered into a long period of happiness and fruitful work. The lyrical violence of his colours was accompanied by a refined graphic power. In the year of his meeting with André Breton he painted *The Liver is the Cockscomb* (1944). He settled in Sherman (Connecticut) after 1945, and produced *Engagements* (1947) and *Agony*. But fate called: he had a fire in his studio in 1946, a cancer operation, a car accident in 1948, and his wife left him while he was in hospital. Suicide.

GÖTZ Karl-Otto (Aachen 1914). Backed by Will Grohmann and Edouard Jaguer, this Düsseldorf painter was a member of the Cobra and Phases groups. He exhibited in 1960 at Cordier in Paris. His painterly violence puts him on the common border of Lyrical Abstraction and Abstract Expressionism.

GRAVEROL Jane (Brussels 1909). The daughter of a friend of Verlaine's, she studied painting at Brussels and did not meet the Surrealists until 1949 after having founded the *Temps mêlés* group with André Blavier. She was in charge of *Les Lèvres nues* publishing house and journal from 1954. In drawings like *If the heart tells you so* (1961), and paintings

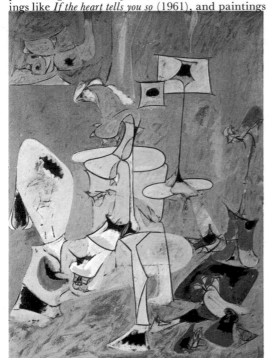

GORKY, ARSHILE: *Engagement II*. 1947. Oil on canvas, 128 × 98 cm. The Whitney Museum of American Art, New York

like *Unsilvered Mirror* or *The Forgers*, she did a kind of caustic tattooing on classical works by means of highly ironical yet joyful collages full of erotic poetry.

GUGGENHEIM Peggy. After opening a gallery in London in 1938, Peggy Guggenheim asked her friend Marcel Duchamp to help her look for works of modern art. During the war, her Art of this Century Gallery was a prestigious showplace for the Surrealists who had taken refuge in the United States. She was Max Ernst's wife from 1942 to 1945. In 1946 she was responsible for launching Jackson Pollock in his great drip painting period. Her famous private collection is stored in Venice; it was exhibited in London in 1965 and in Paris at the end of 1974.

HANTAÏ Simon (Bia, Hungary 1922). Breton introduced the first exhibition of Hantaï's work in Paris in 1953. At that time his painting, *Collective Narcissism*, for example, was full of biological symbolism. Afterwards Hantaï left Surrealism, drew closer to Mathieu (1957) and Lyrical Abstraction, and produced abstract and obsessive 'environments' such as his *Whites* of 1973.

HARE David (New York 1917). A self-taught artist whose first exhibition was at the Art of this Century Gallery in New York in 1944. Since 1941 he has produced 'enhanced' photographs and he was editor-in-chief of the review *VVV*. Hare married Jacqueline Lamba, who was separated from Breton in 1944. He moved from photography to sculpture and produced some bronzes such as *Thirsty Man* (1946) and *Golem of Egypt*, then paintings and collages like *Cronus Descending* (1968).

HANTAÏ, SIMON: *Composition*. 1953. Oil on canvas. 50 × 39.5 cm. Private collection

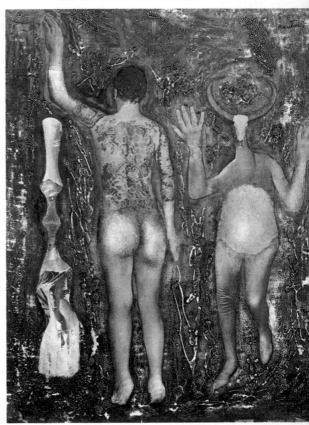

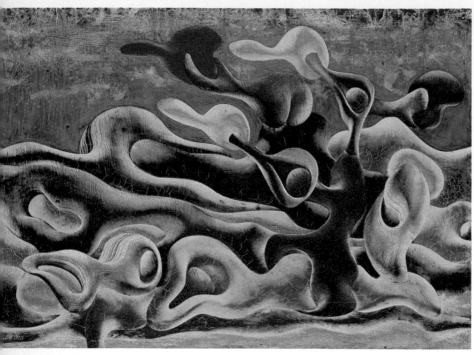

HANTAÏ, SIMON: *Untitled*. 1953. Private collection

HAUSNER, RUDOLF: *Adam*. 1968–9. Tempera, 102 × 72 cm.
Magarete Infeld collection

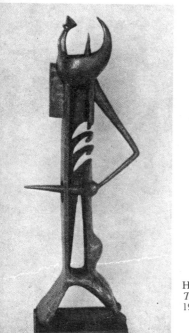

HARE, DAVID:
Thirsty Man
1946. Bronze

HAUSNER Rudolf (Vienna 1914). After studying art at the Vienna Academy, Hausner was at first an Expressionist painter. His still lifes and his nudes caused him to be included in the infamous Nazi exhibition of 'degenerate art' in Munich in 1937. In Vienna in 1962 Hausner organized an exhibition entitled *Surrealism— The Fantastic Painting of the Present Day*, where works by members of the Fantastic Realist group and the Surrealists proper were brought face to face for the first time. Hausner was the oldest member of the Vienna group and afterwards became Professor at the Vienna and Hamburg Fine Arts Academies. The lesson of the primitives—and of Pop Art—seems sometimes to be conveyed in this painter's enigmatic figures. He is concerned above all with man's painful solitude, that of *Laocoön* (1968) or of *Adam* (1968).

HAYTER Stanley William (London 1901). Associated with the Surrealists between 1934 and 1940, Hayter introduced graphic automatism into his engravings whose rigorous yet free style is at the bounds of abstraction.

HEISLER, JINDRICH: *Drawn-out Glue*. 1944

HEISLER Jindrich (Chrast, Czechoslovakia 1914–Paris 1953). This poet was a friend of Toyen's and associated with the Czech Surrealist group *c.* 1938. He took refuge in Paris after the war. *Casemates du sommeil* is a collection of 'realized poems'. His book-objects (1950) and the collages of his 'Surrealist alphabet' go a long way in the Surrealist tradition of exploring beyond verbal poetry.

HENRY Maurice (Cambrai 1907). After participating in the experiments of the Grand Jeu group (1928–31) he remained a member of the Surrealist group until 1961. He was famous for his

HAYTER, STANLEY WILLIAM: *Couple*. Etching

HENRY, MAURICE: *Homage to Paganini*. 1936. Property of the artist

humorous drawings in which the absurd and the marvellous mingle. His *Homage to Paganini* is a bandaged violin.

HÉROLD Jacques (Piatra, Rumania 1910). He often took part in the activities of the Surrealists, whom he met in Paris *c.* 1933, and left definitely in 1951. Hérold conducted his experiments in something approaching solitude. He was a member of the Main à Plume group during the war, and in 1947 he exhibited (at Maeght) an 'altar' dedicated to the *Grands Transparents* of Breton. In 1957 he published his *Maltraité de peinture* and lived a secluded life in the shadow of the Château Lacoste, a house in which the Marquis de Sade had lived. *Femmoiselle, Je t'raime* (1936) and *André Breton* (1971) are evidence of the constancy of his vision of the marvellous in a world of transparencies with crystalline protuberances.

Michel Butor: *Jacques Hérold*, Paris, 1964.
Patrick Waldberg: *Jacques Hérold*, Chicago, n.d.

HÉROLD, JACQUES: *André Breton.* 1971. 100 × 73 cm.
Galerie de Seine, Paris

HÉROLD, JACQUES: *La Femmoiselle.* 1945. Sculpture.
Galerie Françoise Tournié, Paris

HIRSCHFIELD Morris (Poland 1872–New York 1946). A shoemaker until 1917, Hirschfield began to paint *c.* 1939. His naïve, linear icons showed, above all, happy women. He was dis-

HIRSCHFIELD, MORRIS: *Zebras.* 1942. Oil, 86 × 127 cm.
Private collection

covered in 1939 by Sidney Janis, then by the Surrealists, who considered him one of the masters of the marvellous.

HIRTUM Marianne van (Namur 1935). A poet who published *Les insolites* (1956), Marianne van Hirtum met André Breton and took part in Surrealist activities from 1959. Her statues have a magical quality. She lives and works in Paris and spends her nights in making China ink drawings. Their meticulous composition verges on the fantastic. She exhibited at Cordier in 1959. Her plastic poetry places her in the line of the most nocturnal Surrealism.

HIRTUM, MARIANNE VAN: *Untitled*. 1973. Private collection

HUGO Valentine (Boulogne-sur-Mer 1887–Paris 1968). Her exact and flowing composition with its decorative spirals is used to remarkable effect in portraits of her friends. She has also illustrated countless poems. She was a member of the Surrealist group between 1930 and 1936. Her *Dream of 17 January* (1934) is a good example of her universe.

HUTTER Wolfgang (Vienna 1928). He is one of the most representative painters of the Viennese 'Fantastic Realism' school. His rigorous style gives strength to an imagery in which eroticism enters into a rather laboured symbolism. He took part in the Cologne *Surrealismus in Europa* show in 1969.

ISTLER Josef (Slovakia 1919). A painter and engraver with a very precise graphic style, he was a member of the *Ra* group founded secretly at

ISTLER, JOSEF: *Ecstasy*. 1951. Oil on canvas, 235 × 143 cm. Private collection, Prague

HUGO, VALENTINE: *Illustration for a volume of Poems 'Notice for a School Path'*. 1937. Bibliothèque Nationale, Paris

Prague in 1942 under the German Occupation. He later took part in the activities of the revolutionary Surrealists. After 1948, like the other artists of the Czechoslovak avant-garde, he went through a difficult period under the Communist regime. Istler's work came to light again during the 'Prague Spring' and showed a tendency to develop towards abstraction.

JACOBSEN Egill (Copenhagen 1910). He exhibited for the first time at Copenhagen in 1945 before joining the Cobra group. His painting is typical of the more Expressionist tendency of this group.

JACOBSEN Robert (Copenhagen 1912). When he was a member of the revolutionary Surrealist

JACOBSEN, ROBERT:
The Man with the Snake.

JACOBSEN, ROBERT:
Grishi, 1952

movement, Robert Jacobsen worked directly from limestone blocks. He was in the tradition of Surrealist Abstraction, which had developed from Nordic Expressionism. In 1957 he showed his *Dolls*, small figures in welded scrap iron, at Paris. His sculpture, or rather his metal montages, became monumental in scope. The humour and controlled violence characteristic of Robert Jacobsen were integrated in the abstract forms, and the metal—rusty or painted—retained something of the richness of the soil.

JEAN Marcel (La Charité-sur-Loire 1900). The experiments of Marcel Jean were directed by two encounters: that with the Surrealists in 1933 and that with the philosopher Arpad Mezei in Hungary, where he lived from 1938 to 1945. He wrote several books with Mezei, including a history of Surrealist painting. He made decalcomanias in cloth with Dominguez (1937), *frottage*-poems, Surrealist heraldry (1950). Marcel Jean exhibited in Paris in 1946 and in New York in 1949.

JENÉ Edgar (Saarbrücken 1904). An Austrian painter who in 1950 published *Surrealistische Publikationen* he organized the retrospective of Surrealist

JENÉ, EDGAR: *Silvanna*. 1954. Galerie Furstenberg, Paris

Painting in Europe at Saarbrücken in 1952 (introduction by André Breton). His faithfully Surrealist paintings were exhibited in Paris, at the Nina Dausset gallery, in 1948.

JORN, ASGER: *Miming Nothing (or almost nothing)*. 1967. Oil on canvas, 114 × 146. Galerie Jeanne Bucher, Paris

JORN, ASGER: *Woman so close*. 1968. Collage, 85 × 56 cm.

JENNINGS Humphrey (Britain 1907–1950). Jennings was a poet, film-maker and painter. Until just before the war he practised a Surrealist art of considerable quality including such striking works as *Blazing Woman* (1934), *The House in the Woods* (1940).

JOHNS Jasper (Augusta, U.S.A. 1930). Together with Rauschenberg, he was considered in 1956 a leading light of *New Dada*. His first exhibition was held in New York in 1958 and he participated in the EROS Surrealism exhibition in 1959–60 in Paris. His work with papier mâché, painted bronzes and montages anticipates certain aspects of Pop Art.

JOHNSON Ray (Detroit, U.S.A. 1927). Considered to be a proponent of Pop Art, he came to it with a knowledge of the poetic element that he learned from Surrealism. His collage-portraits of *Elvis Presley* (1955) and of *Shirley Temple* (1967), like his *Homage to Magritte* (1962), prove the point.

JORN Asger (Vejrum, Denmark 1914–Colombes 1973). Jorn moved from Danish abstraction *c.* 1946 to the revolutionary Surrealist group, before taking part in the Cobra movement, and then the Situationist International, one of whose tendencies he was directing. He owed to Surrealism his sense of

symbolism, and to Expressionism his taste for coloured, graphic expressions of violence which are to be found in all his works. His book, *Pour la forme; ébauche d'une méthodologie des arts*, was published in Paris in 1958. In Denmark he founded the Silkeborg Museum, and in Paris in 1968, together with Noël Arnaud, he published a book of pataphysics: *La Langue verte et la cuite*. The considerable extent of his work and his unshakeability make him the master of a certain tendency in European Surrealism—one that Alechinsky was to follow *c.* 1960.

Guy Atkins: *Jorn in Scandinavia, 1930–1953*, London, 1968.

KIESLER Frederick (Vienna 1896–New York 1966). Far from manufacturing 'machines to live in', for Kiesler architecture should be 'magic'. He designed the Art of this Century Gallery in New York, and organized the international exhibition of Surrealism at the Maeght Gallery in Paris, in 1947.

KLAPHECK Conrad (Düsseldorf 1935). Influenced at first by Ernst and Tanguy, in 1955 Klapheck discovered the poetic virtues of the type-

KLAPHECK, CONRAD: *Illumination*. 1962. 120 × 100 cm. Galerie André François Petit, Paris

writer. He was associated with the review *Phases* in 1959 and the group around Breton, who praised him in the last edition of *Le Surréalisme et la peinture* (1965). The finished representation of the machine and the surprise title which Klapheck gave it in the manner of Magritte make this painter a European forerunner of Pop Art.

KLEE Paul (Münchenbuchsee, Switzerland 1879–Locarno 1940). The son of a singing teacher, Paul Klee studied in Berne, where he received his school certificate in 1898. His decision to become a painter was unproblematic. He left for Munich to study under Knirr and Stuck; then he visited Italy in 1901–2. His engravings of 1903–5 are fantastic figures in the Expressionist tradition. He went to

KLEE, PAUL: *Part of an Unfinished City*. 1914. Watercolour, 16.5 × 18 cm. Private collection

Paris for the first time in 1905, when the Fauves were in the ascendant. The following year he settled in Munich, married, and exhibited his engravings. He led a family life, played the violin, and in 1907 his wife bore him a son, Félix. This was a happy period in which he produced Impressionist-style paintings.

Klee discovered Van Gogh in 1908 and Cézanne the following year. He exhibited at the Munich Secession and at Berne. It was in 1911, the year in which he illustrated Voltaire's *Candide*, that he had his decisive meeting with Kandinsky and the artists of the Blue Rider group. This group saw the 'inward world' as more important than the external reality. The musician Schönberg was one of the members. Kandinsky brought about the main artistic revolution of the century: the birth of pictorial abstrac-

KLEE, PAUL: *Window*. 1919. Watercolour, 22 × 23.6 cm.
Private collection

tion. Thanks to the Blue Rider, Klee intensified his
experiments which, with the discovery of works by
Picasso, Braque, Delaunay in Paris in 1912, and
above all a trip to Tunisia (1914), were directed
towards colour. It was when he returned from his
Tunisian journey that Klee wrote in his *Journal*:
'Colour possesses me' and at that point his painting
interpreted Cubism with unusual freedom. Klee
was a private in the German army from 1916 to
1918 but did not stop painting. It was the period of
his picture-poems and his cosmic landscapes.

His fame began in 1920. He exhibited three
hundred and fifty-six works at Munich and was
invited by Gropius to teach at the Bauhaus. He
taught there for ten years, in Weimar and then
when the Bauhaus moved, in Dessau. His first

KLEE, PAUL: *The Last Village in the Valley*. 1925. Gouache.
Private collection

American exhibition took place in 1924 and the
Surrealists were among the first to support him in
France with an exhibition in 1925 and a collective
volume in 1929 (biography by Grohmann, essays
by Aragon, Crevel, Eluard, Tzara, and so on).
After more travelling (Italy and Corsica in 1927;
Brittany in 1928; Egypt in 1929), he exhibited in
New York in 1930 and then accepted a post at the
Fine Arts Academy in Düsseldorf. He was dismissed
from his post by the Nazis. His first exhibition in
Britain was not held until 1934. He was allocated a
prime position in the Munich exhibition of 'de-
generate art' in 1937, and the German authorities
confiscated a hundred of his works. This idiotic
persecution and growing ill-health over-shadowed
the last part of his life in Berne, Switzerland. His
painting, which entered the famous period of
ideographic writing, with the large-format works
of 1938 and the series of *Angels* (1939) grew more
abstract and more tragic.

KLEE, PAUL: *Green Courtyard*. 1927. Oil on cardboard,
22 × 28 cm. Private collection

Paul Klee's writings (*Creative Confession*, 1920;
The Nature of Nature, 1923; *Pedagical Note-
books* 1925) express his ideas on art which, for
him, 'does not reproduce the visible, but makes
visible'. In his works the artist meditates on 'living
form' and tries to 'move from the model to the
mould'. There is hardly any reference in Klee's
works to the Surrealist ideas of poetry in painting
through the fusion of the imaginary and the real.
But he was concerned, in painting 'forces', to bring
about a synthesis between 'the marvellous and the
schematism proper to the imaginary world'. In the
extreme variety of his works and techniques, Paul
Klee offered a magisterial integration of the poetic
and the abstract.

His early engravings are dark expressions of the viscous, for instance *Actor II* (1904) and *Pessimistic Allegory of the Mountain* (1904), and he produced watercolours like *Young Pierrot's Head* (1912) and *Seaside Road* (1913). From *Motif from Hammamet* (1914) to *Flora of the Dunes* (1923) Cubism seems to intermingle with an Islamic abstraction of intensely coloured carpets. The 'cosmic landscapes' such as *Orange-tinted Blue-moon Roof* (1916) are both geometric and colourist. It was the period when Dada was beginning to make a noise in Zürich. All his life Klee remained indifferent to the activities of the avant-garde. With the experimentation of the Bauhaus, where he met Kandinsky again, his geometric approach intensified somewhat and he sought after plastic rhythms but without losing contact with the world of dreams. This period produced such characteristic paintings as *Lower and Upper Animals* and the oils of 1919–20, for instance *The Yellow Magician* and *Ruined Village*.

Then figures appeared, which he treated with a humorous graphic style: *The Saint* (1921), *The Fate of Two Young Girls* (1921), *Sganarelle* (1922), *Train Procession* (1923). His very geometric constructions or 'absolute-paintings', with arrows indicating the directions, corresponded to the beginning of the Bauhaus period. A measure of symbolism was added to the geometry in order to entice us into the *Cosmic Flora* (1923). Some technical experiments with 'scraping' and a spray-gun took place between 1925 and 1930, as in *Pastoral* (1927) and the

KLEE, PAUL: *Lomolarm*. 1923. Musée National d'Art Moderne, Paris

KLEE, PAUL: *Amorino Rosso*. 1933. Watercolour, 21 × 32 cm. Galerie Berggruen, Paris

KLEE, PAUL:
Castle and Sun. 1928

KLEE, PAUL:
In Copula. 1931

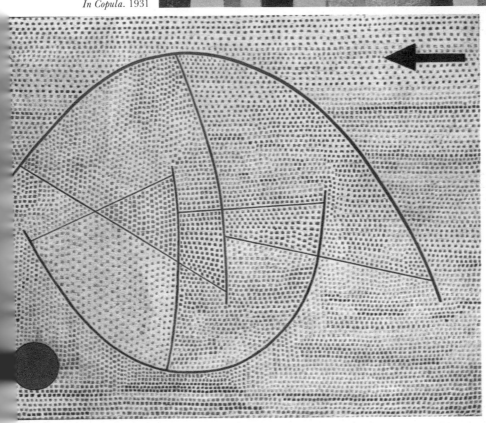

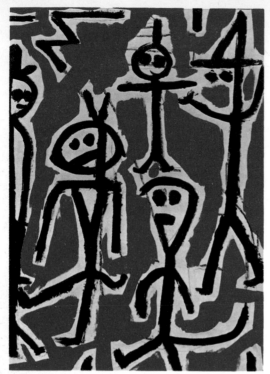

KLEE, PAUL: *Lure*. 1938. Watercolour and distemper, 48.5 × 34 cm. Private collection

charming *Room of Singers* (1930). Then he undertook chromatological experiments in which the chequered colour-work created an oneiric magic. The richness of invented forms is unbelievable in the series which Klee produced between 1923 and 1934: Cubist constructions, lyrical perspectives, individuals (*The Sage*, 1933), portraits (*Smoker's Head*, 1929), patterned landscapes (*Artificial Rock*, 1927), geometrical arrangements (*A Little Room in Venice*, 1933), *Distended Surfaces* (1930), 'atmospheric' visions (*Wandering Soul*, 1929), layers of colour (*Dance of the Moths*, 1923; *Castle and Sun*, 1928; *In Flower*, 1934), pointillism and imitation mosaics (1930–2) and finally the picture writing which opened Klee's last period.

From *Secret Writing* (1934) to *Writing* (1940), pictograms are arranged on a pictorial page, often a large-format page, and the hieroglyphs are

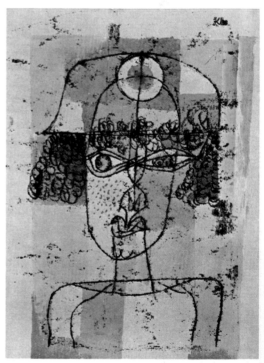

KLEE, PAUL: *Portrait with Smashed Nose*. 1920. Watercolour, 31 × 23.5 cm. Private collection

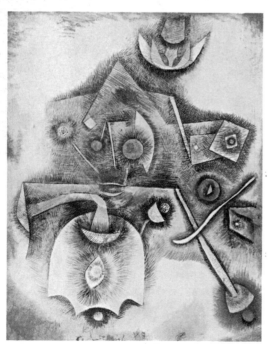

KLEE, PAUL: *March Flowering*. 1926. Oil on canvas, 26.5 × 21.5 cm. Private collection

redolent of a humour which does not however cancel the premonition of death in *Pathetic Germination* (1939), *The Cemetery* (1939) and *Alea jacta* (1940). Paul Klee was not a Surrealist in his ideas nor in his way of life, but he was one of the most astounding poets of painting in the twentieth century, and in this respect the Surrealists could only acknowledge him as one of their company.

René Crevel: *Paul Klee*, Paris, 1930.
G. Di san Lazzaro: *Klee*, London, 1957.
Will Grohmann: *Paul Klee*, London, 1955.

KOLÁŘ Jiří (Protivin, Czechoslovakia 1914). Since his first exhibition in Prague in 1939, Kolář has made a number of discoveries in the art of collage. His recent '*rollages*' are made with parallel strips which press a given image against itself and produce something like an Op Art treatment of the original.

KUJAWSKY, JERZY: *Third Space*. 1960. Private collection

KUJAWSKI Jerzy (Ostrow, Poland 1922). Kujawski took part in the Warsaw Uprising in 1944 against the Nazi Occupation and went to Paris in 1945. He has made systematic use of *raclage* to obtain effects which depend on a kind of Surrealist abstraction. Kujawski was present in 1947 at the international Surrealist exhibition in Paris.

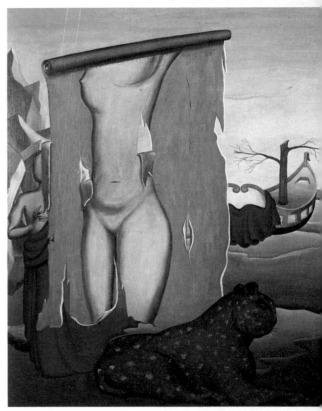

LABISSE, FÉLIX: *The Golden Fleece*. 1942. Painting in petrol on board, 55 × 46 cm. Galerie de Seine, Paris

LABISSE Félix (Douai 1905). Labisse became a Surrealist in 1938 and with a somewhat severe brush produced solemnly erotic pictures (for instance, *The Golden Fleece*). He was supported by Desnos (1945) and became a member of the Belgian revolutionary Surrealist group in 1946, but he was ignored by the Breton group. His painting places him not far from Magritte among the imagists of cruelty.

Robert Desnos: *Félix Labisse*, Paris, 1945, new edn, 1957.
Christian Dotremont: *Labisse*, Brussels, 1946.

LABISSE, FÉLIX: *Médusine*. Colour lithograph, 76 × 56 cm. Galerie Jardin des Arts, Paris

LAGARDE, ROBERT: *Brothel Opening on the Courtyard. We're visiting the Garden*

LACAN Jacques. A psychoanalyst whose medical thesis, *De la paranoïa dans ses rapports avec la personnalité*, Paris, 1932 (*Paranoia Considered in its Relation to Personality*), was of great interest to the Surrealists when it was published. Jacques Lacan has become a guru-figure of present-day French theoretical psychoanalysis. In a style which has even been compared with that of the poet Mallarmé, Lacan offers an authoritative mixture of linguistics and Freud.

LAGARDE Robert (Béziers 1928). A primary school teacher in Algeria until 1962, Lagarde used *raclage* in an original way in 1951 in his 'images taken from black'. He has created a number of Surrealist objects and panels, such as *Brothel Opening on the Courtyard, We're Visiting the Garden* (1965). Lagarde has taken part in all the exhibitions of the Surrealist group since 1959.

LALOY Yves (Rennes 1920). Laloy was an architect at first and from 1951 devoted himself to a form of painting which applies formal geometrism to fantastic figurative work. He took part in the Surrealist exhibitions and he is mentioned in Breton's book. He is something of a recluse on the Cancale coast, but his work proves that the artistic poetry of Surrealism can accommodate a geometrical abstraction often condemned by orthodox Surrealists.

LALOY, YVES: *Untitled. c.* 1950. Galerie la Cour d'Ingres, Paris

LAM Wifredo (Sagua-la-Grande, Cuba 1902).
After studying in Spain, where his wife and
daughter died in 1931, Lam met Picasso in Paris in
1937. His exact yet rich style was already for-
mulated. He came to know the Surrealists on their
way into exile, in Marseilles in 1940, and he

LAM, WIFREDO: *Personajes con pajaro negro*. 1972. Oil,
50 × 70 cm. Private collection

returned to Cuba. From *Malembö* to *Two Characters*,
(1957), his painting has remained constant to a
certain austere poetry. He returned to Paris after
the war and took part in all the Surrealist exhibi-
tions since *First Papers* in 1942.

LEHERB Helmuth (Vienna 1933). He was
present at the *Surrealismus in Europa* exhibition in
Cologne in 1969. He is a painter ideologically
outside the Parisian line but produces fantastic
images to which dream makes a contribution of
nocturnal space and eroticism, as in *The Sleepwalkers*
(1959).

LEIRIS Michel (Paris 1901). Leiris is an etho-
logist by profession and a specialist in Black Africa.
He was associated with the Rue Blomet group,
and then with Surrealism until 1929. Leiris is the
author of *L'Age d'homme* (1938) and his poems
were collected as *Haut-Mal* (1943). He has written
major articles on his painter friends, especially
Picasso, Masson and Miró.

LE MARÉCHAL Jacques (Paris 1928). He
wrote verse at first; his first exhibition of painting
was in 1955 in London. Le Maréchal is independent
and even reclusive. He has produced visions of
great richness: *New York formerly Stalingrad* (1960)
is a dizzy Babel of a place.

LE ROUX François (Paris 1943). This self-
taught artist began to paint *c.* 1970 erotic visions

which are reminiscent of Clovis Trouille. In *Water
Daffodils*, for example, he abandons satirical
humour in order to take hallucinatory obsession to
its limit and beyond.

LE MARÉCHAL, JACQUES:
The Engineer Eats Houses. c. 1960.

LESAGE Augustin (Saint-Pierre-les-Auchel
1876–1954). Lesage was a miner who produced his
first 'medium' painting between 1911 and 1912. It
is an astonishing panel 3 m × 3 m. Since 1932 he
has devoted himself to painting. The Surrealists
became interested in the type of automatism by

which Lesage produced his symmetrical, connected and repetitive images. The Institut National de Paris has tried to study his automatism experimentally.

LESTIÉ Alain (Hossegor 1944). After studies at Bayonne and Bordeaux, Lestié was noticed at the Paris Biennale in 1967. His first one-man exhibitions took place in 1965 in Paris, New York and Copenhagen. His approach is meticulous and his *trompe l'oeil* effects owe their humour to Magritte. The absurd contributes to the poetry of the enigmatic. The theme of the intimate document lost and refound (for instance in *Communication, Abundance and Maternity*) endows his memory dreams with a special melancholy.

LESTIÉ, ALAIN: *Melodrama*. 1973–4. 116 × 89 cm. Private collection

LE TOUMELIN Yahne (Paris 1923). In 1955–7, with canvases such as the *Isle of Nine Flambeaux* and *Figure of Time*, Yahne le Toumelin adopted a fantastic Symbolism which earned him the praise of Breton. Subsequently he changed to a lyrical non-figurative style.

LE TOUMELIN, YAHNE: *The Last Morning at Kaer Sidhi*. 1957

184

LJUBA, POPOVIC AMEKSE LJUBOMIR.
The Prize and the Lotus. 1973.

LJUBA Popovic Amekse Ljubomir (Tuzla, Yugoslavia 1934). He exhibited at Belgrade in 1962 with a group of young painters such as Gakovic and Velickovic, and showed himself to be one of the most inventive imagists of the younger generation of Surrealists. Ljuba's world is a universe enclosed by formal delusion in a kind of aquarium of bulb-like shapes, corals and sponges, uniting a sense of painterly grandeur with the complexity of obsession. Works by Ljuba were justly included among the major indications of a Surrealist renewal in a special exhibition at Brussels in 1969.

René de Solier: *Ljuba*, Paris, 1969.

LOUBCHANSKY Marcelle (Paris 1917). Since the time of her first exhibition, in Paris in 1949, Marcelle Loubchansky has tended towards lyrical abstraction. André Breton wrote the introduction to her exhibition of 1956 because he found in her formal spontaneity a sense of Surrealist automatism.

MABILLE Pierre (1904–1952). Dr Mabille was a psychoanalyst and essayist who was attracted to Surrealism *c.* 1935. His articles in *Minotaure*, especially his commentary on Victor Brauner's eye accident, led to his 1940 anthology, *Miroir du merveilleux.*

MAGRITTE René (Lessines 1898–Brussels 1967). The son of an unsuccessful merchant, Magritte was the eldest of three boys. He had a happy childhood in spite of several moves (Gilly, Châtelet, Charleroi). His friends relate a number of anecdotes in which his early sensitivity to odd things can be related to his paintings. A captive balloon fell on the family house at Gilly. Then *c.* 1905, when he was walking in a cemetery with a little girl, he met a painter at an easel. But at the age of fifteen he had a profound shock. The absence of any reaction at time shows how profound it must have been. One night at Châtelet all the

family went desperately in search of Regina Magritte, his mother, but she had killed herself in the river, the Sambre.

The following year he met Georgette Berger at the Charleroi Fair; she was thirteen and he was enchanted by her. He lost sight of her but met her again by chance in 1920, married her in 1922, and remained attached to her alone to the end of his life.

Magritte was not a good scholar. He was painting by 1915 and left college in order to follow, though not assiduously, the courses at the Academy of Fine Arts in Brussels. Cubism and Futurism were in the air but Magritte found Feuillade's films (*Fantomas*) more fruitful. The year 1920 was a decisive one. He met Georgette, and the future Belgian Surrealists, Goemans, Lecomte, Mesens and Nougé, and he saw a Chirico for the first time—in reproduction. He was most impressed.

However, after national service (1921) and his marriage, he worked for a time in a wallpaper factory (Peters-Lacroix, in Haren), and tried his hand at abstract painting together with Servranckx. It was a fruitless experiment. In 1925 Magritte painted his first Surrealist work, *The Lost Jockey*, and took the style up enthusiastically, sometimes painting a canvas a day. A jockey is galloping over a desolate landscape where leafless trees themselves are cut into transparent leaf-shapes, each branch appearing as a vein (a theme he took up again in a gouache of 1942). Henceforth Magritte's style was determined. He elicited 'ideas' from the world of the mind, and executed them with a cold, dispassionate technique. Apart from an Impressionist period—the 'sunlight' phase of 1940–6 where he was interested in colourism and the effects of Van

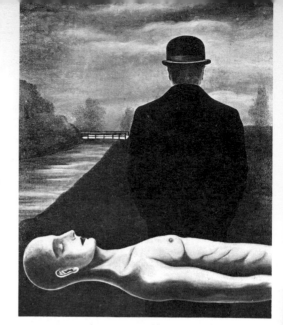

MAGRITTE, RENÉ: *The Thoughts of the Solitary Walker.* 1926–7. 138 × 108 cm. Private collection

Goghian brushwork, and a brief *période vache* lasting for three months in 1948 when he applied his paint in a vaguely Impressionist way—he remained all his life the precise painter of *The Lost Jockey*. Nevertheless his imagery went through a number of phases, depending on various admixtures of oneirism and intellect, and the predominance of certain themes.

From 1925 to 1927 Magritte's visions were oddly disturbed and rather dark. A man in a bowler hat, seen from behind, is moving towards a bridge at night; the image of his own death lies in the foreground, behind him—the *Thoughts of the Solitary Walker* (1926). In *The Big Journeys* (1926) shapeless branches change into a ligneous woman whose hollow legs reveal a suburban landscape. Two of his most astonishing pictures of 1926 are *The Threatened Assassin* and *Popular Panorama*. In the first, a fairly large-format picture (152 × 195 cm), we are faced with an enigmatic silent-screen still. A man in a suit with his right hand in his pocket is listening to a horn-gramophone—perhaps to a voice? Behind him, near a suitcase, a naked woman is stretched out on a red sofa. She is dead and blood is flowing from her mouth. But can this quiet, unconcerned man be the murderer? Through the open, unglazed window, three men peer into the room. In the background there is a landscape of extinct volcanoes. The threat of the title comes mainly from the two people in the foreground, who stand one on either side, waiting for the suspect to come out. One is armed with a club, the other with

MAGRITTE, RENÉ: *The Lost Jockey.* 1926. Collection: Madame R. Michel

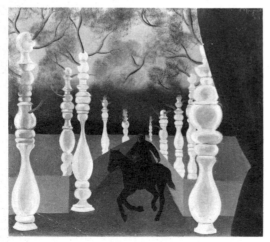

a net. They are in bowler hats, like policemen in mufti. The dream-like faces of all these men, all alike, suggest strongly that we are in a slow-moving nightmare. It is easier to interpret *Popular Panorama*, if you remember the psychoanalytic distinction between the super-ego, the ego and the id. This picture is divided into three levels: above the sea calmly caresses the beach but no sky is to be seen. In the middle the ego is symbolized by undergrowth where the tree trunks stand out firmly against the ground. You could take refuge in this forest and move about there without being seen. The sandy soil of the super-ego has become a soft humus. On the third level, visible through a kind of opening

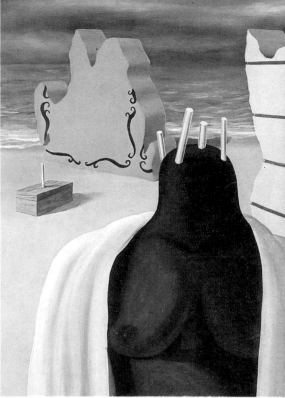

MAGRITTE, RENÉ: *Vestal Offerings*. 1926. 95 × 73 cm. Isy Brachet collection, Brussels

MAGRITTE, RENÉ: *Polar Light*. 1927. Collection: Carlo Ponti and Sophia Loren, Rome

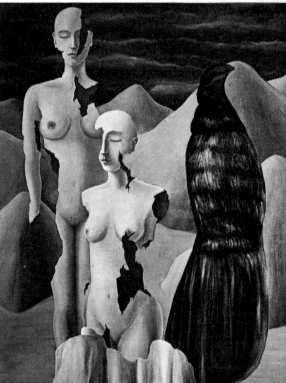

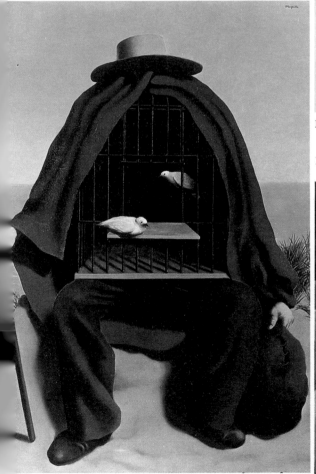

MAGRITTE, RENÉ: *The Therapeutist*. 1937. Galerie Urvater, Brussels

(for this is the id with its secrets) we see deserted houses in front of a black sky. The windows are curtainless, black and unseeing. There is no smoke from the chimney.

This theme of the deserted house—surely a reference to the tragic disappearance of his mother—recurs in other works, for example in *Revelation of the Present*, where a phallic finger points across the demolished section of a small deserted castle, or in the absurd construction of *Mental Vision*. It is most, indeed violently, evident in the mass of empty houses entitled *The Chest* (1960).

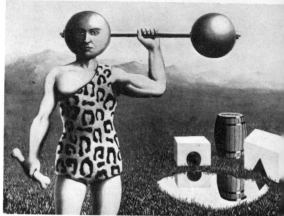

MAGRITTE, RENÉ: *Perpetual Motion*. 1934. Oil on canvas, 54 × 73 cm. Private collection

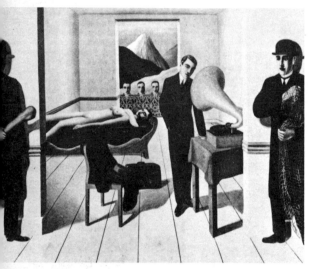

MAGRITTE, RENÉ: *The Threatened Assassin*. 1926. 152 × 195 cm. Museum of Modern Art, New York

Magritte and Mesens published the review *Oesophage* in 1925. Only one issue appeared and Magritte then edited *Marie, Journal bimensuel pour la belle jeunesse*. Three numbers appeared in 1926 and their ironic, Dadaist content was anti-Bretonian in the Picabia style. The Belgian Surrealists were by no means subservient to the Paris group. It was Paul Nougé who in 1927 arranged the link between the Belgians and André Breton. Magritte had his first quarrel with him in 1929. In 1927 he began to exhibit, without great success, at the Centaure Gallery in Brussels. The Centaure had supported him from the year before, and that allowed him at last to devote himself to painting. He settled at Perreux-sur-Marne and entered a new period. It was more intellectual and now a

cold, clear-cut tonality emphasized the caustic nature of his paralogical meditations. He painted such famous pictures as *Threatening Time* (1928), *Perpetual Motion* (1930), and *The Human Condition* (1934). He superimposed the body on the face of the woman in the unpleasant leer of *Rape* (1934). In *Threatening Time* a country chair, a wind instrument and the mutilated torso of a classical Venus appear in ghostly form in the sky, but the sea remains calm. The same or nearly the same fetishist objects are in flames in *The Ladder of Fire* (1933); the clinical neatness of the combustion depends on an oneiric and clearly erotic content. In spite of the painter's protests, other sexual symbols have been discovered in a number of his pictures, for example in *Loving Perspective* (1935), where the door reveals a beautiful tree and an empty house. In *The Traveller* (1933) the fetishist objects (armchair, torso, trombone, peaceful lion and oval mirror) are in a ball floating in the sky. Celestial themes appear often in Magritte's work and always in an absurd context. Psychoanalytically it is an expression of happiness. Between his love and his passion for his art Magritte was a happy painter. Always dapper, even at difficult times, he painted very neatly in a corner of his bedroom, and his far from eccentric *petit-bourgeois* life was characterized by long-lasting placidity.

The fetishism for quasi-obsessional objects disappeared but Magritte re-examined other themes instead: for instance, in *Perpetual Motion* and in the different versions of *The Human Condition*, he used the more structural process of superimposition. The dumb-bell and the athlete's head in *Perpetual Motion* are superimposed so that our perception

vacillates. Hence the effect of movement. As for the superimposition of the painted canvas and the landscape—the painting within a painting—it indicates the morbid delight of the realist painter demystifying the principles of his art by taking them to a mutually contradictory limit-point. An empty case beside a gun is inscribed 'countryside' and positioned before the nothingness of a black background in a picture of 1930, *The Charm of the Countryside*.

The period of the great cold Magrittes was especially fruitful. It lasted until 1940–1. The painter's fame crossed the Atlantic in 1936, thanks to the exhibition of his work in New York at Julian Levy. It crossed the Channel in 1938 with the exhibition which Mesens organized at the London Gallery.

When the war broke out Magritte was in Belgium. Most of the Surrealists fled to the United States, but Magritte was among those who stayed in Europe. From 1940 to 1946 he was in his Renoir period. He tried to continue his 'idea painting' in a Van Gogh style. But Impressionism had been a step towards a form of 'pure painting' and the logic of his present style seemed to demand a form of abstraction. Magritte's stance was directly contrary to the 'plastic music' of Impressionism: his field

was that of the image, composed not for the eye or what the eye brings to the life of the spirit, but for the intellect, which goes dizzy, spins, vacillates when it realizes something of the universal absurdity of life. But in pictures like *Lyricism* (1943) and *The Sleepwalker* (1946) the painterly application is pointlessly associated with ideas—and poor ones at that.

A short flirtation with the Belgian Communist Party (1945) and commitment to the activities of the revolutionary Surrealists (1946–8) prevented Magritte from taking up with Breton after the war, and in 1947 he was considered, at the time of the exhibition at the Maeght Gallery, as having 'ceased to move in the orbit of the movement'. However he

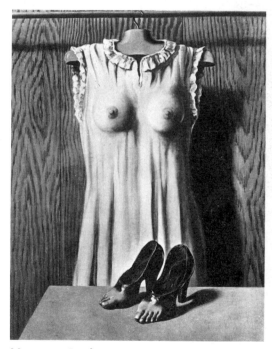

MAGRITTE, RENÉ: *Philosophy in the Boudoir*. 1947. 81 × 61 cm. Collection: Thomas Claburn Jones, N.Y.

MAGRITTE, RENÉ: *Rape*. 1945. 65 × 50 cm. Private collection

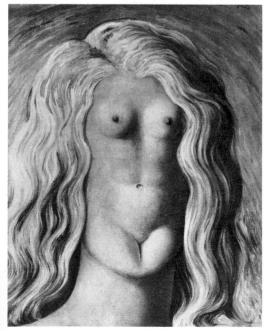

painted *Alice in Wonderland* (1946), *The Beautiful Vessel*, and the famous female composition with the live breasts, *Philosophy in the Boudoir* (1947).

After his 'striped period', which luckily had no sequel, Magritte was once again at his most inspired: *The Song of Love* (1948), *Memory*, a marble head whose forehead oozes blood—standing for an incapacitated memory—*The Freedom of the Spirit* (1948) and *The Labours of Alexander* (1950).

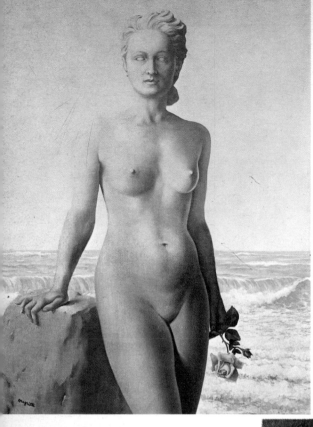

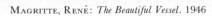
MAGRITTE, RENÉ: *The Beautiful Vessel*. 1946

MAGRITTE, RENÉ: *The Big Family*. 1947.

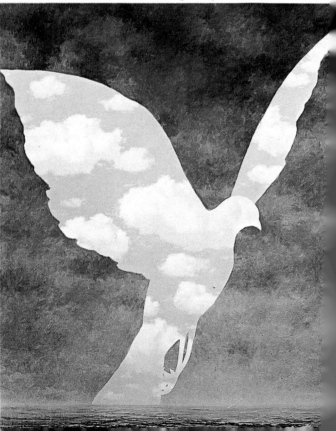

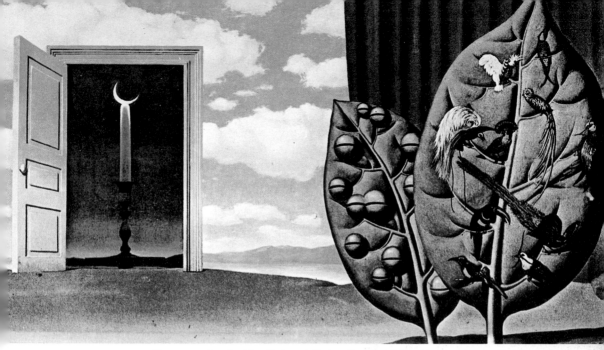

MAGRITTE, RENÉ: *The Enchanted Realm*. Detail. 1952.
Circumference 72 m. Casino, Knokke-le-Zoute

Two found ideas were exemplified by the coffins which take the shape of living people, as in *Madame Recamier* (1951), and the objects or entire pictures using a *trompe-l'oeil* technique: for instance the sinister *Private Diary* (1951). This technique was particularly apt for plumbing Magritte's oneiric imagination, though it did not put him among the Surrealists of the marvellous. His images are rarely in the category of that 'ascending sign' with which Breton wanted to impress them. In spite of the influence of Chirico, Magritte worked in a 'vertically descending' direction, and his humour was on the whole derisive. For him, woman, nude and chaste, was an immobile object: often a beautiful statue but also a grotesque Russian doll, or the trunk of an ancient statue, or both at the same time, as in *La Folie des Grandeurs* (1960). And think of the brick tree, the cloud bird, or the bird of leaves or clay, the reversed siren which is a woman as far as its legs go but a fish otherwise (*Collective Invention*, 1948), and the descent of the face into the body (*Rape*). Magritte reduces beings and things to an inferior order not of deliquescence but of petrifaction.

However there is a Magritte of beautiful nocturnal light, as in *The Empire of Lights*, which he painted in 1952 and took up again in 1958. The moon shines in the tree and the window of the house is alight. Has love forgotten the old empty house? This 'Empire' recurs in the long mural (72 m) which Magritte painted for the casino at Knokke-le-Zoute in 1952. Here he revives his favourite themes and elevates them by sheer repetition to the level of myth: bird-leaves, women carrying birds, a medieval tower softening into a snake, a crescent moon in a clear sky, an inverted siren, an eagle-headed glacier, a trombone in flames, disproportionate objects (a bird's feather set against the leaning Tower of Pisa), apples adorned with wolves, a tree stump whose root holds the abandoned axe, an inhabited house inside a tree-trunk, a spherical bell split horizontally (a nameless object, and a maternal symbol of the kind Magritte scattered throughout his work), a placid lion and an old man sitting down, as in *The Therapeutist* (1937) whose hollow body is replaced by a bird-cage (in *The Liberator*, 1947, this negative body was replaced by a white page bearing the Magrittian fetishes of flying bird, pipe, key, and glass). The strange old man holds a diaphanous symbol of female beauty, a monstrance of pearls, bearing a mouth and two eyes which fix your own. This long summary of Magritte's imaginary life is called *The Enchanted Realm*.

From 1952 to 1957 Magritte published his own magazine *Carte d'après nature* and, from 1961 to 1964, he edited the review *Rhétorique*. In his articles he outlined ideas to which he often returned: his paintings are not psychoanalytical symbols and, for him, dream is not so much a source of poetry as the most lively form of apprehending the mystery of the visible world. In his journalism he describes

his painting as a kind of precise paralogical critique of perceived reality. *The Human Condition* shows us, by means of the mythic identity of painting and nature, that things are never exactly as we see them, and that they are never painted as they are. Physical constants—especially weight—are contradicted by Magritte's demon. A heavy stone is suspended in the air (*The Castle in the Pyrenees*, 1959). Some people are talking in the open air (*Infinite Reconaissance*, 1963) or are superimposed on the façades of houses (*Golconda*, 1953). Part and whole, container and contents, beginning and end, are subjected to transitions. Here is an egg instead of a bird in a cage (*Elective Affinities*, 1933) and trees which are leaves. In fact, Magritte's enigmas always remain unresolved. In the 'art of resemblance', he wrote in 1961, his concern was 'the description of an absolute thought; that is, a thought whose meaning remains unknowable—like that of the world'. In his paintings Magritte joins the company of the philosophers of the Absurd, the philosophy which dominated European thought in the period 1945 to 1960.

Is Magritte Surrealist when he paints a pipe and puts underneath: 'This is not a pipe'? Much has been written on this verbal negation of an object which painting can only show in imagistic terms. This pipe cannot be smoked. Magritte refuses to play the game of the 'reality principle' which persuades us almost to identity image and object, in order to make life easier. The realistic style he kept to enabled him to create illusion more easily

than any other. Only the present-day Hyperrealists can claim to go further. By the verbal act of an inscription, Magritte cancelled all 'real' imagery in the fiction, as he did when he drew a piece of cheese (1936) and wrote below: 'This is a piece of cheese'. By insisting thus, he shows that it is a proposition we have reason to doubt. Surrealism was much less interested in such critiques of reality than in introducing the imaginary into the real. Magritte was closer to the essentials of Surrealism when he published in 1929, in *Variétés* No. 3 and in *La Révolution surréaliste*, No. 12, drawings in which the writing, like someone bursting with laughter, indicates a vague white form next to a bouquet of trees. This playfulness was reminiscent of the Surrealist games. Magritte was offering a play on definitions. One of the most famous products of this game was appropriately entitled *The Dream Key* (1930). There is an egg which calls itself acacia, a woman's shoe the moon, a bowler hat the snow, a lit candle the ceiling, an empty glass a storm, and a hammer the desert. These definitions respect the criteria of the unforeseeable proper to the Surrealist 'image'.

Beyond quarrels and quirks, Magritte re-associated himself with Breton. In 1962 he declared magnanimously: 'Breton has always been a friend of mine', and Breton introduced the catalogue of Magritte's exhibition at Iolas in Paris in 1964. Magritte's reputation has continued to rise dizzily since 1953, the year when he exhibited in London, New York, Paris and Rome. The next year he had a big retrospective in Brussels and in 1956 he received the Guggenheim Prize for Belgium. His exhibitions became more frequent, and the young painters of the Pop Art movement acknowledged him as a master. In the spirit of *Enchanted Realm*, he carried out a large mural at the Palais des Beaux-Arts in Charleroi. Contrary to most of the Surrealists, Magritte hardly emerged from the world of painting and drawing. For him mural painting was not very different from easel painting. He exhibited collages in 1930 at Goemans, and his 'objects' were a few bottles painted and arranged in the shape of a woman, such as *The Lady* (1932) or adorned with a Picassoist label (*A Picasso for Special Occasions*), or even drowned in clouds (*The Sky*, 1943). Shortly before his death, he produced some designs for sculptures which took up the constant themes of his painting. They were cast in bronze and exhibited in 1968 in Paris, like a posthumous message.

MAGRITTE, RENÉ: *Window and Skittle*. 1925–30. Oil on canvas, 74 × 64 cm. Galerie André François Petit, Paris

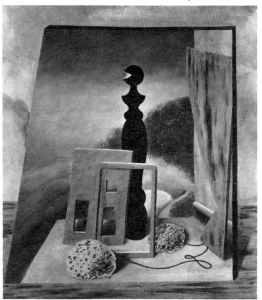

Marcel Marien: *Magritte*, Brussels, 1943.
Paul Nougé: *René Magritte ou les images défendues*, Brussels, 1943.
René Passeron: *Magritte*, Paris, new edn, 1973.
Louis Scutenaire: *Magritte*, Antwerp, new edn, 1964.
James Thrall Soby: *René Magritte*, New York, 1965.
Patrick Waldberg: *René Magritte*, Brussels, 1965.

MALET Léo. The writer and poet Léo Malet was associated with the activities of the Surrealists from 1934. He invented the process of 'laceration' (or *décollage*) of superimposed posters and sheets (1938) which was revived by Raymond Hains in 1950. Malet created unusual objects. His model in *Surrealist Street* at the Paris exhibition of 1938 was

MALKINE, GEORGES: *The Second Sight.*-1967. Oil on canvas, 55 × 33 cm. Galerie de Seine, Paris

MALET, LEO: *Dummy: in the background Dummy of Dominguez*. 1938. International Exhibition of Surrealism, Galerie des Beaux-Arts, Paris

Paris from New York, he produced, between 1966 and his death, about a hundred figurative works with a precise though light style and Magritte-like ideas. A warm calm emanates from Malkine's pictures, yet his life was all agitation and instability.

MARIA Maria Martins, known as (Campanha, Brazil 1900). Maria's sculpture was as far removed from the efflorescences of *Art Nouveau* as the Brazilian jungle, and introduced oneirism into the vegetal fantastic.

MARIE-LAURE Vicomtesse de Noailles, known as. The wife of the Vicomte Charles, one of the first patrons of Surrealism in Paris, Marie-Laure produced paintings with considerable technical expertise. Her lyrical abstractions were essentially visionary works. *Le Gapeau* is a good example of her non-figurative oneirism.

ruled out of order by the organizers; the red fish in a bowl he had stuck in place of a stomach in his dummy was judged unacceptable. He also invented collage-objects in which the play of mirrors reverses and multiplies the image.

MALKINE Georges (Paris 1898–Paris 1969). A newspaper merchant and accountant, a traveller in dustbins, a sailor, elephant hunter, ship's pilot, film actor and printer's reader, husband since 1948 and father of four, Malkine in his 'absolute Surrealism' (Breton) still found time to paint. He was a friend of Desnos's, and in 1927 exhibited some pictures (for example, *Attraction*) from his first automatic period (1922–6). When he returned to

MARIE-LAURE, VICOMTESSE DE NOAILLES: *Le Gapeau*. 1967. 50 × 50 cm. Galerie André François Petit, Paris

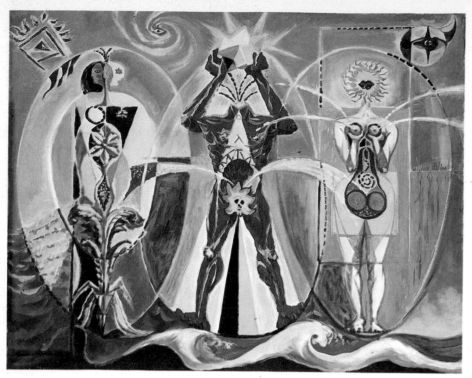

Masson, André: *The Emblematic Man.* 1939.

Masson, André: *The Hotel of Birds.* 1939.

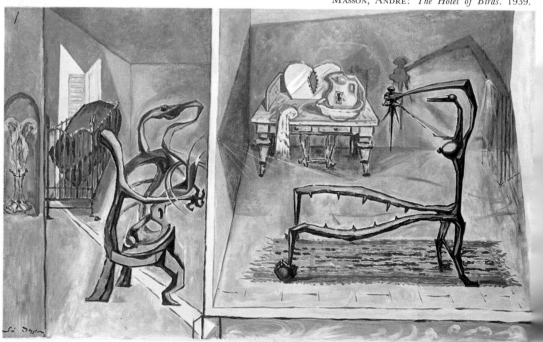

MARTINI Alberto (Oderzo 1876–Milan 1954).
A Symbolist painter who illustrated Edgar Allan
Poe between 1905 and 1908, Martini met the
Surrealists *c*. 1928 and afterwards produced a
slightly sugary pictorial meditation on the
transparencies of visual perception.

MASSON André (Balagny 1896). André was of
peasant descent. He lived in the area of his birth
until he was eight. After a short stay in Lille, the
family moved to Brussels where Masson entered the
Académie des Beaux-Arts. He received his first inti-
mation of emotion as a painter from the work of
James Ensor. In 1912, on the recommendation of
Verhaeren, his parents sent him to the Ecole des
Beaux-Arts in Paris to study fresco-painting. In
1914 a scholarship allowed him to visit Tuscany and
he also stayed in Berne. He was called up and
severely wounded in 1917 at the Chemin des
Dames. He spent some months in hospital, before
convalescing for a year in the South of France where
he met Soutine.

André Masson knew nothing about the Dadaist
agitation. He went to Paris in 1922, where he lived
as best he could, and met Max Jacob, Henri
Kahnweiler, Juan Gris and Derain. His painting
was then based on a somewhat academic Cubism.
In 1923 he took a studio in the Rue Blomet, and

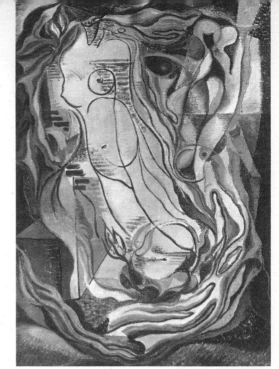

MASSON, ANDRÉ: *The Amphora*. 1925. Oil, 81 × 54 cm.
Private collection, Paris

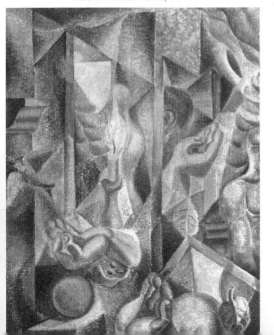

MASSON, ANDRÉ: *Cardinal Points*. 1924. Oil, 92 × 65 cm.
Galerie Louise Leiris, Paris

became a neighbour of Miró. Artaud, Leiris and
Limbour were soon his friends and he met Aragon
and Breton who bought his *The Four Elements*
(1923). He introduced Miró to Breton. The Rue
Blomet group had begun experiments in graphic
automatism in 1923, and had been associated with
the Surrealists since its foundation. Masson's
designs were then very free by reason of the fluidity
of his line and the oneiric character of his figures.
He became a frequent illustrator of *La Révolution
surréaliste*.

Masson made portraits of his friends in 1925 and
illustrated books by Limbour and Leiris. Between
1923 and 1927, he painted canvases such as *Tomb
at the edge of the Sea, Cardinal Points, The Constellations*.
He never succeeded in reproducing in his paintings
the automatic liberty of his drawings. Then he in-
vented his sand pictures (in 1927). In a lecture at
the Pavillon de Marsan, he described their origin.
He threw some glue on a canvas and covered it with
sand. He repeated the operation several times on
the same surface, and obtained random shapes
which he interpreted with the aid of a brush stroke
here and there. The pictorial matter suggested
visions in the painter's imagination. These were
often violent themes, in which animal life pre-
dominated: *Dead Horses, Horses Eating a Bird, Sacri-*

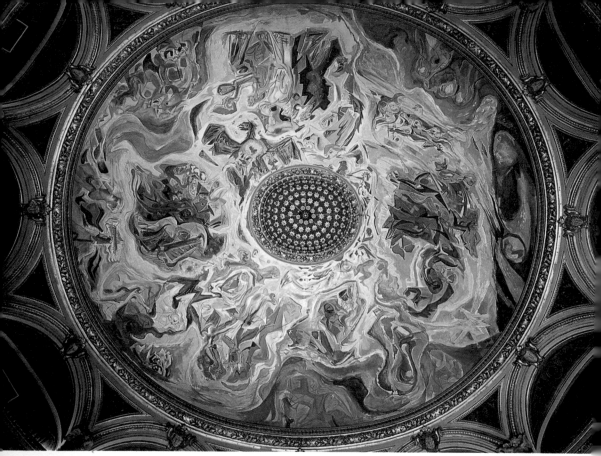

MASSON, ANDRÉ: *Ceiling of the Odéon Theatre*. 1964. Paris

MASSON, ANDRÉ: *The Captives*. 1932. Oil, 54 × 73 cm.
Galerie Louise Leiris, Paris

ficed Bird, Fish Fight. Masson produced his first sculpture, *Metamorphosis*, and illustrated Sade's *Justine*.

At the time of the *Second Manifesto* (1929) Masson was expelled from Breton's entourage. That did not stop him from exhibiting, as if nothing had happened, at the Surrealist shows. Together with Giacometti he produced some large-size decorations in 1929, and worked in pastels in 1930. The drawings and paintings of the *Massacres* series and the *Abattoirs* appeared in 1931. Masson lived part of the year in the South of France and settled in 1932 at Grasse, where he met Matisse. The first theatre sets he designed were for the Russian Ballet (Léonide Massine) at Monte Carlo.

He entered his *Minotaure* period. The review was founded in 1934. It published illustrations by Masson. He discovered Spain. After several walking holidays wandering with his wife in Andalusia and Castille, he settled in Catalonia, at Tossa de Mar. He painted insect pictures and prepared the series

196

MASSON, ANDRÉ:
*Malevolent Miracle Workers
Threatening the People
from the Heights*. 1964.

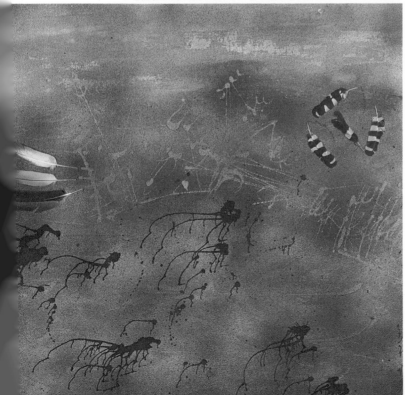

MASSON, ANDRÉ:
The Blood of the Birds

of *Sacrifices* which appeared in 1936. When the Civil War broke out, Masson returned to France and resumed his association with the Surrealists. *Drawings and Paintings of the Spanish Civil War* and the series of drawings for *Mythology of Nature* and *Mythology of Being* reflect Masson's interests at the time. His first meeting with Jean-Louis Barrault took place in 1937; he designed the scenery for *Numance*. The two men often worked together, especially after the war.

At the international Surrealism exhibition in Paris in 1938 Masson exhibited a model decorated with an aphorism, and in 1939 he made some Surrealist objects with flotsam and jetsam from the beaches of Brittany. This was the period of his 'pictorial-paroxysms', some *Suntraps*, and some new sand pictures such as *The Earth* (1939). He painted imaginary portraits of the great German Romantic painters, and the general exodus took him to the crowded port of Marseilles at the end of 1940. In 1941 he left Europe. He met Breton again in Martinique and illustrated *The Snake Charmer of Martinique* which was published in 1948. His first retrospective was held at the Museum of Baltimore in 1941. He took part in the activities of the Surrealists in exile, but again quarrelled with Breton over the review *View*. This break was definitive. His pictures of the period treat biological themes: for instance *Meditation on an Oak Leaf* or *Germination* (1942). Masson's work in many media was prolific: drawing, pastels, sculpture, objects. In 1945 he returned to France.

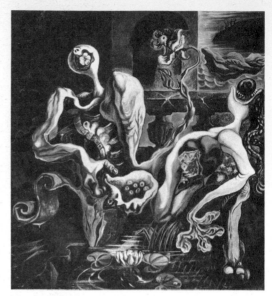

MASSON, ANDRÉ: *Lovers' Metamorphosis.* 1938. Oil, 100 × 89 cm. Galerie Louise Leiris, Paris

MASSON, ANDRÉ: *The Ravaged Garden.* 1934. Oil, 82 × 116 cm. Galerie Louise Leiris, Paris

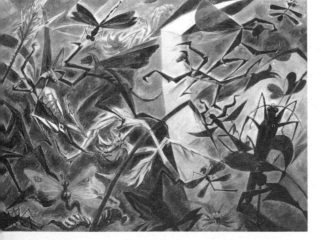

Whereas the Paris Surrealist group tried to renew itself in Paris, notably with an exhibition at Maeght in 1947, Masson kept up his former relations with Artaud, Barrault, Bataille and Leiris, and began to visit Sartre whose influence was considerable at the time, as well as Salacrou, Grémillon and Ionesco. In Sartre's journal, *Les Temps modernes*, he published some 'chronicles' taken from his book *Le Plaisir de peindre*. The title itself—'The Pleasure of Painting' —is significant. Masson, like Max Ernst, had arrived at a form of painting which was more sensual, and in which pictorial values were more important than literary ones. Masson then entered his best period, and from 1962 he was at the height of his creative powers. *Fish Orgy* (1962), *Scorched Men and Women in Armour* (1963), several *Délires Lansquenet* (1963–4) and above all *Malevolent Miracle Workers Threatening the People from the Heights* (1964) prepared the way for what is undoubtedly Masson's masterpiece, the ceiling of the Paris Odéon (1964). There forms swirl and, in spite of what Masson pretended to have taken from the East 'for his painting of the inessential' (*Quadrum*, 1956), the discernible lyricism is closer to Rubens than to China. Decorative, lyrical, cruel, his painting of the 1960s benefited from the spontaneity but eschewed the conventions of Surrealism.

Masson's fame was restricted to Surrealist circles until the end of the Second World War. Then it began to spread partly as a result of the many theatre and opera sets he designed. Grémillon's

MASSON, ANDRÉ: *Untitled.*

MASSON, ANDRÉ:
Approaches of Night. 1956

MASSON, ANDRÉ: *Metaphysical Landscape*. 1939. Oil, 81 × 100 cm. Galerie Louise Leiris, Paris

lovely film *André Masson ou les quatre éléments* (1959) also helped. His retrospectives in Vienna (engravings, 1958), at the Venice Biennale (1958), in Berlin and Amsterdam (1964), and at the Musée National d'Art Moderne (1965), brought together a series of rather disparate experiments, while the painter as he grew older (as is often the case) entered his most creative phase. Masson's success was recognized by official institutions: he received the Grand Prix National des Arts in 1954, and he was a member of the National Museums Council from 1962.

Surrealism owes to André Masson, now a painter of the School of Paris, the solid proof—given in the heroic days of the movement—of the rich fertility of graphic automatism. It is also indebted to him for

MASSON, ANDRÉ: *Goethe Listening to the Voices of Nature*. 1940. Oil. Galerie Louise Leiris, Paris

the technical invention of sand pictures. Without lending itself to too simple a psychoanalytic interpretation, Masson's painting is characterized by sadistic obsessions which bring out the meaning of the titles, and introduce the oneiric into the pictorial. Masson's eroticism places woman at the heart of the cruelties of nature, among the insects, wounded birds, and storms. His *Erotic Trophies* (aquatints, 1962), like his illustrations for Rimbaud (*Une Saison en enfer*, 1961) and for Sade (*La Philosophie dans le boudoir*, 1961), are evidence of the persistence of the Surrealist spirit in a painter who ultimately found expressive values and the 'pleasure of painting' more important than oneiric imagery— the same path that Ernst and Miró followed. But Surrealism in painting could not be restricted to the one figurative tradition typified by Dali, Magritte, Tanguy, Delvaux and Labisse. Masson, who advanced more daringly than many others along the road of artistic oneirism, shows that far from making painting 'a lamentable expedient' (as Breton put it), this road in fact led to the autonomy of the pictorial.

Jean Cassou: *Masson*, Paris, 1965.
O. Hahn, *Masson*, New York, 1965.
M. Leiris and G. Limbour: *André Masson and his Universe*, London, 1947.

MATTA Roberto Matta Echaurren, known as (Santiago de Chile 1911). After an education at the College of the Sacred Heart and the Catholic University of Santiago, Matta was awarded an architect's diploma in 1931. He started a successful interior decorating firm but soon gave it up and left for Europe. His travels took him to Spain, Italy, Yugoslavia, Russia and Britain, where he met Magritte, and to France, where he worked in Le Corbusier's studio.

It was only in 1937 that Matta began to draw and paint, together with Gordon Onslow-Ford. The two friends decided to become painters. Matta, with a letter of recommendation from Lorca (shot in the meantime by Spanish fascists), went to see Dali who introduced him to Breton. Breton was then running the Gradiva Gallery in Paris and strongly encouraged the young Chilean and introduced him to his group. This was the *Minotaure* era. Matta published an article in *Minotaure* in 1938 entitled 'Mathématique sensible-architecture du temps' and after illustrating *Les Chants de Maldoror* together with other painters in the group, he worked on large-format paintings which were to constitute the series of *Psychological Morphologies*. He stayed in Britain with Onslow-Ford. They left together for the United States at the beginning of 1939. A number of Surrealists, notably Tanguy and Kay Sage, friends of Matta's, were not long in going

MATTA, ROBERTO MATTA ECHAURREN: *The Way of the Creator*. 1957. Oil on canvas, 81 × 100 cm. Galerie Jacques Tronche, Paris

universally evoked, without anecdotal allusions, by the shapes of electrical devices, overhead lines, spark gaps, pylons, and wires where tortured or crazy people are caught. A kind of Expressionism developed in Matta's work between *Painting* (1945) and *The Angry One* (1958). He seemed to move away from figurative experimentation and to revert to the *Psychological Morphologies*. *The Unthinkable* (1957) offered a certain abatement of this trend.

MATTA, ROBERTO MATTA ECHAURREN: *The Network of Questions. c.* 1964. Galerie Jacques Tronche, Paris

too. Matta introduced Breton to the painter Robert Motherwell—the spread of Surrealism among American painters during the war is well-known. Matta had a lot to do with the activities of the Surrealists in exile, and took part in the planning of the special issue of *View* (1941) and the first number of *VVV* (1942). He was present at the First Papers of Surrealism exhibition. He illustrated the cover of the last issue of *VVV* (1944). His painting contributed a special transparent poetry to Surrealism. In *The Earth is a Man* (1942), *The Disasters of Mysticism* (1942), *Elminonde* (1943) and *The Glazier* (1944, disappeared) a groundless space is filled with a diffuse, slightly acid light, crossed by networks of lines. The influence of Marcel Duchamp (the 'glazier') was evident in this phase, and Matta, who painted in 1942 *The Bachelors, Forty Years After*, took part in an exhibition at Julien Levy, New York, on the theme of chess. But in 1944, while the size of his paintings increased, disturbing figures, who looked as if they had emerged from Wifredo Lam's pictures, began to appear: *Dizziness of Eros, To Escape from the Absolute* (1944), *How Ever* (1947).

The painter explained this development: he was more aware of the 'horrible crisis of society' and subsequently it became clear that he was trying in *Rosenbelles* (1953) and *The Djamilla Question* (1957) —which brought him the Marsotto Prize in 1962— to express his political protest through painting. The inhuman excesses of industrial society, in the form which it had taken in the United States, the dangers of the Cold War and atomic *angst* are

Suddenly, in about 1962—perhaps in order to repress a sentimentality which was slipping into his dream work—Matta introduced clay into his paintings. Now his emaciated individuals grimace

MATTA, ROBERTO MATTA ECHAURREN: *Les Croques-vie*. 1974. Canvas, 100 × 81 cm. Galerie Jacques Tronche, Paris

most appallingly. Then, very soon the painter returned to his great epic paintings—now bigger than ever. He was not afraid of a format of 8 m × 2 m, for instance in *Eros Sapiens*. Eros's presence in the inextricable entanglement of a Matta painting testifies to the fact that he is in general less *sage* than sorrowful. The silhouettes of people coupling can be glimpsed through the forms of industrial machinery, but the glaucous water in which Matta submerges the entire world is a sea in which one could swim without fear.

The painter had left the United States in 1948 and he returned to Europe by way of Chile. From 1950 to 1954 he lived in Rome, then after another voyage to Chile and to Peru, he settled near Paris. In 1956 he carried out a mural at the UNESCO Palace in Paris and then he went back to South America (1961). He made several visits to Cuba (1963, 1964, 1966, 1967) and the students invited him to Venezuela in 1965. The following year he was teaching at Minneapolis School of Art. Then, with a mixed itinerary in between, he painted a large mural on the Palazzo dei Notai in Bologna (1967).

Matta's connections with Breton's Surrealism, even though they were close during the war when they were both in the United States, were abruptly severed when he was expelled from the group in 1948 (a private matter was the real cause). Matta seems to have been affected by this excommunication, which was lifted in 1959. His fame had grown worldwide in the meantime and he was at Albisola in 1955 together with Asger Jorn, Corneille and a few other Situationists. Matta, who remains a leading figure of the Surrealist generation of the immediate pre-war period, had reached the high point of his creativity. He continued to elaborate his universe in an independent spirit. His attempt at political protest in painting was not approved of by orthodox Surrealists, however committed politically they were on another level. It could not be said, however, that Matta was falling into the ideological traps of 'Socialist Realism'. In a problematic synthesis he connected his indignation over events with the permanent magic of his pictorial vision. The fulness of his space and the graphic violence of his figures and forms matches the twilight subtlety of his colours. That was enough to

MATTA, ROBERTO MATTA ECHAURREN: *Growth*. 1955

MATTA, ROBERTO MATTA ECHAURREN:
When the Roses are Beautiful. 1951

MAYO, ANTOINE MALLIARAKIS: *The Lovers of the Valley of Hell.* 1972. Private collection

produce on the artistic level the oneiric ambiguity which Surrealism tried to elicit in so many different ways.

MAYO Antoine Malliarakis, known as (Port-Saïd 1905). Mayo was the son of a Greek engineer and a French girl. In 1922 he studied architecture in Paris and frequented the Montparnasse of Modigliani, Tzara, Picabia and Prévert. He met Desnos in 1927 but his contact with Breton was inconclusive. In Berlin in 1928 he became a friend of Crevel's and he returned to Paris in 1929 for his first one-man show. He was to be seen at the Grand Jeu. His painting evolved from symbolic landscape (*My Lady*, 1929) to a fantasy close to Max Ernst (*The Bird*, 1937). After the war which he spent at Cannes—where he was working for the cinema with Carné, René Clair and Becker (1950)—he turned

MAYO, ANTOINE MALLIARAKIS: *What a Beautiful Summer!* 1972. Private collection

towards a form of painting that was often very close to Magritte, and characterized by rather heavy 'ideas': *Magic Silence* (1970), *The Infinite* (1972) and *The Siesta* (1972).

MEDEK Mikuláš (Czechoslovakia 1925). Medek is one of the strongest personalities of the new generation of Surrealists. He worked outside official circles and organizations after 1948, and came to the fore at the time of the 'Prague Spring' of 1968. His painting was strictly Surrealist at first, but turned to a form of allusive abstractionism with figurative details.

MESENS, E.-L.-T.: *Naked in the Forest.* 1959. Automatic writing. Galerie Françoise Tournié, Paris

MESENS E.-L.-T. (Brussels 1903). Mesens started as a compositor and began to write poetry at the same time as he joined the Surrealists. He was a very active organizer of the movement in Belgium, then in England. The Minotaure exhibition (Brussels, 1934), Surrealism Today (London, 1940), and Surrealist Diversity (London, 1945) were organized by Mesens. His *Poèmes* were published in 1959 and he made a number of collages.

MICHAUX Henri (Namur 1899). The poet of *Lointain Intérieur* (1937) did not take part in any exhibition, or any anthology of orthodox Surrealism, which indicates the sectarian and restricted nature of the official movement. In language, draughtsmanship and painting (which he dis-

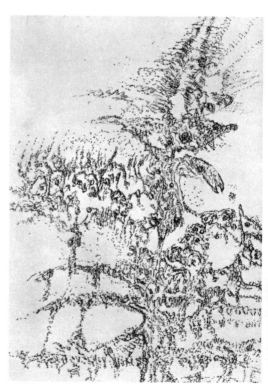

MICHAUX, HENRI: *Pen Drawing.* Collection: M. and Madame Brache, Paris

covered in 1925, through Klee and Ernst), Michaux was one of those who most profoundly plumbed the 'inward model'. His graphic work was more faithful than that of many others to automatism and was shown as a whole in Paris in 1965.

MIRÓ Joan (Barcelona 1893). Miró was the son of a goldsmith. He drew as a child, but after studying art he abandoned it in 1910 for a business career. He fell gravely ill in 1911. His parents had just bought a farm at Montroig near Taragona and he convalesced there, and that house remained a privileged place for him all his life. At the Gali Art School in 1912 he was introduced to painting and met Lorens Artigas, with whom he later produced several ceramics. Impressionism, Fauvism and Cubism were all stages he passed through and his painting of those early years is rather Fauvist.

In 1916 he discovered the avant-garde reviews of Paris, especially *Nord-Sud* in which Reverdy proclaimed Surrealism. In Barcelona in 1917 Picabia published his Dadaist review *391* and Miró got to know him. In temperament the Catalan painter was reserved, dreamy and anxious. The fun of Dada protest interested him without influencing him. He exhibited for the first time in Barcelona, at Delmau, a collection of meticulously realistic landscapes. Throughout the whole early period, until 1924, Miró worked in the direction of rigorous figurative work. In 1919 he went to Paris. He said the city 'quite knocked him over'. He met Picasso who bought a *Self-Portrait* from him (1919). That was the beginning of the friendship between the two Catalans.

From 1920 Miró spent the summer in Montroig and the winter in Paris, where his studio in the Rue Blomet was next to Masson's. His first ex-

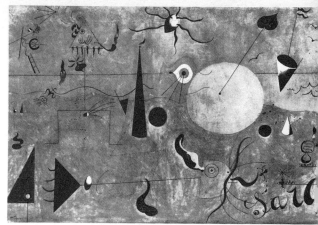

MIRÓ, JOAN: *Catalan Landscape*. 1923–4. Oil on canvas. 63 × 100 cm. Museum of Modern Art, New York

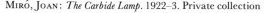

MIRÓ, JOAN: *The Carbide Lamp*. 1922–3. Private collection

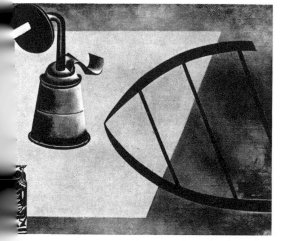

hibition in Paris was held at the Galerie la Licorne in 1921. It was not very successful and he had great difficulty in making ends meet at that time. But the Rue Blomet group (Artaud, Desnos, Leiris, Limbour, Masson) turned to automatic experiments, where what Miró then called 'the murder of painting' had a spontaneous effect which would soon be recommended by the poets of 'automatic writing'. With his *Ploughed Land* (1923) Miró suddenly changed his perspective and went in for figurative experiments of which *The Carbide Lamp* (1920) is the best example. These were followed by a reluctance to mark spaces and a 'plane painting' which Miró kept to ever after. He took it firmly in the direction of a form of 'pictorial-writing' analogous to that of Paul Klee.

His meeting with the Surrealists, Aragon, Eluard and Breton in 1924, made him keep to his decision to go beyond purely plastic work in the direction of 'pictorial poetry'. *The Harlequin Carnival* which he painted in this phase is a repertory of the signs or oneiric objects which Miró still arranged on the double plane of ground and background. Perhaps there is a window, up there on the right, looking onto the night and a mountain peak. Under the window, a dark circle is crossed by an arrow. Under the circle there is a kind of table bearing a fish, birds, and other mysterious things. Under the table cats are playing. There is extreme disorder meticulously designed: a ladder stands stiffly on the left, while two vermicular shapes intersect at the middle of the picture. A moustachioed moon, a squirrel emerging from a dice, starfish, sirens, musical notes

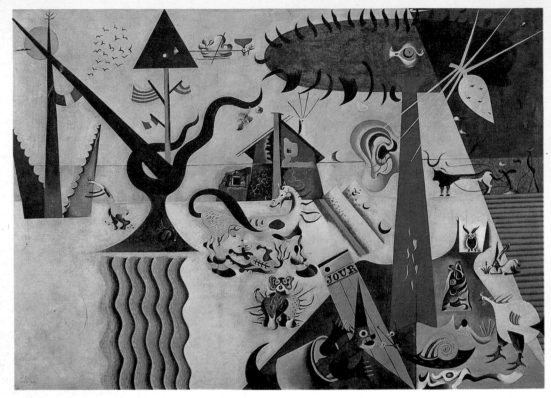

Miró, Joan: *Ploughed Land*. 1923–4. 66 × 94 cm. Galerie
Maeght, Paris

and a wooden ball whose cup is looking at you with
its eye, are all elements in the picture. Miró moved
more in the direction of greater economy, as his
Pastoral (1923–4) shows, but he had already chosen
his direction. He was an admirer of Gaudi (whose

Miró, Joan: *Nocturne*. 1938. Oil on cardboard. Private
collection, New York

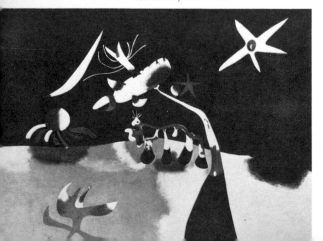

architecture he had found so enchanting), and his
dreams were haunted by fluid and flaccid shapes,
larval objects. Miró also believed in the use of irony
and he was intrigued by the insect-like, toy-like
forms which disgusted Breton. Breton saw the
arrangements of this too painterly painter as 'a
certain arrestation of the personality at the infantile
stage, which does not preserve it from unevenness,
prolixity, and from play and, intellectually, assigns
limits to its evidence' (*Genèse et perspective artistiques
du surréalisme*, 1941). However it was Miró, it seems,
who convinced Breton that painting could pursue
the orthodox lines of automatic writing. Only in
1958 did Breton recognize Miró as a great poet of
form.

Together with Ernst, Miró suffered the censure
of the Surrealists for designing Diaghilev's sets for
Romeo and Juliet (1926). The dissension did not last
long. The year before, he had exhibited at the
Galerie Pierre (preface by Péret) and the dream-
pictures he painted between 1925 and 1927 were
lessons in Surrealism. At the Villa des Fusains,
Rue Tourlaque, Montmartre, where he worked, he

met Arp, Eluard, Ernst, Goemans and Magritte. He came under the influence of Paul Klee, and the purification of his forms in the direction of the diagram or blueprint showed Michel Leiris that he was reaching an 'understanding of space'. *Woman with a Newspaper* (1925), *Person Throwing a Stone at a Bird* (1926) had not yet reached the extreme deprivation of *Blue Triptych* (1961) or *The Blue Mark* (1973), but already, though not without a certain humour approaching caricature, the figurative ellipse was leading to abstraction.

Miró gradually overcame his financial problems, travelled to the Netherlands, painted his large *Dutch Interiors* and married in 1929. That was the year of his *Imaginary Portraits*. Then he emerged from the confines of painting with his *papiers collés* and constructions (1930). In that year his fame crossed the Atlantic and he exhibited in New York at the Valentine Gallery. Sculpture, objects, scenery, costumes, tapestry designs: Miró was widening his field. In 1932 Pierre Matisse put him under contract in New York. His experiments with materials led him to paint on glass paper, on masonite (1936) and on copper. A new period opened up for him. His forms became violent and nightmares of terror seemed to inhabit his brush. On the eve of the Civil War, he left Spain where he was staying and produced for the pavilion of the Spanish Republic in the Universal Exhibition in Paris a big mural, *Mowing-Machine*. The women he painted in this period were the most cruel products of the Surrealist imagination, in their frequent sadomasochist emphases: *Woman Seated, Head of a Woman* (1938). What would be Ubuesque monsters to a figurative eye are in fact emblems—what psychologists call 'generic images'. They concentrate all the painter's aggressive anguish at the sinister road that European society seemed more and more inclined to take: war in Spain, the Munich Pact, the noise of the jackboot, racism. The image of woman stands in the imagination of poets and painters for both *angst*-ridden sarcasm and admiring sublimation. In what might be called his 'eroticism', Miró followed the practice of most of the painters of the movement who, contrary to the poets, were more sadistic than chivalrous in their depiction of woman.

The war came. In 1939, Miró was at Varengeville with his friend Nelson, the architect. There he met Braque, Queneau, Calder. He produced some engravings and in 1940 began the famous series of *Constellations* which would assure the exiled Breton that Surrealist painting had not died after his departure. In an article which appeared in 1958 (*L'Oeil*, 1958, p. 55, and the preface to *Constellation* published in 1959 by P. Matisse) Breton expressed his admiration for this series of gouaches. In the inextricable interlacing of their graphic line and the variations visible from one to the other,

they offer a kind of oneiric continuity and a formidable artistic presence. Miró, who had now left Varengeville, returned to Spain. He went first to Majorca, then to Montroig, and to Barcelona, where he finished his *Constellations* in 1941. They were exhibited in New York in 1945.

In 1941 the Museum of Modern Art in New York put on the first Miró retrospective. The painter did not go to the United States until 1947 when he received a commission for a decorative work in Cincinnati. He is listed in the catalogue of the Surrealist exhibition at the Gallery Maeght (1947) but he did not go back to Paris until 1948, after eight years' absence. The era of retrospectives and

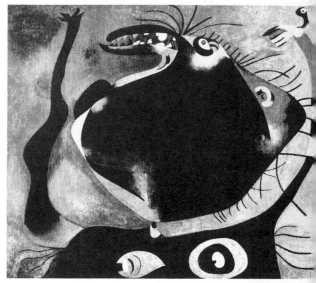

MIRÓ, JOAN: *Head of a Woman*. 1938. Oil on canvas. 45 × 53 cm. Collection: Mr and Mrs Donald Winston, Los Angeles

of major commissions had begun. Miró executed murals in the Hotel Hilton in Cincinnati (1947), at the University of Harvard (1950) and, with Artigas, a ceramic wall at the Palais de l'UNESCO in Paris (1959), ceramic murals at Harvard and at Barcelona (1970). The retrospectives followed one after another: Berne (1949), the Venice Biennale (1954), Brussels, Amsterdam, Basle (1956), New York (1959), Paris (1962), London (1964), Tokyo and Kyoto (1966), Saint-Paul-de-Vence for his seventy-fifth birthday in 1968, Munich (1969), New York (1972 and 1973) and Paris (1974). His fame was worldwide.

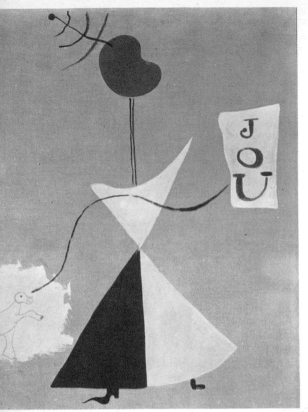

MIRÓ, JOAN: *Woman with a Newspaper*. 1925.

In 1938 he had published in the review *XXe Siècle* an autobiographical fragment entitled 'I dream of a big studio'. In 1956 his friend the architect J.-L. Sert built him the studio of his dreams at Palma. In fact, from 1955 to 1959, Miró practically ceased to paint in order to devote himself to ceramics and to engraving on wood (1958). When he started painting again in 1960, he produced his series on a white ground, and an almost monochrome blue triptych (*Blue I, II, III*). World painting had then reached the most intense flowering of Lyrical Abstraction; Tachism and the blue monochrome works of Klein were in the news or entering into history. Miró could not ignore these influences and lessons. He has kept his taste for research and experimentation until his old age. His pictorial poetry took advantage of every method: he burnt some canvases (1973), lacerated and perforated others (1962), and made sculptures from found objects (1967). In 1964 Miró placed in the gardens of the Maeght Foundation, at Saint-Paul-de-Vence, some enormous bovine and lunar sculptures. The Museum also has a Miró room.

But to what extent is Miró still a Surrealist painter, in spite of the independent spirit that very early on distanced him from all groups? First, by his method of work. He described it (cf. J.J. Sweeney,

MIRÓ, JOAN: *Woman Seated II*. 1939. Oil on canvas, 160 × 129 cm. Peggy Guggenheim Foundation, Venice

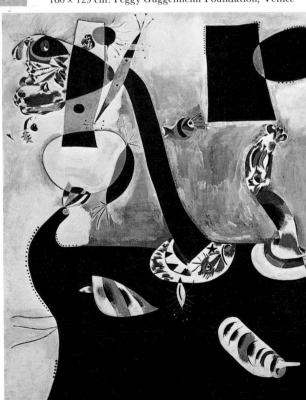

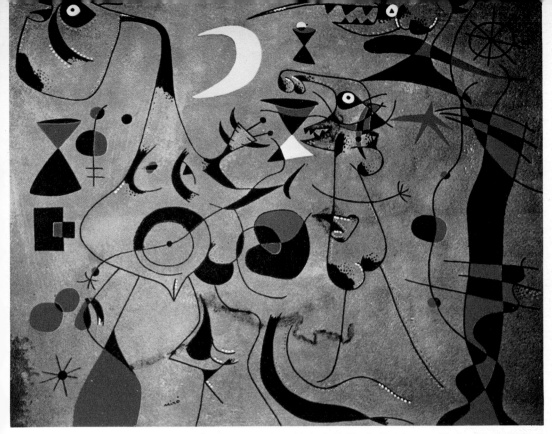

MIRÓ, JOAN: *People in the Night Guided by the Phosphorescent Tracks of Snails*. 1940–1

'Miró' in *Art News Annual*, No. 23, 1954, p. 187).
Starting from an emotion which decides for him the
essential matter of the painting, he gives himself up
to uncontrolled spontaneity. Then he abandons,
files, forgets this first fine impulse. One day he takes
out the canvas, rediscovers it 'and works at it
coldly like a craftsman'. This slow work is accom-
panied by a meditation on the forms which he has
rediscovered in this way. Of course, Miró's method
is not original since a number of painters do exactly
the same thing. It is in the repertory of personal
forms that we find the suggestive power that makes
his works not so much condensed dreams as
machines for making people dream. The genius of
Miró consists in introducing into forms and into the
pictorial substance, without going as far as pure
abstraction, an astonishing, strange and disturbing
oneiric charge. Hence the importance of Miró's
'pictural vocabulary'. In addition to the devouring-
devoured woman (1938), there are (and only by
way of example): hands and feet with fingers like
petals, ovoid forms (*Dutch Interior I*) turning in
patches (of blue), sharp triangles, moons and moon-

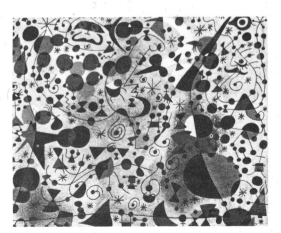

MIRÓ, JOAN: *The Poetess*. 1940. Gouache on paper,
38.1 × 45.7 cm. Collection: Mr and Mrs Ralph F. Colin,
New York

lets, carnivorous flower shapes with contractile filaments, serpentine silhouettes, spirals centred on a black dot (a host of them in *The Poetess*, 1940), jaw profiles, with teeth or not, sometimes simple semicircular patches (*The Red Sun Eats the Spider*, 1948), ropes (sometimes actual adjunctions), stars, limp arrows, little men—like those in children's drawings—with staring eyes (*Woman*, 1969), commas,

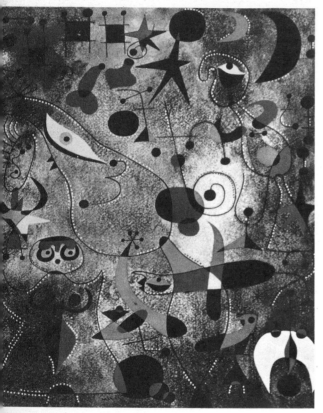

MIRÓ, JOAN: *Waking at Day-break*. 1940–1. Private collection

full stops, wandering lines (*Bird Composition*, 1971), vertical washes (*Triptych, The Hope of the Man Condemned to Death*, 1974), and somewhat flaccid breasts (*Woman*, 1974) or breasts reduced to a dotted circle. All this is treated with a taut or easy line, according to the period.

Miró's sculptures and montages put him next to Picasso on the most painterly fringe of Surrealism. He is even very orthodox with his *Poetic Object*

(1936) with its woman's legs in a parakeet's perch. A fork stuck upright in a box (1929) is entitled *Woman and Bird*, a theme which Miró was to repeat to the point of obsession. A bronze such as *Woman* of 1967 may be described as a kind of bell with attributes and a vaginal-like gap. Incessant humour fuses the forms that Miró gives to the things that he claims to paint. He is among those who almost cross the borderline of caricature to keep themselves more in the order of things where poetry is born. His ceramics, on which he worked so insistently, show his affective concern for clay. The material seems to root its form in a kind of rough archaism.

But do labels matter? Some want to consider Miró an abstract painter; and why not? he is less so than Hans Arp and like him he gives his forms an erotic and symbolic life. Miró is not a Surrealist because of some regard for orthodox doctrine. On the contrary. He and his figures refer us to

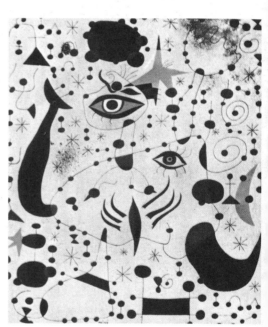

MIRÓ, JOAN: *Numerals and Constellation in Love with a Woman*. 1940–1. Private collection

Surrealism. 'Picto-poetry', to use Brauner's term, exists in Miró's work by virtue of the practice of free writing, and his use of it puts him among the front rank of poets in paint of this century. He is,

in fact, near Paul Klee, but the smiling detail of Klee's drawings gives way to a more ferocious humour in Miró.

Jacques Dupin: *Joan Miró*, London, 1962.
S. Hunter: *Joan Miró: His graphic work*, London, 1959.
Jacques Lassaigne: *Miró*, Paris, 1963.
J. T. Soby: *Joan Miró*, New York, 1959.

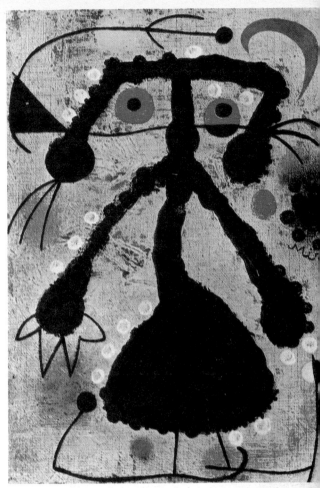

MIRÓ, JOAN: *Sad Traveller*. 1955. Colour lithograph. Bibliothèque Nationale, Paris

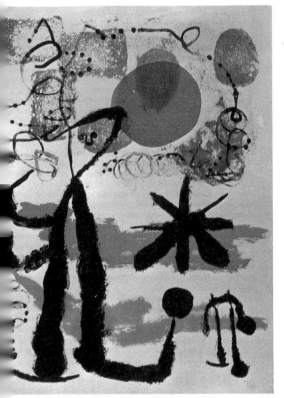

MIRÓ, JOAN: *The Tender Effects of Moonlight at Dawn Crossed by a Beautiful Bird*. 1954. Oil on canvas, 24 × 17 cm. Private collection

MOLINIER, PIERRE: *The Flower of Paradise*. Private collection

MOLINIER Pierre (Agen 1900). If we are to believe him, Molinier's three passions in life are 'painting, girls and guns'. The conjunction of the first two of these from 1950 on made him one of the masters of pictorial eroticism. *The Big Fight* (1951), *The Angel Awakes* (1955), *The Amorous Twins* (1962) wrap in hairnet stockings the often cruel embraces of lesbians with burning eyes. Breton and the Surrealists were fascinated by this passionate freedom, and Raymond Borde's film, dedicated to Molinier, was given an ovation at the Bordeaux Festival of Eroticism in 1966.

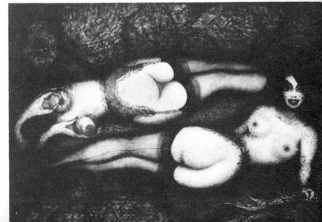

MOREELS Pierre (Brussels 1939). Moreels lives in the Paris area. He is a sculptor who carves directly, in heavy blocks of wood, quasi-abstract forms on which dream-meditation imposes its themes: his *Totem* (1970) on the beach at Port-Barcarès is 7 m in height. He has also produced

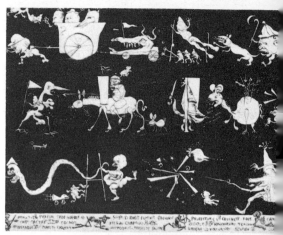

MOREH, MORDECAÏ: *Oaths in French.* 1971. Dry-point etching and aquatint

Jerusalem, Florence and Paris, where he settled from 1962. He is a very fine engraver and mixes cruel irony with a cosmic sense of the marvellous.

Nothing links him to the Parisian Surrealists, but his fantastic and strange, somewhat Chagallian circus, where love and death are entangled, and his multi-lingual *Lists of Abuse* (1970) take oneirism to the point of black humour.

René Passerson: '*L'Ironie de Mordecaï Moreh*', Moreh catalogue, Heidelberg, Kurpfälzisches Museum, 1972.

MORTENSEN Richard (Copenhagen 1910). Mortensen, like the sculptor Robert Jacobsen, moved from Nordic Surrealist Abstraction to revolutionary Surrealism (1946). He expresses the imaginary in the plastic qualities of the work and the colour schemes, and then tries to integrate geometric exactitude with the use of automatism. After a long spell in Paris (1946–62), he returned to Denmark and came close to Constructivism.

MOTHERWELL Robert (Aberdeen, U.S.A. 1915). After extended university studies, Motherwell, who lived in Mexico between 1941 and 1943, had his first show in 1944, in Peggy Guggenheim's Gallery in New York. He was then in contact with the exiled Surrealists, and his painting which was close to Abstract Expressionism at that time found them a lively inspiration. Motherwell later became one of the painters whom the spirit of Surrealism took towards Lyrical Abstraction.

MOREELS, PIERRE: *Who are You?* 1973. Private collection

series of erotic drawings in which Surrealist automatism liberates clusters of obsessions. This entitled Moreels, in addition to several exhibitions of his sculpture, to participate with Bellmer and Balthus in the Les Enfers Exhibition at Antibes in 1966.

MOREH Mordecaï (Baghdad 1937). Moreh emigrated to Israel in 1951 and studied art in

was supported by F. Smejkal and the review *Phases* from about 1964. Muzika was the oldest of the young Czechoslovak artists who became known at the time of the Prague Spring. In 1968 he took part in the Surrealism Today exhibition at the Maya Gallery, in Brussels, and in 1969 in the Surrealism in Europe exhibition, in Cologne.

NASH Paul (London 1889–Boscombe 1946). Before the war he was an active member of the English Surrealist group, but he touched on or used almost all the styles of his time, notably Constructivism, before becoming during the last (as in the first) war, official war painter.

NIEUWENHUYS Jan (Amsterdam 1922). Associated with the Cobra group between 1948 and 1951, this painter found his particular graphic poetry through the influence of Paul Klee and Brauner.

NOUVEAU Henri (Brasov, Rumania 1901–Paris 1959). A musician who was independent of any group, he produced abstract designs in 1923 and met Paul Klee at the Bauhaus in 1928. His paintings on paper, small-format works which he exhibited

MOTHERWELL, ROBERT: *Surprise and Inspiration.* Gouache, oil and collage, 102 × 64 cm. Peggy Guggenheim Foundation, Venice

MUZIKA Frantisek (Prague 1900). Muzika's painting, for instance his *Towers* (1965), joins a sense of the monumental and an oneiric power. He

NOUVEAU, HENRI: *Untitled.* 1940. 36 × 24.5 cm. Galerie de Seine, Paris

MUZIKA, FRANTISEK: *Theatre II.* 1944. Galerie Ales, Hluboka, Czechoslovakia

OELZE, RICHARD: *The Dangerous Desire*. 1936. Oil on canvas, 12 × 16 cm. Collection: Claus Hegewisch, Hamburg

on the eve of the Second World War, for instance *Winged Dancestep* (1940), temper the invention of viscous monsters with a certain humour.

OELZE Richard (Magdeburg 1900). A former pupil of the Weimar Bauhaus (1921-6), he discovered Max Ernst and Surrealism *c.* 1932, the date of his arrival in Paris. His painting (*Everyday Tortures*, (1934), *Fernscape* (1935), *The Wait* (1936)) is made from *frottages*, and interpreted decalcomanias. It continually oscillates between oneiric figuration and the viscous flux of fantastic forms. An interruption of ten years (1936–46) retarded his fame. After travelling to Switzerland and Italy, Oelze decided to settle in North Germany, at Worpswede, in 1946, then in 1962 at Porteholz. He seemed to find there an environment which accorded with the anxious storms of his 'inward model'.

OKAMOTO Taro (Tokyo 1911). A painter who stayed in Paris from 1929 to 1940 and was connected with Surrealism between 1946 and 1948. He belonged to the Abstraction-Creation group. Afterwards he turned to Lyrical Abstraction. His

Surrealist period, to which he sometimes returned, runs counter to abstraction in order to treat oneiric themes figuratively, as in *1000 Hands*.

ONSLOW-FORD Gordon (Wendover, Bucks. 1912). Together with Matta, whom he met in 1937, Onslow-Ford turned to painting and met the Surrealists. His activity in Paris, London and New York finally led him to Mexico in 1941. He contributed to the review *Dyn* (Paalen) and then left Surrealism altogether in order to move towards Lyrical Abstractionism.

OPPENHEIM Meret (Berlin 1913). Oppenheim is a painter and sculptor who was in the first rank of the creators of Surrealist objects. She went to Paris in 1931 and met Giacometti, who was then in his Surrealist period. Her *Fur cup and Saucer* has often been shown since the Fantastic Art: Dada, Symbolism exhibition in New York, 1936. *My Governess, Miss Gardenia* and *The Squirrel* are evidence of the persistence of her imagination, like the 'Cannibal Feast'—which she organized at the EROS exhibition at Cordier in Paris, in 1959.

PAALEN Wolfgang (Vienna 1905–Mexico 1959). Paalen started painting early. He studied art in Munich. After an initial 'cycladic' period, he went to Paris and exhibited in 1934 with the Abstraction-Creation group. Shortly afterwards he converted to Surrealism and showed his pictures at Pierre in 1936. Paalen invented the *'fumage'* process which produced misty effects. His use of interpreted automatism resulted in major fantastic visions such as *Totemic Landscape of My Childhood* (1937) and *Struggle of the Princes of Saturn*. His *Articulated Cloud* is an umbrella made of sponges. He went into exile in Mexico in 1939 and in 1940 he organized, together with the poet César Moro, an international Surrealist exhibition, but left the movement in 1941. Paalen founded the review *Dyn* (1940–4) and the Dynaton movement. He tried, in

OPPENHEIM, MERET: *Fur Cup and Saucer*. 1936.
Museum of Modern Art, New York

PAPAZOFF, GEORGES: *The Couple*. 1928. 92 × 73 cm.
Galerie de Seine, Paris

PAALEN, WOLFGANG: *Struggle of the Princes of Saturn III*. 1937. 100 × 73 cm. Galerie Jacques Tronche, Paris

PAALEN, WOLFGANG: *Future Ancestral Persons*. 1947. 80 × 80 cm. Galerie de Seine, Paris

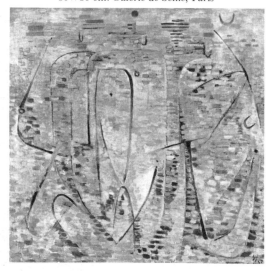

a 'plastic cosmogony', to unite the dream use of pre-Columbian art and the reflective use of modern science. His book *Form and Sense* was published (in English) in 1945. Paalen returned to Paris in 1952, renewed his association with Surrealism, and produced some major lyrical works which made his last exhibition in Mexico in 1958 an impressive occasion.

PAPAZOFF Georges (Yambol, Bulgaria 1894– Vence, France 1972). Papazoff left Bulgaria to study and at first wanted to be an architect. Between Prague and Munich, where he stayed in 1918, his vocation became clearer: he would be a painter. He wandered a little—Vienna, Berlin and Geneva—before arriving in Paris in 1924. He soon met the Surrealists and exhibited with them. At that time he was an adherent of what was later known as 'Abstract Surrealism', and his 'sand pictures' drew attention in 1929. But his independent temperament prevented him from really joining a group. His fame was reaching its height as a result of simultaneous exhibitions in the United States and Europe when he himself stopped it short. He was a friend of Derain's, and after Derain's death he retired to Vence in 1953. Supported by

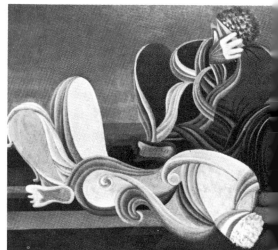

PAPAZOFF, GEORGES: *The Gladiators II*. 1957. 81 × 100 cm. Galerie de Seine, Paris

loyal friends like Rolf de Maré and Henri-Pierre Roché, he continued until his death his exact and lyrical meditation in paint.

PARENT Mimi (Montreal 1924). A painter who extended her lyrical art by adopting a number of techniques including embroidery and poker work, Mimi Parent was married to the poet Jean Benoît and lived in Paris from 1947. She was associated with the Surrealists after the EROS exhibition at

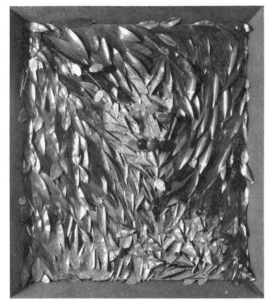

PARENT, MIMI: *Your Little Afternoon Tea, Miss.* 1966. Object. Galerie Françoise Tournié, Paris

Cordier in 1959, where she arranged the Crypt of Fetishism. She produced a number of objects, notably *Your Little Afternoon Tea, Miss* (1966).

PEDERSEN Carl-Henning (Copenhagen 1913). Pedersen was a self-taught artist who started painting at the age of twenty. He joined the *Linien* group in Copenhagen. His experiments were abstract at that time but influenced by Expressionism. He shared Richard Mortensen's and Ejler Bile's admiration for Kandinsky and Klee, and that brought him close to Miró, Picasso and Surrealism. He went to France in 1939. Together with Bile and Jorn he was a member of the Danish group *Helhesten* (The Horse of Hell) between 1940 and 1945. After the war his fame spread and he travelled to Lapland (1946), Iceland and the Netherlands (1948), Greece and Italy (1951), Crete (1957), Turkey (1959), Ceylon, India, Nepal (1960). His name appears in the Cobra exhibition catalogue in 1949, and his first retrospective was in Copenhagen in

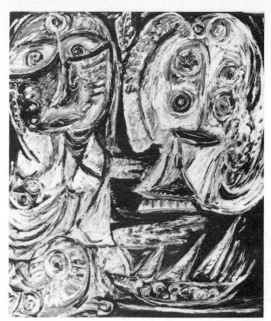

PEDERSEN, CARL-HENNING: *Divine Couple with a Blue Sailing Ship.* 1966. Oil on canvas, 122 × 103 cm. Galerie de France, Paris

1950. Pedersen was Expressionist, Abstractionist and Surrealist, though no label is precise enough for his emphatic brushwork and delicate use of colour which put him somewhere between Klee, Jorn and Alechinsky on one of the most painterly roads of picto-poetry.

Christian Dotremont: *Carl-Henning Pedersen*, Copenhagen, 1950.

PEDRO Antonio (Cape Verde Islands, 1900). Pedro went to Paris in 1934 and became a follower of Dali. At Lisbon in 1942 he founded the review *Variante* and from 1943 to 1945 he lived in England. Three years after starting a Portuguese Surrealist group in 1947, he stopped painting.

PENROSE Sir Roland (London 1900). A painter and collector, and friend of Max Ernst's, Eluard's and Picasso's, Penrose, his wife Valentine and Mesens, organized an international exhibition of Surrealism in London in 1936. Penrose's art was influenced by Ernst's. He produced original collages from postcards, for instance *Magnetic Moths* and *The Real Woman* (1938), and Surrealist objects such as *The Last Voyage of Captain Cook* (1936). Penrose was largely responsible for Picasso's reputation in Britain.

PEDERSEN, CARL-HENNING:
Earth and Heaven. 1973

PERAHIM, JULES:
Object to Touch. 1974

PERAHIM Jules (Bucharest 1914). Like Brauner and Hérold, Perahim contributed to the Rumanian avant-garde reviews *Unu* and *Alge* between 1930 and 1933. The *Antiprophet* (1930) and *The Machine-Gun* (1932) are fairly close to some Magrittes. Between 1933 and 1969 Perahim designed scenery and illustrated a number of books. He exhibited in Moscow as well as at New York, Paris, Milan and Tel-Aviv. He has been in Paris since 1969 and has returned to the jagged fantastic images which make *Erotic Boomerang* (1969) and *Tomorrow Morning* (1970) rather bland oneiric figurations.

PÉRET Benjamin (Rézé 1899–Paris 1959). The poet of *L'Immortelle Maladie* (1924) liked to rebel, and did so from the age of sixteen. He became a member of the Communist Party in 1926 and was soon a Trotskyite. In 1931 he was expelled from Brazil for subversive activities. He later joined the Anarchist troops who went to defend the Spanish Republic. He was called up in 1939 and imprisoned. He sought exile in Mexico in 1941. When he returned to France after the war, of all the founders of Surrealism Péret was one of those most liable to mix fierce polemics with lyricism.

PICABIA Francis Martinez de, known as Francis (Paris 1878–Paris 1953). Picabia was the son of a Cuban diplomat. From adolescence he was fascinated by the School of Paris. After his 'orphic' period (1907) Picabia was one of the first to

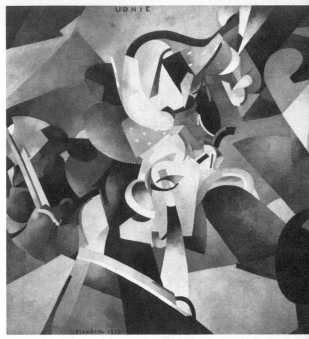

PICABIA, FRANCIS MARTINEZ DE: *Udnie*. 1913. Oil on canvas, 300 × 300 cm. Musée National d'Art Moderne, Paris

PICABIA, FRANCIS MARTINEZ DE: *Craccae*. *c.* 1927. Oil, 116 × 89 cm. Galerie Jacques Tronche, Paris

PICABIA, FRANCIS MARTINEZ DE: *Rubber*. 1909. Watercolour. 45.5 × 61.5 cm. Musée National d'Art Moderne, Paris

PICABIA, FRANCIS MARTINEZ DE: *Carnival*. 1924.
100 × 81 cm. Galerie Jacques Tronche, Paris

PICABIA, FRANCIS
Now and Then.
1946

commit himself to non-figurative painting with
Rubber (1909) and then the major canvases of 1912
(*Udnie, Catch as Catch Can*). During the war he was
in the United States, together with Gabrielle Buffet
and Duchamp. It was the time of *291*, a pre-
Dadaist review, and of the machine period. Picabia
went to Barcelona and *291* became *391* in 1917. He
published the review until 1924. In the meantime
he had met Tzara, together they introduced Dada
to Paris, and Picabia shocked the Salon d'Automne
with his mechanist pictures. In 1921 he broke with
Breton and the *Littérature* group. *Relâche*, a ballet
containing the film *Entr'acte* by René Clair (with a
scenario by Picabia), maintained an offhand atti-

PICABIA, FRANCIS MARTINEZ DE: *The Clowns*. 1925–8.
Oil on canvas, 16 × 89 cm. Galerie Jacques Tronche,
Paris

tude to the young founders of the Surrealist move-
ment. Picabia withdrew to his château in Provence,
enjoyed himself on his yacht, and arrived in 1927
at his 'transparencies' period: *The Clowns, Hera,
Craccae*. He moved to Golfe-Juan with Olga Mohler
in 1939 and during the war produced commercial
nudes to escape the tedium of his former osten-
tation. His retrospective at Drouin in 1949, *Fifty
Years of Pleasure*, drew the attention of the young
painters of Paris, who saw Picabia (like Marcel
Duchamp) as a major opponent of art as a religion.

Georges Ribemont-Dessaignes: *Picabia vu en transparence*
(with P. Waldberg), Paris, 1961.
Michel Sanouillet: *Picabia et 391*, Paris, 1965.

PICASSO Pablo Ruiz, known as Pablo (Malaga
1881–Mougins 1973). He was the son of a drawing
teacher who, when he realized the extraordinary
gifts of his son at the age of ten, gave him his own
painting tools. Pablo Picasso (he adopted his
mother's name) went to Barcelona with his family
in 1895, and entered the School of Fine Arts there.
At the age of seventeen, because of a serious illness,
he spent a few months at Horta de Ebro. Then he
mixed in Barcelona avant-garde circles. He made
his first trip to Paris in 1900.

In 1904 he was staying at the Bateau-lavoir, Rue
de Ravignan, Montmartre, Paris. He got to know
Apollinaire and his circle. Picasso's early periods,

the Blue Period (1900–5) then the Rose Period (1905–6), were making him famous when he suddenly produced the astoundingly new *Demoiselles d'Avignon* (1907). Cubism of course originated from this key painting of the century.

All his life Picasso experimented with the most advanced possibilities of painting. We are concerned here with his links with the Surrealists, which may be considered under three aspects.

First, Picasso was a precursor of Surrealism, whom those who started the movement acknowledged as such. In addition, he may be thought of as Surrealist between 1925 and 1937, in certain paintings at least. Even though it is true that all his work is characterized by an Expressionism in which the pictorial qualities are more important than any ideological message, they nevertheless all carry, right up to the end, a violence, humour and oneiric emphasis which are typically Surrealist.

Breton worshipped Picasso, even before he wanted to take advantage of his fame for political reasons. 'That the position held by us now could have been delayed or lost depended only on a failure in the determination of this man', he wrote (*Le Surréalisme et la peinture*), and went on to say: 'His desirable perseverance is a valuable assurance that we can eschew appeals to any other authority. . . . If Surrealism is to set itself any particular line to follow, then it must go where Picasso has gone and will go.' This quotation dates from 1925 and it is the innovator Picasso of the pre-war period, the friend of Apollinaire whom Breton is praising. Cubist

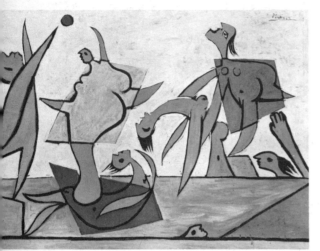

PICASSO, PABLO RUIZ: *Beach Game*. 1933. Oil, 97 × 130 cm. Galerie Louise Leiris, Paris

PICASSO, PABLO RUIZ: *Games on the Beach*. 1932. Ink Drawing, 25 × 35 cm. Galerie Louise Leiris, Paris

PICASSO, PABLO RUIZ: *Composition*. 1933. Watercolour, 40 × 50.5 cm. Galerie Louise Leiris, Paris

mathematics has nothing to do with the spirit of Surrealism, but its questioning, rebellious attitude and its suspicion of mere good manners certainly have much to do with the essence of Surrealism. We must remember that Cubism caused a furore in the Chamber of Deputies in 1911 and that Cubist painters were treated as 'malefactors'. That was all to the taste of the young Surrealists. Better still, Picasso had designed the scenery for the

PICASSO, PABLO RUIZ:
The Dance. 1925

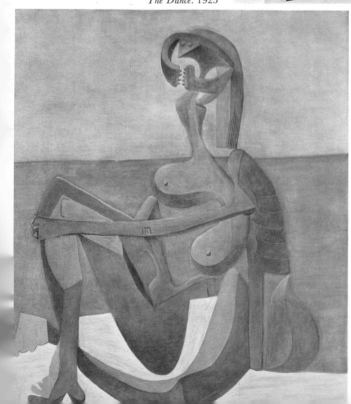

PICASSO, PABLO RUIZ:
Swimmer Sitting on the Beach. 1929

PICASSO, PABLO RUIZ: *Minotauromachia*. 1935. Etching,
50 × 70 cm. Galerie Louise Leiris, Paris

Mamelles de Tirésias, Apollinaire's Surrealist drama of 1917. The drop for *Parade* (Cocteau, Satie, 1917) was a joyful, 'delirious' work in the Surrealist sense, which no longer had any Cubist characteristics. As for the curtain for *Mercure* (a ballet by Satie and Massine, 1924) it was highly praised by the Surrealists. On the same level of Cubism, in 1913, with his *Woman in a Chemise*, Picasso had given an object-lesson in the oneiric translation of reality.

PICASSO, PABLO RUIZ: *Girls Playing with a Toy Boat*. 1937. Oil, charcoal and pastel on canvas, 128 × 195 cm. Peggy Guggenheim Foundation, Venice

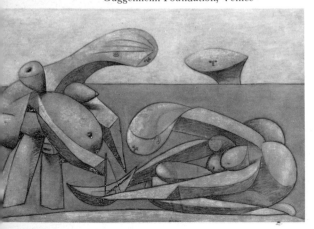

Eluard and Breton found this painting a spur to dream-meditation, with its hanging, pointed breasts fixed with nails in an accumulation of triangles and trapeziums, falling so it seems between the arms of a chair. Wild hair, clothing in disarray and a newspaper add humour and a tinge of realism to the blind portrait of a supposed woman. Picasso was to go much further in the same direction.

If we are to believe Alfred Barr, Picasso discovered the beauty of the human body as a result of his collaboration with Diaghilev—his marriage with dancer Olga Kokhlova and the social successes of his 'période duchesse' brought him into this world. After the first war he had reverted to lonely concentration on his work which the Dinard period and even more that at Boisgeloup were to take to a form of nightmare Expressionism. The great picture *Three Dancers* (1925) marks the beginning of this phase, according to some commentators. In fact, *Woman Asleep in an Armchair* (1927), which neglects pictorial rhythm in order to emphasize the deliberately monstrous nature of the portrait, is Picasso's most violent manifesto. *Figures on the Beach* (1931) mixes female curves with a kind of crustacean struggle. *Woman Throwing a Stone* (1931) has the hard quality of a sculpture whereas *Bathers Playing with a Ball* (Boisgeloup, 1932) is reminiscent of Max Ernst in the odd gracefulness of the monsters' movement. In sculptures such as *Woman's*

Head (1932) we find the same emphasis, as we do in a number of drawings—which Picasso always produced in abundance—for instance, *Crucifixion* (1932). The next year Picasso acknowledged his association with the Surrealists in a drawing entitled *Surrealist Composition* (1933), in which he seems to have collected a number of typical motifs, the human-chair, soft ladder and so on. Montages such as *Glove Construction* (1930) and *Butterfly Composition* (1934) which elicited tributes from Breton ('Picasso in his element', 1933, *Le Surréalisme et la peinture*), are in fact chance encounters of elements from which the 'light of the image' happened to glance.

It was in his Boisgeloup studio that Picasso drew *Wounded Bull, Horse and Female Nude* (1934) which is obviously a Surrealist work. The inverted nude and the savaged mare are connected with the Minotaur theme which appeared at this time and which was to haunt Picasso's work until *Guernica* (1937).

The Surrealist sensibility cultivated myth and can rightly claim the Minotaur cycle as its own, much more so than the tauromachias which Picasso owed to his Spanish interests. The Minotaur period is marked with the seal of Picasso, who put a rather friendly Minotaur on the cover of the first number of the journal *Minotaure* (1933). In the famous

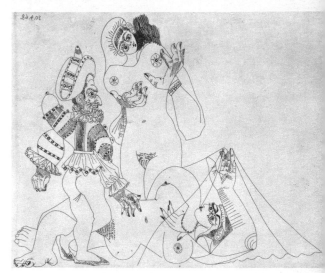

PICASSO, PABLO RUIZ: *Untitled.* 1968. Etching, 47.5 × 57 cm. Galerie Louise Leiris, Paris

PICASSO, PABLO RUIZ: *Maia, the Artist's Daughter at two and a half, Holding a Boat.* 1938. Oil, 73 × 54 cm. Galerie Louise Leiris, Paris

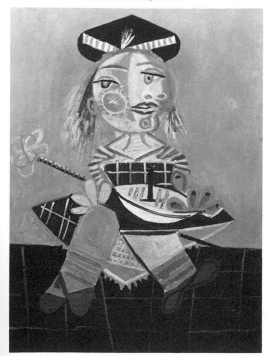

series of aquatints known as the 'Vollard Suite' (1933 to 1937), the Minotaur is first sensual and serenely pagan (1934). Then, wounded in the arena, it undergoes its mythical fate. Finally, in the four last plates, it becomes a blind Oedipus and roars its despair. An engraving of 1935, *Minotauromachia*, summarizes Picasso's meditations on this myth: a little girl holds a lighted candle which reveals the gasping woman on the back of the wounded mare. The Minotaur stretches out its hand to the light as if it wanted to put it out. A man is escaping by a ladder. The Minotaur—defeated—is also in the fine design for a curtain for Romain Rolland's *14 Juillet* (1935).

It would seem that the Minotaur myth, which Picasso connected with bull-fighting, evoked only one superficial aspect of his imaginary world. The evidence for this is that after 1937 the myth disappeared from his work and Picasso returned to his petrified figurations. In the meantime he had emerged from his '1935 depression' while writing automatic poems which are undeniably orthodox Surrealist in approach. The period of the portraits in which the often tear-covered face of Dora Maar undergoes a tragic transformation is also the period of *Two Nudes on the Beach* (pen and gouache, 1937), of *Woman Sitting with a Book* (pastel and oil) and of *Girls Playing with a Toy Boat* (oil, charcoal and chalk, 1937), which is one of Picasso's masterpieces. In this large canvas with its subtle browns and blues, the two women in the foreground become two indefinite objects with shapes which are both Cubist and bulbous in effect, but not so as to deprive them

entirely of feminine grace. On the horizon described with a single line there is the enormous rearing head of a female monster, disturbing clear space and offering an anxious presence: the spy who watches unseen the innocent play of the girls in the foreground, a Pan-like presence in the depths of nature.

In this way, Picasso shows the extent of his plastic range. The calm light and graphic exactitude are wholly suitable to his descent into the study of the monstrous and the marvellous. In 1937, he painted *Guernica*, which in spite of the presence of a bull is not in the direct Surrealist tradition. A political event might well become the object of a protest, and the history of Surrealist protest in pamphlet and magazine form shows that, but it was never considered to be a sufficiently 'inward' subject in the eyes of the purists of the movement. Picasso, like Eluard and Tzara, was close to the Communist Party during the German Occupation. He stayed in Paris and kept the Main à Plume group going. The cover of *Conquête du monde par l'image* (1942, a Main

à Plume booklet) shows the famous bull made from bicycle handlebars which was shown at the Salon d'Automne in 1944 in a retrospective which drew considerable, not entirely favourable, attention.

Later, when he was associated with the World Peace Movement, Picasso made some posters which drew sour comments from Breton, but his *Portrait of Stalin* shocked the dictator's disciples. Picasso withdrew yet again into his creative solitude, and began a series of paraphrases of some of the classical masterpieces of art (*The Woman of Algiers*, after Delacroix, and *Las Meninas*, after Velasquez); it is interesting that most of the works he chose have some connection with the theme he was then so intrigued by: the painter and his model. The erotic force of the aquatints of 1968 accord with a constant feature of Surrealism but also with very longstanding tradition. Of course, if we take Surrealism as always being a strict orthodoxy, Picasso was never a Surrealist. But Surrealism is a very broad movement, whose artistic variety I have insisted on

PICASSO, PABLO RUIZ: *Crucifixion*. 1930. Oil on wood, 50.8 × 66 cm. Private collection

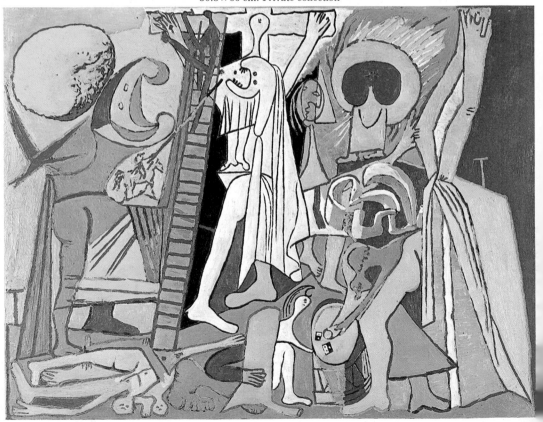

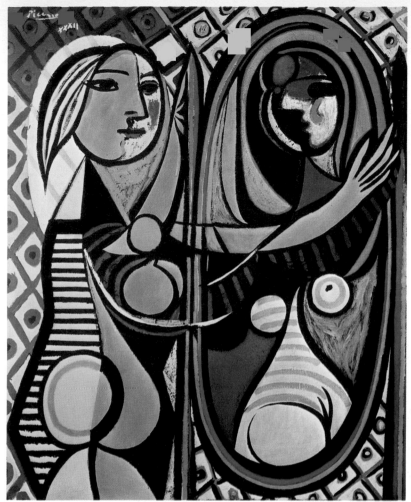

PICASSO, PABLO RUIZ: *Young Girl at the Mirror.* 1932.
Oil on canvas, 160 × 129.5 cm.

throughout this book. Picasso in his best periods always paid sufficient attention to the basic Surrealist principles of the introduction of oneirism into pictorial poetry, and we can certainly recognize in his works in that vein, right up to the end of his long life, the man whom Breton admired so much.

Brassaï: *Conversations avec Picasso*, Paris, 1964.
Jean Cassou: *Picasso*, Paris, new edn, 1960.
Jean Cassou: *Pablo Picasso*, Paris, 1975.
Pierre Daix: *Picasso*, Paris, new edn, 1973.
Fernande Olivier: *Picasso et ses amis*, Paris, ninth edn, 1954.
Roland Penrose: *Pablo Picasso*, London, 1958.
Jaime Sabartès: *Picasso, portrait et souvenirs*, Paris, 1946.
Antonina Valentin: *Picasso*, Paris, 1957.
Christian Zervos: *Picasso*, Paris, 1961.

PIEYRE DE MANDIARGUES André (Paris 1909). The author of *Lys de mer* (1956) and *La Motocyclette* (1963) is one of the Surrealist writers who has paid most attention to the plastic arts. He has been associated with the Breton group since 1947; in 1956 he produced a volume on the *Monstres de Bomarzo*.

POLLOCK Jackson (Cody, Wyoming 1912–1956). Pollock was first influenced by North American Indian art and then by Picasso. He met the Surrealists who took refuge in the United States during the war. He took the drip technique, occasionally used by Max Ernst and Masson, to the level of a wholly new technique in painting. In

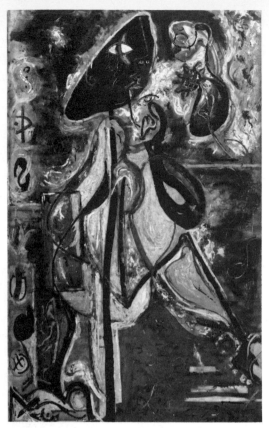

POLLOCK, JACKSON: *Woman Moon*. 1942. Oil on canvas, 175 × 109 cm. Peggy Guggenheim Foundation, Venice

1946 he exhibited at the Art of this Century Gallery in New York the products of this process of gestural painting in which Surrealist automatism is associated with randomness. A nervous poetry is the end-product of Pollock's inextricably entangled forests of dripped paint.

J. Cassou: *Jackson Pollock et la nouvelle peinture américaine*, Paris, 1959.
J. Robertson: *Jackson Pollock*, London, 1960.

PRÉVERT Jacques (Paris 1900–Paris 1976). Prévert was a friend of Tanguy's whom he met in a barrack-room at Lunéville. He was associated with the Rue du Château group and took part in the activities of the Surrealists between 1925 and 1929, the date of the *Second Manifesto*. His poetry, from *L'Ange garde-chiourme* (1930) to the famous post-war volumes (*Paroles*, 1945), mixes a popular spirit with sharp humour. His songs and films, *Drôle de Dame*, *Les Enfants du Paradis*, *Les Visiteurs du soir*, were directed by Marcel Carné, and served to spread the Surrealist spirit among a wide public.

RAY Man (Philadelphia 1890–Paris 1976). After studying architecture, Ray worked in 1911 in a publicity agency and attended an anarchist cultural centre, the Ferrer Center, where he first exhibited in 1913, the year of his marriage to Adon Lacroix. His painting, as in *Dream*, was then rather nebulous, and he produced pictures made from cloth samples. He moved with his wife to Ridgefield (New Jersey) where he tried to organize an artists' community. In 1915, at the Daniel Gallery in New York, he exhibited some canvases which brought together Cubist design and Fauvist colour work: *The Village* (1913) and *AD MCMXIV* (1914).

His meeting with Marcel Duchamp in 1915 was decisive. With Duchamp he published reviews such as *The Blind Man* and *Rongwrong* and helped to change *Camera-work*, Stieglitz's journal, into *291*, a

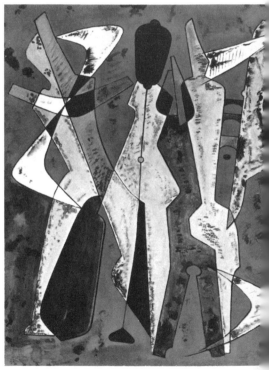

RAY, MAN: *Promenade*. 1915. 61 × 49.6 cm. Private collection

pre-Dadaist magazine which Picabia later transformed into *391*. In the Stieglitz, Picabia and Duchamp circle, any form of conventional art, even a certain synthetic Cubism of the kind which Ray

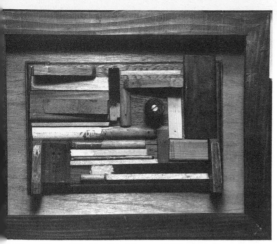

RAY, MAN: *The Furnished Rooms, 1921*. 1969. Construction of elements in wood in the form of a picture and presented in a box, 33 × 40 cm. Galerie Françoise Tournié, Paris

then practised (*Promenade*, 1916), was forbidden. He started to work on glass, and made some photographic experiments. Man Ray painted his aerographs with a spray gun (1918) where a certain automatism, helped by chance, was already determinative: *Admiring the Cinema* (1919) is an abstract and lyrical success in this sense.

Man Ray arrived in Paris an enthusiastic Dadaist. The young people of the *Littérature* circle supported him when he exhibited at the Librairie Six in 1921. The following year he became a professional photographer, produced several photographic portraits, invented rayograms, and thus gave his name to a technique of photography without using a camera which Christian Schad and Moholy-Nagy had also discovered. An object is placed on sensitive paper and exposed to the light for a few seconds until the paper shows a 'white shadow' of the object. Man Ray developed this technique until he could produce works of considerable lyrical power in which the play of white and black brings about an ambiguous synthesis of day and night. Man Ray became famous as a photographer among the Surrealists, not only for his volume of rayograms, *Champs délicieux* (1922), but for his photographs, especially the portraits of Kiki of Montparnasse (1924–7) which are more striking than his paintings.

The portraits he painted of *Kiki* (1923) and of *Duchamp* are very like Modiglianis. Man Ray the painter was hardly able to find his own original voice among the various influences he reflected: Synthetic Cubism, which occurs in *The Sweepers* (1959) and represents a new version of the subject

and technique of *Promenade* (1915); the influence of Chirico in *Misunderstood* (1939), *Fine Weather* (1939), *Night Sun* (1943), and in *La Rue Férou* (1952); the influence of Duchamp not only in his initial Cubism, but in the machine people, and semi-geometric robots of *The Twin* (1939), *The Infinite Man* (1942). Man Ray was by this time in the United States and had been there since 1940; he only left again in 1951, to return to France. Then there was the influence of Magritte in his famous drawings of 1936–7, which were 'illustrated' by Eluard's poems in the volume *Les Mains libres* (1937), and especially in *La Fortune II* (1941), which shows a billiard table on a beach under ironically coloured clouds, and in *Talking Picture* (1957); and a fairly academic geometric abstraction is at work in the fine series *Revolving Doors* (1942), *The Storm* (1948) and *Julia's Rhythm*. How can we safely categorize Man Ray as a painter among all these tendencies?

His own voice is certainly heard in such paintings as *Fine Weather* (1939) which manages an amazing synthesis of various influences. In front of a stone wall where a break shows a patch of clear sky in an otherwise sombre view, a man is standing. He is

RAY, MAN: *Rue Férou*. 1952. Oil on canvas, 80 × 59.8 cm. Private collection

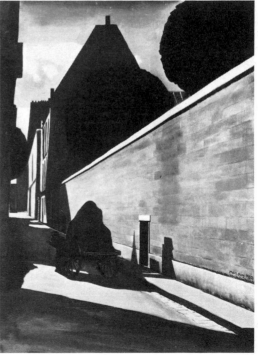

RAY, MAN:
Swedish Landscape. 1925

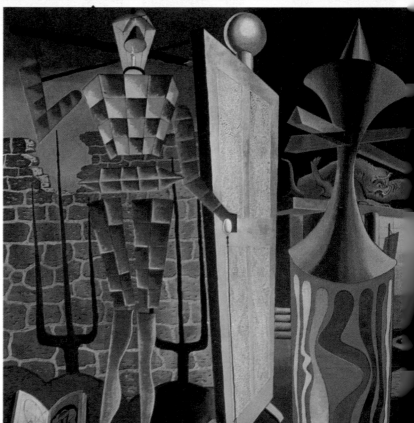

RAY, MAN:
Fine Weather. 1939

230

a kind of harlequin with disjointed limbs, and his reddish clothing looks like brickwork. His head is essentially a candle alight beneath a snuffer. At his feet an old geometry book lies open. The middle of the painting is taken up by a screen which is also a door. The harlequin is touching the door handle. A thread of blood runs down the door from the keyhole and gathers on the ground. To the right there is a second, probably female, individual,

It is true, however, that if Man Ray had produced only paintings, he would not be among the major Surrealist artists. His drawings are naïve and, in spite of their Magritte-like touches, are not the products of a great draughtsman. It was the photographs and objects of Man Ray which so intrigued the Surrealists. Apart from the rayograms, Man Ray made very effective use of solarization (the Sabattier effect), obtaining, for instance in the portrait of Lee Miller, a ghostly and at the same time sensual effect. Man Ray was rightly persuaded to make films and in *Emak Bahia* (1927), *L'Etoile de mer* (1938) and *Le Mystère du Château de Dé*, shot at the Noailles in 1929, he was able to find a personal

RAY, MAN: *Rayogram*

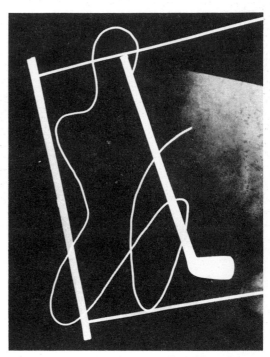

RAY, MAN: *Rayogram*

something like a bobbin with a multicoloured skirt under which feet can be discerned. Behind her (or him) there is a billiard table with a pathway running under it, and a glass-windowed building with a yellow light inside. On the terrace a fierce struggle is taking place between a dinosaur and a rhinoceros against the jet black night. Two baulks of timber cross one another behind the animals locked in combat; two candelabra-vegetables grow behind the first harlequin and in front of the wall. The whole picture gets its extraordinary effect by means of visual solecisms, such as the juxta-positioning of brightly-coloured areas in a general context of muted passages.

style halfway between the mechanical ingenuity of abstract films and the lyrical sadism of Dali and Buñuel, whose shock success in 1929 somewhat eclipsed any reaction to Man Ray as a film-maker.

Man Ray's objects come between Duchamp's ready-mades and Giacometti's 'symbolically functioning objects'. They are Surrealist in all respects with the bonus of an inimitable poetic humour. One of the first of these was *The Enigma of Isidore*

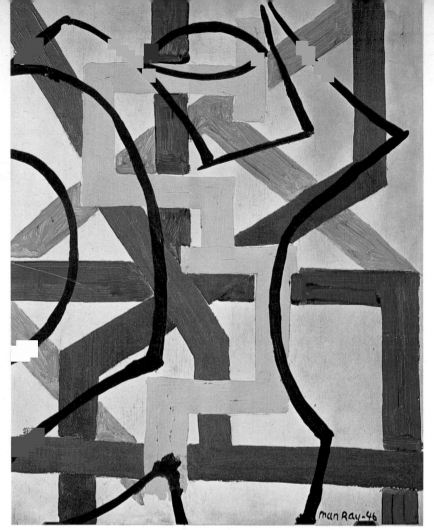

RAY, MAN: *Julie's Rhythm*. 1946

Ducasse (1920), a kind of mysterious parcel. The most famous is certainly *The Gift* (1921) in which the smooth under-surface of an iron has been fitted with spikes. Others worthy of mention are *Ball without Snow* (1922), *The Sleeve in the Sleeve* (1960) and *The Furnished Apartment of 1921* (1969). Most of Man Ray's objects are 'unpleasant objects', but he also calls them the 'objects of his affection'. Together with his rayograms and his charming portraits (like those of Kiki, Dora Maar and Juliet Brower, his second wife), it is the objects that put Man Ray among the most original Surrealists.

Man Ray: *Self-Portrait*, Boston, 1963.

REIGL Judith (Kapuvar, Hungary 1923). Judith Reigl went to Paris in 1950 and was vaguely associated with Surrealism between 1953 and 1955

before becoming a more deliberate Lyrical Abstractionist. André Breton said that her paintings were the first to translate Lautréamont into the language of the eyes. Great sweeping *raclage* effects give the rather decorative forms of *Feverish Lights* (1953) something of the quality of a seascape.

REMEDIOS Remedios Lissaraga Varo, known as (Anglès, Catalonia 1913–Mexico 1963). Remedios was the daughter of an engineer who took to painting early on. Her meeting with Benjamin Péret during the Spanish Civil War (1936) was her introduction to Surrealism. She went to Paris and then moved with Péret to Mexico in 1942. They separated in 1948 and Remedios stayed in Mexico where her strange painting was extraordinarily successful in 1954 and 1964.

232

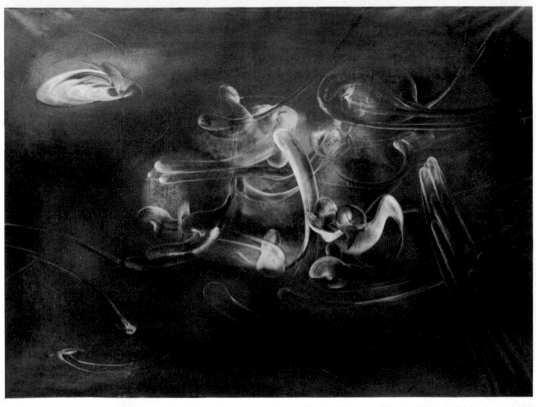

REIGL, JUDITH: *Torches of Chemical Marriages*. 1954

RICHTER, HANS: Scene from film '*Dreams that Money Can Buy*'. 1944

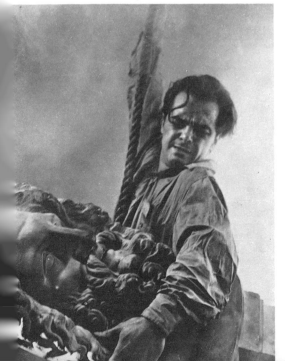

RICHTER Hans (Berlin 1888). After his first experimental exhibition in Munich (1916), Richter took part in Dadaist activities at the Cabaret Voltaire in Zürich. His *Visionary Portraits* (1917) were soon replaced by his abstract experiments and his '*rotules*', rolls from which shapes are unravelled. These led him to the cinema with *Rhythm 21, 23, 25*. His *Film Studies* (1926), his *Chapeau Vol-au-vent* (1927) are more Dadaist than Surrealist. In America he produced some cartoon films: *Dreams that Money can Buy* (1944, with sketches by Calder, Duchamp, Ernst, Man Ray and himself), and *8 × 8*, on the theme of chess (with Arp, Calder, Cocteau, Duchamp, Ernst, Huelsenbeck, Tanguy), from which two extracts were taken: *Dadascope* (1957) and *Passionate Pastime*.

RIOPELLE Jean-Paul (Montreal 1923). Riopelle was associated with the Canadian automatists and with Borduas, with whom he exhibited in 1946. In that year he went to Paris where he came

233

under the influence of Wols and Lyrical Abstraction. He co-signed the manifesto *Refus global* (Montreal, 1948) and in theory was close to Surrealism, although his painting with its sensuous treatment of the paint related him more to the *matiéristes*, for instance Dubuffet and certain members of the Cobra group. His retrospective *Ficelles et autres Jeux* was held in Paris in 1972.

ROY Pierre (Nantes 1880–Milan 1950). Pierre Roy was an extremely cultured man and a former student of the Ecole des Langues Orientales. His work was picked out by Apollonaire at the Salon des Indépendants in 1913. Around 1920 he came under the influence of Chirico and his paintings hardly escape the bonds of that convention in his

SAGE, KAY: *To-morrow is never.* 1955. Oil on canvas, 135 × 95 cm. Metropolitan Museum, New York

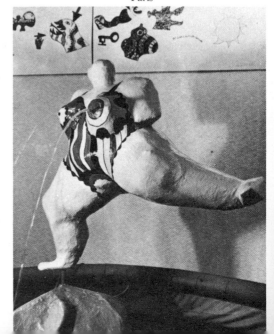

ROY, PIERRE: *Oenology.* 1931. Oil, 73 × 54 cm. Galerie André François Petit, Paris

SAGE Kay (Albany, N.Y. 1898–Woodbury, Conn. 1963). After studying in Milan, where she exhibited her abstract works in 1963, Kay Sage developed more figurative fantastic visions. She went to Paris in 1937 and was noticed by the Surrealists at the Salon des Surindépendants. She became the mistress of Yves Tanguy who married her in 1940. They lived together at Woodbury, Connecticut, and in this period the haunted space of the ghost cities endowed her canvases, such as *Tomorrow is Never* (1955), with a lyricism at once nervous and serene. Tanguy's death (1955) cast a shadow over the last years of her life. Her collection of poems, *Mordicus* (1962), was illustrated by Dubuffet.

SAINT-PHALLE, NIKI DE: *Nana Fountain.* Galerie Iolas, Paris

precise use of *trompe-l'oeil* effects (*Visit of a Windmill, Oenology*). Roy was a great traveller and liked to collect unusual stones, and flotsam and jetsam, to make his assemblages. His Paris retrospective in 1967 drew the attention of the practitioners of the New Realism.

234

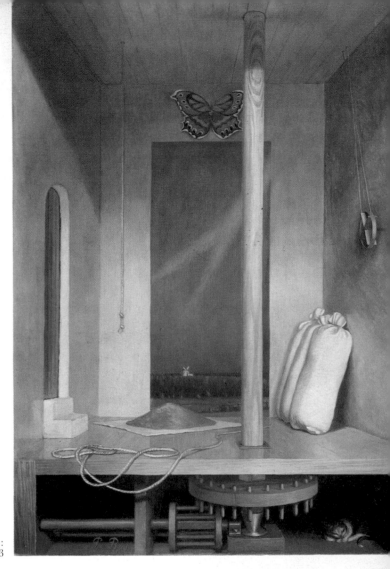

ROY, PIERRE:
Visit of a Windmill. 1933

SAINT-PHALLE Niki de (Paris 1930). The daughter of a general and at first a cover-girl, Niki de Saint-Phalle was one of the New Realists of 1961. The lyrical violence of her *Mother's Hearts*, kinds of assemblage, and her *Nanas*, enormous Ubuesque characters in brightly coloured plastic substances, put her at the centre of the cross-roads of Surrealism, Expressionism and Pop Art. At the Moderna Museet in Stockholm visitors enter a *Nana-Cathedral* through a vaginal door.

SAVINIO Andrea de Chirico, known as Alberto (Athens 1891–Rome 1952). While his brother Giorgio became a painter, Savinio studied

SAVINIO,
called ALBERTO:
Untitled. 1928

music at the Athens Conservatoire and then in Munich. He stayed with his brother in Paris from 1911 to 1915 and he made his first pen drawings. Without abandoning music he published some verse, such as *Les Chants de la mi-mort* (1914) and *Hermaphrodite* (1919). Between 1926 and 1934, in Paris, he developed his interest in painting in oils, gouache and pastels. His work is reminiscent of the *pittura metafisica*. Savinio often designed for the theatre, and his work for his ballet *Vita dell' Uomo* is especially interesting. A talented and many-faceted man, Savinio suggested (in the preface to the Italian edition of *Chants de la mi-mort*) that he was the source of his brother Giorgio's 'dummy period'.

SAVITRY Emile (Saigon 1903). Aragon introduced Savitry's exhibition in 1929 which consisted of paintings inspired by a reading of Lautréamont. Apparently the success of this exhibition made Savitry suddenly decide to stop painting. He left for Tahiti with Malkine. He returned to painting in 1945, but not to Surrealism.

SCHNEIDER Gérard (Sainte-Croix, Switzerland 1896). Schneider went to Paris in 1916. His

Schneider, Gérard: *Abstract Composition*. Musée National d'Art Moderne, Paris

thought was closer to that of Gurdjief than to that of André Breton. Since 1944 he has practised a form of gestural automatism with an emphasis on violence. Associated with the revolutionary Surrealists in 1946, Schneider became one of the major figures of Lyrical Abstractionism.

SCHOENDORFF Max (Lyons 1934). After studying literature, Schoendorff became Roger Planchon's co-worker from 1955 to 1958. He got interested in the cinema and produced some designs for the theatre, notably for Antonin Artaud's *La*

Schoendorff, Max: *The Word Key*. 1968. 100 × 81 cm. Galerie Verrière, Lyons

Pierre philosophale (1964). In his Lyons studio Schoendorff produces meditative pictures close to 'abstract Surrealism'. The warm tones and somewhat ragged forms of his dream-world are characterized by a certain amount of clothes fetishism. This can be seen for example in *Initial Catastrophe* (1967) and in *The Word Key* (1968).

SCHRÖDER-SONNENSTERN Friedrich (Lithuania, 1892). After an incredibly hard life (penal institution, agricultural worker, groom, smuggler, healer, prison, mental hospital) he began at the age of about sixty to use coloured pencils for his sardonic and lyrical images. Bellmer introduced the Surrealists to his work in 1959 and he exhibited at their EROS show (1959) and the *L'Ecart absolu* exhibition (1965). Since then Schröder-Sonnenstern has been represented at major exhibitions of fantastic art and is a good example of the inspired self-taught artist.

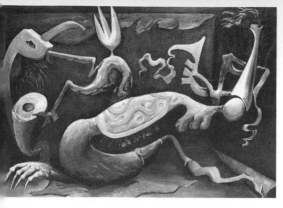

SELIGMANN, KURT: *The Second Hand*. 1940. 83 × 123 cm.
Galerie de Seine, Paris

SELIGMANN Kurt (Basle 1901–Sugar Loaf, U.S.A. 1962). A Swiss painter who was fascinated by heraldry, demonology and magic, he became associated with the Surrealists between 1934 and 1944. His *Ultra-Furniture*, a kind of stool with female legs, was a very successful exhibit at the International Surrealist Exhibition in Paris in 1938.

SÉRAPHINE DE SENLIS, Séraphine Louis-Maillard, known as (Assy 1864–Senlis 1934). A self-taught painter and housewife, who suffered

SÉRAPHINE DE SENLIS, known as, SÉRAPHINE LOUIS-MAILLARD: *The Tree of Paradise*. c. 1929. Musée National d'Art Moderne, Paris

from obsessive delusions, Séraphine was discovered by Uhde *c.* 1920, and became famous for her large paintings which are both decorative and oneiric, and in which bunches of flowers are packed with eyes that fix the spectator.

Wilhelm Uhde: *Cinq maîtres primitifs: Rousseau, Vivin, Bombois, Bauchant, Séraphine*, Paris, 1949.

SILBERMANN Jean-Claude (Boulogne-Bilancourt 1935). Silbermann started as a poet when in 1958 he published his *Au puits de l'ermite*. He began to paint *c.* 1961. In 1963 he cut strips of plywood in

SILBERMANN, JEAN-CLAUDE: *Artful Sign: Atheist Hatred*. 1966. Painted wood. Private collection

an imaginative way to produce his 'artful lessons' in which humour and a precise style go hand in hand. His object *Sauve qui peut*—'A design for a votive offering for a wrecker'—was exhibited at *L'Ecart absolu* (1965).

ŠÍMA Joseph (Jaromer, Czechoslovakia 1891–Paris 1971). Síma was a civil engineer who moved to France in 1921, where he at first worked for a master glazier. On two occasions he happened to observe thunderstorms which impressed him and gave rise to his 'electric storm' period (1926–8). That was when he met Breton and soon after founded (together with Roger Gilbert-Lecomte and René Daumal) the Grand Jeu group, which thereupon broke with the Surrealists. Síma's painting reflects his constant interest in 'space-light'. He returned to stained-glass in 1959. His mystical element kept him at the periphery of Surrealism.

SKLENÁŘ Zdenek (Czechoslovakia 1910). His life on the periphery of avante-garde circles and the precision of his uncompromising experimentation

SÍMA, JOSEPH: *Untitled*. 1933. National Gallery, Prague

gave Sklenář the reputation of being the 'last of the Surrealists' when he exhibited in Prague in 1948. He was not, of course, the last.

SPOERRI Daniel (Galati, Rumania 1930). After studying dance and pantomime in Zürich and Paris, Spoerri contributed his 'trap-pictures' to the Neo-Dadaist revolt against the traditional arts. These are assemblages of ordinary things presented on a surface, but stuck so that the surface can be hung on the wall, for instance. These still lifes sometimes emit a mysterious quality.

SPOERRI, DANIEL: *The Shower*. 1962. 64.5 × 90 cm. Schwarz Gallery, Milan

STEINBERG Saul (Rumania 1914). A caricaturist whose 'balloons' omit the text thus enhancing the effect of the drawings which have great humorous and satirical power. His collections *The Passport* (1954) and *The Labyrinth* (1958) follow in the tradition of Magritte and Maurice Henri, offering meditations on the often ludicrous intermingling of words and things and revealing the metaphysical implications of the linguistic absurd.

STEJKAL Martin (Czechoslovakia 1944). Stejkal's interpreted images are in the orthodox Surrealist tradition. For instance, in several progressive states, he transforms the photograph of a surgical operation into a portrait of Karl Marx—a work of his Prague period. His drawings and paintings evoke a certain *angst* with their accumulations of military scrap and were exhibited at Brno and Paris in 1972.

STERPINI Ugo (Rome 1927), Sterpini and the architect Fabio de Sanctis made delusional furniture, such as his *Armchair with an Armed Hand* (1965), which interested the Surrealists.

ŠTÝRSKÝ Jindrich (Cermna, Czechoslovakia 1899–Prague 1942). Štýrský met Toyen in 1922 and took an active part in the development of the Czechoslovak avant-garde group *Davestil* (with its review *Red*) towards Surrealism. His 1927 exhibition in Paris was introduced by Philippe Soupault and in Prague in 1933 he was one of the founders of the review *Surrealismus*. His paintings, for ex-

STÝRSKÝ, JINDRICH: *The Bathe*. 1934. Collage. Galerie Françoise Tournié, Paris

ample *The Bathe*, and especially his coloured collages, where sarcastic humour, anti-conformist and anti-clerical violence are given a free hand, assure him an important place in the struggle for freedom which has always been his main concern.

SVANBERG Max-Walter (Malmö, Sweden 1912). Fundamentally a craftsman, Svanberg became well known for his rich, poetic representations of women. He was attacked by polio in 1934. Ten years later he founded the Minotaure, a Surrealist group which almost immediately dispersed. Together with Karl Hulten, he founded in 1946 the Imaginist movement, which showed its work in Paris in 1953, and the Surrealists discerned a painter of the marvellous in Svanberg. An exhibition at L'Etoile Scellée (1955 and an entire issue of *Médium* (No. 3, 1954) are evidence of their enthusiasm for Svanberg, who did not meet Breton personally until 1964. Using an original medium of mixed ink pastels, but also glassware adjunctions, Svanberg has produced something approaching erotic icons (*The Messenger Maid of my Childhood with China Carnation*). His 'pearl mosaics' such as *Portrait of a Star I, II*, in addition to the traces of a sadism very much evident among the other Surrealist painters, accord with the mysticism of the 'Eve with Two Amphorae' of Breton's *Arcane 17*.

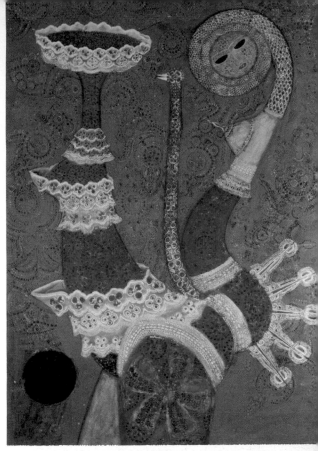

SVANBERG, MAX-WALTER: *The Messenger Maid of My Childhood with China Carnation*. Lund collection

SVANBERG, MAX-WALTER: *Untitled*. Gouache. 65 × 50 cm. Galerie André François Petit, Paris

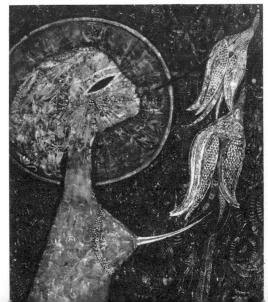

SVANKMAJER Jan (Prague 1934). After study-
ing the fine arts and theatre in Prague from 1950 to
1958, Svankmajer met his future wife in 1960. In
1969 he got to know Vratislav Effenberger, the
theoretician of the present-day Czechoslovak
Surrealists. From 1958 to 1964, Svankmajer pro-
duced drawings, collages and objects. Then he de-
voted himself to the cinema. His shorts, *The Last
Trick of Mr Edgar and Mr Schwarcewald, Garden, A
Quiet Week at Home*, and *Ossuary*. were shown at
several festivals, as was *Natural History Cabinet*
(1967). After 1969 he took part in the activities of
the Prague Surrealists. After a series of collages and

now lives in Prague as an independent painter. She
exhibited with the MAG group in Prague in 1964
and at the Nouvelle Figuration show at the Manès

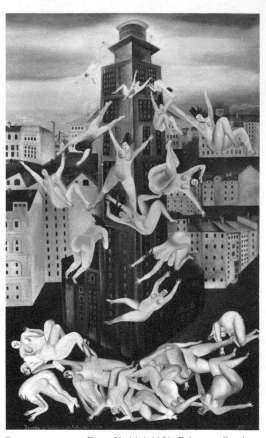

SVANKMAJEROVA, EVA: *Untitled*. 1971. Private collection

SVANKMAJER, JAN: *Untitled*. Object. Private collection

objects (1972–3) he began in 1974 a series of experi-
ments on the relations of touch and vision. He made
some 'touch objects'. His one-man shows have
taken place in Prague, at the Semafor Theatre
(1961) and at the Viola Theatre (1963).

SVANKMAJEROVA Eva (Kostelec, Czecho-
slovakia 1940). After studying in Kostelec, then in
Prague (1954 to 1962), Eva Dvorakova married
Jan Svankmajer. In 1968 she visited France. She

Gallery in 1969. Her painting owes something to
primitives but is technically competent and her
figurative precision includes humour in her fantasy.

TAMAYO Rufino (Oaxaca, Mexico 1899). Tam-
ayo is of Zapotec origin and had his first exhibition
in 1926, in Mexico. On the periphery of the official
realist painting (Siqueiros) he translates the lessons
of pre-Columbian cosmic symbolism into a fantastic
art which is very close to the Surrealist spirit. His
many exhibitions in New York, Paris, Zürich and
Recklinghausen (*Reich des Phantastischen*, 1968)
make him one of the masters of Latin-American
fantastic art.

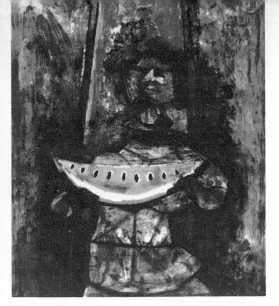

TANGUY Yves (Paris 1900–Woodbury, Conn. 1955). He was the son of a naval officer from Locronan (Brittany). After secondary school in Paris he became an apprentice in the French Merchant Navy off the coast of Africa and South America. National service as an infantryman took him in 1921 to Lunéville, where Jacques Prévert was in the same barrack room. This meeting rescued him from a breakdown; nevertheless he signed on for service in Tunisia. He was released in 1922 and accompanied Prévert to Montparnasse.

Tanguy lived from odd jobs and on his wits. He worked in a press agency and for a broker, and even became a tram conductor for a time. Together with Prévert he discovered Lautréamont's works in Adrienne Monnier's bookshop where he read issues of *La Révolution surréaliste*. The direction he was to take was becoming clear. In 1923 Tanguy is said to have jumped from the open platform of a bus at the risk of breaking his neck, because he had seen a Chirico in Paul Guillaume's window. He began to paint without any formal art training. In 1924, Marcel Duhamel who was the son of the director of a big Parisian hôtel and whom Prévert had got to know during military service, rescued his friends from misery by renting a house for them at 54 Rue du Château, Montparnasse. From then on the house was a home for Surrealists with nowhere to stay. There the group spent many hours in typical Surrealist games.

The day after the fuss at the 1925 Saint-Pol Roux dinner at the Closerie des Lilas, Tanguy and his friends visited André Breton. It was a fateful meeting. Tanguy's painting, which was rather hesitant when he first embarked on automatic work, began to show the style he favoured for thirty years: milky visions of a more or less precisely defined space. The distant horizon is sharp or vague according to the period. This 'continental shelf' is

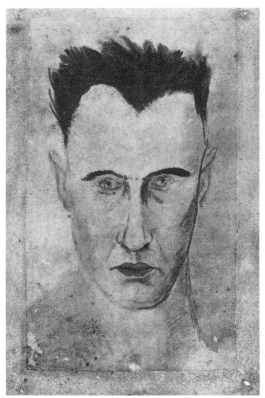

TANGUY, YVES: *Self-Portrait*. 1925. Watercolour, 13.5 × 8.5 cm. Galerie André François Petit, Paris

inhabited by creatures halfway between organic life and minerals. From its seventh issue (June 1926), *La Révolution surréaliste* regularly reproduced Tanguy's works. *Genesis* (1926) is composed rather in the manner of a *'cadavre exquis'* (the game of consequences the Surrealists played so often in the Rue du Château): there is a kind of dark, fleecy

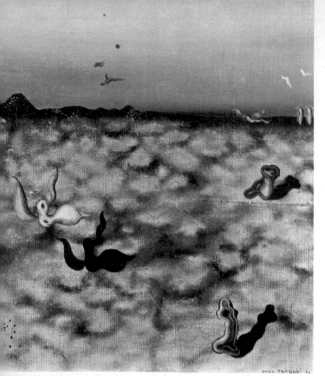

the horizon gradually becomes blurred. In *Boredom
and Peace*, the ground is as uneven as an oily sea and
the horizon is vague. The bony fossils and
scattered corals are connected by imperceptible
threads. But their shadows are dark on the ground
and seem to attract light from the direction of the
spectator's right shoulder. Tanguy is very fond of
this kind of lighting from the front on a misty back-
ground. Its full pictorial effects are apparent in
Indefinite Divisibility (1942).

Tanguy worked meticulously in a bare white
studio with nothing in it but a primed canvas. His
nervous tension and the somewhat neurotic charac-
ter of his dream world were enough to enclose him
in this universe at the boundaries of life. No human
being ever appears in his fossil deserts, where the
unpotable water erodes the vestiges of former cata-
strophes. When the war broke out, Tanguy re-
joined in New York the American abstract painter
Kay Sage with whom he had had an affair in 1939,
and married her. In 1941 other Surrealists escaped
to the United States. After a trip to the west,

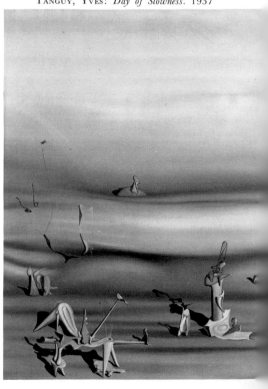

TANGUY, YVES: *Day of Slowness*. 1937

menhir in transparent scumble-work but without
any highlights, from which a hand, presumably
divine, emerges. Behind the menhir, a little dancer
ascends a tightrope to the top of an obelisk. On
the vaguely marshy ground there is a green snake
and a mysterious abandoned black cone. A tree is
growing on the top of the menhir. More typical of
Tanguy's style are *They Shoot Me Tomorrow* (1927),
The Flight of the Owls, Your lights Are Shifting—in
which the creatures rise above the precisely de-
lineated horizon—*The Plain of Springs* (1929), a
beautiful prospect of hills marked with streams, and
Death Watching his Family.

Tanguy's works after the African journey he
made in 1930 seem to have been influenced by his
emotive reaction to the geology of the wilderness.
But his dreamscapes had already prepared for that.
The Cupboard of Proteus (1931), *The Ribbon of Excess*
(1932), where in front of a nebulous boundary
beyond which horizon and sky are confused, equi-
vocal beings twist and dance in a bright, clear
light, *The End of the Ramp* (1934), *Between Grass and
Wind*, are paintings from this period and show how

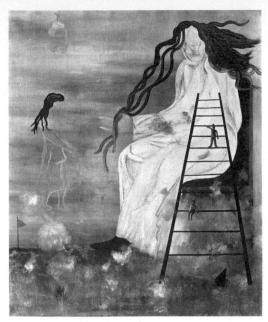

TANGUY, YVES: *Untitled*. 1926. 100 × 81 cm. Galerie
André François Petit, Paris

centre, a mushroom head, calcified timber like
concrete pylons scattered here and there, schistose
fragments whose beds are revealed by the oblique
light, quadrangular palettes, weathered bones, soft
pyramids, a prism in the left-hand corner, coral
shapes everywhere—a bleached nightmare vision.

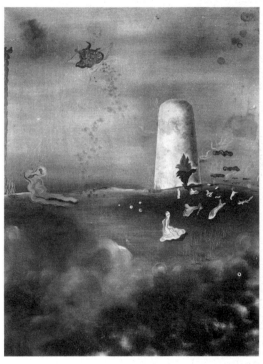

TANGUY, YVES: *Death Watching his Family*. 1927.
100 × 81 cm. Galerie André François Petit, Paris

Tanguy and Kay Sage moved to a farm at Wood-
bury, Connecticut. The barn served as a studio and
proved a fertile retreat. Tanguy took American
nationality in 1948 but did not lose contact with the
other Surrealists. Ernst was at Sedona (Arizona)
and he went to see him there in 1951. Two years
later when he had exhibitions in Rome, Milan and
Paris, Tanguy made an extended trip to Europe. He
was fifty-five at the time of his death, probably
brought on by drinking, and at the height of his
career.

In 1942, when the review *Verve* devoted a special
issue to him, he painted *Northwards Slowly* and
Indefinite Divisibility, where the objects grow bigger.
The Last Days (1944), *Closed Sea, Open World* (1944),
The Procurer (1945) were followed by the odd
Tachist and nocturnal chaos of *Real Numbers* (1946).
Tanguy's last picture was *Imaginary Numbers* (1955).
Shortly before he had painted his 'testament',
Multiplication of the Arcs (1954). M. Soby, his bio-
grapher, has said that Tanguy obviously sensed that
Multiplication of the Arcs would sum up the wishes
and interests of a lifetime. With a misty, even a
foggy sky, the plain in the foreground is almost
completely covered with an immobile yet swarming
mass. The variety of forms, of flints, trochleas,
knuckle-bones, and so on, is almost infinite. Some
constantly recur: the large round pebble shape or
the viscous substance which emanates from the

Tanguy did not neglect any of the illusionist
tricks of figurative painting: concavities, lines of
recession to the horizon, diffuse or directed lighting,
with modulated shadows. Nevertheless his work is
more abstract than that of many painters who
schematize living and even human shapes. In
Tanguy's painting there is nothing among his
figures which we cannot name or at least describe.
His dream world is a unique, ever-consistent vision.
He relies on one initial obsessive point. Yet this
apparently restricted theme opens on to an un-
restricted moral and emotional cosmos: space,
germination, an ever-increasing population of
bone-creatures, ageing, petrifaction, living death,
suffocation in an unbreathable element, atmos-

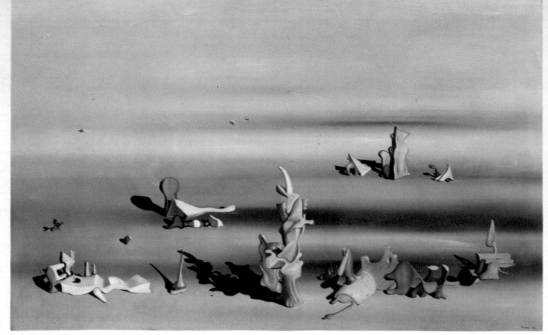

TANGUY, YVES: *If it were*. 1939. Private collection

TANGUY, YVES: *Between Grass and Wind*. 1934. Oil on canvas, 46 × 34 cm. Galerie de Seine, Paris

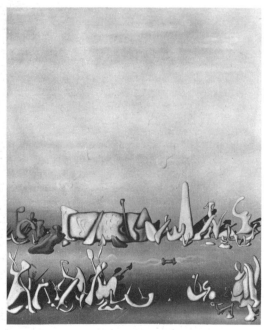

the perspective losing itself in air and water, the volcanic slag, the funereal end of a not entirely unsufferable tragedy. All this is contained in his canvases.

Under Tanguy's influence Kay Sage's painting began to feature a similar, though somewhat less murky space. But few disciples have succeeded in making, with the same perseverance, Tanguy's descent in search of an inward model. Anyone trying to follow him produces stereotyped work. This shows the unique and inimitable nature of his pictorial poetry. Tanguy's fame has not yet brought any major retrospectives, but his following is assured, especially in America; and grows, rather than fades with time. Tanguy is inimitable but the lesson of his lonely undeterred struggle is one that young painters would do well to study rather than the uncertainties of contemporary practice.

André Breton: *Yves Tanguy*, New York, 1947
James Thrall Soby: *Yves Tanguy*, New York, 1955.

TANNING Dorothea (Galesburg, Ill. 1910). When she was still at school she illustrated Beardsley, then took off for Chicago, and New York where she worked as a film-extra and model. The exhibition *Fantastic Art, Dada, Surrealism* (New York, 1936) opened her eyes to Surrealism and started her on her career as a painter. In a precise, obsessive style she paints the dreams of young girls intent on

pheric chamber, aftermaths of disaster—there is even a hint of the legendary town of Ys, said to have been engulfed by floods not far from Locronan—

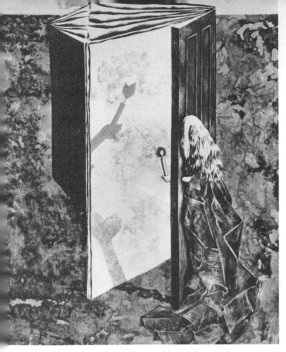

their bodies: *Birth Day* (1942), *The Friends' Room* (1946). She met Max Ernst in 1942, married him in 1946 and went to live with him in the solitude of Sedona (Arizona). They moved to Huismes, Val de Loire, France in 1955, and then to Provence. Her painting has become more allusive, mixing nebulously errant sensual shapes. Sometimes, when the figurative work is even more precise, an enormous dog takes part in the neurotic orgies. Tanning designed some *décors* for Balanchine and illustrated André Pieyre de Mandiargues' *La Marée* (1962).

TEIGE Karel (Czechoslovakia 1900–Prague 1951). Teige was the moving spirit and theoretician of the Czechoslovak Surrealist group whose exhibition he organized at the Salle Manès in 1935. He continued to organize the group in 1938 even though V. Nezval announced its disbandment. He published his manifesto *Le Surréalisme à contre-courant* in that year, and produced some interesting collages. When war came Czechoslovak Surrealists had to work in secret. Then the Communist 'coup'

TANNING, DOROTHEA: *Fatala. c.* 1945. Lithograph in colours. Private collection

TANNING, DOROTHEA: *Meeting.* 1952.

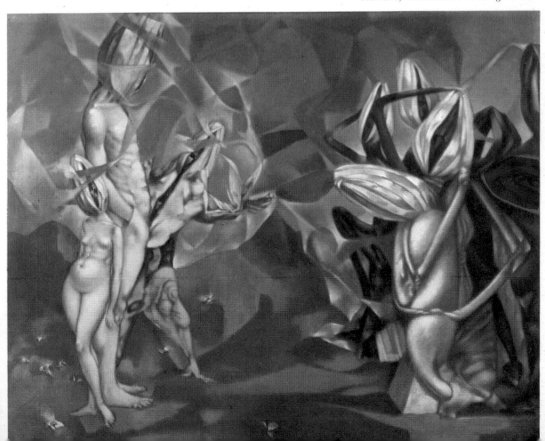

in 1948 brought a new check on artistic freedom. Kalandra was executed in 1950 after a Stalinist show-trial and Karel Teige and his companion Joska committed suicide on their arrest in 1951.

TÉLÉMAQUE Hervé (Port-au-Prince 1937). After studying art in New York, where he was influenced by Gorky, Télémaque went to Paris in 1961. His work is related primarily to Abstract Expressionism but erotic themes mingle with his

fetishistic eroticism is tinged with enough humour to move his essential Surrealism in a Pop Art direction.

TERROSSIAN Jean (Paris 1931). Terrossian began to paint *c.* 1960. The influence of Gorky and Matta is obvious in such works as *The Trap* (1965). Terrossian then took objective representation far enough to elicit an elliptical poetry in successful works like *Nuptial Flight* (1965) and *Half-Crime, Half-Reason* (1971).

THEIMER Ivan (Olomouc, Czechoslovakia 1944). After four years at the Higher School of Arts and Crafts in Czechoslovakia and two years at the Ecole des Beaux-Arts in Paris, Theimer produced monumental sculpture at Olomouc, Huk-

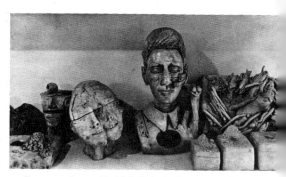

THEIMER, IVAN: *Untitled*. Galerie Taménaga, Paris

TÉLÉMAQUE, HERVÉ: *Confidence*. 1965. Object/Painting, 195 × 130 cm. Private collection

valdy and Prerov. He left Prague in 1968. He is now a painter, engraver and sculptor and lives in Paris and at Poët-Laval (Drôme). The unity of his work relies on his enigmatic though cool juxtapositioning of volumes, or smiling and wounded heads. In the foreground of his engravings with their infinite horizons, he puts a round hole through which he inserts a thread.

forceful automatism. Around 1963 the use of adjunctions, and then a kind of visual purification, led to such picture-objects as *Confidence* (1965), in which

TIKAL Václav (Czechoslovakia 1906–1965). Tikal joined the Ra group shortly after it was founded in 1942 and took part in the group's major exhibition at Brno in 1947. His work puts him among the highly figurative Surrealists, though later he showed abstract tendencies.

246

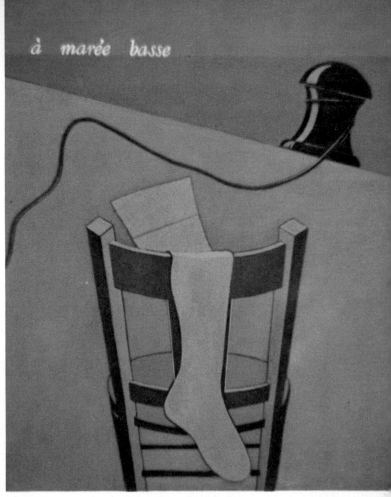

à marée basse

TERROSSIAN, JEAN:
Half-Crime, Half-Reason. 1971

TOPOR, ROLAND: *Untitled.* 1967

TOPOR Roland. Topor is a former student of the Ecole des Beaux-Arts in Paris. He started as a painter and began drawing to earn a living. His work revealed a unique, lyrical vision of the absurd which places him among the followers of Magritte. Topor has illustrated Gogol, Tolstoy, and George Sand. He has invented a game, *Topsychopor*, and published several collections of drawings, among them *Anthology* and *The Truth about Max Lampin*, as well as novels, including *Erika*, an erotic work of 150 words and 150 pages.

TOVAR Ivan (San Francisco de Macoris, Dominican Republic 1942). Tovar's first exhibition was held in San Domingo, and he then showed work at the Paris biennials from 1963. He went to Paris in 1964 and exhibited at the *Spirit of Surrealism* show in Cologne in 1971. His painting is reminiscent of Dedicova and even Yves Laloy. He uses a quasi-abstract technique to display creatures or objects

247

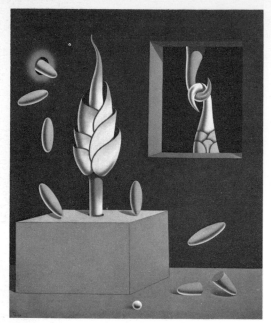

Tovar, Ivan: *A Heavy Secret*. 1974. Oil on canvas, 100 × 81 cm. Galerie Albert Loeb, Paris

Czechoslovak avant-garde group was held at the D.37 Theatre in Prague. Works by Muzika, Sima, Stýrský, Toyen and other fantasy painters were exhibited. The influence of a highly figurative Surrealism was paramount. This was the period when Toyen was producing such canvases as *Fright* and *Horizon*. *The Sleeper* (1937) is a young girl with her back to us; she is holding a butterfly net and seems frozen in mid-sky; but her schoolgirl's smock is open at the back and we can see that it is empty.

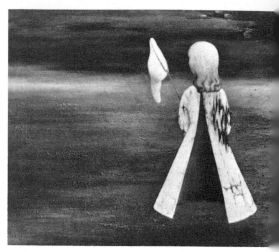

Toyen, Marie Cernunová: *The Sleeper*. 1937. Collection: Mr Philip B. Nichols, London

which are both erotic and mechanical. *The Windball* (1971) is a good example of his ability to produce fantasies controlled by precise ornamentation.

TOYEN Marie Cernunová, known as (Prague 1902). Toyen was a member of Prague avant-garde circles from 1921. She began by painting abstractions which already contained themes which would be constant in her work: *angst* and mystery. She was the companion of Stýrský, whom she met in 1922, and took part in the activities of the Davetsil group which was influenced by Cubism, Expressionism and Abstraction. After an initial period in which she drew on popular tradition for the style of *Dancers* and *The Magi*, she made some experiments in automatism. *The Drowned Ship* (1937) and *Swamp* (1938) display a spontaneity which prefigures the effects of Abstract Expressionism. Gradually her paintings fill with dream imagery as in *North* (1931), and *The Red Ghost* (1934) with its cracked rocks and eerie haze.

Surrealism arrived officially in Prague when Breton and Eluard were welcomed in 1934 (and greeted by the Communist Party newspaper). Next year, Toyen visited Paris with Stýrský. Henceforth her loyalty to Surrealism and her friendship with Breton never failed. In 1937 an exhibition of the

A major Toyen exhibition in Prague in 1938 celebrated the painter's adoption of a figurative style which remained, until 1947, very close to that of Magritte and the dream narrators. But Toyen's work in this vein always exhibits an extremely effective simplicity and a kind of melancholic poetry which is less intellectual than Magritte's. A woman in a white veil is seated on a stool in a kind of desert-like place. Behind her blue fishes are piled up to the level of her head. But at a distance, above the horizon, the fishes are bleached skeletons. This picture of 1943, *In the Long Shadows*, appears to be a meditation on the theme of hunger. *The Dangerous Hour* (1942) shows an open-winged eagle, as if on a standard, with white, crossed strangler's hands. *The Process of Liberty* (1946) features a woman covered with peas in pods, a symbol of consummation or fertility. This is the period of Toyen's drawings when the theme of anxious protest was amplified by political themes:

Desert Spectres (1937), *The Shoot* (1940), *Hide Yourself, War* (1944). The same tendency reappears in 1949 in the series of etchings *Neither Wings nor Stones*: *Wings and Stones*. Here the birds which so often haunt Toyen's imagination—and the works of many Surrealists—are accompanied by skeletons.

In 1945, in Prague, Toyen exhibited the works she had produced in secret during the dark years of the German Occupation. Her exhibition at Denise René's Gallery in Paris in 1947 came only a short while before her definitive move to France. She thus escaped the fate of the intellectuals and artists of the Czechoslovak avant-garde after 1948. She took part in the activities of the Parisian group and her friendship with Breton is well expressed in: 'Introduction à l'oeuvre de Toyen' (*Le Surréalisme et la peinture*, pp. 207–14): 'I can never recall without emotion Toyen's noble countenance, the tremor deep within, but at the same time the rock-hard resistance to the most savage attacks, and her eyes like pools of light.'

The rock did in a sense crack, to allow the ghost of a wolf to appear, in *At Château Lacoste* (1946), a reference to the Provençal home of the Marquis de Sade, a hero of the Surrealists. After 1950, with *They Rise at Daybreak* and *Tied and Retied*, space becomes fuzzier, and Toyen's line concentrates on essentials; the colour is often austere but remains subtle here and there; human profiles are mixed with birds. *The Green Table* gives the impression of a deserted country, with an empty house and two pairs of birds preparing to fight. With the *Sleepwalker* (1958) where the theme of the *Sleeper* of 1937 is recalled in an elliptical, near-informal style, the

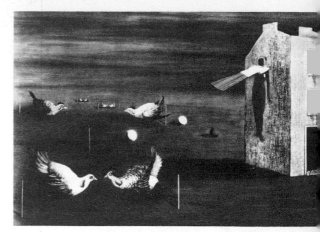

Toyen, Marie Cernunová: *At the Green Table*. 1945. Private collection

white shade whose body is touched by darkness is spinning on a tightrope. *Midnight at the Heraldic Hour* (1961) is a dream in which luminous presences tease the imagination half way between Brauner's 'twilights' and Rorschach ink-blots. This *Sleepwalker* is closely related to *The Woman in White* (1958) and *The Mirage*, in which the discreet eroticism of this or that detail—a ringed finger, the only wholly

Toyen, Marie Cernunová: *The Dangerous Hour*. 1942. 92 × 73 cm. Galerie André François Petit, Paris

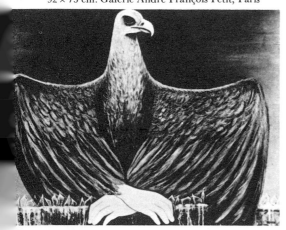

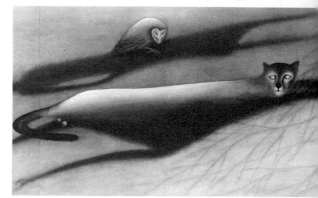

Toyen, Marie Cernunová: *The Mirage*. 1967. 60 × 120 cm. Galerie André François Petit, Paris

figurative element of *The Woman in White*—shows that Toyen shared Surrealism's descent in the 1960s towards the dark core of erotic oneirism. There are more tragic notes in some works, for

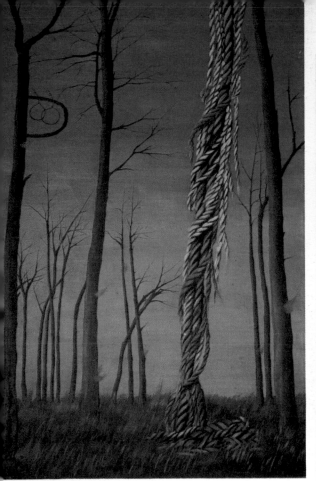

TOYEN, MARIE CERNUNOVÁ: *On the Edge of the Wood.* 1945. Oil on canvas, 107 × 71 cm. Galerie de Seine, Paris

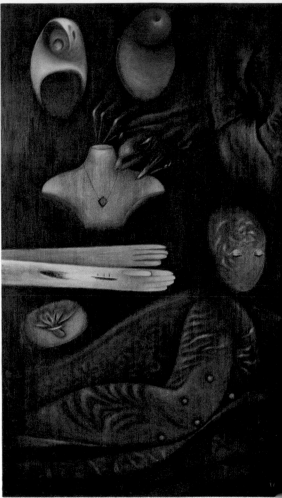

TOYEN, MARIE CERNUNOVÁ: *One in the Other.* 1965. Oil on canvas, 149 × 89 cm. Private collection

example in *Breathing Space* (1943) which shows a headless woman hanging by the feet, or in *At a Certain Time* (1963) in which the naked breasts of a girl driven mad by fear of rape are seen behind the dark panes of a window. More characteristic of Toyen's allusive manner is *One in the Other* (1965) where objects from a fetishist dream, notably a pair of very long white gloves cut off at the wrist, are arranged neatly on a dark ground, to suggest words on a page.

Toyen is little known outside the circle of initiates, since she has hardly exhibited anything for some years. But her works once seen linger in the mind. She has successfully combined figurative allusion and the suggestive power of pure pictorial work. *There is a Nightingale in the Night* (1960) continues her obsession with birds, and shows granulated forms sparkling like stalactites before a distant moon. The veins of a leaf or an open pod, the petrified head of a fox (or wolf) interrupt this night time of equivocal figures so familiar in Toyen's work.

André Breton, J. Heisler and B. Péret: *Toyen*, Paris, 1953.

TROUILLE Clovis (La Fère 1889). After studying at the Ecole des Beaux-Arts in Amiens, Clovis Trouille stopped painting and in 1920 became a make-up artist for advertising models. (In 1960 he received a national award for professional achievement.) When he took up his brush again in 1930 he worked on his 'anti-everything picture' *Remembrance*, which was in the style of *The Palace of Wonders* (1907), the only work he had produced

until then. He was discovered by the Surrealists at the Exhibition of Revolutionary Writers and Artists, and took to an extreme several Surrealist principles:

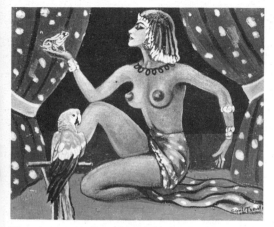

TROUILLE, CLOVIS: *A Woman of Tenderness*. Oil on canvas, 22 × 27 cm. Galerie de Seine, Paris

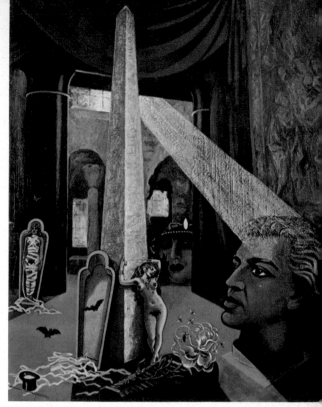

TROUILLE, CLOVIS: *The Sleepwalking Mummy*. 1942. 100 × 81 cm. Private collection

black humour, anti-clericalism, eroticism, and a kind of absolute yet peaceful rebellion. From *The Orgy* (1930) to *Voyeuse* (1961), by way of *A Woman of Tenderness*, *Dialogue on Carmel* (1944), *My Obsequies* (1945) and *My Grave* (1947), not forgetting *The Great Amiens Poem* in which Christ is shown laughing, Clovis Trouille's very precise Sunday paintings combine Surrealism with popular imagery. In 1963 his erotic works were shown (behind locked doors) at Cordier's in Paris. One of his paintings supplied the title for the 'sexy' Broadway revue *Oh! Calcutta* (1970).

Jean Marc Campagne: *Clovis Trouille*, Paris, 1965.
Raymond Charmet: *Clovis Trouille*, Paris, 1972.

UBAC Raoul (Malmédy, Belgium 1910). A painter from the Ardennes, he went on a European walking tour when he was nearly twenty, and worked as an industrial photographer until the war. In 1930 he abandoned his first attempt at painting. He specialized in monochrome work. His photomontages appeared in Nos 10 to 11 and 12–13 of *Minotaure*. One of these was a solarization, and the magazine also illustrated his 'fossil' views of Paris. Around 1938 he took to pen drawing before trying slate sculpture. At one time he was connected with the Cobra group and, especially in sculpture, con-

UBAC, RAOUL: *Fossil of the Bourse, Paris*. 1937. Photo relief

centrated on the abstractionist tendency in Surrealism and its interest in the qualities of the material.

URSULA Ursula Schultze-Bluhm, known as (Mittenwald 1921). Since her first exhibition in 1954 Ursula has joined the ranks of the spontaneists whom the Surrealists compare to mediums. She has produced objects, bronzes and collages which extend Bellmer's erotic dreamwork.

VELIČKOVIČ Vladimir (Belgrade 1935). After studying architecture in Belgrade, Veličković worked in a state-controlled studio at Zagreb (1962–3). In 1966 he moved to Paris. His many exhibitions have shown him to be as virtuoso a draughtsman as Bellmer. But his sadistic obsessions with bloody

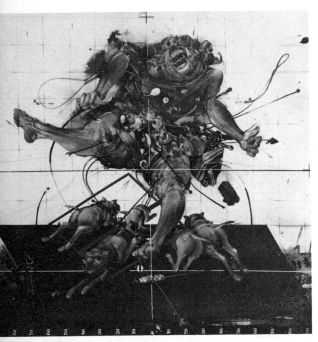

VELIČKOVIČ, VLADIMIR: *Bites*. 1972. Oil, crayon and chalk on canvas, 195 × 195 cm. Galerie Hervé Odermatt, Paris

childbirths attended by rats, with spiny creatures under the scalpel, and anatomical illustrations link him more with Antonin Artaud's version of tragedy than with the marvellous as understood by the Surrealists.

VIVANCOS Miguel (Mazarron de Murcia 1897). Vivancos was a colonel in the Spanish Republican Army. He began to paint *c*. 1950, the year in which

VIVANCOS, MIGUEL: *The Garden of Birds*. 1954. Collection: Anatole Jakovsky

André Breton wrote the introduction to his Paris exhibition. His still lifes and his *Garden of Birds* (1954) are close to the work of the Douanier Rousseau.

VOZNIAK Jaroslav (Suchdol, Czechoslovakia 1933). Vozniak's first exhibition at Prague in 1963 put him in the tradition of the Surrealist collagists. He then came closer to Pop Art in his cruel and disturbing collages.

VULLIAMY Gérard (Paris 1909). Vulliamy was at first a member of the Abstraction-Creation group, and in 1934 turned to Surrealism. In 1936 with *The Mystery of the Nativity*, and above all in 1937 with his large canvas *The Trojan Horse*, he revealed a fantastic vision in which a Boschian fire gives the viscous flux of forms a disturbing sense of cosmic slaughter. Vulliamy had been Eluard's son-in-law and in 1971 took part in the activities of the Main à Plume group. After the war he reverted to abstraction. *The Trojan Horse* was re-exhibited in Paris in 1971. It is almost unique among Vulliamy's pictures and is one of the masterpieces of Surrealism.

VULLIAMY, GÉRARD: *The Mystery of the Nativity*. 1936. Oil
on wood, 34 × 42 cm. Private collection, Switzerland

WALDBERG Isabelle (Oberstammheim, Swit-
zerland 1911). After studying in Montparnasse and
at the Ecole Pratique des Hautes Etudes (ethno-
graphy and sociology), Isabelle Waldberg held her
first sculpture exhibition at the Art of this Century
Gallery in New York in 1944. Her sculpture, as in
The Hunt (1962) or *The Casket* (1965), merges a
subdued lyricism with controlled and unaccus-
tomed forms. She was included in the Surrealist
retrospectives of 1971 (Cologne) and 1972 (Munich
and Paris).

WALDBERG, ISABELLE: *The Sextant*. 1954. Metal. Height
105 cm. Private collection, Paris

WILSON, ROBERT 'SCOTTIE': *Hand-made pendrawing. c.* 1944.
Collection: E.-L.-T. Mesens, London

WILSON Robert 'Scottie' (Glasgow 1888–1972).
Scottie was a junk dealer who emigrated to Canada.

253

When he was about forty he began to make pen drawings whose intricate convolutions are reminiscent of North American Indian art.

WOLS Wolfgang Schülze, known as (Berlin 1913–Paris 1951). Wols was the son of the Head of the Saxon State Chancellery and spent his youth in Dresden. From the age of seven he showed exceptional ability as a musician, especially on the violin. He became interested in photography which he learned as a pupil of Genga Jones. In Berlin in 1932 he came for a short time under the influence of the Bauhaus before moving to Paris. He lived by giving German lessons and making portrait photographs, and began work on some small format watercolours. These were his 'psychic improvisations', where Surrealist humour and dreamwork were interlinked with the delicacy of a Klee. Together with his companion Grety whom he had met in Paris in 1933, he went for a time to Barcelona and then returned to Paris where he was briefly the official photographer of the Pavillon d'Elégance at the 1937 Exhibition. When war broke out he was interned as a German citizen for fourteen months. On his release in November 1940 he took refuge in Cassis. Alcohol

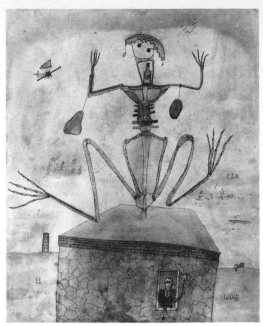

WOLS, WOLFGANG SCHÜLZE: *The Frog's Skeleton*. 1939.
Watercolour, 37 × 29 cm. Galerie Beaubourg, Paris

WOLS, WOLFGANG SCHÜLZE: *Bikini Piano*. 1939–40.

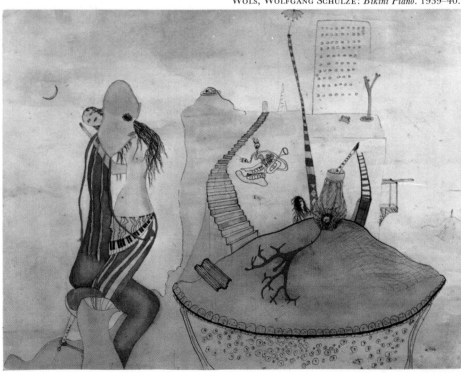

and pain give his graphic work a sharp visionary quality. At Dieulefit (Drôme) in 1942 he met the collector Henri-Pierre Roché and René Drouin mounted an exhibition of his watercolours in 1945. Sartre's friendship, the influence of the tragic Artaud, and his transition to work in oil in larger formats are important events in these years, which is also the period of the *Ruined Cathedrals* exhibited

WUNDERLICH, PAUL: *Sofa. c.* 1970. Etching

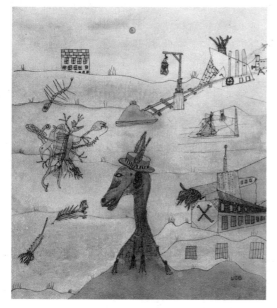

WOLS, WOLFGANG SCHÜLZE: *The Little Horse*. Watercolour, 27 × 23 cm. Galerie Beaubourg, Paris

by Drouin in 1947: generous swirls indicate one of the origins of lyrical abstraction. Wols, who was known as the 'last of the *peintres maudits*', took a cure for alcoholism and his work was moving in a new direction when he died from accidental poisoning. His meditation on death and his serenity, which he took from Lao-Tse, was married in his work with a certain sarcasm, but also with an acute sense of the marvellous and an exemplary use of freedom.

WUNDERLICH Paul (Berlin 1927). Wunderlich studied art at the Hamburg Fine Arts Academy. He was in Paris from 1960 to 1963 before accepting a chair at his old academy. In 1967 he left the post to devote himself to his own experiments. His first Paris exhibition was in 1972 and included the series of lithographs *20 June 1944* (the date of the unsuccessful plot against Hitler); their dark Expressionist technique illustrates the themes of

suffering and mutilation. An erotic dimension and a Surrealist evocation of the marvellous entered Wunderlich's work when he began to study the rôle of women, and in particular Karin (his wife and a professional photographer). Sometimes Karin's photographs are the inspiration behind Wunderlich's paintings and engravings, whose precise yet oneiric imagery reveals the ancient dialectic of sex and death.

ZIMBACCA Michel (Paris 1924). A poet of Syrian origin who made a short film—*Square du Temple*—from his window, he was associated with the Surrealists from 1949 and together with Benjamin Péret and Jean-Louis Bédouin made the film *l'Invention du monde* (1950).

ZIMMERMAN Jacques (Hoboken, Belgium 1929). This painter had the backing of Edouard Jaguer and the review *Phases*. His first exhibition was held in Brussels in 1951.

ZIMMERMAN Mac (Stettin 1912). A Munich painter in the line of Tanguy, whose message he rather sweetens. Zimmerman exhibited at the Surrealism in Europe exhibition at Cologne in 1969.

ZIVANOVIC-NOE Radojica (1903–1944). He was a member of the Yugoslav Surrealist group (centred on the review *Nemoguié* from 1930) whose particular use of dream motifs is in the Dali tradition.

ZÜRN Unica (Berlin-Grünewald 1916–Paris 1970). Zürn met Bellmer in Berlin in 1953, and then began to draw and produced the collection *Hexentexte*. In Paris she lived with Bellmer and he helped her to show her drawings and gouaches. Unfortunately she was a schizophrenic and repeated attacks forced her on several occasions into psychiatric clinics in Berlin, Paris and La Rochelle. She published *Oracles et spectacles*, poems illustrated with engravings; *Sombre Printemps*, a childhood autobiography, and *L'Homme-jasmin*, about her psychiatric

ZÜRN, UNICA: *Untitled*. Drawing. Galerie le Point Cardinal, Paris

ZÜRN, UNICA: *Untitled*. 1959. Drawing. Galerie André François Petit, Paris

problems. Finding life intolerable, she committed suicide by jumping from a window. Her pen drawings express most intensely her obsessions and tragic life.

Glossary of terms
and techniques

ADJUNCTION, ASSEMBLAGE, ACCUMULATION.

Adjunction (Fr. 'adjonction') is a process by which the painter adds various materials, sawdust, sand, glass chips, to the (oil) paint on his canvas or board; or sticks onto the picture scraps of paper, cardboard, cloth, and so on, which are mixed or not mixed with the paint; or fixes objects (in various ways) on the painted surface: old clothes, pieces of furniture, bits of machines, even working neon light tubes.

Papiers collés were invented by Braque and Picasso in 1912 and are 'adjunctions' or additions to the painting. If the picture consists exclusively of juxtaposed fragments cut from other images (prints), or pieces of paper, cloth (Enrico Baj), they are known as *collages*. If the artist juxtaposes real objects, he is producing *assemblages*, as is the case with Daniel Spoerri's shower fixed on a canvas; or *accumulations* as with some of Arman's boxes. If the assemblage abandons the structure of the easel painting and assumes some special shape on the wall or in space, we call these properly *montages*, *relief-montages* or *object-montages*.

The hazy areas between these various processes are of great artistic and poetic interest. There are the sand pictures of André Masson, which are made by adjunction; and the Merz collages of Kurt Schwitters which are on the borderline between collage and assemblage. The reliefs of Hans Arp (1917) or Mortensen are pictures made from cut wooden boards superimposed on one another and then painted: these are not adjunctions but paintings with special supports, as are Marcel Janco's painted plaster reliefs (1916). Relief paintings covered with cloth or plastic sheet in which the shape is submerged (Aline Gagnaire, *Portraits*, 1962; Pol Bury, 'multi-plans' under plastic membranes, 1960) also use adjunctive techniques, as well as *assemblage* and *relief-montage*. In the case of glass or where the work is displayed between two sheets of glass (Marcel Duchamp, *The Bride Stripped Bare by her Bachelors, Even*, 1913–22) the main technical problem depends on the support.

The history of adjunctions in painting has been considerably richer since the onset of the Dada movement. It is in fact very old. We must go back beyond Cubism and Futurism to the medieval icons encrusted with precious stones. Obviously the artist's intentions determine the use of this or that process in novel and individual ways.

AEROGRAPHY.

Man Ray gave this name to the process of painting with a spray gun, which he often used in 1918 to 1920, sometimes on glass.

ANALOGY.

A fundamental principle of alchemy and astrology which has been defined as follows: 'all which is found above has its analogy below . . . and everything constitutes a unity' (Zohar). The human body is seen as a microcosm. The imaginary process of reason which the modern sensibility finds in this principle recommended it to poets and especially to the Surrealists. In a text of 1947 ('Signe ascendant' in *Néon*, No. 1 and *La Clé des champs*, 1967), André Breton writes: 'I have never experienced intellectual pleasure anywhere but on the level of analogy' and he adds, while regretting the loss of primordial knowledge: 'Only the analogical trigger fascinates me; it is the only way in which we can influence the world engine. The most sublime word we possess is the word LIKE, whether it is actually uttered or not.'

Some of the Surrealist painters made frequent reference to esoteric traditions, for instance Paalen, or Baskine who was associated with the Surrealists between 1946 and 1951. In Brauner's work we find the most precise references to traditional symbolism. In general, analogical cosmology, in its theoretical aspects, has been seen by painters as an obstacle to subjective freedom.

ANTI-ART.

The various forms of this attitude of artistic rebellion have appeared since the first Dada tremors and Jacques Vaché's dictum, 'art is absurd' (1917). In 1920, in Berlin, Huelsenbeck and Hausmann proclaimed the death of art at a Dada exhibition where the positive statement was that Dada is politics. This conception of art as futility, in relation to political questions, reappeared in France in certain forms of anti-art after the May 1968 manifestations. Closer to the Surrealist spirit, however, is the anti-art which attacks the idea of an artistic career, the cultural or natural privileges (talent, genius) of the artist, denies the value of technique or labour in the production of works of art, and even rejects the very notion of a work of art, supporting instead the theory of a diffuse form of creativity with which all people are endowed: an 'anti-élitist' form of spontaneity and an art reduced to play and expressive, instinctive and sometimes (as with Dubuffet) hedonistic behaviour, akin to *Art Brut*, or 'non-professional' art. Whatever the part played by the anti-art movement in the renewal of the forms of art itself, the Surrealists have always shared Lautréamont's fervent wish that poetry should be made by all and not by one.

ART BRUT.

In 1948 Jean Dubuffet, André Breton and Michel Tapié founded the Compagnie de l'Art Brut, whose aim was to gather together, study and preserve the products of the self-taught, the marginal and outcast figures, the unknown, primitives, prisoners or the sick. This is not a matter of anti-art but instead of spontaneous, non-professional art, as alien to the suasions of culture as to those of fame and fortune, and of course the art market. The exhibition of *Art Brut* in Paris in 1949,

at René Drouin's Gallery, offered two hundred works by fifty individuals, among them those of the schizophrenic Aloyse (1886–1964), the primitive Benquet, the primitive 'Scottie' Wilson, the medium Crépin, and Adolf Wölfli (1864–1930). Since the start of the movement the Surrealists had paid attention to artists whom Breton locates 'on the periphery' in *Surréalisme et la peinture*. The anti-cultural attitude which the phrase *Art Brut* seems to signify and which appears in several of Dubuffet's written works is in fact the stance of unusually cultured people.

AUTOMATISM. In the *Premier Manifeste* or *First Manifesto* of 1924, André Breton defined 'Surrealism' thus: 'n. masc., pure psychic automatism, by which an attempt is made to express, either verbally, by writing or in any other way, the true functioning of thought. The dictation of thought, in the absence of all control by the reason, excluding any aesthetic or moral preoccupation.' This is also a definition of automatism as conceived by the Surrealists. It is quite distinct from what behavioural psychologists understand by the term. It is not a matter of inborn reflexes (breathing, for example), or of learned reflexes (walking, for instance), or of habits. It is something closer to the 'ambulatory automatism' of sleepwalkers or the 'mental automatism' of Clérambault (hallucinations and other states attributed by the subject to some reality external to him), or even reversions by adults to infantile attitudes, which Freud calls 'repetition-compulsion', or 'repetitive automatism'.

Whatever it may be, 'automatic writing' (and its extension into the automatism of painting and sculpture), of which Breton says that 'it has remained one of the two main approaches of Surrealism' (the other being dream representation; *cf. Genèse et perspective artistiques du surréalisme*, 1941), has less to do with psychology than with an ethic of freedom and knowledge. In this view automatism is no return to mechanical forms of behaviour but a higher form of behaviour to which one attains only with difficulty.

The Rue Blomet group (Masson, Miró) practised this kind of spontaneity from about 1923. Examples of it are to be found—though in a different, essentially more automatic mode—in such mediumistic painters as Crépin or Lesage. Whatever their exact nature, the various forms of graphic and painterly or sculptural automatism must not be confused with random processes where the arbitrary nature of the material is said to decide how the painter's work turns out. Lyrical abstraction, whether gestural, or concerned with the physical matter of expression, or deriving from 'abstract expressionism', draws inspiration from the lessons of Surrealist automatism.

CADAVRE EXQUIS. '*Cadavre exquis*' or '*Corps exquis*', literally 'exquisite body, or corpse'. In 1925, at 54 Rue du Château, the Surrealists played a form of Consequences. Everyone wrote a word on a sheet of paper, folding it to hide what was written before passing it to his neighbour. The first sentence obtained in this arbitrary manner was 'The exquisite body drank the new wine'. This Surrealist game in which the random procedure is a form of dream-work was often practised in Surrealist drawing. Azevedo and his Portuguese friends produced a form of *cadavre exquis* painting in 1948.

COLLAGE. Whereas the *papiers collés* of Braque and Picasso are 'adjunctions' of a fundamentally plastic, painterly and sculptural kind, collages are compositions of paper scraps cut from prints or magazines, then assembled and stuck to an essentially designed base, in order to produce an *image*, in the Surrealist sense, that is, a strange encounter with a particular emotional or dream-like, 'oneiric' effect. The history of the word's usage, and the influence it has had in various aspects of art, have resulted in the present-day references to musical, fictional, cinematographic and other collages. Bona, Bucaille, Eluard, Ernst, Hayter, Hérold, Léo Malet, Malkine, Mesens, Penrose, Prévert, Stýrský, almost all the Surrealists, have produced collages, some of which have been published in an anthology. The main ones are:

Max Ernst, *The Woman with a Hundred Heads* (1929), *Dream of a Little Girl who Wanted to Become a Carmelite Nun* (1930), *A Week of Happiness or the Seven Capital Elements* (1934).

Léo Malet, *Howl at Life* (1939).

Max Bucaille, *The Cries of the Enchantress* (1939), *The Dredger of Dreams* (1950).

Bona, *The Sap Rising* (1963).

The collages of the Czech artist Jiří Kolář consist of parallel strips which give a repeat or Op-art effect to a given image.

The *découpages* of René Passeron (1965–71) are stuck to a neutral ground and are one-piece images cut with a razor blade from a document.

DECALCOMANIA. In about 1935 Oscar Dominguez applied the term 'decalcomania without any preconceived aim' to the technique of monotype: the paint is applied to a smooth surface and then another sheet is applied to it, with more or less pressure, and peeled off immediately. The product of this may be the starting-point for a new interpretation but may also be offered as it is. This process has given rise to some very interesting discoveries. Dominguez uses it mainly on paper. Max Ernst, Marcel Jean and Masson applied it to canvas, and Bucaille to sheets of glass to obtain subtly luminous effects (1947).

DRIPPING. A process sometimes known as 'oscillation' or 'projection' which consists of passing a punctured tin of paint over a canvas laid on the ground. The patterns made by the falling drips of paint are said to reflect the painter's creative gestures. Masson and Ernst occasionally produced work in this way. Jackson Pollock systematically used drip techniques for the colossal canvases he exhibited at the Art of this Century gallery in New York (1964).

EROS. If it is true to say, as did the Surrealists, under the influence of psychoanalysis, that libido is fundamental to each one of us as an 'indestructible core of darkness' (Breton), poetry should be its prime manifestation. Of course painters such as Svanberg can offer celebrations of womanhood exhibiting something like the sublimation techniques of Breton, Eluard and Aragon. Yet in its artistic aspect, the Surrealist understanding of eroticism tends to a kind of avid misogyny. Bellmer and Molinier see woman in terms of lust. Delvaux, Magritte and Labisse are obsessed by the iciness of the feminine. And the Surrealist women painters, Valentine Hugo, Leonora Carrington, Dorothea Tanning, Toyen, Bona and even Leonor Fini seem nearly always to succumb to the 'masculine' vision of woman-as-child and woman-as-object, as if it were imbued with some magical significance. Towards 1950, when Surrealism was in something like a refractory period, its proponents began to interest themselves especially in the erotic ground of poetry. The International Surrealist Exhibition at Cordier (Paris) in 1959 offered a *Cannibal Feast* by Meret Oppenheim as its typical fare.

FROTTAGE (literally 'rubbing'). A process often practised by children and 'discovered' by Max Ernst in 1925. He used it for the illustrations to the *Histoire naturelle* of 1926 prefaced by Hans Arp. In the process paper or cloth is placed or stretched over a rough surface or some kind. Pencil or brush or some other appropriate medium is rubbed over the paper so that the irregularities of the object below are reproduced. The simplicity of the method and the visual poetry that Max Ernst was able to elicit from it show—should we doubt the fact—that no process is dominant over human creativity, and that the artist's ability is not reduced by artistic automatism.

FUMAGE (literally 'smoking'). A lighted candle is brought close to a moderately inflammable surface so that the carbon from the combustion leaves smoky traces on the surface as desired. Camille Bryen and Wolfgang Paalen used the method from 1935.

HALLUCINATION. Hallucination may be defined as a perception without any object. The observer supposes that what he is in fact projecting into space is real. Emotional themes (fear, anxiety, devotion) and obsessional topics (frightful animals, divine beings) may enter into certain hallucinatory psychoses. Pseudo-hallucination does not include any spatialization of illusory phenomena. Hallucination should not be confused with 'delirium of interpretation', as in the case of paranoia. When Max Ernst, in regard to the invention of *frottage* (1925), talked of using his 'hallucinatory faculties' he was not referring to the use of hallucinogens but merely to the voluntary and conscious development of a kind of waking dream dependent on the material he was examining (grooves in a parquet floor). Certain hypnagogic states may help artistic creation, but hallucination proper is accompanied by mental inadequacies (temporary or not) that are too serious for the sufferer to be able to integrate them to achieve constructive creation.

HYSTERIA. A nervous state characterized by extreme suggestibility on the part of the sufferer who is affected by various functional disturbances and by mythomania. Oneirism, psychomotor automatism, and certain autosuggestive amnesias are often observed in hysterics. Hysteria was studied by Charcot at the Salpêtrière Clinic in Paris and probably gave Freud the initial impulse for his psychoanalytic method in 1885. The Surrealists celebrated the fiftieth anniversary of hysteria (1878–1928) in *La Révolution surréaliste* (No. 11).

IMAGE. The Surrealist understanding of the image is at the basis of their theory. It is not a matter of sensory or mental simulacra of any reality, as is the case in the psychology of perception, dreams or mental processes. Nor is it a question of metaphor or metonymy, which are modes of discourse. The Surrealist image is an irrational collision of psychological states—words, representations, objects— a '*trouvaille*' or 'found thing' which astonishes the individual himself.

André Breton, adverting to the idea of the poetic image held by Saint-Pol Roux, Reverdy and Apollinaire, systematizes its operation and extends its rôle to all areas of art: 'Only the image, in its arbitrary and abrupt aspect, allows me the full extent of my freedom, a freedom so complete that it scares me', he writes in an article of 1925. In the *Manifesto of Surrealism* (1924) he emphasizes the fact that 'it is from the to some extent fortuitous connection of the two terms that a special light has been struck—the *light of the image*, to which we shall be infinitely sensitive. The value of the image depends on the beauty of the spark given off.' Later,

in 1947 (*Néon*, No. 1), Breton was to add that that light could not arise from 'unworthy associations' and that the image should be characterized by a 'sign in the ascendant'. We might add another criterion of the Surrealist image: if its 'light' depended only on the degree of surprise it evoked, its effect would run the risk of diminishing with time. Happily for Surrealism, its best images have lasted, and that is enough to prove that they are not solely the products of chance.

IMPRINTS. Among the automatic artistic processes which 'encourage inspiration' we must include finger prints and marks, and the imprints of all objects: cloth and various other materials, soaked or loaded with ink or paint. In photography, rayograms and schadographs are processes of the same kind.

MANIFESTOS OF SURREALISM. These are theoretical and polemical texts which were milestones in the history of the movement, assuring André Breton—who wrote or edited most of them—his historical rôle as master theorist of Surrealism. Associated or dissident groups produced countless manifestos. The following may be counted among the manifestos of orthodox Surrealism:

> *Manifeste du surréalisme*, 1924 (*Manifesto of Surrealism*)
> *Second Manifeste du surréalisme,*, (*Second Manifesto of Surrealism*) in the last number of *La Révolution surréaliste*, 1929
> *Prolégomènes à un troisième manifeste du surréalisme ou non*, 1942 (*Prolegomena to a Third Manifesto of Surrealism or Not*)
> *Du Surréalisme en ses oeuvres vives*, 1953 (*Surrealism in its Living Works*).

MARVELLOUS, THE. The supreme aesthetic category of Surrealism, the very essence of beauty, which some people attack out of a strangely sad hatred. 'The marvellous is always beautiful; anything marvellous is beautiful; only the marvellous is beautiful' (Breton, *Manifeste du surréalisme*, 1924). The marvellous in the Surrealist understanding is an impassioned fusion of wish and reality, in a *surreality* where poetry and freedom are one. It appears in the extraordinary in the form of the 'light of the image' and, in opposition to 'sordid life', features 'love that is worthy of admiration' or 'love that is mad'. In a text of 1936, *La Clé des champs*, André Breton makes a plea for the 'marvellous as against mystery' and maintains that 'abandonment to the marvellous' is the 'sole source of eternal communication between human beings'.

MUSIC. 'There is no mystery in music, and for that reason it is the art which most pleases people,

that in which they always find more *sensations*', says Chirico. And Eluard writes: 'I don't like music, all this piano taking away everything I like' (*Donner à voir*). Breton claimed that music was a 'confusional activity'. This negative attitude, which shows the opposition of Surrealism to any art of pure sensation—and dogmatically it includes music as a whole among such arts—was not expressed any more exactly until 1944 when André Breton wrote 'Silence d'or' in *La Clé des champs*.

OBJECTS. One of the major innovations of twentieth-century art and one of its debts to Surrealism is certainly the invention of a creative act without historical precedent: the montage of objects with a symbolic function. Fetishes, talismans, and certain pious or cult objects, as well as some products of popular crafts, where dream is operating, are not included.

Around 1914 Marcel Duchamp gave the ready-made its rôle as a challenge to the sacred space of the museum. Bottle-racks, a porcelain urinal, exhibited in place of works of art, have as their effect a form of anti-art sarcasm. Closer to the Surrealist object, however, are Man Ray's inventions, his *Present*, for example (an iron fitted with spikes), and the Dada objects. Here humour is an essential component.

The true 'objects with a symbolic function' were created by Giacometti after 1930: *The Time of Traces, Palace at Four in the Morning, The Invisible Object* (1934). The last-mentioned was the last to be produced by Giacometti, and was remarked on by Breton in 'Equation de l'objet trouvé' (*Documents*, 1934). Two years later a major exhibition of objects was held at Ratton, in Paris, which was introduced by Breton ('Crise de l'objet' in *Cahiers d'Art*, special issue, 1936). In addition to natural objects (rough, interpreted or incorporated), disturbed or found objects, and objects from ethnological or mathematical collections, the exhibition included Surrealist objects proper, and in particular Meret Oppenheim's *Fur Cup and Saucer* (1936) and a number of object-pictures and object-poems.

The 'paranoiac-critical' method of Salvador Dali was especially rich in found things: a rainy taxi, a telephone with a living lobster for a receiver. But all the Surrealist painters and sometimes the poets mounted objects as works. The most famous are: Picasso's *Object* (1933), Seligmann's *Ultra-furniture*, Brauner's *Wolf-Table*, Bellmer's *Doll*, Magritte's *Girl-Bottles*, Dominguez' *Never*, the models of *The Surrealist Street* at the International Exhibition (Paris, 1938) and, more recently, Sterpini's *Armchair with an Armed Hand*, or even Marcel Jean's *Ghost of a Gardenia*.

As against the conventional perception of things, Breton wrote, in 1924, an *Introduction au discours sur*

le peu de réalité and Ferdinand Alquié stressed the Surrealist activity of 'de-realization'. Conversely, however, Surrealism aims at an 'objectification' (Breton) of desire and dream in objects bearing a 'light' which is none other than that of the poetic image.

ONEIRISM. In psychology, a term indicating a series of hallucinations characteristic of such confusional states as alcoholic intoxication, but in Surrealism to be understood in a wide sense: all the phenomena of dream and waking dream in which images, affected by emotional considerations and precise passionate considerations, do not accord with waking logic. A special alien quality gives to an image—even a perceptual image—the look of belonging to the world of dream. During the 'sleep period' (1922), the Surrealists voluntarily submitted to a 'wave of dreams' (Aragon) and Desnos continued for a long time his experiments in automatic speaking in a lethargic state. One of the 'two great ways' which Breton distinguishes in Surrealist painting is oneiric figuration; the other is the way of automatic spontaneity. In *The Secret Life of Salvador Dali*, Dali tells how he tried to reproduce the images of his dreams on a canvas placed opposite his bed. No true Surrealist painter has been daunted by the problem of dream representation.

PARANOIA. Paranoia is a disorder studied especially by the psychologists Kraepelin and Kretschmer. It may be defined as a lasting and systematic delirium of interpretation but without any lasting mental deficit. The French psychoanalyst Jacques Lacan offered a post-Freudian explanation of the phenomenon, as in his *De la paranoïa dans ses rapports avec la personnalité* (Paris, 1932), and from it Salvador Dali derived his use of the term, which appears for instance in his *La Femme visible* (1930). He speaks of his paranoiac method, which is a 'spontaneous method of irrational knowledge based on the interpretative-critical association of delirious phenomena'. This deliberately confused definition indicates in fact the permanent state of nervously enthusiastic fabrication Dali required in order to produce an active fusion of the imaginary and the real in all areas of art and life. The Surrealists took very seriously a 'method' which Breton (in 1934) called 'a first-order instrument' (*Qu'est-ce que le surréalisme?*). The lively intellect and sarcastic humour of Salvador Dali, the erotic themes and gustatory images which he included in his 'delirious interpretations' of William Tell or Millet's *Angelus*, and his 'eccentric' personality have made an essential contribution to the fame of paranoia as a 'method'.

PHOTOGRAPHY. Dadaists such as Raoul Hausmann produced photomontages *c.* 1920. These are a variety of collage. Closer to photography proper were the experiments of Stieglitz and the review *Camera-Work* at the Photo-Secession in New York, in 1913. When Man Ray turned to photography *c.* 1920 he introduced a form of lyricism which was to make him a frequent illustrator of *La Révolution surréaliste*. The freezing of an extraordinary image by the lens, the anti-realistic effects of *Boulevard Edgar Quinet* or *Motor Race*, were extended by Ray into technical experimentation and such inventions as the rayogram and solarization. He published a volume of rayograms, *Delicious Fields*, in 1922, and in 1934 he issued in New York the collection *M.R. Photographs, 1920–34, Paris*. Brassaï illustrated some texts of Breton's in *Minotaure*. Among Surrealist photographers one should also mention Cartier-Bresson, Blumenfeld, Boubat, Agnès Varda, Izis, Doisneau, Clergue. Somewhat closer to a process of technical alchemy are David Hare's *photos chauffées*, or 'heated photographs', of 1941 and Raoul Ubac's 'fossils', a kind of photo-relief obtained by superimposition during the printing of a positive and negative of the same image, slightly out of focus. These 'fossils'—among which the most noteworthy are those of the Eiffel Tower and the Paris Opéra—were published by Ubac in *Minotaure* (Nos. 2 and 12–13, 1937).

PICTO-POETRY. In *75 H.P.*, a journal he founded at Bucharest *c.* 1924, Victor Brauner published his *Manifeste de la picto-poésie*, a well-chosen term for the Surrealist notion of painting. Far from being restricted to visual attractiveness, or 'retinal' pleasure (to use a Duchampian term), painting should be an activity of the spirit allowing access to knowledge of the deepest impulses, or even a mode of double vision, but in any case bringing about an exciting confrontation of the mysteries of the 'objective' world with those of the subjective mind.

PSYCHOANALYSIS. The psychoanalytic method of neurosis therapy was developed by Sigmund Freud and aims at using the interpretation of resistances and affective transferences to evoke in the patient an awareness of the traumas and conflicts which have fixed certain complexes in an infantile stage of development.

Psychoanalysis is also a theory of personality grounded in the results of the cure which is said to allow, by means of a confrontation of the conscious and the unconscious, an understanding of the dynamic relations between the super-ego, the ego and the id (in other terms, the moral personality, the everyday personality, and the instinctive personality).

'Applied psychoanalysis' is an attempt to extend into all human activities, and especially art, the analysis of latent affective contents which those activities display only at an unconscious level.

RACLAGE (literally 'scraping' or 'thinning'). In any painting consisting of a number of successive layers, it is possible to scrape away part of the last application in order to reveal the underlying surface. A comb or a piece of wood can be used for this purpose, and the effect produced depends on the nature of the instrument used. In his *Cities* series (1927) Max Ernst made systematic use of *raclage*. Esteban Francès in 1936 and Kujawski *c.* 1946 also used the technique in a non-figurative context. In order to avoid conventional effects, *raclage* is often combined with other processes such as *frottage* and decalcomania.

RAYOGRAMS. Man Ray gave his name to a photographic process that had already been used in 1916 by Christian Schad ('schadography') and whose volume *Delicious Fields* he had printed (1922). Objects are placed on a light-sensitive surface and by a kind of radiography are made to appear as white shadows on a black ground.

READY-MADE. Marcel Duchamp 'signed' ready-made objects, industrial products such as a bottle-rack, a bicycle wheel and a porcelain urinal, in all twenty or so between 1914 and 1925, and presented them as works of art. In *The Bride Stripped Bare by Her Bachelors, Even*, a work on a sheet of glass left unfinished *c.* 1922, the influence of the ready-made is easily discernible, but here the chocolate-grinders and so on are integrated into a work of art, and are themselves to some extent sacralized, instead of being used to attack the religion of art. Perhaps this contradiction explains why Duchamp left this 'large glass' unfinished.

SAND (paintings using). André Masson (1927) spread glue on a canvas and covered it with sand. On agitating the canvas, the sand fell away, except from the areas where the glue had been applied. The result of this technique is arbitrary but interpretable shapes. Masson used the same technique several times on the same canvas.

More recently the Spanish painter Tapiès produced sandy surfaces with only a few imprints. This technique is said to exclude the randomness which was the original Surrealist effect of Masson's sand.

SOLARIZATION. A photographic process using the Sabattier effect to produce unusual images. During developing a negative is re-exposed for a variable period so that the whites turn grey, but with a whiteish ring-effect. The opposite result is obtained with a positive. Man Ray's first solarizations were shown in *S.A.S.D.L.R.* No. 3 (1931).

SURREAL. This philosophic term is not to be confused with the 'supernatural' of religions or the 'transcendence' of the mystics. Three quotations from André Breton suffice to define the surreal: 'I believe in the future resolution of these two states which seem so contradictory—dream and reality—in a kind of absolute reality or surreality, as it were' (*First Manifesto*, 1924). 'Everything goes to show that there is a certain aspect of spirit where life and death, the real and the imaginary, past and future, communicable and incommunicable, high and low, cease to be perceived as contradictory. One might search in vain for any other central impulse for Surrealist activity than the hope of finding this point' (*Second Manifesto*, 1929). 'Everything that I love, everything that I think and feel, persuades me to hold a special philosophy of immanence in accordance with which surreality is comprised in reality itself and is neither superior nor external to it. Similarly the container is then the content' (*Surréalisme et la peinture*, 1965). For the artistic sensibility, the surreal is manifested in the marvellous; it is that 'light of the image' of which André Breton speaks.

SURREALISM. Here is a number of definitions which the Surrealists themselves have offered: 'Surrealism, *n. masc.*, pure psychic automatism, by which an attempt is made to express, either verbally, in writing, or in any other way, the true functioning of thought. The dictation by thought, in the absence of all control by the reason, excluding any aesthetic or moral preoccupation' (*First Manifesto*, 1924).

'Surrealism is not a new, easier means of expression, nor even a metaphysics of poetry. It is a means of total liberation of the mind and of all that resembles it. . . . Surrealism is not a form of poetry. It is the cry of the mind turning back on itself, and it is determined to break apart its fetters' (Declaration of 27.1.1925, reproduced in Nadeau, op. cit.).

'A work of art can only be termed Surrealist if the artist has tried to reach the total psycho-physical field (of which the field of consciousness is but an insignificant part)' (André Breton, *Surréalisme et la peinture*, 1945).

'We must remember that the idea of Surrealism is directed merely to the total recovery of our psychic strength by a means which is no more than a vertiginous descent within us, the systematic illumination of hidden places and the progressive clouding of other areas, a perpetual excursion to absolutely forbidden territory' (André Breton, *Second Manifesto*, 1929).

'Surrealism is the method by which we know the *actual* mechanism of thought and the true relations between the expression of thought and the world on which it acts in fact' (Louis Aragon, 'Le Surréalisme et le devenir révolutionnaire', *L.S.A.S.D.L.R.*, No. 3, p. 1).

'Surrealism is inspiration recognized, accepted and practised; no longer as an inexplicable visitation but as a demonstrable faculty' (Louis Aragon, *Traité du style*, Paris, 1928).

'I hasten to reject a misunderstanding: the claim that poetry is to be included among means of expression. . . . Against that I set poetry *as an activity of the spirit* (Tristan Tzara, 'Essai sur la situation de la poésie', *L.S.A.S.D.L.R.*, No. 4, 1934).

'Surrealism is neither a school nor a sect and it is certainly much more than an attitude. In the most aggressive and total sense of the term, it is an adventure. It is an adventure of man and of reality which both impel in one and the same movement' (*Hautefréquence*, a group pamphlet, 24 May 1951, quoted by J.-L. Bédouin, *Vingt ans de surréalisme, 1929–1959*, Paris, 1961).

'Surrealism is an encounter between the temporal aspect of the world and eternal values: love, freedom and poetry' (*Médium*, n. s., No. 1, 1953).

Groups

Several groups were formed in France and in other countries. Some were more or less like Breton's own group whereas others were a little different.

The *Documents* group, organized around the review of that name and directed by Georges Bataille.

Le Grand Jeu, directed by Gilbert-Lecomte, Daumal, Vailland, Henry, Síma.

La Main à Plume, directed by Arnaud, Chabrun, Patin, Dominguez.

Le Sensorialisme, directed by Jean Legrand (1942–5).

Le Groupe surréaliste révolutionnaire (the Revolutionary Surrealist Group), whose most important members were: Appel, Arnaud, Bucaille, Constant, Corneille, Dotremont, Jacobsen, Jaguer, Jorn, Labisse, Lorenc, Mortensen, Passeron, Riopelle and Tardos (1946–8).

Cobra, directed by Dotremont (1948–51).

L'Internationale situationniste (the Situationist International), directed by Debord, and *Situationist Times*, directed by Asger Jorn, both produced by the Situationist movement.

The group around the review *Dyn*, directed by Paalen.

The group around the review *Méta*, directed by Karl-Otto Götz.

The *Nuclear Movement*, an Italian group directed by Baj and Dangelo (1951–60).

The Belgian group, directed by Mesens (1922).

Davestil, a Czech group, run by Nezval, Stýrský, Tiege and Toyen (who came to Surrealism in 1934).

The Danish group connected with the review *Konkretion*, directed by Wilhelm Bjerke-Petersen, then by Jorn, Jacobsen, Mortensen (1935–7).

Ra, a Czechoslovak group, with Lorenc, Mizera, Miskovska, Istler, Kundera, Lacina, Zykmund and Tikal as leading members (1942–8).

Les Automatistes (the Automatists), a French-Canadian group, directed by Borduas (1948).

The group in Halmstad (Sweden), led by Stellan Mörner and Esaias Thören (1930–9).

Art et Liberté (Art and Freedom), the Cairo group, led by Georges Hénein (1934–50).

The English group, directed by (Sir) Roland Penrose.

There were also active groups in Japan, Mexico, Chile and Portugal, and several in Rumania.

Reviews

Camera-Work Stieglitz (New York 1903–15), became *291* Stieglitz, Duchamp, Picabia (1915–17), then *391* Picabia (Barcelona January 1917 No. 1–No. 4, New York No. 5–No. 7, Zürich No. 8, Paris No. 9–No. 10, November 1924).

Les Soirées de Paris Apollinaire and Céruse (No. 18, November 1913—Nos. 26–27, July 1914).

Maintenant Cravan (Paris 1913–15).

Sic Birot (Paris January 1916—Nos 53–54, December 1919).

Nord-Sud Reverdy (Paris May 1917—No. 16, October 1918).

Dada Tzara (Zürich July 1917—Paris No. 8, September 1921).

Der Ventilator Baargeld (Cologne 1919).

Der Dada Hausmann (Berlin 1919–20).

Littérature first series Aragon, Breton, Soupault (March 1919—No. 20, May 1921), second series Breton, Soupault, then (from No. 4) Breton (March 1922—No. 13, June 1924).

Proverbe Eluard (January 1920—No. 6, July 1921).

L'Esprit nouveau Dermée, then Ozenfant and Jeanneret (October 1920—No. 28, January 1925).

Cannibale Picabia (Paris two issues in 1920).

Aventure Vitrac (Paris October 1921—No. 3, January 1922).

Le Coeur à barbe Tzara (Paris, one number in April 1922).

Manomètre Malespine (July 1922—No. 9, January 1928).

Merz Schwitters (Hanover 1923—No. 24, 1932).

Surréalisme Goll (one number in October 1924).

La Révolution surréaliste Péret and Naville (December 1924–July 1925) Breton (July 1925, No. 4–No. 12, December 1929).

Le Grand Jeu Gilbert-Lecomte, Daumal, Síma, Vailland (1928).

Le Surréalisme au service de la révolution Breton (July 1930—Nos 5–6, May 1933).

Nemoguié (The Impossible) (Belgrade 1930).

Documents Bataille (April 1930, special Surrealist number in 1934).

Minotaure Tériade (June 1933–December 1937) Skira (December 1937, No. 10–No. 12, October 1938).

Surrealismus Stýrský, Toyen (Prague 1933).

Bulletin international du surréalisme (Prague No. 1 1935, Brussels No. 2 1935, London No. 3 1936).

Variétés.

Clé, bulletin of the International Federation of Independent Revolutionary Artists (FIARI), Breton and Rivera (Mexico 1939).

Dyn Paalen (Mexico 1940–4).

Cahiers de la main à plume Arnaud (Paris 1941–3).

VVV Breton, Duchamp, Ernst (New York June 1942—No. 3, February 1944).

View (Special Surrealist issue 1942).

La Révolution la nuit Bonnefoy (Paris 1946).

La Part du sable (Cairo 1947).

Néon Breton (Paris 1948–9).

Le Surréalisme révolutionnaire Arnaud, Dotremont, Jorn, Lorenc (Paris one number in April 1948).

Bulletin international du s.r. Dotremont (Brussels June 1948).

Méta Götz (1948—No. 10, 1953).

Cobra Dotremont (Brussels, Copenhagen, Amsterdam 1949—No. 10, October 1951).

Le Petit Cobra (Brussels 1949—No. 4, 1951).

Le Petit Jésus Arnaud (Paris 1950–2).

Médium Schuster (two series 1951—No. 13, 1955).

Le Messager boiteux de Paris Arnaud (Paris 1953).

Phases Jaguer (Paris 1954—No. 10, 1964, second series in course of publication).

Le Surréalisme même Breton (Paris 1956—No. 5, 1959).

Bief (Paris 1958—No. 12, 1960).

La Brèche, action surréaliste Breton (Paris 1962—No. 8, November 1965).

L'Archibras Schuster (Paris 1967—No. 7, 1969).

Analogon (Prague, one issue in 1968).

Bulletin de liaison surréaliste Bédouin (Paris from 1969).

Coupure (No. 1 1969, for those former members of the Breton circle who disclaimed the name Surrealist).

Exhibitions

1925 Painting. Galerie Pierre Loeb, Paris.

1928 *Le Surréalisme existe-t-il?* Paris.

1929 *Abstrakte und Surrealistische Malerei und Plastik.* Kunsthaus, Zürich.

1931 Paintings and collages. Hartford, Conn.

1932 Paintings and collages. Julien Levy Gallery, New York.

1933 Paintings. Galerie Pierre Colle, Paris.

1934 *Minotaure.* Palais des Beaux-Arts, Brussels. Paintings, Zürich.

1935 *Cubists and Surrealists.* Copenhagen. Surrealist works. La Louvière, Belgium. Surrealist works, Santa Cruz de Teneriffe, Canaries.

1936 International Surrealism exhibition, Burlington Gallery, London. *Fantastic Art, Dada, Surrealism.* Museum of Modern Art, New York. Surrealist objects. Galerie Ratton, Paris.

1937 International Surrealism exhibition. Ginka Gallery, Tokyo. *Surrealist Objects and Poems,* London.

1938 International Surrealism exhibition. Galerie des Beaux-Arts, Paris. Objects from Mexico. Galerie Pierre Colle et Renou, Paris. Surrealist works. London Gallery, London. Surrealist works. Robert Gallery, Amsterdam. Surrealist works. Santiago de Chile.

1940 *Surrealism Today.* Zwemmer Gallery, London. Surrealist works. Oxford. *Exposicion internacionale del Surrealismo,* Mexico.

1942 Several exhibitions in Britain. *First Papers of Surrealism.* Reid Mansion, New York.

1945 *Surrealist Diversity,* Arcade Gallery, London. Surrealist works. Palais des Beaux-Arts, Brussels.

1947 *Le Surréalisme en 1947.* Galerie Maeght, Paris. *Prise de terre,* Groupe Surréaliste Révolutionnaire. Galerie Breteau, Paris.

1948 Surrealist works. Prague. Surrealist works. Santiago de Chile.

1949 *L'Art Brut.* Galerie Drouin, Paris. Surrealist works. Lisbon.

1952 *Surrealist Painting in Europe.* Saarbrücken. *Imaginisterne.* Göteborg, Sweden.

1954 *The Fantastic.* Venice Biennale.

1956 Surrealist works. Chile. Surrealist works. Puerto-Rico.

1958 Paintings. Houston.

1959 Paintings. Galeria Schwarz, Milan.

1959– *Exposition Internationale du Surréalisme,* EROS.
1960 Galerie Cordier, Paris.

1960 *Development of Surrealist Painting in Japan.* National Museum of Modern Art, Tokyo.

1960– *Surrealist Intrusion in the Enchanter's Domain,*
1961 Arcy Gallery, New York.

1961 *Mostra internazionale del Surrealismo.* Galeria Schwarz, Milan.
Surréalistes et précurseurs. Palais Granvelle, Besançon.
Masters of Surrealism: Ernst to Matta. Obelisk Gallery, London.
Surrealist exhibition. Galeria Schwarz, Milan.

1962 *New Forms of Surrealism and Relationism.* Cultural Centre, Belgrade.

1964 *Le Surréalisme, sources, histoire, affinités.* Galerie Charpentier, Paris.
Imaginative Painting. Museum of Decorative Arts, Prague.

1965 *L'Ecart absolu.* Galerie de l'Oeil, Paris.
Surrealism and the Fantastic, outdoor section. São Paulo.

Quelques Ancêtres du surréalisme. Bibliothèque Nationale, Paris.
Aspekte des Surrealismus. Gallery of Modern Art, Basle.
La Fureur poétique. Musée d'Art Moderne de la Ville de Paris.
A phala. São Paulo.

1968 *The Pleasure Principle.* Czechoslovakia.

1969 *Surrealismus in Europa.* Baukunstgalerie, Cologne.
Signes d'un renouveau surréaliste. Galerie Brachot, Brussels.

1970 *Résonances surréalistes.* Galerie Zerbib, Paris.
Surrealism? Moderna Museet, Stockholm.

1971 *Der Geist des Surrealismus.* Baukunstgalerie, Cologne.

1972 *Le Surréalisme, 1922–1942.* Haus der Kunst, Munich; Musée des Arts Décoratifs, Paris.

1978 *Dada and Surrealism Reviewed,* Hayward Gallery, London.

Notes

1 The Barrès 'trial' was organized by Breton in spite of Tzara's opposition. It was also a trial of talent and 'national values' and took place on 13 May 1921 in the rooms of the Sociétés Savantes in Paris. See the account of the meeting in Nadeau, *Histoire du surréalisme*, (Paris, 1945, pp. 51–3).

2 Those excluded from the *Second Manifesto* were Artaud, Delteil, Gérard, Limbour, Masson ('envious' of Picasso and of Max Ernst), Soupault, Vitrac, who were all richly insulted. Breton also broke with Naville, Desnos, Duchamp, Ribemont-Dessaignes, and Picabia, though more politely. On the other hand he re-admitted Tzara (*Les Manifestes du surréalisme*, Paris, 1946; cf. also Nadeau op. cit. pp. 176–86).

3 Reply to Jean Bernier, *Clarté*, 1925 (cf. Nadeau op. cit., p. 101).

4 In the pamphlet against Anatole France, *Un Cadavre* (1924).

5 *Ci-gît Giorgio de Chirico, le feuilleton change d'auteur*, introduction to an exhibition (1926).

6 This text was signed by all the members of the group and appeared in *La Révolution surréaliste*, No. 5 (1925) (cf. Nadeau op. cit., pp. 297–300).

7 *La Conquête de l'irrationnel* (Paris, 1935).

8 In 1948, in the tract *A la niche les glapisseurs de Dieu*, the Surrealist group tried to nip in the bud any attempts at a religious 'takeover' of Surrealism. In 1951 Carrouges gave a lecture on Surrealism at the Centre Catholique des Intellectuels Français. Henri Pastureau criticized Breton for not attacking the action. Breton and Péret answered Pastureau's complaint by saying that he had trumped the whole thing up from nothing but did break with Carrouges. The pamphlet *Haute Fréquence* (24 May 1951) recalled the basic principles of Surrealism and brought the incident to a close (Bédouin, *Vingt Ans de surréalisme, 1939–1959*, (Paris, 1961), pp. 186–90; the relevant pamphlets are quoted on pp. 305–11.

9 *Premier Bilan de l'art actuel* (Paris, 1953).

10 *Manifeste des surréalistes roumains* (1947).

11 Oil on canvas, 195 × 233 cm. Collection William Copley, Paris. In their *Histoire de la peinture surréaliste* (Paris, 1959), Jean and Mezei date it 1947. But Max Ernst convinced Patrick Waldberg that it is as old as 1942 (*Max Ernst, propos et présence*, Paris, 1959; Waldberg, *Max Ernst*, Paris, 1958).

12 Jurgis Baltrusaitis, *Le Moyen Age fantastique* (Paris, 1955).

13 André Pieyre de Mandiargues, *Les Monstres de Bomarzo* (Paris, 1957).

14 *L'Ecart absolu*, exhibition catalogue, Galerie de l'Oeil, 1965, especially Gérard Legrand's *Une Apparence de soupirail*.

15 'Time in books has lost its freshness since the *Très Riches Heures*', wrote Breton. He thought that the illustrations to *La Médecine pittoresque, Musée médico-chirurgical, 1834–1837* amounted to a masterpiece of the Surrealist spirit (cf. *Le Surréalisme et la peinture*, 1965, p. 166).

16 Those in question are Gustave Moreau, Puvis de Chavannes, Carrière.

17 Cited by Huyghe, *L'Art et l'homme* (Paris, n.d.), Vol. 3, p. 348.

18 Quoted in the exhibition catalogue, *Quelques Ancêtres du surréalisme*, Bibliothèque Nationale (Paris, 1965).

19 Olivier Revault d'Allonnes, *Du symbolisme au classicisme, théories*, selected by Maurice Denis (Paris, 1964), p. 14. Aurier published a kind of manifesto of pictorial Symbolism in *Mercure de France*. He sees the work of art as necessarily 'ideistic', symbolist, synthetic, subjective and decorative.

20 Breton, 'Du symbolisme' (1958), *Le Surréalisme et la peinture* (1965), p. 362.

21 Roger Caillois, *Au coeur du fantastique* (Paris, 1965).

22 Breton, *Martinique charmeuse de serpent*, a poem illustrated by André Masson.

23 *Le Surréalisme et la peinture* (1965), p. 64.

24 Reply to James Johnson Sweeney, 'Eleven Europeans in America', in *The Museum of Modern Art Bulletin* (New York, 1946), Vol. XIII, No. 4–5, pp. 20–1; cf. Arturo Schwarz, *Marcel Duchamp* (Paris, 1969), p. 6.

25 Descartes, *Méditations métaphysiques, III*, speaks of it as the 'lowest level of freedom'. When applied to the 'beauty of indifference', we have one of the basic problems of aesthetics.

26 Collected by Duchamp himself in *La Boîte verte* (1934) and *La Boîte en valise* (1938, published in 1940).

27 On the cover of No. 21 of *391*, March 1920, Picabia recopied *L.H.O.O.Q.*, with Duchamp's permission, but forgot the beard.

28 The drawing *Caoutchouc* (1909) might be classed as one of the first non-figurative works of the twentieth century, if some decorations by Schmittals are omitted. *Udnie, Catch as Catch Can* and *Edtaonisl* (1912) are large abstract canvases.

29 *Pensées sans langage* (Paris, 1919), p. 103 (quoted by O. Revault d'Allonnes, op. cit., p. 134).

30 A drawing published in No. 4 of the June 1915 issue of *291*. The title of the drawing gives its its provocative value. The same is true of the motor-car lamp entitled *Portrait of a Young American Girl in a State of Nudity*, or of the hooter entitled *The Holy of Holies*. There is also the ink-blot which owes everything to its title, *Our Lady* (1920).

31 This review became *291* in March 1915 because Stieglitz lived at 291 Fifth Avenue, New York. In Barcelona in 1917 it became *391*, edited by Picabia.

32 Gabrielle Buffet-Picabia, *Aires abstraites* (Geneva, 1967), p. 161.

33 *Dada, art et anti-art* (Brussels, 1965), pp. 16 ff.

34 In *Merz-Holland Dada* (1923).

35 *Le Surréalisme et la peinture* (Paris, 1928; New York, 1945; Paris, 1965).

36 That is the position of Pierre Naville in No. 3 of *La Révolution surréaliste*, April 1925 (cf. Passeron, *Histoire de la peinture surréaliste*, op. cit., pp. 61 ff).

37 'Genèse et perspective artistiques du surréalisme' (1941), *Le Surréalisme et la peinture* (1945), p. 94.

38 *Qu'est-ce que le surréalisme?* (Brussels, 1934), p. 25.

39 In fact approved by Breton in a text of 1941, whereas elsewhere he accuses him of infantilism ('Genèse et perspective . . .', *Le Surréalisme et la peinture*, 1945, p. 94, 1965, p. 70).

40 *Le Surréalisme et la peinture* (1945), p. 8.

41 *Le Surréalisme et la peinture* (1945), pp. 21–2 and 30.

42 'The somewhat fortuitous association of the two terms produced a special light—the light of the image, to which we shall prove extremely sensitive. The value of the image depends on the beauty of the spark' (André Breton, *Les Manifestes du surréalisme*, op. cit., p. 38).

43 This formula of Lautréamont's was often taken up by the Surrealists.

44 Breton, *Les Manifestes du surréalisme*, op. cit.

45 This is the word Miró used for his own experiment *c.* 1925.

46 'Crise de l'objet', *Le Surréalisme et la peinture* (1945), p. 126.

47 I opposed this fusion in the case of a written history of visual Surrealism (*Histoire de la peinture surréaliste*, op. cit., pp. 15 and 40). My present suggestion would allow an overall view close to that of several authors, such as Alfred Barr and Michel Sanouillet.

48 F. Alquié, *Philosophie du surréalisme* (Paris, 1955).

49 *L'Homme révolté* (Paris, 1951), and Breton's reply on this point, *Sucre Jaune*, in regard to Lautréamont, *La Clé des champs* (Paris, 1952) p. 387.

50 The enquiry 'Le Suicide est-il une solution?' in *La Révolution surréaliste*, No. 2 (1925).

51 Aragon, 'Une Vague de rêves', in *Commerce* (October 1924).

52 Quoted by Nadeau, *Histoire du surréalisme*, op. cit., p. 106.

53 Breton, 'Premier Manifeste', *Les Manifestes du surréalisme*, op. cit., p. 28.

54 Breton, introduction to *La Femme 100 têtes* by Max Ernst, a volume of collages (1929).

55 *Le Surréalisme et la peinture*, op. cit., p. 46.

56 Leiris, 'Joan Miró', *Documents*, No. 5 (October 1929), p. 263.

57 *Ceci est la couleur de mon rêve.*

58 'Genèse et perspective . . .', *Le Surréalisme et la peinture*, op. cit., pp. 67–8.

59 René Passeron, *Histoire de la peinture surréaliste*, op. cit., pp. 68 and 87. See also J. Dupin, *Joan Miró* (Cologne, 1961).

60 Ibid.

61 R. de Solier, 'Hans Hartung', *Quadrum*, No. 2 (November 1956).

62 *Über das Geistige in der Kunst* (1913).

63 A term used by psychologists for the interior monologue, or stream of consciousness: Egger (1881), Charcot, Gilbert Ballet (1886), Saint-Paul (1902), (Jean Cazaux, *Surréalisme et psychologie*, Paris, 1938).

64 Rimbaud, 'Lettres du voyant', *Lettres de la vie littéraire d'Arthur Rimbaud* (Paris, n.d.).

65 Not cited in the *Anthologie de la poésie surréaliste* by J.-L. Bédouin (Paris, 1964).

66 'Vitesse et Tempo', *Quadrum*, No. 3 (1957), p. 15 (Passeron, 'Conscience et peinture', in the issue of *L'Herne* in homage to Henri Michaux, Paris, 1966, p. 396).

67 'L'Art des fous la clé des champs' (1948), *Le Surréalisme et la peinture*, op. cit., p. 316.

68 'Genèse et perspective . . .', *Le Surréalisme et la peinture*, op. cit., p. 70.

69 'Manifeste du surréalisme', *Les Manifestes du surréalisme*, op. cit., p. 65.

70 *Les Insolites* (Paris, 1956).

71 E. Souriau, 'Le Mode d'existence de l'oeuvre à faire', *Bulletin de la société française de philosophie* (1956), No. 1, p. 5.

72 Gilles Ehrmann, *Les Inspirés et leurs demeures* (Paris, 1962), p. XXXIX (introduction by André Breton).

73 Marcel Brion, *La Peinture allemande* (Paris, 1959), p. 158.

74 Dubuffet, *Prospectus aux amateurs de tout genre* (Paris, 1946), pp. 50–4.

75 Ibid., p. 70.

76 M. Carrouges, 'Le Hasard objectif', *Le Surréalisme* (1966) (Paris–The Hague, 1968), p. 272.

77 Pierre Mabille, 'L'Oeil du peintre', *Minotaure*, No. 12–13 (1939). Sarene Alexandrian, 'Victor Brauner l'illuminé', *Cahiers d'Art* (1954). Alain Jouffroy, *Brauner* (Paris, 1959), p. 26.

78 From a lecture at the Pavillon de Marsan, March 1961. Quoted in the catalogue of the André Masson retrospective at the Musée National d'Art Moderne (Paris, March 1965), pp. 9–10.

79 *L.S.A.S.D.L.R.*, No. 6 (May, 1933), pp. 43–5, reprinted in 'Au-delà de la peinture', *Cahiers d'Art*, No. 6–7 (1936) where the date is given as 10 August 1925. Max Ernst also describes his invention of collage in 1919 in similar terms.

80 Paris, 1926.

81 The album *Grisou* with an anthology of 'explicated decalcomanias' is still unpublished (Marcel Jean and A. Mezei, *Histoire de la peinture surréaliste*, op. cit., p. 266).

82 'The craftsman does not become a poet by mere enthusiasm. It is not by exalting technique that he is able to give the spectator an illusion of avoiding technique and reaching the heights. Everything for the man who works with his hands, whether engraver, sculptor or painter, is a matter of technique; I would go so far as to say, thinking of Grünewald,

Tintoretto, El Greco and the sculptors Juan de Juni and Berruguete, that it is a matter of technical hysteria', *Traité du paysage* (Paris, 1941), p. 17.

83 I have tried to make a list, *Histoire de la peinture surréaliste*, op. cit., p. 193.

84 *Histoire de la peinture surréaliste*, op. cit., p. 266.

85 *L.S.A.S.D.L.R.*, No. 5, p. 13.

86 *Les Dessous d'une vie ou la pyramide humaine* (Paris, 1926).

87 *Traité du style* (Paris, 1928), p. 188. The two foregoing texts are quoted from and commented on by F. Alquié, *Philosophie du surréalisme*, op. cit., pp. 20–2.

88 Breton, *Position politique du surréalisme*, p. 37. Quoted by Alquié, op. cit., p. 186.

89 *La Création artistique et les promesses de la liberté* (Paris, 1973), p. 132.

90 A letter to H.R. Lenormand in the Bibliothèque Doucet, Picabia bequest, doc. 1920. Revault d'Allonnes also quotes the end of the letter: 'And we approach this search for knowledge by regression to childhood. Children are closer than we are to knowledge because they are closer to nothingness and knowledge is nothing', op. cit., p. 133.

91 James Johnson Sweeney, Miró article, in *Art News Annual*, no. 23 (1954), p. 187.

92 We must remember that the Paris streets were only supplied with electric lighting *c.* 1920. It was possible at the time to see a façade blazing with Mazda lamps.

93 Ibid., p. 105.

94 A. Breton, 'Hommage à Saint-Pol Roux', *Les Nouvelles littéraires* (1925).

95 'Manifeste du surréalisme', *Les Manifestes du surréalisme*, op. cit., p. 38.

96 'Au-delà de la peinture', *Cahiers d'Art*, No. 6–7 (1936).

97 E.L.T. Mesens, preface to the catalogue of the Max Ernst exhibition at Knokke-le-Zoute (1953, Jean and Mezei, op. cit., p. 77).

98 *La Révolution surréaliste*, No. 9–10 (October 1927), No. 11, 1928. *Variétés*, Special Surrealist issue (1929). Examples cited in Nadeau, op. cit., pp. 277 and 279, and in Jean and Mezei, op. cit., pp. 164 and 167.

99 'Le Merveilleux contre le mystère' (1936), *La Clé des champs* (Paris, 1973).

100 Freud, *The Interpretation of Dreams* (Collected Works, standard edition, Vols. 4 and 5).

100b I was correcting the proofs of this book when Sarane Alexandrian's very interesting work appeared, *Le Surréalisme et le rêve*. It contains detailed accounts of the associations between Surrealism and oneirism. It is rather surprising however that no painter has the right to the title 'President of the Republic of Dreams' (Part II, pp. 241 ff).

101 *La Vie secrète de Salvador Dali* (Paris, 1942), p. 169.

102 'L'Ane pourri', *L.S.A.S.D.L.R.*, No. 1, p. 9.

103 *The Letters of Sigmund Freud*, edited E.L. Freud (New York, 1960), letter of 1938 to Stephan Zweig, No. 304.

104 See George du Maurier's novel (1891).

105 Gilles Deleuze and Félix Guattari, *L'Anti-Oedipe* (Paris, 1972).

106 Aimée was in gaol, having knifed an actress. She had lost her memory by the time she appeared before the magistrate. Any real punishment would have freed her from her masochistic fixation. A 'cure' of this kind owes nothing to the doctor and the deep causes of the masochistic syndrome were not revealed. As for Aimée, she was back in the mental home a few years later.

107 Salvador Dali, *La Femme visible* (Paris, 1930).

108 I have described, following Jean and Mezei, the epic session during which he had to defend himself before the group in 1933. See Passeron, op. cit., p. 342.

109 Jurgis Baltrusaitis, op. cit.

110 *Dali de Draeger*, edited by Max Gérard (Paris, 1968).

111 *Vie secrète de Salvador Dali* (Paris, 1942), p. 169.

112 Ado Kyrou, *Le Surréalisme au cinéma* (Paris, 1953); J.-B. Brunuis, *En marge du cinéma français* (Paris, 1954); *L'Age du cinéma*, No. 6 (1951), special Surrealism issue.

113 *Le Surréalisme et la peinture*, op. cit., p. 275.

114 J. Baltrusaitis, *Aberrations* (Paris, 1957), pp. 47–72; Roger Caillois, 'Natura pictrix', *Cahiers du musée de poche*, No. 1 (March 1959), p. 33.

115 *Documents*, special issue, 'Intervention surréaliste' (1934), republished in *L'Arc*, No. 37 (n.d.), p. 17. Giacometti refused to allow it to be included among the Surrealist fetishes. He had broken with the Surrealist group since he had been required to explain his 'defection'. He had in fact very firmly disowned his Surrealist period (*L'Oeil*, 15 January 1955).

116 Frank Popper, *Naissance de l'art cinétique* (Paris, 1967), pp. 122–3. This interesting book is largely restricted to the equivocal 'retinal' notion of optics and kinetics, and very few Surrealist objects are referred to. Dominguez, for instance, is cited only in regard to his decalcomanias.

117 Jean and Mezei, *Histoire de la peinture surréaliste*, op. cit., pp. 280, 312, 336; Passeron, op. cit., pp. 278–84.

118 *Chants de Maldoror*, end of Chant IV.

119 Robert Benayoun, *Erotique du surréalisme* (Paris, 1965), pp. 230–1.

120 René Passeron, 'La Poïétique', *Revue d'esthétique* (1971), No. 3.

121 *Surréalisme et sexualité* (Paris, 1971), p. 331; the same idea is found in R. Passeron, 'Le Surréalisme des peintures', in *Entretiens sur le surréalisme* (Cérizy, 1966; Paris–The Hague, 1968), pp. 256–7.

122 Aragon, *Le Con d'Irène* (n.p., 1928), pp. 19–20; quoted by X. Gauthier, op. cit., p. 224.

123 André Breton, introduction to *Contes d'Arnim* (Paris, 1933).

124 *Le Surréalisme et la peinture*, op. cit. (text of 1938 edition), p. 144.

125 'Crise de l'objet' (1936), *Le Surréalisme et la peinture*, op. cit., p. 276.

126 *Second Manifeste du surréalisme* (1929).

127 *The Vision of René Magritte*, catalogue of the exhibition at the Walker Art Center, Minneapolis, September–October 1962.

128 René Passeron, *Magritte* (Paris, 1970), p. 74.

129 *Ceci n'est pas une pipe*, or *La Trahison des images* (1928). André Blavier, *Ceci n'est pas une pipe, contribution furtive à l'étude d'un tableau de René Magritte* (Verviers, 1973).

130 *L'Art de la ressemblance*, catalogue of the Magritte exhibition at the Obelisk Gallery (London, 1961).

131 *Minotaure*, No. 3 (1934).

132 *La Conquête de l'irrationnel*, op. cit., p. 12.

Bibliography

Abstract and Surrealist American Art, Modern Institute of Art, June–July, 1948 (Beverly Hills, California, 1948).

ADES DAWN, *Dada and Surrealism Reviewed* (catalogue of the exhibition at the Hayward Gallery, London, 1978) (London, 1978).

ALECHINSKY PIERRE, *Idéotraces* (Paris, 1966).

ALEXANDRIAN SARANE, *L'Art surréaliste* (Paris, 1970).

ALEXANDRIAN SARANE, *Dictionnaire de la peinture surréaliste* (Paris, 1973).

ALEXANDRIAN SARANE, *Le Surréalisme et le rêve* (Paris, 1974).

ALQUIÉ FERDINAND, *Philosophie du surréalisme* (Paris, 1955).

ARAGON LOUIS, *Traité du style* (Paris, 1928).

ARAGON LOUIS, *La Peinture au défi* (Paris, 1930).

ARAGON LOUIS, *Les Collages* (Paris, 1965).

ARP HANS, *On My Way* (New York, 1948).

ARTAUD ANTONIN, *L'Art et la mort* (Paris, 1931).

BALTRUSAITIS JURGIS, *Le Moyen Age Fantastique* (Paris, 1955).

BARR ALFRED, *Fantastic Art, Dada, Surrealism* (New York, third edn, 1947).

BÉDOUIN JEAN-LOUIS, *Vingt Ans de surréalisme, 1939–59* (Paris, 1961).

BÉDOUIN JEAN-LOUIS, *La Poésie surréaliste* (Paris, new edn, 1965).

BELLMER HANS, *Die Puppe* (Karlsruhe, 1934).

BELLMER HANS, *Die Puppe* (Berlin, 1962).

BENAYOUN ROBERT, *L'Érotique du surréalisme* (Paris, 1965).

BRETON ANDRÉ, *Manifestos of Surrealism* (Michigan, 1969).

BRETON ANDRÉ, *Surrealism and Painting* (London and New York, 1972).

BRETON ANDRÉ, *L'Art magique* (Paris, 1956).

BRETON ANDRÉ, *Constellations* (New York, 1959).

BRION MARCEL, *L'Art fantastique* (Paris, 1961).

BRUNIUS J.-B., *En marge du cinéma français* (Paris, 1954).

BUFFET-PICABIA GABRIELLE, *Aires abstraites* (Geneva, 1957).

CAILLOIS ROGER, *Au coeur du fantastique* (Paris, 1965).

CASSOU JEAN, *Sophie Taeuber-Arp* (Paris, 1964).

CASSOU JEAN et al., *Les Sources du Vingtième Siècle* (Paris, 1961).

CAZAUX JEAN, *Surréalisme et psychologie* (Paris, 1938).

CHIRICO GIORGIO DE, *Memorie della mia Vita* (Milan, 1945).

DALI SALVADOR, *The Secret Life of Salvador Dali* (New York, new and enlarged edn, 1961).

Dictionnaire abrégé du surréalisme (Paris, 1938).

DOMINGUEZ OSCAR, *Deux qui se croisent* (Paris, 1946).

DUCHAMP MARCEL, *Collection of the Société Anonyme, Inc.* (New York, 1920; new edn, Yale, 1960).

L'Ecart absolu (catalogue of the exhibition at the L'Oeil gallery) (Paris, 1965).

EDWARDS HUGH, *Surrealism and its Affinities: The Mary Reynolds Collection* (Chicago, 1956).

EHRMANN GILLES, *Les Inspirés et leurs demeures* (Paris, 1962).

ELUARD PAUL, *Donner à voir* (Paris, 1939).

ELUARD PAUL, *Voir* (Geneva, 1948).

ERNST MAX, *Max Ernst: Thirty Years of his Work, a Survey* (Beverly Hills, 1949).

ERNST MAX, *Beyond Painting and Other Writings by the Artist and His Friends* (New York, 1948).

ESTIENNE CHARLES, *Le Surréalisme* (Paris, 1956).

FIERENS PAUL, *Le Fantastique dans l'art flamand* (Brussels, 1947).

First Papers of Surrealism (catalogue of the exhibition) (New York, 1942).

FOWLIE W., *Age of Surrealism* (Bloomington, Ind., 1960).

GAFFÉ RENÉ, *Peintures à travers Dada et le surréalisme* (Brussels, 1952).

GASCOYNE DAVID, *A Short History of Surrealism* (London, 1935).

GAUTHIER X., *Surréalisme et sexualité* (Paris, 1971).

HAUSMAN RAOUL, *Courrier Dada* (Paris, 1958).

HEISLER J., *Cache-toi, guerre* (n.p., 1947).

HÉROLD JACQUES, *Maltraité de peinture* (Paris, 1957).

JANIS SIDNEY, *Abstract and Surrealist Art in the United States* (San Francisco, 1944).

JEAN MARCEL and MEZEI ARPAD, *Histoire de la peinture surréaliste* (Paris, new edn, 1967) (First edn translated as *The History of Surrealist Painting*, London, 1960).

JOUFFROY ALAIN, *Une Révolution du regard* (Paris, 1964).

KLEE PAUL, *On Modern Art* (London, 1948).

KLEE PAUL, *Pedagogical Sketchbook* (New York and London, 1963).

KYROU ADO, *Le Surréalisme au cinéma* (Paris, new edn, 1963).

LASCAULT GILBERT, *Le Monstre dans l'art occidental* (Paris, 1973).

LAUTRÉAMONT, *Maldoror* (Harmondsworth, 1978).

LEBEL ROBERT, *Premier Bilan de l'art actuel* (Paris, 1953).

LEGRAND FRANCINE-CLAIRE, *Le Symbolisme en Belgique* (Brussels, 1971).

LEVY JULIAN, *Surrealism* (New York, 1936).

MAGRITTE RENÉ, *Autobiographie* (Brussels, 1954).

Masters of Surrealism (catalogue of the exhibition at the Obelisk Gallery) (London, 1961).

MESENS E.-L.-T., *Surrealist Diversity* (London, 1945).

MONNEROT JULES, *La Poésie moderne et le sacré* (Paris, 1945).

MOTHERWELL ROBERT, *The Dada Painters and Poets: An Anthology* (New York, 1951).

NADEAU MAURICE, *The History of Surrealism* (New York and London, 1965).

PAALEN WOLFGANG, 'Form and Sense' in *Problems of Contemporary Art* (New York, 1945).

PAPAZOFF GEORGES, *Sur les pas du peintre* (Paris, n.d.).

PASSERON RENÉ, *Histoire de la peinture surréaliste* (Paris, 1968).

PICABIA FRANCIS, *Dits* (Paris, 1960).

PIERRE JOSÉ, *Le Surréalisme* (Lausanne, 1966).

PIEYRE DE MANDIARGUES ANDRÉ, *Les Monstres de Bomarzo* (Paris, 1957).

Quelques Ancêtres du surréalisme (catalogue of the exhibition at the Bibliothèque Nationale) (Paris, 1965).

RAY MAN, *Revolving Doors* (Paris, 1925).

RAY MAN, *Alphabet for Adults* (Beverly Hills, 1948).

RAY MAN, *Self-Portrait* (Boston, 1963).

RAYMOND M., *From Baudelaire to Surrealism* (New York, 1950).

READ HERBERT, *Surrealism* (London, 1936).

RICHTER HANS, *Dada, Art and Anti-Art* (London, 1965).

ROY CLAUDE, *Arts fantastiques* (Paris, 1960).

RUBIN W. S., *Dada, Surrealism and their Heritage* (New York, 1968).

SANOUILLET MICHEL, *Dada à Paris* (Paris, 1965).

SAVINIO ALBERTO, *Vie des fantômes* (Paris, 1965).

SOUPAULT PHILIPPE, *Collection fantôme* (Paris, 1973).

Surrealism Today (London, 1940).

Le Surréalisme en 1947 (Paris, 1947).

Surréalisme et Précurseurs (Besançon, 1961).

Le Surréalisme, edited by F. Alquié (Paris, 1968).

TANGUY YVES, *A Summary of his Works* (New York, 1963).

TZARA TRISTAN, *Sept Manifestes Dada* (Paris, 1924).

WALDBERG PATRICK, *Surrealism* (London and New York, 1966).

ZÜRN UNICA, *L'Homme-jasmin* (Paris, 1970).

List of Illustrations

Illustrations on dust jacket: GIORGIO DE CHIRICO *The Enigma of a Departure*, 1916. SALVADOR DALI *Persistence of Memory*, 1931. PAUL DELVAUX *The Dryads*. MAX ERNST *Long Live Love or the Wonderful Country*, 1923. FÉLIX LABISSE *Médusine*. RENÉ MAGRITTE *Philosophy in the Boudoir*, 1947. ANDRÉ MASSON *Untitled*. JOAN MIRÓ *Sad Traveller*, 1955. FRANCIS PICABIA *The Clowns*, 1925–8. YVES TANGUY *The Alphabet of the Wind*, 1944.

Photographs

Pierre Berrenger : 120; Bulloz : 22; Jorn Freddie : 64, 165; Galerie Beaubourg : 254, 255; Galerie Jeanne Bucher : 139, 175; Galerie Jean Fournier : 170; Galerie de France : 37, 114, 153, 174, 184, 218; Galerie Jardin des Arts : 182; Galerie Louise Leiris : 26, 37, 81, 195, 196, 197, 198, 199, 200, 222, 224, 225; Galerie Albert Loeb : 248; Galerie Maeght : 206; Galerie Odermatt : 252; Galerie l'Œuf du beau bourg : 166; Galerie André François Petit : 41, 45, 59, 121, 122, 123, 124, 136, 139, 140, 145, 152, 158, 162, 165, 176, 190, 192, 193, 234, 235, 239, 241, 242, 243, 249, 256; Galerie de Seine : 125, 130, 133, 137, 153, 172, 181, 183, 185, 193, 203, 213, 215, 216, 221, 232, 235, 237, 244, 250, 251; Galerie Françoise Tournié : 63, 151, 172, 204, 217, 229, 237, 239; Galerie Jacques Tronche : 119, 201; Garanger-Giraudon : 168; Giraudon : 22, 88, 91, 93, 95, 98, 99, 100, 101, 104, 106, 111, 115, 116, 118, 132, 139, 144, 158, 160, 208, 226, 237; Josse : 75, 120, 121, 137, 142, 149, 151, 160, 161, 167, 178, 182, 183, 187, 194, 202, 216, 218, 219, 220, 230, 242, 244; Lauros-Giraudon : 42, 67, 79, 93, 95, 99, 102, 106, 108, 110, 139, 148, 158, 159, 173, 179, 186, 196, 197, 226, 236, 238, 239; Librairie le Minotaure : 131, 233; Roger-Viollet : 58, 90, 129, 138; François Walch : 115, 126, 181, 184 (archives Galerie de France).

Index